William Holman Hunt

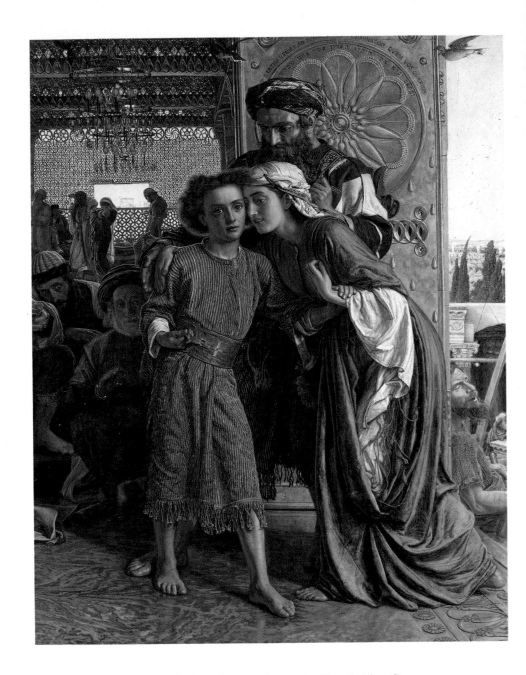

The finding of the Saviour in the Temple (detail)

William Holman Hunt

THE TRUE PRE-RAPHAELITE

Anne Clark Amor

CONSTABLE · LONDON

First published in Great Britain 1989
by Constable and Company Limited
10 Orange Street, London WC2H 7EG
Copyright © 1989 by Anne Clark Amor
Set in Linotron 11pt Bembo by
Rowland Phototypesetting Limited
Bury St Edmunds, Suffolk
Printed in Great Britain by
St Edmundsbury Press Limited
Bury St Edmunds, Suffolk

British Library CIP data
Amor, Anne Clark
William Holman Hunt: the true Pre-Raphaelite
1. English paintings. Hunt, William Holman
I. Title
759.2

ISBN 0 09 468770 6

TO MY HUSBAND

Contents

Illustrations

All the illustrations are by Hunt unless otherwise stated

The finding of the Saviour in the Temple (detail) frontispiece

between pages 64 and 65

Illustrations

Self-portrait, 1875
The Birthday (Hunt's second wife, Edith), 1868
The Plain of Esdraelon from the Heights above Nazareth, c.1876
The Beloved, 1898
First portrait of Hunt by Sir William Richmond, 1878
The Triumph of the Innocents, 1887
Miss Flamborough (Hunt's daughter, Gladys), 1882
The Tracer (Hunt's son, Hilary), 1886
Draycott Lodge from the lawn★
The entrance to Hunt's studio★
The Dining Room at Draycott Lodge★
The Drawing Room★
May Morning on Magdalen Tower, 1890
The Miracle of the Holy Fire, 1899
The Pearl, 1890
Second portrait of Hunt by Sir William Richmond, 1900
The Light of the World, 1853

★photograph

Introduction

Fashion in fine art being as ephemeral as in design, Pre-Raphaelitism was in the doldrums from the outbreak of the First World War until the fifties. Since then, many books on the Pre-Raphaelites, their inspiration, work, wives, mistresses and models have been published. Holman Hunt, who claimed with some justification to be the founder-member of the Brotherhood, has of course been included in these; but, since his two-volume autobiography, long out of print, there was no well-researched, full-length life until Anne Clark Amor took up the challenge.

Both Dante Gabriel Rossetti and John Millais have been more appealing to the general reader. Their early work, Rossetti's 'stunners' and Millais' portraits of society women and pretty children have again become sought after by dealers and collectors and prices have soared in consequence. Rossetti's and Millais' contrasting good looks and their family backgrounds seemed more glamorous. Also, the endless speculative gossip about their marriages was intriguing.

Poor Hunt, the son of a plebeian city warehouse manager and best remembered as a Victorian religious painter with a moral message, was unlikely to attract as much notice from an increasingly irreligious public. People of the fifties and sixties were more broad-minded and saw nothing intriguing about his marriages. The passing of the Deceased Wife's Sister's Act in 1907 was either forgotten or of little interest.

Even during the Second World War, *The Light of the World* was still the 'Protestant icon' and had for many years been the most popular picture in the world after the *Mona Lisa*. But Van Gogh's *Sunflowers* had taken over in the thirties and colourful prints of them hung on schoolroom walls and in contemporary flats.

Evelyn Waugh, who greatly admired Hunt's work, wrote to me before he died that he 'aspired to write a life of Hunt'. He complained that whereas Hunt's painting had received plenty of attention from art historians and critics, nothing was known of his private life. His character seemed enigmatic. During a weekend I spent with Evelyn and his wife, and in the correspondence which followed, he asked if Hunt had 'had any escapades' as a young man and complained that we knew nothing of his courtship of the two Waugh sisters. He wondered 'what went on' during the ten years after Hunt's first wife Fanny Waugh's death and how 'he finally settled' for her much younger sister Edith. Evelyn's father had found Hunt 'impenetrably aloof in his prime', and the general impression left by a few surviving anecdotes was that he was 'not a likeable man'.

I owned and had access to a great deal of material about Hunt's private life

and was anxious to help Evelyn. Most unfortunately he died before using my research, or even beginning to write what promised to be a splendid definitive biography.

With few exceptions, I did not admire Hunt's paintings. It was with trepidation that I ventured to write my version of his private life, until he married my grandmother Edith Waugh as his second wife when she was thirty-one and he was fifty.

I am sure that Evelyn would have been astounded by my revelations and even more interested in Clark Amor's scholarly book which includes the next thirty-three years until he died in 1910.

I discovered that Hunt's private life was as sensational as those of the other six Pre-Raphaelite Brothers and I was able to correct many false impressions. His father was not only a talented draughtsman and amateur water-colourist, but well-read and owned a small but erudite library. Like many intelligent men he had no head for business. He wasted time and money on unsuccessful property deals and litigation, just as his father and grandfather had before him, to recover the family's extensive lands and property confiscated when their ancestor opposed James II and was exiled to France. Although this ancestor returned with the army of William III, determined on justice, his efforts proved in vain. I vaguely dismissed this genealogical research, thinking it more romantic for a genius to spring from generations of impoverished, underprivileged forebears.

In portraits and sketches, his looks had never much impressed me, but judging by memoirs and letters and even more complimentary references quoted by Clark Amor, he was found wonderfully attractive by both sexes. He was also much loved by his many friends, to the point of youthful infatuation in Millais' case and desperation in that of the young Rossetti.

All the Brothers were extremely generous to each other, not only financially, if one of them were in dire need of 'tin', but recommending each other's work to rich patrons, which seems extremely altruistic. Clark Amor reveals more evidence of these praiseworthy qualities.

I was surprised to discover that Hunt's favourite pastimes, when not working like a maniac – he was known affectionately as 'the Mad' – were boxing, rowing, foxhunting, dancing, 'stunner-hunting' and attending posh parties. Even when far from affluent he dressed in the height of fashion, patronising Poole the Savile Row tailor and surpassing Millais in sartorial elegance. At his first wedding, the sandalwood oil with which he scented his beard was found pleasantly intoxicating. He was never a church-goer and, until he was twenty-six, was an agnostic despite a passionate interest in the Middle East, as well as in the history of Christianity, Judaism and Islam, conceived as a child from his father's copiously illustrated Bible. I agree with Clark Amor that it was largely due to the high-church Combes of Oxford and their subsequent loving patronage that he decided to concentrate on religious subjects.

In my book I did not take the conception of the first version of *The Light of the World* sufficiently seriously and confess I suspected a more material than spiritual motive. I also felt that it was Carlyle who had precipitated Hunt's

hasty departure for the Middle East, leaving some pot-boilers for his pupil Fred Stephens to finish.

When Carlyle called at Hunt's studio to see the picture, far from praising it like many high-church admirers, he condemned it as 'a papistical fancy'. He objected that Christ never strolled about wearing priestly robes, a golden crown, jewels and a halo. In real life He was footsore, ragged, dusty, hungry and exhausted by the hot sun and cold winds. Vehement, Carlyle shouted that Hunt should leave forthwith for the Holy Land and depict biblical scenes from Christ's life against realistic, authentic backgrounds. Fired with renewed enthusiasm for his original idea, Hunt took his advice.

On reaching Jerusalem, he led an exemplary moral life and was popular with the Christian and Jewish communities. Although his Arab servants thought his preoccupation with painting eccentric, they became devoted and respected him as a fair-minded master, a good shot and a fine horseman. He was also brave and when threatened by bloodthirsty brigands in the desert, stood his ground and then marched them back to the city at gunpoint to the British Consulate, where they were at once arrested.

When writing my version of Hunt's private life, I inferred from contemporary letters that during his first visit to the Middle East, he had quarrelled with some scoundrel called Gobat. However, in his reminiscences the only clue was a cryptic footnote. I ignored this, thinking it of no importance to my subject. Thanks to Clark Amor's more diligent research, I now discover that this arch-enemy was none other than the Bishop of Jerusalem – for a dedicated religious painter, this was an unfortunate choice.

The Bishop was head of the Anglican Mission. Homosexuality was rife among the boys at the Mission School but the Bishop was corrupt, took bribes and chose to ignore this. For pecuniary advantage, he forced the innocent daughter of Christian converts into a marriage with a notorious criminal suffering from syphilis. In fact, he committed endless crimes against the Christian and Jewish communities. Hunt was outraged, but when he confronted him, Gobat slammed the church door in his face.

Back in London, Hunt had many problems beside rows with the Bishop to occupy his mind. He had resolved that he could not return to the Middle East without a wife. She must be healthy and strong physically, adapt to the climate, ride fearlessly, be practical, domesticated and good-looking enough to serve as a model when needed.

Long before leaving England, on a model-hunting expedition he had discovered a teenage 'stunner' working as a barmaid at the rowdy Cross Keys public house in Chelsea. Her name was Annie Miller. She was swabbing spilt beer and filth off the floor. Her feet were bare, she was unkempt, her cascades of red-gold hair were verminous and she was illiterate. Nevertheless, Hunt could see that she was a beauty. He employed her as a model and, realising that she was also intelligent, gradually conceived the idea of making her his fair lady. Were she to become refined, take elocution and deportment lessons and learn to read and write, she might well suit him as a wife. Her sordid background must be hushed up so as not to scandalise his new grand friends. He had begun by hinting and then actually proposing that, were she to

become suitably accomplished and ladylike, he would reward her with a wedding-ring. Annie agreed to co-operate. While he was away in Syria he would pay for her education. She was installed in a respectable household to learn etiquette and put in the charge of a governess. This was all a bit of a lark for Annie. Money was left with Fred Stephens, who was always short of 'tin' and tempted to borrow from the fund in emergency. Also, like all their painter friends, he found Annie irresistibly attractive.

Hunt was delighted to find that during his absence Annie had made much progress with her education. She had become even more beautiful and surprisingly sophisticated and elegant. Having kept her part of the bargain, she saw no reason to delay their marriage.

However, he was preoccupied; work came first and he needed money. There were pictures to finish, patrons and dealers as well as many old friends to see. He suffered from attacks of malaria and toothache. His father died and Hunt unwisely promised him on his deathbed to look after his younger sister Emily and supervise her painting. He decided that they should share a house and studios in Kensington. There were many complications. He always chose the most laborious and time-consuming method of solving a problem – a real glutton for punishment.

Annie lived in Chelsea and felt neglected. Faint heart never won fair lady. Her life without him was much more fun, flirting with admirers, boating on the river, dancing at the Cremorne and making love with Rossetti. Sexually repressed until middle age, I feel that Hunt had little understanding of women. He had no close relationship with his mother and was only intimate with one of his five sisters, Emily, for a short time. In love affairs best friends are always a menace. Madox Brown noted in his diary that they all seemed 'mad about Annie'. She looked radiant and 'siren-like'. Hunt became furiously jealous of Rossetti. There were endless rows about unpaid bills and Annie's frivolity. Instead of using Hunt's allowance to pay for her lessons and rent, she spent it on fashionable dresses. The wretched Stephens became their go-between. It was obvious to me that Emily would get sick of house-keeping and detest and resent Annie drifting in and out looking ravishing. She took herself off to stay with Uncle Hobman to paint backgrounds in the country.

It was the last straw for Hunt, beset by problems and paranoid over Annie's suspected infidelities, when Emily wrote that she and Uncle Hobman were deeply shocked to read in *Household Words*, a journal owned and published by Dickens, a scandalous account of a depraved, lascivious affair Hunt had had with a field girl. Some time ago, he had picked up Emma Watkins at Ewell and installed her in his London studio to pose as the shepherdess for his picture *The Hireling Shepherd*. The satirical sketch was an 'infamous libel' according to Hunt's old friend Wilkie Collins.

When Hunt called on Dickens, who had no idea that the story involved him, they made friends and Hunt was persuaded not to sue and attract even more publicity. We have Clark Amor to thank for revealing that Hunt's main fear was that the scandal should reach Bishop Gobat. Not for the first or last time, 'the Mad' became paranoiac and although three years had passed since

he had left Jerusalem, he published a booklet describing the Bishop's in-
iquities. The Committee of the Jerusalem Diocesan Missionary Fund could
not ignore these allegations, but they supported and vindicated Gobat with
the Archbishop of Canterbury's approval. I wonder what Evelyn Waugh
would have made of this?

Clark Amor rightly condemns Annie for her subsequent behaviour in-
volving her lover Lord Ranelagh. She could have sued Hunt for breach of
promise but, choosing an awkward moment, sold him his compromising
love-letters and drawings of her instead. I found her fascinating and was so
disgusted by Hunt's unsavoury, sanctimonious letters advising Stephens
how to negotiate this transaction, that I was delighted to discover that she
married Lord Ranelagh's first cousin and lived in comfort and happiness for
the rest of her life.

Thomas Woolner, a postman's son and the only sculptor among the seven
original Pre-Raphaelites, had prospered and was courting Fanny, the eldest
and favourite daughter of George Waugh, a successful chemist who owned
much valuable London property and a country house in Leatherhead. When
he proposed to Fanny she turned him down, finding Hunt, whom he had
introduced as his best friend, far more attractive. Fanny had several unmar-
ried sisters and Woolner was encouraged to woo Alice who already fancied
him. Edith was still in the schoolroom, but when she caught a glimpse of
Hunt, it was love at first sight. Alice told her mother what a disreputable life
Hunt had led. Mrs Waugh was horrified, but all was well in the end and Hunt
and Fanny were at last happily married. As the bridegroom he kissed Edith, a
bridesmaid at the wedding; from that moment she became even more
obsessed by him. Perhaps sandalwood oil is an aphrodisiac?

When Fanny was five months pregnant, to the Waughs' dismay Hunt
insisted she accompany him to the perilous Middle East. She was angelic and
adored him. They were delayed in Florence, thanks to an outbreak of cholera
in Alexandria; and Fanny died an agonising death shortly after giving birth to
their son Cyril Benone. Hunt was brokenhearted and eventually returned to
the Waughs' in London with the baby. Emily was furious when Hunt refused
to give her custody and never spoke to him again.

Edith took charge of Cyril and confessed her undying love when sitting to
Hunt for her portrait, commissioned by her father to celebrate her twenty-
first birthday. Hunt fled. Although desperate for a wife, he was not in-
terested; it was illegal for a widower to marry his deceased wife's sister. As
Cyril's guardian, Edith had every excuse to write Hunt long letters and
enjoyed his replies.

On Hunt's return to Europe, despite frantic, cold-blooded courting of
young ladies, none was prepared to face the rigours of life in the Middle East.
Edith had waited for eight years. Clark Amor is more compassionate with
genius than I am. Hunt was not in love with Edith but dreaded returning to
Jerusalem without his son and a wife. After much painful indecision she told
her parents that they were determined to marry. Poor Edith was obliged to
leave home penniless; neither the Waughs nor Woolners spoke to her again.
Loyal as ever, Stephens and Clare, his newly-wedded wife, took her in until

she left for Switzerland. Typically, Hunt kept her waiting for many anxious weeks, until at last she triumphed and achieved a legal Swiss marriage and a white wedding.

Mercifully Hunt fell deeply in love with Edith and she proved an ideal wife, coping courageously with appalling and even dangerous situations in the Middle East. When pregnant, she thought nothing of riding for hours in the blazing sun and never complained. Palestine having a British Consulate, both her children were illegitimate. Clark Amor does not mention Bishop Gobat's reactions, perhaps he was dead?

When they finally settled in an elegant London house, surrounded by the many beautiful things which Hunt had collected over the years, mostly in Italy, Edith suffered socially. Old friends rallied round and some people were broad-minded, but hostesses were wary or even hostile, referring to her as Hunt's concubine. Her sister Alice proved her worst enemy and much to Hunt's and Millais' astonishment, Woolner spread rumours that in their youth they were homosexuals; there was no truth in this. No wonder Edith became obsessed with projecting a highly respectable image. Every hint of Hunt's scandalous past was suppressed. Fred and Clare Stephens knew too much: Edith encouraged Hunt to quarrel with them, their most loyal friends. I found this shocking. Of course Stephens became bitter about Hunt's ingratitude for the many services rendered. After all, he had been one of his first pupils and had painted most of the second version of *The Light of the World*; he got no credit for this. He was quite a good painter, but not in the same class as Hunt and wisely became an art critic. Thinking of 'class', Edith was a snob and had created a salon. Clare was a nobody; Stephens had taught her to read and write.

Hunt became Holy Hunt, a favourite of the Queen, the grand old man, the only true Pre-Raphaelite, with a gifted, beautiful, young wife. Edith fared better socially than Effie Millais despite her illegal marriage, which was at last legalised three years before Hunt died. He was on good terms with the Prince of Wales, who eventually awarded him the O.M.

The relationship between a biographer and his or her subject is unique. Hunt has become Clark Amor's hero. I wonder if Evelyn Waugh would have found him a 'likeable man'?

CHAPTER I

— ✿ —

Child of the city

IF William Hunt had not been taught from his infancy that painting was a vagabond profession, he might easily have become an artist. From his early childhood he liked to occupy his leisure hours with a paint-brush or pencil, and turned out some admirable little water-colours. But he was an obedient child, and when his father told him that his future lay in the sedate world of business, he dutifully resigned all hopes of an artistic career, and set aside his paint-box for Sundays and high holidays.

Originally the Hunts hailed from the north of England, and in the seventeenth century owned extensive lands and property around the docks in Hull. But an ancestor who opposed King James II was exiled to France, and his property was confiscated. Returning with the army of William III, he spent the remainder of his life in litigation, but failed to recover the ancestral fortune.

William Hunt's father was more realistic than his ancestors. Firmly setting aside all dreams of reclaiming his inheritance, he migrated to London and applied himself to sober business, becoming manager of a warehouse in the City. Encouraged by his father to take up the same occupation, William Hunt started as a messenger boy and worked his way up to the position of copy clerk. By diligent application he progressed steadily, until, in his early twenties, he became manager of Chadwick's Warehouse in Wood Street, off Cheapside. In 1822 he married Sarah Hobman, a daughter of William Hobman of Rotherhithe. Sarah's mother, Annie, a dark haired beauty six feet tall who was thought to have gipsy blood, had borne her husband twenty-two children, though only three boys and three girls survived into adult life.

William Hobman was a horsebreeder who had made a fortune

supplying draft horses to the army. Sarah, though small in stature, had inherited her mother's dark good looks and was her father's particular favourite. One day, contrary to his wife's wishes, her father insisted on taking her to a horse fair where she caught smallpox. Luckily the scarring was not serious, but William Hobman bitterly reproached himself for her illness and spent the rest of his life trying to make amends to her. Even for her sake, however, he was unable to give up the compulsive gambling with which he squandered his fortune, and after his death it was found that he had mortgaged his property to pay his debts. As a result, the family estate had to be sold.

Sarah's three brothers, William, Christopher and Alfred Hobman were all wealthy, and when she married William Hunt, it was generally considered that she had married beneath her. In temperament she was a forceful woman with a strong sense of propriety, and she continually harped on the lost family fortunes. In the spacious, upstairs apartment that went with her husband's job as warehouse manager, Sarah Hunt began producing children, in the fulness of time reaching a grand total of five girls and two boys.

On 2 April 1827 Sarah gave birth to their first son, and shortly afterwards had him baptized at St Giles', Cripplegate. Mindful of their own slender means, they named him William Hobman, after his rich uncle, in the conscious hope that the boy might ultimately become his heir. They also constantly referred to the material advantage of buttering up Uncle William, who although married, was childless. Detesting such sycophancy, and hating the prosaic-sounding Hobman name, the boy was later delighted to discover that it had been mis-spelt *Holman* on his baptismal certificate, and by his own choice was henceforth known as Holman Hunt.

In 1831 William Hunt moved to a larger warehouse in Dyer's Court, Aldermanbury, backing onto the Guildhall, and the family went to live in a house in the north east London suburbs, but the young Holman continued to haunt the warehouse, keenly observing everything that went on there.

'I was from the first meant for a citizen of the most thorough business training,' wrote Hunt in later years, 'the more so because from babyhood I delighted in a dangerous taste for pencil markings.'[1]

Soon after the Hunts moved house, fever broke out in the family, and Mr Hunt stayed at home to look after the invalids. Luckily Holman was not infected, and having recently been given some

theatrical prints, begged his father to paint them for him. To his delight, Mr Hunt readily agreed, and afterwards at the boy's earnest request, allowed him to borrow a brush and paints.

'How I idolised the implements when they were in my possession,' he wrote. 'The camel-hair pencil, with its translucent quill and rosy-coloured silk binding up its delicate hair at the base, all embedded together as in amber, was an equal joy with the gem-like cakes of paint. I carried them about with me in untiring love!'[2]

Unfortunately, before long he lost the beautiful camel hair brush, and though he searched high and low, he could not find it. In desperation he decided that he must try to make another. Looking at his own fine, straight, camel-coloured hair in the mirror, he cut off a lock and whittled a stick for the handle, working as quickly as he could for fear of discovery. When it was finished, he carried it carefully to his father.

'I went forward to him, holding the trophy very tenderly lest it should fall to pieces,' he wrote. 'He turned his eyes; they became bewildered; his usual loving look made a frown from him the more to be dreaded. I fortified my spirit, saying, "Thank you very much, father, for your brush." He took it with, "What's this?" and turned it over. Breathless, I sobbed; he burst out laughing, and so brought a torrent of tears to my eyes. He exclaimed, "Oh, I see, it's my brush, is it?" caught me up and tossed me aloft several times, ending with a scrubbing on my cheek from his close-shaven chin. This was the reception of my first work of art.'[3]

Hunt's father was the dominant influence of his childhood years. Although he was cautious and prudent in all his affairs, and was deeply preoccupied with the running of the warehouse, Mr Hunt was at heart a man of culture. He had inherited a small but select library, and spent much of his leisure time with his books and with the prints which he collected whenever he could afford them. A series of attractive landscapes, unostentatiously framed in black and gilt and inscribed, 'drawn by William Hunt, aged 9, 1809'[4] hung on the walls of his Aunt Nancy's sitting room. Aunt Nancy, who was childless, doted on her nephew and his children, and was never happier than when she was surrounded by the family. In after years Hunt recalled vividly 'Aunt Nancy with the bluest of eyes, and with cheeks vermeil-veined by the pencilling of nature, and with impulses of the most imperious benevolence!'[5] She loved the arts, and it was probably due to her influence that Hunt developed a taste for the theatre. It was she who

engaged a box and took the entire family to see Edmund Kean as Sir Giles Overreach, in his last public performance.

Although Mr Hunt had little time for painting, he believed that every man should have a hobby, and ideally one that was useful, instructive, and beneficial to the family. His own favourite pastime, which fulfilled all these criteria, was keeping scrapbooks, which he maintained as much for his children's instruction as for his own pleasure. Every Sunday, after the ceremonial reading of a chapter from the Bible, the scrapbooks were brought out, and Mr Hunt explained the pictures as the children pored over the bright pages. In this way he taught his children more of kings and queens, of people, places and national and international events than they learnt in many months of dull, formal schooling. One of the scrapbooks survives, with an inscription in Hunt's own hand to the effect that his interest in his father's scrap-books helped to determine him to become an artist.

Believing that it would be useful to him in his future business training, Mr Hunt usually took his son with him to work. The warehouse premises, which dated from the rebuilding of London after the Great Fire of 1666, were vast, with a complicated warren of cellars extending beneath the neighbouring houses. The great building shook with the eternal rumble of the hand-operated machines for winding cotton onto reels. Little Holman hated the young women winders, who caught him and kissed him when he passed, though he tried hard to avoid their notice. His favourite was Henry Pinchers, who worked in the velvet-binding room, and always made him laugh. Unlike his father and uncles, who all boasted splendid beards, Pinchers was clean-shaven. One day, with child-like frankness, Holman asked him why he had no whiskers, and Pinchers replied that it was because he always bit them off inside his mouth. According to Pinchers, Robin Badfellow used to come into the binding room in the middle of the night and undo all the work that he had done the day before.

Best of all, the boy liked to accompany one of the porters, who carried massive weights of goods about the City in a knot on his head. Soon he knew the mazy winding walkways intimately, and loved every inch of the City, from the narrow lanes and portalled walls, to the grassy nooks with their towering elm-trees, where rooks cawed ceaselessly as they built their nests.

Sometimes Holman managed to slip away from the warehouse unnoticed, and roam the city streets alone. On one such occasion, when he was only five years old, he was attracted by a large crowd of

people outside Newgate Prison. Curiously he edged forward, until a strange man hoisted him on his shoulder for a better view. Many years later, Holman's daughter Gladys recalled how the sickening sight that met his eyes haunted him for the rest of his life:

'High above the crowd, dangling from a rope, was a doll-like figure with a long black skirt that flapped in the wind.

It was with a feeling of indescribable nausea that the child realised he was witnessing an execution. He struggled so violently, that the man set him down upon the pavement, and he ran blindly home.'[6]

This may have been the execution in 1832 of Elizabeth Cooke, for the 'burking', or smothering, of Catherine Walsh.

One day Holman was in the packing room with an assortment of lead pencils, copying a picture of Britannia, when his father came in with a buyer.

'And is this little boy part of your stock-in-hand, sir?' asked the buyer.

'I cannot say, sir, that he has qualities conducive to business, but he has the great merit that when provided with paper and pencil we hear no more of him for hours,' replied Mr Hunt.[7]

In the winter of 1834, Mr Hunt took Holman with him to the home of an artist, whom he had commissioned to paint a picture of Herne Bay. The artist was also working on a painting of the burning of the Houses of Parliament, and Holman, who was enthralled by the process, begged to be allowed to stay on and see him at work. As a result, he was permitted to watch through a little window on the stairs. Meanwhile, the artist's wife went about her normal household duties, boiling the kettle, setting the table and cutting the bread with total indifference to the miraculous process going on in her husband's studio. Finally, to the boy's astonishment, the artist himself came downstairs and ate his tea like any ordinary mortal. When at last a porter came and took Holman home, he sat down in a corner with his pencils and paper and recreated the painting from memory.

At the age of eight, Holman was dispatched to boarding school. By way of consolation, his father gave him some drawing books and lithographs to copy. Mr Hunt visited him often, and could not resist sketching with him. The boy endured the rigours of school life without complaint, and worked hard at his lessons. One of his schoolbooks, dated 12 September 1837, shows that even at the age of ten he wrote in a splendid copperplate. It shows, too, how heavily his schoolwork was biased in favour of simple accounting and currency

conversion, as befitted a boy who was meant to follow his father into trade. Soon after his eleventh birthday he was given a second-hand copy of *Extracts, Elegant, Instructive, Entertaining, in Prose, etc., Books third, fourth and fifth*, 1791. The book was acquired from Crawford's Circulating Library, and the child feasted on this book, which contained sections on natural history, geography, narratives, etc., a list of 'Men of Learning and Genius', and a chronological table of inventions and discoveries.

Sometimes the monotony of boarding school life was broken when his rich uncle, William Hobman, turned up at the school in a fine carriage and took him out to dine at an expensive establishment in town. In the holidays, Holman spent many happy weeks with the Hobmans at their home, Rectory Farm in Ewell, Surrey. The farmhouse was a long, rambling, two-storey building, picturesquely covered in white weather boarding. When he was in his teens, Holman painted the spacious farmhouse kitchen, with its simple furnishings and domestic equipment. Chickens, that wandered in at will through the open doorway, are searching for crumbs on the floor, and a slim figure in a homely bonnet and gown is identified on the back of the picture as the youthful artist's mother.

Another frequent guest at the farmhouse was Holman's cousin, Alfred, whose wealthy father, Alfred Hobman, had presented him with a fine cob which he kept at Ewell. The two lads delighted in riding the cob on local excursions, taking turns in the saddle. As they grew older, they took an extra mount, and scampered over Banstead Downs to Epsom Racecourse and Ashted Park. Holman delighted in outdoor activity of all kinds, including swimming and boating. From the age of ten he took up boxing at which he quickly became proficient.

When Holman was twelve years old, he told his father that he wanted to become an artist. Mr Hunt was horrified. Though he felt almost as passionately about painting as his son, he could not tolerate the notion of art as a career for him, and warned him that artists almost invariably ended up dissipated, penniless, hounded by creditors, and addicted to drink. He reinforced his awful warnings by citing the case of George Morland, who despite his tremendous talent and the widespread popularity of his rural scenes, had died in 1804 in total destitution. Just in case Holman should be tempted to ignore his admonitions, he withdrew him immediately from school to set him to work as a warehouse messenger.

Young Hunt, however, had seen enough of warehouses to appreciate the soul-destroying drudgery involved, and determined at all costs to avoid such a fate. Hearing that a former schoolfellow was about to quit his job as a copying clerk in the office of an estate agent, he forestalled his father by applying for the job. The proprietor, Mr James, was somewhat nonplussed by this bold approach, but agreed to give the boy a test in arithmetic and handwriting, confidently expecting him to fail. To his astonishment, Hunt passed the test with full marks, earning considerable praise for his copperplate handwriting. Accordingly, Mr James offered him the post, and Mr Hunt, though astonished, could only applaud his son's acumen in securing better-paid employment.

It was a fortunate accident which had led Hunt to the estate agent's door, for Mr James was an enthusiastic amateur artist who specialized in poetic landscapes. Quickly discovering Hunt's talent, he gave him a box of oils, a set of brushes and a palette, and as soon as the pressure of work permitted, they spent a whole day painting together.

Soon after he started work, Hunt enrolled at a mechanics' institute where he attended evening classes in drawing. He also began to haunt the National Gallery, which at that time contained only about 60 paintings, many of them dirty and unglazed. Other pictures had been artifically 'mellowed' with a decoction of tobacco juice to give them the effect expected of old masters. Hunt made a small copy of Titian's *Bacchus and Ariadne*, which he loved, and was nonplussed when a lady to whom he showed it remarked that blue was 'such a vulgar colour'. Comments of this sort, which typified the prejudices of the age, were a clear warning of the struggle which lay ahead for a youth of determination and ability, who had already formulated personal values of artistic truth and fidelity to nature.

Meanwhile his father, satisfied that he was now settled in a respectable career, took him to see John Varley, a professor of water-colour landscape who lived in a six-roomed house in the Bayswater Road. Varley was the realization of all Mr Hunt's warnings about artists. He was penniless, and lived with his wife and four fat, yapping King Charles' spaniels, in constant hiding from the bailiffs. He also practised astrology, and told Hunt that he would achieve considerable success as an artist, reaching critical turning points in his career at the age of seventeen and again at twenty-seven. Varley died soon afterwards, but in the event his prophecy proved remarkably accurate.

Hunt now decided that he was in urgent need of a master to teach

him portraiture, and with his father's permission laid out some of his salary on lessons from Henry Rogers, a portrait artist in the tradition of Sir Joshua Reynolds. One of Hunt's earliest efforts was a self-portrait, painted at the age of fourteen, which demonstrates the remarkable degree of skill that he had already acquired. But he quickly fell out with Rogers' views, and later had to unlearn much that he had taught him. Rogers deplored his use of colour. In his view, greens should always be 'mellowed' into soft yellows and browns. Green was an unromantic, vegetable colour which had no place in landscape painting. So convinced was he of the correctness of his view, that he staked his opinion against that of established masters without a qualm:

'You must not paint foliage green, like a cabbage . . . Constable, who is just lately dead, tried to paint landscape green, but he only proved his wrong-headedness; in fact, he had no eye for colour,'[8] he said emphatically.

Mr James retired from business, and Hunt entered the London agency of Richard Cobden's Manchester based calico printing business. Cobden had not yet entered Parliament, though he had unsuccessfully contested the Stockport constituency in 1837, and with six other Manchester merchants had founded the Anti-Corn-Law League in 1838. When Hunt entered the firm, Cobden was already neglecting his own business interests to lecture up and down the country, and was achieving a reputation which prepared the way for his election as Member for Stockport in 1841.

With developing political awareness, Hunt took a keen interest in Cobden's progress and was broadly in sympathy with his views. As a junior employee in the Cateaton Street establishment, Hunt did not attract the great man's notice, though he produced some original calico designs on millboard, and was encouraged to paint the wooden panels in the office in oils with enlarged pictures from Dickens' *Barnaby Rudge*. In his spare time he read avidly, persevered with his portrait lessons, and on Sundays went into the country with his paint-box. His favourite haunt was Chingford Church, where he spent many happy hours painting in the shade of an ancient yew-tree. He had long since given up church-going, having decided that the preacher had nothing of value to impart to him.

When Hunt had been with Cobden's for some time, he took advantage of a slack period to paint a portrait of Hannah, an elderly Jewess who regularly sold oranges, apples, and paper twists of nuts and raisins in the warehouses around Aldermanbury. Returning to the

premises unexpectedly one day, Cobden found the picture hanging up to dry, and was so delighted when he recognized the sitter, that he forgot to reprimand the artist. This little episode was widely talked about, and unfortunately Mr Hunt got to hear of it. Furious at this encouragement of wayward talents in his son, which he regarded as the height of irresponsibility, he stormed round to Cateaton Street and threatened to remove him unless sufficient work could be found to prevent him from wasting time in forbidden pursuits.

It was this incident that finally led to a show-down between father and son. With unexpected courage, Hunt announced to his father that come what might, he would find a way to become an artist, and would do it without placing any form of financial burden on the family. Faced with this show of resolution, Mr Hunt relented, and gave him a letter of introduction to the Sculpture Department of the British Museum, which resulted in his being given permission to draw there. Mr Hunt also secured him a modest studio in the City where he could paint portraits. His sister Elizabeth emptied the entire contents of her money box into his hands to help defray his costs, an act of generosity which Hunt never forgot. In later years he contributed to her support, and provided an annuity of £10 for her at his death.

Feeling that he had embarked at last on the arduous career of his choice, Hunt moved in thankfully. Many of his former colleagues and other acquaintances, who had admired the portrait of Old Hannah, had expressed the wish that he would paint their portraits. His first client ordered miniatures of himself and his future bride. Hunt executed the commission with care, and the client expressed himself extremely satisfied. In his naïvety, Hunt let him take the pictures away on approval, whereupon he disappeared without paying. Bitterly discouraged, Hunt followed up his other 'commissions', only to find that the clients had changed their minds. Hunt was eventually forced to admit that his attempt at independence had failed, and returned to his father in humiliation.

Despite his lack of success, Hunt persevered with his studies, working three days a week at the British Museum, and two days a week at the National Gallery. He felt very isolated, and longed to gain admission to the Royal Academy Schools. Sympathizing at last with his son's struggle to earn a living, Mr Hunt wrote in 1843 to the Professor of Sculpture at the Royal Academy, Sir Richard West-macott, who gave Hunt an admission ticket to the Royal Academy lectures, which he attended with enthusiasm.

For the first time in his life, Hunt attended the prize-giving at the Royal Academy, greedily drinking in every detail of the great ceremonial occasion. George Jones, the Master, an erect, military-looking man who was famous for his pictures of battles, led the procession. In sharp contrast, Turner, a shambling, inelegant old man with a large head, brought up the rear. Interest centred on the award for a series of drawings from the antique, and it was generally expected that a clever thirty-year-old artist named Charles Fox would win the coveted gold medal.

The great audience was hushed, as the Master mounted the rostrum and read out the name of the winner: John Everett Millais. Amid wild applause, a slim, blue-eyed fourteen-year-old with fair curls tumbling over his white collar rose eagerly to his feet. Willing hands lifted him from seat to seat until he descended into the arena, where he bowed and approached the desk to receive the medal. Fox, who only got the third prize, refused to get up when his name was called, but the students forced him to go up and receive his medal.

Hunt was exhilarated by his first glimpse of the boy genius, who had been accepted in the Academy Schools at the age of ten years. At sixteen, he felt that he himself had got nowhere. That year he submitted a drawing in the hope of gaining admission, but to his disappointment, it was rejected. 'This failure sadly humiliated me; but I found a means of lessening the bitterness of the defeat to my family by explaining that I had but half time to work at simple drawing,' he wrote.[9]

Nevertheless, his faith in his own ability was in no way diminished, and the humiliation merely served to stiffen his will to succeed. Though he was already beginning to experience the difficulties and disappointments against which his father had warned him, he was determined to fulfil his own destiny. What Millais had done, he too could achieve. Perhaps in the days that lay ahead, he would get to know the boy, and ask him the secret of his success.

CHAPTER 2

— ❀ —

The vagabond profession

THOUGH Hunt continued to haunt the Royal Academy and occasionally caught distant glimpses of Millais, he was too shy to introduce himself. In the year that followed the prize-giving, he twice submitted drawings, only to be met with point-blank rejection. Gradually he grew more despondent, more especially because he had nobody in whom he could confide.

One day, Hunt was painting alone in the East Room when the doors opened, and a boy in a belted black velvet tunic, with bright shoulder-length curls spilling over his white collar, skipped into the room. Johnny Millais had all the grace of a leggy young colt, and looked much younger than his fifteen years. Long afterwards, Hunt recalled the encounter vividly: 'By and by he danced round until he was behind me, looked at my drawing for a minute, and then skipped off again. About a week later I found the same boy drawing from a cast in another room, and returned the compliment by staring at *his* drawing. Millais . . . turned round suddenly and said, "Oh, I say, you're the chap that was working in Number 12 the other day. You ought to be in the Academy." '[1]

A long conversation then ensued, in which Millais said how much he liked Hunt's drawing, and expressed the opinion that if he submitted one or two of the same calibre for probationership, he would be admitted immediately. This unexpected praise was music to Hunt's ears, and he asked Millais what method he recommended.

'Oh, the blocking-out system serves to make beginners understand the solidity of figures given by light and shade, modified by reflections and half-tints, and to get over muddling about with dirty chalk; you know all that. Very few fellows stick to it for long. I do sometimes use gray paper with white, but I like white paper just now. You see I

24

sketch the lines in with charcoal, and when I go over with chalk I rub in the whole with wash leather, take out the lights with bread, and work up the shadows till it's finished.'[2]

Much encouraged, Hunt followed his advice, and at the next trial, in July 1844, was admitted as a probationer, becoming a student in January of the following year. Shortly after he was admitted, he met Millais again. 'You've had your hair cut,' said the boy, pointing a finger at Hunt with childish frankness. He, too, had had his curls shorn, and was wearing his hair in what he described as his 'cockatoo crop'. Inviting Hunt to call him by his first name, he pressed him to go home with him to 83 Gower Street, where he lived with his parents, and had the luxury of his own studio.

Hunt accepted his invitation with alacrity. Johnny's studio was large and orderly, and bore the stamp of his own personality. The window looked out on to an unsightly brick wall, which Johnny had disguised by painting over the panes with Gothic figures and patterns in imitation of stained glass. On the walls were arrangements of beads and feathers, small pieces of armour and swords. All these were needed for his new Inca painting of *Pizarro*, on which he was about to start work. There was a large platform at one end of the studio, which would serve as the palanquin on which the doomed Inca was to be carried. Johnny's latest painting, *The Baptism of Guthrum*, which he had only just completed, still stood on the easel. A framed portrait of his half-brother, Clement Hodgkinson, occupied the place of honour above the mantelpiece, and there was a work-table in the corner of the studio, where Mrs Millais liked to sit and sew or read while her son painted.

When they entered the room, Mrs Millais was seated at the work-table with Clement and his wife. She was small and slender, with vivacious black eyes and a spirited expression which Johnny had inherited. Her nose was slightly arched at the bridge, and her glossy dark curls were drawn forward and held in place with little side-combs. Her husband, who arrived later, was descended from an old Norman family living in Jersey, and in his youth had been the handsomest man on the island. Johnny's blue eyes and fresh complexion were directly attributable to his father, who despite his background appeared a thorough Englishman. Mr Millais was obsessively tidy, and often wandered about the room straightening pictures and putting books and papers in order. He took a great interest in Johnny's work, and was always ready to oblige him as a sitter, putting on a

variety of false whiskers and dressing up in outlandish costumes to suit the theme.

Mr and Mrs Millais were more than delighted with Johnny's new friend. Their son had suffered from dreadful bullying in his early days at Henry Sass's Academy in Bloomsbury, and though he was now a universal favourite, his anxious parents had not forgotten it. They confided to Hunt how one fellow, Jack Harris, a promising student but a thorough brute, had twirled the frightened boy above his head, and had marched him about upside-down by the ankles, with his hair sweeping the ground. On another occasion Harris had suspended him upside-down from an open window, until he lost consciousness, and was rescued by passers-by who fetched the headmaster.

Though Hunt had had only the rudiments of an education, and had had little social training, the Millais family respected his genius and made him as welcome as if he were a member of the family. In no time, under Johnny's influence, Hunt was taught how to dance, performing with remarkable ease in a second-hand velvet suit.

Mary Millais was an exceptionally intelligent woman. She was widely read, and helped Johnny by suggesting suitable subjects for his paintings. She was prepared to go to great lengths in the cause of authenticity, often researching difficult questions for him at the British Museum. It was she who designed and made the costumes for his models, putting the garments together at the work-table in his studio and reading aloud to him while he painted. She adored her brilliant son with his angelic good looks, and consciously or unconsciously, strove to keep him in childhood dependency as long as she could. She dressed him in pretty velvet suits, with four-inch white collars, white socks and patent leather pumps. In this way she accentuated all that was childish, even girlish, in his appearance. Despite her outward contentment as a wife and mother, Mrs Millais inwardly resented the stifling of her own personal creativity, and found her fulfilment instead through her son's career. This powerful maternal domination of the boy stifled his natural development and had lifelong effects on his relationships with women.

Hunt saw at once that the Millais family was socially superior to his own, and realized the advantages of being brought up in a household where art was regarded as a highly respected career. Dearly though he loved his own father, he regretted the lack of parental encouragement in the career he had chosen. Life had been easy for Johnny, who had found the path to professional accomplishment smoothed for him at

every turn. Yet Johnny was still imprisoned in childhood, and urgently needed to escape if he was to achieve his true potential. Hunt, who had had to struggle against almost overwhelming odds, had been making his own way in the world for the past five years, and even allowing for the two-year age gap between them, was much more mature than Millais in all respects except his art. His character was strong and determined, and he was prepared to fight for success as an artist no matter what the odds. Yet though Johnny could offer him invaluable advice in technical matters, he had as much to gain from the friendship as Hunt. It soon became apparent to them both that this new intimacy between them supplied a heartfelt need, and was soon to revolutionize their lives.

As the intimacy between Johnny and Holman progressed, Mr Millais invited Mr Hunt to call at 83 Gower Street. Hunt's father was astonished when he found how the Millais family respected the artistic profession, and began to look at matters in a new light as a result, even to the extent of considering whether he could now help his son financially. He had long wished to retire from business life, and had scrimped and saved for years to that end. When Aunt Nancy had died, a few years previously, leaving him a handsome little legacy, he had looked around for an appropriate piece of property to bring him in a rental income. His choice had eventually fallen on a row of suitable houses, though he had needed to supplement the legacy with a mortgage which was to be repaid over six years, using the rental income to meet the repayments. In 1844, having paid off the mortgage, he realized his ambition, and quit the warehouse for ever. He was now forty-four years old. The family promptly moved to a spacious apartment above a furniture shop at 108–109, High Holborn, in Bloomsbury. Holman, as he now wished to be known to his intimate family and friends, was allocated a big room at the top of the building as his studio. He was exultant at this piece of unexpected good luck, and even more so when his father told him that he need no longer pay for his board.

Regrettably this good fortune did not last long. The solicitor whom Mr Hunt had employed for the conveyance of his houses had been grossly negligent. He had accepted the word of the vendor that the vendor's son, who had inherited the property, was dead. This was not in fact the case, and as soon as the mortgage had been paid off, the son turned up, claiming not only his houses, but six years' back rent on the property. Later, Mr Hunt found out that the son had been a party to

the confidence trick all along, and had divided the proceeds with his father.

A lifetime's business experience had not prepared Mr Hunt for fraud on this scale. His brief encounter with the legal profession had been a total disaster, and at the back of his mind were his father's words about the futility of engaging in long and costly litigation. Instead of taking the perpetrators to court, he reached a compromise with them, taking out a further large mortgage, which hobbled him financially like a ball and chain for the rest of his life. Deeply though he regretted it, he was not now able to offer his son the free board and lodging that he had promised, though at least Hunt now had a decent studio conveniently located near the British Museum.

In 1846 Hunt exhibited his first picture, *Little Nell and Her Grandfather*, at the British Institution. His social conscience had been awakened while he worked for Richard Cobden, and he read the novels of Dickens avidly whenever he could lay hands on them. The story of *The Old Curiosity Shop* had grown out of 'Master Humphrey's Clock', a short serial story which Dickens had begun writing for *Bentley's Miscellany*. Realizing as he worked on the story that it had great possibilities, Dickens had extended it and published it in serial form in 1840 and 1842. The death of Little Nell reminded Dickens so forcibly of his emotions on the death of his sister-in-law, Mary, with whom he was secretly in love, that he had had the utmost difficulty in finishing the story. Dickens wrote to his friend, John Forster, about little Nell's death: 'Nobody will miss her like I shall. It is such a very painful thing to me, that I really cannot express my sorrow . . . Dear Mary died yesterday, when I think of this sad story.'³

The Old Curiosity Shop made a powerful impact on the Victorian imagination, and in choosing *Little Nell and Her Grandfather* as the subject of his painting, Hunt was making a direct appeal to popular taste. The resulting picture was highly competent, and indicated a rapidly maturing talent in the nineteen-year-old artist. In the same year he exhibited at the Royal Academy for the first time. His picture was called *Hark*, and the subject, which was also calculated to please the public, was Hunt's seven-year-old sister, Emily, holding a watch to her ear.

Finding suitable models was something of a problem to Hunt, for he could not afford to employ a professional sitter. At least for the time being, he had to make do with members of his family, and this had some bearing on his choice of subjects. He was still deeply influenced

by his reading, and found the subject for his next major work in the novels of Sir Walter Scott. It was entitled *Dr Rochecliffe performing Divine Service in the cottage of Joceline Joliffe at Woodstock*. 'I chose a subject from *Woodstock*, because it belonged to a class of pictures most popular, and so offered a fair chance of sale, as well as due exercise in serious inventiveness,' wrote Hunt.[4] He entered the painting for the Royal Academy Exhibition of 1847. Although it was well placed at the Academy, it was under the line. Nevertheless, on varnishing day it had attracted much favourable comment from established artists, and Hunt, who had priced it at £40, had high hopes of selling it.

To Hunt's disappointment, several weeks went by and no buyer emerged. Eventually he decided to go and stay with his uncle, William Hobman, at Rectory Farm, to nurse his bruised ego and find suitable subjects for his brush. He loved the village of Ewell and its environs, which he described lyrically in his memoirs:

> The village itself had no sense of modern bustling or hurry: all was arranged spaciously, all work executed with deliberation, and with such unostentation that externally there was but little to distinguish the chemist's shop from the baker's, or any other tradesman's house from that of his neighbour. On the outskirts of the trading centre there were gentlemen's homes and farmsteads . . . The water from the spring bore itself away in an opposite direction, first carolling along a pebble-strewed channel into a shallow pool crossed by a flat bridge, whence by the quiet searcher might be seen red-spotted trout poised in mid-water, and casting their sun-shadows onto the mossy gravel below, steady as though painted there. In the region beyond, the stream expanded, bordered by well-tended lawns patterned with gaily flowered garden beds; between these widened borders lay an islet with weeping willows kissing the surface of the water . . . A stone's throw off, the pulsing wheel drew one's attention, and enticed one's steps along a road to the face of the mill, where whitened men bearing sacks of flour descended . . .[5]

William Hobman, ever sympathetic to his nephew, paid him to paint his portrait. One day the Rector, Sir George Glyn, saw him painting the church, which stood close by Rectory Farm and was scheduled for demolition, and told him that if he liked the finished picture, he would buy it. With wry humour Hunt painted his own name on one of the tombstones in the foreground. While he was working on this picture,

29

Hunt received a letter from F. Glendinning, who had won the Art Union Prize of £20. Having much admired Hunt's *Woodstock* painting, Glendinning now offered to devote his prize money to purchasing it. Hunt was uncertain whether or not to accept, but his uncle, who had a very sensible approach to business matters, strongly advised him to do so, pointing out that this would enable him to buy materials for the work of the coming year. A stranger's recognition of a first picture was worth the twenty missing pounds, he said.

When Hunt returned to Bloomsbury, he began work on his first major religious painting, *Christ and the Two Maries*. Urgently needing palms to copy, he set off one day for Kew Gardens with James Keys, a fellow student. Though he worked from 7.30 a.m. he was nowhere near finished when closing time approached. Luckily, the keeper was singularly sympathetic, and lopping a twelve-foot-long branch from a palm tree, he gave it to Hunt to take back to his studio. Dusk was already gathering when they set off towards Turnham Green, with Hunt in front and Keys behind, bearing Hunt's trophy on their shoulders. Suddenly there was a shout and Keys came to a halt, exclaiming that something disagreeable had fallen down his neck. Fishing inside his coat collar, Hunt felt a cold, dry object, about the size of a man's hand. Drawing it out, he discovered that it was a dead bat, which had evidently been dislodged from the branch.

Despite much hard work on his picture, Hunt was dissatisfied with the figure of Christ. The canvas had had to be enlarged, but when it came back from the colourman's he realized that it was still too small. Unfortunately he had now spent all his money, and had to put it aside and paint portraits for cash. For the time being, however, he suffered from a deep sense of failure, from which Millais finally rescued him by praising the character of the painting. 'I explained to him the system of painting without dead colouring, which I had more than ever been following in the progress of this work,' Hunt wrote. It was his intention to take up the work again when his financial position improved, but in the event half a century elapsed before he finished it.

It was at about this time that a fellow student arranged for Hunt to borrow Ruskin's *Modern Painters* for twenty-four hours. Hunt sat up all night reading it with mounting excitement. 'Up to that day', he wrote, 'I had been compelled to think that the sober modern world tolerated art only as a sort of vagabondish cleverness, that in England it was a disgrace, charitably moderated in very exceptional cases, and

that if toleration of it lingered at all, it would not be in intellectual and elevated circles . . . Of all its readers none could have felt more strongly than myself that it was written expressly for him.'[7]

Hunt now began a new painting, this time taking his inspiration from a volume of Keats's poems that he had bought from a barrow for fourpence. His subject was *The Flight of Madeline and Porphyro during the drunkenness attending the revelry*, from *The Eve of St Agnes*. As the painting progressed, Hunt took Millais back to his studio to see it. Millais, in turn, invited Hunt to call at his home to see his own work, *Cymon and Iphigenia*. Millais was at that time in dispute with his mother, having informed her that he could no longer tolerate his studio being used as a general sitting-room. Mrs Millais attempted to lobby Hunt on his arrival, and, not wanting to be drawn into a domestic dispute, he hurried into the studio.

'He was now a tall youth,' wrote Hunt of his friend; 'his bronze-coloured locks stood up, twisting and curling so thickly that the parting itself was lost; he dressed with exact conventionality to avoid in any degree courting attention as a genius.'[8]

Though the delicacy of his earlier years had been replaced by robust health, due in the main to his vigorous pursuit of outdoor activities, Millais was exceedingly thin. William Millais, his artist brother, in later years recalled Johnny's preoccupation with his weight: 'My brother, up to the age of twenty-four, was very slight in figure, and his height of six feet tended to exaggerate the tenuity of his appearance. He took pleasure in weighing himself, and was delighted with any increase in weight.'[9] On one occasion, finding that he weighed nine stone, Johnny remarked, 'I ought to be going about in a menagerie as a specimen of a living paper-knife.'[10]

Having inspected the picture, Hunt produced the precious volume of Keats from his pocket and began reading it aloud in a parson-like saw while his young friend painted. Though Millais laughed at Hunt's delivery, he was enthusiastic about Keats's poetry. Somewhat to Hunt's disappointment, however, he could not be persuaded to read Ruskin's *Modern Painters*, believing that it was better to stick to his own principles than adopt the views of others.

Hunt now put forward the view that 'the course of previous generations of artists which led to excellence cannot be too studiously followed . . . but their treatment of subjects, perfect as they were for their time, should not be repeated.'[11] He and Johnny questioned the inflexible rules that all figures in a picture should be set on an 's'-shaped

ground line, and that the several parts of a composition should be apexed in pyramids. They saw no reason why the light should always fall on the principal figure, or why one corner should always be in shade. In their view, these rigid rules were paralysing, and made no real sense.

'For what reason is the sky in a daylight picture made as black as night? And then about colour, why should the gradation go from the principal white, through yellow to pink and red, and so on to stronger colours? With all this subserviency to early examples, when the turn of violet comes, why does the courage of the modern imitator fail?' Millais asked. 'If you notice, a clean purple is scarcely ever given these days, and pure green is as much ignored.'[12]

At this juncture, Mrs Millais knocked at the door, with a tray of tea. 'I really can't let you in, Mama,' he returned. 'Please put the tray down at the door, and I'll take it myself.'[13]

When they had finished their discussion, the two young artists joined the rest of the family in the parlour. Mrs Millais was still furious with her son, and attempted to canvass Hunt's support, but Johnny put his father's guitar into his hands and persuaded him to play his favourite air from *Rigoletto*, while he himself played backgammon with his mother until her good-humour was restored.

In the next few months, the intimacy between the two young men increased almost daily. Finally, as the Royal Academy Exhibition of 1848 loomed nearer, Johnny invited Hunt to his studio, where they could work companionably day and night together, until their paintings were finished. Delighted, Hunt accepted. From time to time, to relieve the monotony, he would paint a piece of drapery for Johnny, who in return would work on a head for Hunt. While they worked, they had lively discussions about art, and drank coffee to keep themselves awake. In particular, they talked about the cartoons of Raphael, and condemned 'The Transfiguration'. Hunt cited Charles Bell's *Anatomy of Expression*:

I hope I am not insensible to the beauties of that picture, nor presumptuous in saying that the figure is not natural. A physician would conclude that this youth was feigning. He is, I presume, convulsed; he is stiffened with contractions and his eyes are turned in their sockets. But no child was ever so affected. In real convulsions the extensor muscles yield to the more powerful contractions of the flexor muscle; whereas, in the picture, the lad extends his

arms, and the fingers of the left hand are stretched unnaturally backwards.[14]

Both Hunt and Millais were united in regarding this picture as a definite stage in the decadence of Italian art, and aired their views to their fellow students at the Royal Academy. One of these remarked that he presumed that they were therefore Pre-Raphaelites, a label which clung to them, until they began to use it themselves to describe their own particular views on art. Such opinions were regarded as akin to treason by the Academicians, very few of whom would have challenged the established theory of art, which stifled virtually every attempt at originality. If any of them doubted those theories, they kept such thoughts to themselves, for to acknowledge them openly was to court rejection. Wives and children had to be fed, and if a man was to make a living by his brush, he must accede to popular taste.

Eventually the pictures were handed in, and the two friends were able to relax. They used their new-found freedom to attend the last great Chartist demonstration on 10 April 1848. The object of the rally was to march to the Houses of Parliament to present a petition to the Government. Chartism was essentially a working-class movement devoted to universal suffrage, vote by ballot, payment of members of Parliament, and other electoral reforms. There were fears that the demonstration would get out of hand, and Johnny's anxious parents made Hunt promise to look after their son. But the government was determined to prevent the march taking place, and had laid its plans accordingly.

Hunt and Millais joined the procession at Russell Square, accompanying the demonstrators over Blackfriars Bridge to Kennington Common. From their vantage-point outside the enclosure they had a prime view of the orators on the van in the centre of the green. The celebrated Fergus O'Connor, who led the demonstration, was taken by a policeman to the Police Superintendent, on a promise that he would not be detained. When he returned, the crowd dispersed at his request. Riflemen menaced the demonstrators from the surrounding rooftops, and Blackfriars Bridge was barred by police. There were sounds of a bloody affray, which Millais was all for investigating, and Hunt had difficulty in dragging him away. At that moment the skies opened and a deluge of rain effectively dispersed the crowds.

While Holman and Johnny were thus engaged, an event was taking place in Scotland which was to have a profound effect on Johnny's life;

for on this day, in the drawing-room of Bowerswell, on the east side of the Tay, Euphemia Gray was married to John Ruskin. The relationship was to prove disastrous, ending in a much-publicized divorce. After much anguish and heart-searching, Euphemia was eventually to become Mrs John Millais.

Meanwhile, Hunt and Millais had many other preoccupations. They had recently joined the Cyclographic Club, whose members provided a drawing each month, and criticized the drawings of the others. The club had been formed by three young artists, one of whom was Walter Howell Deverell. Hunt and Millais joined shortly after-wards, together with Arthur Hughes, and Dante Gabriel Rossetti. The club was short-lived, and the general standard was not high, though Rossetti's drawings attracted their notice. Arthur Hughes wrote afterwards: 'Millais, who was the only man among us who had any money, provided a nice green portfolio with a lock in which to keep the drawings. Millais did his drawing, and one. or two of the others did theirs. Then the "Folio" came to Rossetti, where it stuck forever.'[15]

Hunt's *Eve of St Agnes* was hung in a good light at the Royal Academy Exhibition, and attracted a great deal of attention. Sur-prisingly, however, Millais's *Cymon and Iphigenia* was rejected by the Hanging Committee. This was a severe blow to Johnny's pride, and in order to take his mind off his failure, his mother sent him into the country. Hunt was accordingly left behind in London at this critical point in his career to face the full onslaught of the critics alone.

CHAPTER 3

———— ❀ ————

The Brotherhood

OPENING day at the Royal Academy found Hunt nervously wondering what kind of reception his work would be given. In the event, it received considerable attention, but the most significant comment came from a young and totally inexperienced student called Dante Gabriel Rossetti, who declared with noisy and slightly embarrassing enthusiasm that Hunt's *Eve of St Agnes* was the finest painting in the whole exhibition. He also praised Hunt's courage in choosing a work from a little-known poet for his subject matter, instead of the popular literary giants. A common love of Keats drew Rossetti like a magnet to Hunt's studio, and the two men immediately became intimate.

Rossetti was a year younger than Hunt. His father, Gabriele Rossetti, was an Italian political exile, and his mother was the English-born daughter of the Tuscan poet, Gaetano Polidori. The elder Rossetti had eked out a precarious living as a teacher and translator, and had been Professor of Italian at King's College. When, in 1843, he became partially blind and subject to chronic bronchitis, he was no longer able to work. Dante Gabriel's elder sister Maria was accordingly compelled to become a governess, and shortly afterwards his younger brother, William Michael Rossetti, was sent to work as a government clerk, contributing his modest salary of £80 a year to the support of the family. Christina avoided Maria's fate by pleading ill-health, which was probably feigned or imaginary, and which enabled her to stay at home writing her poetry.

Dante Gabriel, far from contributing to the family income, was a drain on the resources of the others, for he went to Sass's Academy, where he trained for admission to the Royal Academy Schools. Quickly becoming bored with copying plaster casts and figures from

classical statuary, he absented himself from the classes, and occupied himself instead with pen and ink imitations of book illustrations, somewhat reminiscent of Gilbert's book designs. He was steeped in literature, and his drawings were of knights in armour and beautiful damsels, all stamped with his own amazing and totally individual style.

Despite his neglect of his studies, he was admitted to the Antique School of the Royal Academy in 1846. Once more restlessness and boredom set in, and his attendance was erratic, but the other students clamoured for his sketches of knights rescuing maidens and rousing incidents from romantic poetry. Hunt was drawn to Rossetti immediately, despite his obvious eccentricities.

'Imagine, then, a young man of decidedly Southern breed and aspect,' wrote Hunt, 'about five feet seven inches in height, with long brown hair touching his shoulders, not caring to walk erect, but rolling carelessly as he slouched along, pouting with parted lips, searching with dreaming eyes; the openings large and oval; grey eyes, looking directly only when arrested by external interest, otherwise gazing listlessly about, the iris not reaching the lower lid, the ball of the eye somewhat prominent by its fullness; the lids above and below tawny coloured. His nose was aquiline and delicate, with a depression from the frontal sinus shaping the bridge; the nostrils full, the brow rounded and prominent, and the line of the jaw angular and marked. His shoulders were not square, and only just masculine in shape. His singularity of gait depended upon his width of hip. Altogether, he was a lightly-built man, with delicate hands and feet; although neither weak nor fragile in computation, he was altogether unaffected by athletic exercise. He was careless in his dress, which was, as then not very usual with professional men, black and of evening cut. So indifferent was he to the accepted requirements of society, that he would allow spots of mud to remain dry on his clothes for several days. He wore a brown overcoat, and, with his pushing stride and careless exclamations, a special scrutiny would have been needed to discern the refinement and tenderness that dwelt in the breast of the defiant youth . . . the language of the painter was wealthy and polished, and he proved to be courteous, gentle and winsome.'[1]

Hunt was already beginning work on his new theme, *Rienzi vowing to obtain Justice for the Death of his young Brother, slain in a skirmish between the Colonna and Orsini factions*. The subject was taken from

Bulwer Lytton's novel, *Rienzi, the Last of the Tribunes*, and Hunt proposed to submit his picture with the quotation:

> But for that event, the future liberator of Rome might have been but a dreamer, a scholar, a poet – the peaceful rival of Petrarch – a man of thoughts, not deeds. But from that time, all his faculties, energies, fancies, genius, became concentrated in a single point; and patriotism, before a vision, leaped into the life and vigour of a passion.[2]

This stirring theme had an irresistible appeal for the son of an Italian refugee, and the choice of subject alone was sufficient to elevate Hunt in Rossetti's imagination. Rossetti listened wide-eyed and full of admiration as Hunt explained how in this work he would set aside all conventional dogma, and seek his inspiration direct from nature. Stirred by the thrilling theme and carried away by Hunt's eloquence, Rossetti was immediately won over to the cause of Pre-Raphaelitism, and begged to be allowed to join with Hunt and Millais in their struggle against the dogma of 'Sir Sloshua' Reynolds. Confident that Millais would welcome this new friend, Hunt gave his provisional acceptance.

In March 1848, Rossetti had asked Ford Madox Brown, an artist a few years older than himself, to accept him as a pupil, but predictably, Brown had set him still-life subjects, and equally predictably, Rossetti had rebelled. For a while he had neglected his art for poetry, and was working alone in the studio of John Hancock, a sculptor and fellow-member of the Cyclographic Club, whom he had met in 1847. Hancock, a wizened little man with a long, thin nose and a squeaky voice, was more affluent than Rossetti, being related to an old-established family of silversmiths and jewellers.

Though bored by Ford Madox Brown's exercises, Rossetti would have been the first to admit that he had learned a great deal from Brown. Born in 1821, Brown had studied from the age of fourteen years in Bruges under Gregorius, a pupil of the French painter Jacques Louis David. Three years later, he had transferred to Antwerp, where he had studied under Baron Gustav Wappers, later moving on to Paris, where he had worked independently in the Louvre. Finally, in 1844 he had gone to live and work in Rome for two years, partly in the hope that the climate would benefit the health of his ailing wife, who died in 1846. In Italy he came under the influence of the German

painters Overbeck and Cornelius, and their fellow artists in the 'Brotherhood of St Luke'. The Brothers, who were satirically called the 'Nazarenes', were dedicated to a revival of medieval art, were sworn to celibacy, and repudiated sensuality, even to the extent of preferring lay figures to naked human flesh. Instead of soft chalk, they favoured sharp pencil outlines, and their preparatory studies and cartoons were particularly sought-after among English collectors.

Rossetti was deeply receptive to the work of the Nazarenes. He was also heavily influenced by William Blake, having bought one of Blake's notebooks from William Palmer, an attendant in the Antique Gallery of the British Museum. In this notebook, Blake poured scorn on the doctrines of Sir Joshua Reynolds. Rossetti was therefore heavily predisposed to favour the views of Millais and Hunt in regard to 'Sir Sloshua'.

Recognizing Hunt's genius, Rossetti begged him to take him as a pupil, but Hunt was unable to agree, partly because he feared the effect of Gabriel's uncouth appearance on his family, with whom he still lodged, and partly because he had already accepted Frederick George Stephens as his pupil. Born on 10 October 1827, Stephens had been crippled for life at the age of nine in an accident at a private school. His father, Septimus Stephens of Aberdeen, who at one time was master of the Strand Union Workhouse in Cleveland Street, had subsequently sent him to University College School, and he had gained his entrance to the Royal Academy Schools in 1844.

Rossetti was excited by the concept of Pre-Raphaelitism, and not content with being provisionally accepted himself, now proposed three additional members. The first of these was his brother William, who was not even a painter, though Gabriel insisted that he had the talent to become one. The second was James Collinson, an artist who was paying court to their sister, the poetess Christina Rossetti: Collinson's favourite themes were religious and domestic subjects, and like Gabriel, he also wrote poems, which were often based on his own paintings. The third was Thomas Woolner, a sculptor with Chartist sympathies whose studio was next door to Hancock's. Woolner was slightly older than Hunt, who described him as 'about five feet eight inches in height, and of robust build; he had thick blond hair inclining to brown, and with his dark eyes he was a handsome youth.'[3]

Woolner shared a studio with fellow-sculptor Bernard Smith, and Rossetti took Hunt there to make his acquaintance. Hunt took to him

immediately, and was impressed by his professional skill. Woolner had been working on a giant figure, ten feet high and swathed in the inevitable damp cloths which were part and parcel of a sculptor's life.

Lack of a proper furnace was a severe handicap to his work, and less talented sculptors won commissions which Woolner, with only an ordinary open fireplace, could not tackle. Despite these handicaps, he was good-humoured, being an excellent raconteur with a fund of entertaining stories, which made him universally popular.

Explaining the situation to Millais, Hunt said: 'The numbers grew so fast, and his [Rossetti's] confidence in our power was so extensive, that I determined to put a limit to the number of probationary members, which I did by adding my nominal painting pupil Stephens. So far I have not yet been able to awaken in him the novice's indispensible passion, but being treated as a real artist may awaken his ambition.'[4]

At one stage they also gave consideration to the claims of Ford Madox Brown as a candidate, and at Rossetti's instigation, an invitation was framed but never delivered. Many years later, Hunt explained the reasons:

1) That he was rather too old to sympathise entirely with a movement that was a little boyish in tone;
2) that although his works showed great dramatic power, they had too much of the grimly grotesque to render him an ally likely to do service with the general public; and
3) that his works had none of the minute rendering of natural objects that the Pre-Raphaelites, as young men, had determined should distinguish their works.[5]

So far, lack of funds had prevented Hunt from seeking the true independence that he so earnestly desired, but his *Flight of Madeline and Porphyro* was sold to the Art Union for £63, being purchased by Charles Bridger, a well-known archaeologist and antiquary. Hunt was glad enough at the time to accept this price, though the painting was resold within the next decade for £250. As soon as the money was safely in his pocket, Hunt took a studio at 7, Cleveland Street, Fitzroy Square, near the workhouse. Giving in to Gabriel's importunities at the last minute, he took an extra bedroom so that Gabriel could join

him, sharing the rent and receiving instruction and advice. On 20 August 1848, Gabriel wrote to his brother William: 'Hunt and I are now settled down quite comfortably, and he is now engaged on the preliminaries for his picture of *Rienzi* . . . Hunt and I went the other night to Woolner's where we composed a poem of 24 stanzas on the alternate system . . . Hunt's stanzas in our poem partook of the metaphysico-mysterioso-obscure.'[6]

The dismal studio which Hunt shared with Rossetti was lit by a single window and the light was further restricted by the monstrous orange stacks of wood in the neighbouring timber-yard. The room itself was large and gaunt, with walls distempered in dark maroon, deepened by the dust and smoke of ages, and this added to the general gloom. It was approached by a badly-lit staircase, shared with a clattering boys' school. Disturbing sounds of beating and sobbing frequently emanated depressingly from the schoolroom.

'Add to these melancholy elements a dimly-lighted hall,' wrote Stephens, 'surcharged by air of which the damp of the timber-yard was not the only source of its mustiness, and a shabby out-at-elbows doorway, giving access from the street that, even then, was rapidly "going down in the world". It was sliding, so to say, to its present *zero* of rag and bottle shops, penny barbers, pawnbrokers and retailers of the smallest possible capital.'[7]

At the time of the move, Hunt was working on *Rienzi*, using a fellow-student for the central figure. Quickly realizing that Gabriel personified the hero, he substituted him as the model. All their friends were agreed that it was an admirable likeness of Rossetti as he was at that time. Stephens wrote: 'The pallor of his carnations was exaggerated and made more adust to suit the passion of the incident; but the large, dark eyes, strangely masked dark eyebrows, bold, dome-like forehead, the abundant long and curling hair falling on each side of the face, and especially the full red lips conspicuous in the picture are, or rather were, of Rossetti to the life.'[8]

Millais was the model for the young knight in armour, Adrian, to the left of the picture. 'Rossetti . . . said that when he looked at Millais's full-face, it was that of an angel,' recalled Hunt. 'The expression marks Rossetti's exaltation of mind when in his more dreamy moods; he possessed, as was already proved in his black and white designs, a true novice's devotion to poetic mysticism and beauty, and a power of invention the exercise of which is meat and drink to the real artist.'[9]

Gabriel had chosen for his own subject *The Girlhood of Mary Virgin*, a picture filled with symbolic references to the life of Jesus. Significantly, he cast his own mother and his sister Christina, who were cloaked in Anglican pietism, in the respective roles of St Anne and the Virgin Mary. Hunt described Christina as 'exactly the pure and docile-hearted damsel that her brother portrayed God's Virgin pre-elect to be.'[10] William Bell Scott, whose poetry filled the youthful Gabriel with enthusiasm, called to see him and found him working in the studio with Hunt. Initially thinking that they were painting in the manner of the Dutch realists, he quickly decided that they were recording nature in a way that was apparently photographic. It seemed to Scott entirely appropriate that Gabriel should use his sister as a model for the Virgin. In the picture, the Virgin and her mother are portrayed embroidering a lily on a scarlet cloth, while a small angel and a white dove, symbolizing the Holy Ghost, look on. A briar with seven thorns and a palm with seven leaves are tied with a scroll inscribed *'tot dolores tot gaudia'* ('so many griefs, so many joys'), and outside, St Joseph prunes the True Vine. A cross entwined with ivy and a crimson cloak symbolizing Christ's raiment complete the picture.

The relationship between Hunt and Rossetti was full of banter and good humour. In a letter to William, ten days after moving in, Gabriel wrote:

Apropos of death, Hunt and I are going to get up among our acquaintance a Mutual Suicide Association, by the regulations whereof any member, being weary of life, may call at any time upon another to cut his throat for him. It is of course to be done very quietly, without weeping or gnashing of teeth. I, for instance, am to go in and say, 'I say, Hunt, just stop painting that head a minute, and cut my throat,' to which he will respond by telling the model to keep the position as he will only be a moment, and having done his duty, will proceed with the painting.[11]

In the same letter, Rossetti added that he and Hunt had prepared a list of Immortals, to be pasted up in their study, so that all decent fellows could add their signatures. The preparation of this list may have been suggested to Hunt by the list of 'Men of Learning and Genius' in his boyhood book *Extracts, Elegant, Instructive, Entertaining, in Prose, etc.*

Millais was still out of town when the first meeting of the proposed

fraternity was called. In a letter to Hunt in September 1848, Gabriel wrote, 'Collinson, my brother and self think that my house will be best adapted for our first meeting, as it is more central.'[12] Gabriel also referred in the same letter to his proposal that his sister Christina should be admitted to the fraternity, which did not meet with the approval of the others:

> When I proposed that my sister should join, I never meant that she should attend the meetings, to which I know it would be impossible to persuade her, as it would bring her to a pitch of nervousness infinitely worse than Collinson's. I merely intended that she should entrust her productions to my reading; but must give up the idea, as I find she objects to this also, under the impression that it would seem like display, I believe – a sort of thing she abhors . . .[13]

Hunt was somewhat alarmed at the prospect of telling Millais that he had enlisted five additional friends to support the cause of Pre-Raphaelitism, and indeed, when Johnny returned to London it was immediately apparent that he was jealous. Until now, he had had Hunt to himself, and had formed such a deep attachment to him that he resented sharing him with anyone, most of all the handsome Gabriel, with his culture and his magnetic southern charm. Woolner at once suspected that the relationship between Hunt and Millais was homosexual, and many years later, Hunt got to hear of this. 'I *can't* think how Woolner can have circulated any story about you and me . . .' Millais wrote.[14] Yet whatever their exact relationship, they were intensely emotionally dependent on each other, and in later years both men found it difficult to establish satisfactory relationships with women.

While this mood of doubt remained with Millais, a meeting was called in his studio. Johnny's parents were even more worried about the possible effects of the association between their boy and these Bohemian friends. The appearance of the candidates for Pre-Raphaelitism was hardly calculated to set Millais's parents' minds at rest, for their attire was far less conventional than that of Hunt and Millais. In particular, Gabriel's outlandish appearance, as described by F. G. Stephens, was disturbing: 'A bare throat, a falling, ill-kept collar, boots not over-familiar with brushes, black and well-worn habiliments, including, not the ordinary frock or jacket of the period, but a very loose dress-coat which had once been new – these were the

outward and visible signs of a mood which cared even less for appearances than the art-student of those days was accustomed to, which undoubtedly was little enough.'[15]

But despite their total lack of expertise as painters, the young men who met together at 83 Gower Street were so amiable and full of enthusiasm that even the reluctant Johnny was quite won over, and they were accepted into the circle. When Gabriel suggested that they should call themselves the Pre-Raphaelite *Brotherhood*, and sign all their paintings with the enigmatic initials *PRB*, the motion was enthusiastically carried.

'Millais and I had thought at first of husbanding only our own fields,' wrote Hunt, 'but the outspoken zeal of our companions raised the prospect of winning waste lands and of gaining for English Art a new realm from the wilds, such as should be worthy of the Race.'[16]

'All the members of the Pre-Raphaelite Brotherhood belonged to the middle or lower classes of society,' wrote William Rossetti later. 'Not one (if I except my brother and myself) had had that sort of liberal education which comprises Latin and Greek, nor did any of them – not even Millais, though connected with Jersey – read or speak French. Faults of speech and spelling occurred among them *passim*. Of any access to "the upper classes" through family ties there was not a trace.'[17]

As a special mark of his approval, Millais showed the Brethren a collection of Lasinio engravings of the fourteenth-century frescos at the Campo Santa, at Pisa, and another set of outlines by Führich in the Retzsch manner. Gabriel was privately rather scathing about the former, and said as much to Brown later, though Brown forced him to revise his opinions. But Führich was one of the Nazarenes, and had a particular appeal to Rossetti.

Twelve years later, Stephens wrote of the Brotherhood, 'The majority of artists did little more than represent studies of dresses, cleverly executed accessories placed upon motionless lay figures, each as inane as its fellow. This was a kind of art our students felt to be quite unworthy of the name, and little else than a disgrace to the nation, being, in short, worked only in the ideal adopted by the decorators of French plum-boxes . . . Above all, they determined these pictures should at least *mean* something; be no longer the false representations of sham sentiment, but express thought, feeling or purpose of the painter's own mind, not a chromatic translation of a novelist or poet. Here lies the gist of Pre-Raphaelitism; this is what really distinguishes

the movement; and herein consists the true service it has done to English art.'[18]

Rossetti's painting gave him endless problems. Hunt advised him to concentrate on the foliage of the vine and the ivy before autumn set in and the leaves fell from the branches. After two weeks' work, he returned to the studio with the leaves too crudely green. He had, it seemed, failed to learn the first lesson. Gabriel was too impatient to stick at anything for long. He had a succession of four or more models for the small angel, each more unmanageable than the last. One gentle little child so irritated him that he stormed wildly around the studio, throwing his tools about until the unfortunate girl screamed with terror. Clouds of dust were raised and Hunt's tranquillity was lost. Finally Hunt restored order, and took Gabriel for a walk in Regent's Park, explaining gently that if the tantrums continued, they would have to separate. This had the desired effect on Rossetti, who modified his behaviour, and finally used Woolner's little sister as a model for his angel.

These were not the only problems. Gabriel continually turned up at the studio with hordes of friends, all expecting to be fed. Hunt had already given up meat as an economy, and scarcely knew how to cater for the endless stream of visitors. To Hunt's eternal irritation, Gabriel also persisted in describing the work of the Pre-Raphaelite Brotherhood as 'early Christian' thereby making it plain that he had an entirely different concept of the work of the Brotherhood from Hunt and Millais. He was altogether too impatient to persevere with anything for long. While outwardly worshipping nature, he was bored by long days in the country, and he painted his leaves with care only under pressure from Hunt. Although Hunt painstakingly lectured him on perspective, the tiles on the floor in the finished picture have multiple vanishing points, and the figure of St Joseph seems too near the foreground figures. Gabriel later said about the movement: 'Pre-Raphaelites! A group of young fellows who couldn't draw . . . Why should we go on talking about the visionary vanities of half-a-dozen boys?'[19]

While this was true of the other five, it was certainly not the case with Hunt and Millais. Yet it was Gabriel who produced the spark of revolutionary fervour in the group, and urged them on to new challenges, broadening their interest in literature, even music and the stage, and encouraging them all the while to extend their own cultural interests. The Pre-Raphaelites were dedicated to reforming the

art of England, curiously enough, not by overthrowing the art establishment of their day, but by gaining acceptance for their work.

'When we agreed to use the letters PRB as our insignia,' wrote Hunt, 'we made each member solemnly promise to keep its meaning strictly secret, foreseeing the danger of offending the reigning powers of the time. The name of our Body was meant to keep in our minds our determination to do battle against the volatile art of the day, which had for its ambition "Monkeyana" frivolities, "Books of Beauty", Chorister Boys, whose forms were those of melted wax with drapery of no tangible texture.'[20]

In October 1848, Millais, who had discharged his outstanding commitments, settled down to produce a series of etchings which he and Hunt planned as illustrations for Keats's poem, *Isabella and the Pot of Basil*. Both William and Gabriel Rossetti modelled for Millais's picture, and described it as 'distinctly marvellous'. Meanwhile, in the studio, the Brethren had been discussing the role of the artist in society, adopting the list of Immortals originally drawn up by Hunt and Rossetti: 'Ordinary children of men fulfilled their work by providing food, clothing, and tools for their fellows; some, who did not engage in such labour, had allowed their minds to work without the ballast of common sense, but the few far-seeing ones revealed vast visions of beauty to mankind,' wrote Hunt.[21] Gabriel copied out their manifesto and list of Immortals, noting degrees of glory by a system of stars, with a declaration: 'We, the undersigned, declare that the following list of Immortals constitutes the whole of our Creed, and that there exists no other Immortality than what is centred in their names and in the names of their contemporaries, in whom this list is reflected.'[22]

The list contained 57 entries, including some collectives, like the Early English Balladists. Only Shakespeare and the Author of Job rated three stars, while Rienzi ranked with Chaucer, Leonardo da Vinci and Thackeray in receiving two stars. As an afterthought, Jesus Christ was promoted to the top of the list with an allocation of four stars. The Brethren's flirtation with atheism was short-lived. A few weeks later Hunt started work on his new picture, *A Converted British Family Sheltering a Christian Priest from the Persecution of the Druids*. This effectively marked the end of his brief non-belief in the soul's immortality.

'As soon as the Pre-Raphaelite Brotherhood was formed,' wrote William Rossetti, 'it became a focus of boundless companionship,

pleasant and touching to recall. We were really like brothers, con-
tinually together, and confiding to one another all experiences bearing
on questions of art and literature, and many affecting us as individuals.
We dropped using the term "Esquire" on letters, and substituted
"PRB". I do not exaggerate in saying that every member of the
fraternity was just as much intent upon furthering the advance and
promoting the interests of his "Brothers" as his own . . . We had our
thoughts, our unrestrained converse, our studies, aspirations, efforts,
and actual doings; and for every PRB to drink a cup or two of tea or
coffee, or a glass of beer, in the company of other PRBs . . . was a
heart-relished luxury, the equal of which the flow of long years has not
often presented, I take it, to any one of us. Those were the great days of
youth; and each man in the company, even if he did not project great
things of his own, revelled in poetry or sunned himself in art.'[23]

Even Collinson, whom they had regarded as amiable but unexcit-
ing, blossomed under the influence of the Brotherhood. His new
picture, *The Charity Boy's Debut*, astounded them all. Gabriel pro-
nounced him 'a born stunner', and his latest poem, *The Child Jesus*, 'a
very first rate affair'. Collinson set to work to illustrate the poem,
which the Brothers planned to use in the journal which they were now
planning to publish. In September 1848 Collinson plucked up suf-
ficient courage to ask the eighteen-year-old Christina Rossetti to
marry him, and although at first she declined, they became engaged to
be married shortly afterwards.

A dragoness of a landlady, six feet tall, presided over Collinson's
lodging in the Polygon. Collinson had no sense of fun, and at the
Brotherhood's Bohemian repasts he could be guaranteed to fall asleep.
One fine moonlit night at Hunt's studio, the Brothers decided to take a
stroll in the country, despite the unwilling Collinson's protests that he
would rather go to bed. Nevertheless, he insisted on going home to
change his boots, and when the Brothers knocked at his door half-an-
hour later, there was no reply. The dragoness, annoyed by the
disturbance, summoned a policeman, who upheld their right to knock
him up. Eventually Collinson got out of bed, and accompanied them
up the hill and over the heath.

'Above and beyond lay moonlight and moon-shaded heath and
common land, decked with drowsy trees against the unchanging and
unclouded heavens,' wrote Hunt. 'Walking down the vale we saw a
settlement of haze, level as water sleeping in the hollow, broad as the
ancient river must have been which scored it out, and this vapour

gradually immersed the trees on the descending slope from roots to topmost branches . . . Continuing our journey, we arrived at a village, where, surrounded by a semicircle of cottages, we seated ourselves on the pedestal of the village pump. Our conversation at first was exclusively for our own benefit, but in the end we set up a lusty shout with a view to waking Collinson for the homeward journey. It was a great hurrah; at the same instant we saw a candle lighted in the first floor window of each cottage of the little hamlet, and twenty or thirty nightcapped heads were thrust out simultaneously at the surrounding casements.'[24]

These were halcyon days for the Pre-Raphaelite Brotherhood. Yet these months of carefree youthful endeavour were not to last for long. Difficulties of a kind they had scarcely imagined lay ahead, and for some of the Brothers the trials and attendant disillusionment would be more than they could bear.

CHAPTER 4

— ❀ —

Broken ranks

As the Royal Academy Exhibition of 1849 loomed nearer, Hunt worked at his picture of Rienzi with passionate intensity. The studio in Cleveland Street was a hive of industry, for even the indolent Gabriel threw himself into his work with an increasing sense of urgency. A look of proud cynicism mixed with a furtive kind of energy burned in his eyes as he stood at his easel, and when he was in the vein he worked day and night, eating whatever was to hand and snatching a couple of hours' fitful sleep in the armchair from time to time.

Despite the pressure of work, Hunt continued to attend the Life Class. One evening as he was returning home, he bumped into his old employer, Mr James, who begged to see *Rienzi*. Though Hunt had only fourteen days left in which to finish the picture, he could not refuse such a kind friend, and took him back to his studio. To his mortification, Mr James entirely condemned the picture.

'Could you persuade yourself that such a weak piece of work could possibly command attention?' he asked. 'It is obvious enough that all the minutiae introduced must have taxed the greatest patience and labour, but who do you think would trouble their heads about that?'[1]

With well-meaning want of tact, Mr James urged Hunt to turn his canvas endways up, paint a tragic head shouting war, famine and slaughter, holding a torch aloft, casting a lurid light on the face. The background, he said, should be as black as possible. Such a picture could be finished in a fortnight, and would claim considerable attention.

Hunt was filled with gloom by the old man's visit. After Mr James had left, he went upstairs to his room and locked the door. Sinking into the armchair, he found himself confronted by his personal devil, a

hairy monster who haunted him in his moments of darkest despair, and who now left him doubled up in torment. Eventually Gabriel heard him talking aloud in anguish, and made him open the door. The fire had gone out in the grate, and Hunt was shivering with cold. Gently Gabriel coaxed him downstairs, fed him and warmed him by the fire, and with all his usual loyalty and enthusiasm, restored his self-confidence and good humour.

Meanwhile, rumours of the excellence of Millais's picture reached the ears of Ford Madox Brown, who went to the Millais home in Gower Street to see it. When he saw the painting, he was so excited by its excellence, that he rushed to see Hunt in his studio, declaring Millais to be 'a master of the most exalted proficiency'.[2] Brown himself usually exhibited at the so-called 'free' exhibition at St George's Place, Hyde Park Corner, where there was no distinguished judging committee, and the only criterion for being hung was the ability to pay for the hanging space.

On sending-in day at the Royal Academy, Hunt and Millais duly presented their work, bearing the enigmatic PRB symbol. Both *Rienzi* and *Lorenzo and Isabella* were accepted. To their surprise, Gabriel was unaccountably absent from the Academy. Both he and his painting had disappeared from the studio in Cleveland Street. Only gradually did it occur to the Brothers that Gabriel had broken ranks. Tormented by doubts and fearful that his painting might be rejected, Gabriel had sent in his picture, bearing the initials PRB, to the 'free' exhibition instead. This gave him a little extra time to finish his work, but meant that his picture would be on public display a whole week before those at the Royal Academy. Everyone was furious with Gabriel, including the Millais family and the Hunts, but Hunt himself, who adored the young man, was more hurt than angry. The studio in Cleveland Street seemed strangely empty without him: '. . . he must have contemplated with revulsion the mere possibility of being rejected at the Academy – an institution which (apart from any crudities or peculiarities in his first picture) might perhaps view him with some disfavour as having abandoned the Academy course of instruction, and learned from an outsider how to handle pigments and brushes,'[3] wrote William Rossetti.

Gabriel's picture in the event aroused considerable interest. The *Athenaeum* said of it: 'The picture, which is full of allegory, has much of that sacred mysticism inseparable from the works of the early masters, and much of the tone of the poets of the same time.'[4]

Nevertheless, his painting remained unsold when the exhibition closed, though it was eventually bought by the Marchioness of Bath for eighty guineas. Rossetti's Aunt Charlotte worked as companion to the Dowager Marchioness, and probably her influence had something to do with it.

Millais had sold *Lorenzo and Isabella* for £150 to three tailors in Bond Street before the exhibition opened. In Hunt's estimation it was the most wonderful painting *ever* by a young man under twenty. To his disappointment, his own picture was assigned by the hanging committee to the Octagonal Room, usually referred to as 'the Condemned Cell'. The *Athenaeum* reviewed the works of both Millais and Hunt unfavourably:

> The faults of the two pictures under consideration are the results of the partial views which have led their authors to the practice of a time when knowledge of light and shade and of the means of imparting due relief by the systematic conduct of aerial perspective had not obtained. Without the aid of these in the treatment of incident and costume we get but such pictorial form of expression as seen through the magnifying medium of a lens, would be presented to us in the mediaeval illumination of the chronicle or the romance. Against this choice of pictorial expression let the student be cautioned. He may gain admirers by it among those whose antiquarian prejudices may be gratified by the clever revival of the merely curious, but he will fail to win the sympathy of those who know what are the several integral parts necessary to making up the great sum of truth.[5]

Unfortunately, this bad publicity eroded the confidence of Millais's three tailors, and obliged him to cut the price of *Lorenzo and Isabella* by half, though the purchasers did at least give him a free suit as a bonus. Pocketing his cash, Millais retired to the country near Oxford to nurse his feelings of resentment towards Gabriel and to paint backgrounds for his pictures.

Gabriel's defection caused consternation and embarrassment in the Brotherhood. Everyone felt that he had behaved badly, but William was bound to him by family allegiance. Collinson and Woolner, while openly sympathetic to Hunt and Millais, were conscious that it was Gabriel who had acted as their sponsor in the Brotherhood. All of

them admired Gabriel's personal genius, and sincerely loved the young man, despite his cowardice.

The Brotherhood continued to meet regularly as though nothing had happened, and they were often joined by non-members in their social activities. During the summer of 1849, Woolner introduced the Brothers to Coventry Patmore. At his house they made the acquaintance of Carlyle, Browning, Tennyson and William Allingham. In such distinguished literary company it is scarcely surprising that the Pre-Raphaelites conceived the idea of producing their own magazine. Patmore was enthusiastic about the project, and undertook to contribute some poems. It was agreed that the publication should be placed on sale to the public.

William wrote to his sister Christina, at Pleaseley Hill, where she was spending a disastrous holiday with Collinson's family, who appeared to disapprove of their engagement. To William's surprise, she rejected his invitation to contribute to the journal, because William North, an eccentric minor novelist whose 'rabid Chartist' views offended her, was to be associated with it. In the event, North's connection with the publication was short-lived.

After the Royal Academy Exhibition, Hunt disconsolately took *Rienzi* back to his studio. His shortage of 'tin' was now acute. To make matters worse, Gabriel had sent a messenger round to the studio to collect his belongings, and claimed to have given notice to Hunt with effect from the previous Lady Day. This meant a financial loss to Hunt, who had to give a quarter's notice on the extra bedroom. He was unable to meet the commitment, and hoped that the landlord would extend his credit until his work was sold. In his reduced circumstances, Hunt had pawned everything with a commercial value in a desperate attempt to remain solvent. At this juncture he received a letter which lifted his wilting morale, even though it could not improve his fortune:

Sir,
Allow me to say how much I was pleased and struck by your picture from *Rienzi*. I appreciate the compliment you have paid my work. The picture is full of genius and high promise.
Your obliged and admiringly,
E. Bulwer Lytton.[6]

When Hunt's spirits were at their lowest ebb, Nockalls Cottingham, an architect aged about thirty-five, whose father had been a celebrated builder and restorer of churches and cathedrals, contacted Hunt and praised his work. Saying that he could find abundant work for the Pre-Raphaelite Brotherhood, he commissioned Hunt to paint four spandrils, for morning, noon, evening and night, for a house that he was decorating, at £50 per picture. Hunt promptly accepted, whereupon Cottingham gave him an order on a colourman for a tube of gold paint. Hunt then introduced Cottingham to Woolner, who sold him a sculpture cheaply on the understanding that this would lead to many lucrative commissions. The Brotherhood was next invited to his house in the Waterloo Bridge Road. They found to their amazement that it was full of Gothic treasures, including rare stained glass, effigies and brasses, which his father had taken from churches in the course of his 'improvements'.

Soon after their visit to his house, Cottingham brought a lady to sit to Hunt for a portrait. Somewhat naïvely, Hunt handed over to him the portrait and two preliminary sketches for the spandrils. A week went by without any word from his patron, and Hunt accordingly wrote him a polite little note, saying that it would be a kindness if he could be advanced half the cash price for each picture. Cottingham replied immediately:

> My patron declines advancing without security and I regret your making the request as regards limit of price, and giving you a positive letter, as though my word was insufficient.
> The commission, however, I have to offer as you desire to have it stated in strict terms as follows:-
> To paint the two pictures of night and morning on panels finding all materials of the best description for the sum of Fifty Pounds to be paid on their completion within six months of the date of this. The pictures to be both painted to my satisfaction in every respect and if they are not so, my fulfilment of this offer to be optional . . .
> You are at perfect liberty to decline the commission if you please as I am acquainted with plenty of men with first-rate ability, who will readily undertake it.'[7]

This letter left Hunt in a mood of profound disgust. Confiding his annoyance to William Rossetti, he swore that he would cut

Cottingham altogether, and leave him to find another man of talent prepared to do the panels for £50 each.

That same afternoon Hunt heard loud and repeated knocking at the front door. Assuming that the landlady was in her usual drunken stupor, and that the maidservant was disinclined to answer, Hunt went downstairs and found Augustus Egg on the doorstep. At his urgent request, he took Egg up to the studio and showed him *Rienzi*, which Egg greatly admired, saying that he thought he could find a purchaser for it. A few days later he asked Hunt to bring it to his studio in Bayswater, so that he could show it to a friend.

Next morning the landlord's patience ran out. He seized Hunt's sketches and books, and most of his furniture, and threw him into the street. Smarting under this final indignity, Hunt had no choice but to transfer his belongings to the study of the ever-sympathetic Ford Madox Brown, and go back home to his family.

Swallowing his pride, Hunt now wrote to Nockalls Cottingham again, with the utmost civility, seeking to clarify matters regarding his commission, and received the following reply:

Sir,
 You will find hereafter in life that a man may be too grasping and greedy, and so overreach himself. I have consulted my patron. At his request I now return your sketches, as he will not avail himself of your services, and I have to beg that you will by return restore to me the order I wrote you for the gold paint.
Yours obediently,
Nockalls Cottingham.[8]

Hunt was not paid for the designs, nor for the portrait. Some time later, Woolner saw his statuette in a shop window copied in Minton-ware, and when he went in and enquired about it, he was told that it was an original design by the rising young sculptor, Nockalls Cottingham, from whom Minton had bought the copyright. Millais expressed his personal contempt for Cottingham in a letter to Hunt, in which he said that it would be 'an act of charity to chastise that snob Cottingham. I never liked the look of the fellow; he was *sloshy* and behaved so at first with Gabriel about his picture.'[9]

Indeed, the only Brother who actually got the better of Nockalls Cottingham was Gabriel, who had insisted on an advance for a commission, but had not done the work. A few months later,

Cottingham left for America, and drowned when his ship, the *President*, was lost at sea. Hunt and the other Brothers had wanted revenge, but were horrified when they heard of his death.

Only two days after his eviction, Hunt received a cheque for £105 from Egg, who had succeeded in selling *Rienzi* to his friend, a well-known private collector named Gibbons. The price he paid even included five pounds for the frame.

Hunt was exultant. He immediately opened a bank account, and took his new cheque book along to his former landlord to settle his outstanding debt. The latter regarded the transaction with extreme suspicion, being convinced that Hunt had been holding out on him all the time. Hunt could not wait to shake the dust of the city off his feet. He packed his bags and set off at once for the Lea marshes, where he spent a blissful month: '. . . the lucid streams were stocked with innumerable roach and dace and other silvery fish,' he wrote, 'and the gorgeously panoplied dragonflies, preying upon the careless butterfly, darted with lightning speed over the water.'[10]

In this demi-paradise, Hunt found the rich landscape that he needed for his new picture, which he called *A Converted British Family Sheltering a Christian Priest from the Persecution of the Druids*. The hut in which the priest is sheltering was painted from an outhouse at his lodgings.

When Hunt returned to London, he learned that Gabriel had managed to sell his picture to the Marchioness of Bath. Having greatly missed his companionship, he decided to take the opportunity to call and congratulate him. One look and they were embracing each other as thankfully as lovers after a quarrel. To celebrate their reunion, they decided to set off together, as soon as they could discharge their outstanding commitments, on a tour of France and Belgium.

In the days leading up to their departure, the Pre-Raphaelite Brothers were preoccupied with their proposed magazine. Gabriel wrote to William that a printer friend of Hancock's had introduced him to Aylott and Jones, the publishers, who were willing to publish the 'Monthly Thoughts', as it was provisionally called. Walter Deverell, whom Gabriel had first met at Sass's Academy, and who had become a close friend of all the Brothers, made enquiries on their behalf into the reasonableness of the cost. It was thought that the printing charges would not exceed £13. At this juncture Woolner

wrote to William Rossetti, saying that the ardour of the new pro-
prietors was so great that he and Gabriel had resolved that William
should be made Editor immediately. The title was now to be
'Thoughts towards Nature'. There was further disagreement about
the words 'Conducted by Artists', which had been proposed for
insertion in the title, but on further reflection it was decided that these
should be left out.

On 27 September 1849 Hunt and Rossetti finally left for France,
travelling to Paris via Folkestone and Boulogne. This was Hunt's first
tour abroad, and he decided to keep a journal, probably with the
notion of publishing it in some form. One of their principal objectives
was to see as much Early Flemish art as possible. 'Rossetti was a
perfect travelling companion,' wrote Hunt, 'ever in the best of
temper, and our journey was overbrimming with delight in the
beauties of nature and art.'[11]

At Woolner's recommendation, they took inexpensive lodgings at
4, Rue Geoffroy Marie, Faubourg Montmartre, a house much fre-
quented by struggling artists, where he himself had once stayed. In the
inevitable letter to William, Gabriel described their activities:

We ran hurriedly through the Louvre yesterday for the first time
. . . There is a monosyllable current amongst us which enables a
PRB to dispense almost entirely with details on the subject. There is
however a most wonderful copy of a fresco by Angelico, a
tremendous Van Eyck, some mighty things by that real stunner
Leonardo, some ineffably poetical Mantegnas (as different as day
from night from what we have in England), several wonderful early
Christians, whom nobody ever heard of, some tremendous
portraits by some Venetian whose name I forget, and a stunning
Francis I by Titian.[12]

Together they visited a morgue, and climbed to the top of Notre
Dame, where they found the view 'inconceivably stunning'. Rossetti,
who spoke fluent French, acted as interpreter for Hunt with his halting
schoolboy phrases. Strangely enough, this son of an exiled Italian and
his best friend behaved with that general distrust of foreigners and
conviction of innate national superiority that were typical of the
nineteenth-century Englishman abroad. Their essential insularity was
in no way impaired by their Continental tour. Nevertheless, the tour
brought them new experiences. Above all, it taught them to despise

the women of Paris. Curiosity drew them irresistibly to Valentino's where they saw the cancan.

'As the groups whirled past us, one after another, in an ecstasy of sound and motion,' Rossetti wrote, 'I became possessed with a tender rapture and recorded it in rhyme as follows: (NB – The numerical characteristics refer to the danseuses.)

> The first, a mare; the second, 'twixt bow-bow
> And pussy-cat, a cross; the third, a beast
> To baffle Buffon; the fourth, not the least
> In hideousness, nor last; a cow;
> The sixth, Chimera; the seventh, sphinx; Come now,
> *One* woman, France, ere this frog-hop have ceased,
> And it shall be enough. A toothsome feast
> Of blackguardism and whore flesh and bald row,
> No doubt for such as love those same. For me,
> I confess, William, and avow to thee,
> (Soft in thine ear) that such sweet female whims
> As nasty backsides out and wriggled limbs
> Nor bitch-squeaks, nor the smell of heated q....s
> Are not a passion of mine naturally.

Now another word in your ear, in prose:- do not let anyone see this letter but yourself, I mean, the family of course; or else scratch out this sonnet first. It is rather emphatic, I know; but, I can assure you, excusable under the circumstances. My dear sir, we have not seen six pretty faces since we have been at Paris, and those such as would not be in the least remarkable in London. As for the ball last night, it was a matter for spueing; there is a slang idiocy about the *habitués*, viler than gentism. And the females, the whores, the bitches – my God!'[13]

Despite their apparent Bohemianism, the two young men were surprisingly puritanical in their attitude to sex. Both, however, had been brought up in a heavily Victorian moral atmosphere. Taught from their infancy that the English were superior to other races, they were made to believe that extramarital sex was a mortal sin, and that women who flaunted their bodies were a snare to be avoided at all costs. Rossetti had been raised in a household dominated by his mother and sisters, who were devout and spiritual, and whom he sought to please at all times.

After two and a half weeks in Paris, the usual shortage of tin obliged

them to move on to Belgium. From Bruges a letter was sent to
Collinson, signed by both Hunt and Rossetti, though actually written
out by the latter. It was prefaced by a sonnet:

<div align="right">

Between Ghent and Bruges
Wednesday Night, 24th October

</div>

Ah, yes, exactly so; but when a man
Has trundled out of England into France
And half through Belgium, always in this prance
Of steam, and still has stuck to his first plan –
Blank verse or sonnets; and as he began
Would end; – why, even when the blankest verse may chance
To falter in default of circumstance,
And even the sonnet lack its mystic span,
Trees will be trees, grass grass, pools merely pools,
Until the end of time and Belgium – points
Of fact which Poets (very abject fools)
Get scent of – once their epithets grown tame
And scarce. Even to these foreign rails – my joints
Begin to find their jolting much the same.

<div align="right">

Bruges: Hotel du Commerce,
25th October 1849.

</div>

Dear PRB,
On the road hither last night I perpetrated only the above atrocious
sonnet, in answer to the voice which urged upon me a more worthy
exercise of my energies. It is all therefore that I can give you.
I believe we have seen today almost everything very remarkable in
Bruges; but I assure you we shall not want to see much of it again.
This is a most stunning place, immeasurably the best we have come
to. There is a quantity of first-rate architecture, and very little or no
Rubens.
But by far the best of all are the miraculous works of Memling and
Van Eyck. The former is here in a strength that quite stunned us –
and perhaps proves himself to have been a greater man even than the
latter. In fact, he was certainly so intellectually, and quite equal in
mechanical power. His greatest production is a large triptych in the
Hospital of St John . . . I assure you that the perfection of character
and even drawing, the astounding finish, the glory of colour, and

above all the pure religious sentiment and ecstatic poetry of those works, is not to be conceived or described . . . In the background of the first compartment there is a landscape more perfect in the abstract lofty feeling of nature than anything I have ever seen . . . His pictures are not painted with oil – he having preceded Van Eyck – but with some vehicle of which brandy and white of egg are the principal components . . .

Friday 26th October

. . . Before leaving Ghent we visited the great Convent of the town – the Beguinage. It is of a vast extent, containing entire streets and squares of its own. Each nun has a house to herself, over which is written not her name, but that of some saint under whose protection she has been pleased to put it. In some cases where the name was more than usually quaint, we felt disposed to knock at the door and ask if he was in; but refrained, as it was rather late, and we feared he might have gone to bed. We witnessed the vesper service, which rather surprised us, as we thought that among the tunes played we could recognise 'Jim Crow' and 'Nix my dolly'. At the end, each nun finds a kind of towel somewhere, which she folds up and puts on the top of her head; during the service, a rather sloshy one goes about with a policeman's bulls eye, collecting coppers. At our entrance and departure, Hunt dipped his fingers in the holy-water stoup, and commenced some violent gesticulations which I was obliged to bring to an abrupt conclusion.

We have bought an extraordinary self-concocting coffee-pot for state-occasions of the PRB. We have likewise purchased a book containing a receipt for raising the Devil, and in Paris a quantity of Gavarni's sketches, which I long to look over with you . . .[14]

On their return to London, there was some talk among the Brothers of taking over a large property in which several of them would rent individual studios. The initials 'PRB' on the doorbell could be interpreted by the uninitiated as meaning 'Please Ring Bell'. But eventually the scheme of an artists' colony had to be abandoned because the property proved too expensive. Instead, Gabriel moved into 72 Newman Street, and invited Hunt to share it with him. Remembering how Gabriel had left him to pay the whole of the bill at Cleveland Street, Hunt cautiously declined. Ford Madox Brown, who was still storing Hunt's belongings, allowed him the use of his studio until he

was suited, and in the meantime he took a bed for the night wherever he could.

Finally, Hunt secured two rooms in Gloucester Road West, Bayswater, in the house where Collinson lodged. But the rooms were too small to paint in, and Hunt realised that he would have to find something more suitable as quickly as possible. Soon his patient search for a permanent studio was rewarded, and on 5 January 1850 he moved into 5 Prospect Walk, Chelsea. Now, thankfully, he was alone for the first time in the studio which was to be his home for the most critical years of his career.

CHAPTER 5

— ❀ —

The storm breaks

I N the autumn of 1849 and the spring of the following year the Brothers concentrated on the production of their magazine. There was endless agonizing over the title, with no less than 65 names being suggested. *The Germ*, which was finally adopted, was suggested by William Cave Thomas, a historical painter and art critic with early leanings towards the Nazarenes. He also wrote its opening address but in the event this was withdrawn. The most popular choice of title, the 'PRB Journal', was rejected because it was thought that it would confuse the public. William Rossetti, in a letter to Stephens, sums up the objections: 'Such Artists and critics as have begun to recognize you as a body tending towards definite aims in art will not know what to think of it; you will lose the distinctive character you possess . . .'[1]

Even when the title had been chosen, the debate was not over. At the last minute, Hunt objected to the large PRB initials which were in the prospectus, and they had to be withdrawn. Finally, on 31 December 1849, the copy for the first number was delivered to the printers.

The contents were impressive. Woolner contributed two poems, 'My Beautiful Lady' and 'My Lady in Death'. These were illustrated by Hunt. Six years later, Edward Burne Jones wrote that Hunt's etching had so little to do with the poem that 'it may well stand for an independent picture, truly a song without words, and yet not wholly speechless, for out of its golden silence come voices for all who would hearken, telling a tale of love.'[2]

All three Rossettis wrote poems for the first number. Gabriel produced 'My Sister's Sleep', Christina contributed 'Dreamland' and 'An End', while William, as editor, launched an unimpressive sonnet on the cover, as well as writing a review. Coventry Patmore obliged them with 'Seasons', and Gabriel wrote a prose story, 'Hand and

Soul'. The contributors remained anonymous throughout, but this practice was abandoned for the remaining issues, in which Christina assumed the pseudonym 'Ellen Alleyn', and all the rest signed their real names. Summarizing the publication's objectives, William wrote: 'An attempt will be made, both intrinsically and by review, to claim for Poetry that place to which its present development in the literature of this country so emphatically entitles it. The endeavour held in view throughout the writings on Art will be to encourage and enforce an entire adherence to the simplicity of nature.'[3]

The first issue went on sale in January 1850, and Hunt immediately managed to sell a dozen copies. Altogether, though, sales proved disappointing, only about two hundred copies being sold from a print run of seven hundred. The Brothers had hoped to take the world of art and literature by storm, but they now began to perceive that the reading public would not be won over without a struggle.

On 18 January Collinson hosted a meeting of the Brothers, but only Hunt and William Rossetti turned up, the weather being 'intensely sloshy'. A debate developed about the limitability of the membership, Hunt maintaining that it should be strictly limited to the original Brethren, and Rossetti and Collinson seeing no such necessity. This was typical of many of the disputes within the Brotherhood, with the Rossettis continually advocating larger numbers and increased informality, while Hunt strove continually for the reverse. In this his sole ally was Millais, who was motivated as much by his subconscious desire to keep Hunt to himself as by any genuine intellectual objections. He was, moreover, greatly influenced by his family, who openly distrusted the influence of Gabriel Rossetti on their son.

The second issue of *The Germ*, which came out in February, contained nothing from Hunt, who was deeply preoccupied with his 'druids' picture, but in other respects was the most impressive number. Gabriel contributed an early version of 'The Blessed Damozel', and Coventry Patmore gave them 'The Stars and Moon'. William Bell Scott was represented by 'Morning Sleep', in blank verse, and Christina provided three splendid poems, 'A Pause for Thought', 'A Testimony', and 'O roses for the flush of youth'. Collinson's poem 'The Child Jesus' was included, with his own fine engraving to illustrate it. Yet despite its quality, the magazine did not sell well, and they began to question whether they could survive for another issue.

Meanwhile, William Rossetti's labours as editor of *The Germ* were rewarded by invitations to contribute to other magazines. The editor

of *The Critic* invited him to review an exhibition at the British Institution, and he went to see it with Gabriel, whose opinions carried great weight with him. Not content with merely advising his brother, Gabriel effectively took over the project, deciding to write the review himself.

One of the artists whose work was on display at the exhibition was Frank Stone, an Academician and art critic, who wrote regular reviews for the *Athenaeum*. Trusting in the anonymity of the article, Gabriel wrote a biting review of Stone's painting, *Sympathy*:

> . . . All we can know for certain from this picture is that on some occasion or other, somewhere, a mild young lady threw her arms (with as much of *abandon* as a lay figure may permit itself) round another sorrowful but very mild young lady; that the faces of these young ladies were made of wax, their hair of Berlin wool, and their hands of scented soap. There is one other piece of knowledge distinctly communicated, viz., that such pictures as this will not sustain Mr Stone's reputation.[4]

Gabriel's scathing comments were entirely justified, but in condemning Stone he was by implication criticizing the work of many Academicians. The article duly appeared under William's initials. Frank Stone was furious, and determined to find out who was responsible for this attack. With his contacts, it was the easiest thing in the world to find out the identity of 'WMR'. He also discovered that William was editor of *The Germ*, that he had been joined in the enterprise by a group of rebellious young men associated with painting and the arts, and that his brother was Dante Gabriel Rossetti, whose *Girlhood of Mary Virgin* had borne the enigmatic cipher 'PRB'. His anger knew no bounds when he realized the identity of the arrogant young puppy who had attacked him, but he was a clever man, content in the short term to bide his time. In his heart he vowed to destroy this rash, self-opinionated young man, and all his associates with him. Gabriel's thoughtless action therefore had very serious implications for Hunt and his friends. Unbeknown to the Pre-Raphaelite Brothers, they were henceforth marked men.

Little suspecting that a furore of disapproval was shortly to break around the Brotherhood, Hunt continued quietly working at his picture. In March 1850 William Rossetti called at Hunt's studio, and reported:

Hunt has just finished the wolf-skin on the foremost savage at the
door . . . The models who sit to him take the boy on the ground for
an extremely ugly girl, and the hindermost savage (his friend
Collins) for an old negress(!) 'Sloshy' [Rainford, a painter who had
occupied rooms at 7 Cleveland Street, when Hunt and Rossetti
shared a studio there] comes now to see him frequently, and is
beginning to look on himself as quite a PRB – talking of 'we', and
saying that Collinson seems quite one of 'us'. It seems, however,
that he is really labouring to free himself somewhat from the slough
of slosh Hunt found him in at first, and has in consequence quite
offended some Lord's son (or some person of the kind) to whom he
showed off his recent attempts.[5]

On 25 March 1850 William visited Hunt again, and reported:

He has been on a foraging expedition to Battersea Fields after
Gypsies, on the recommendation of one who sat to him for his
Druid's head, and as he wants to get some women with good hands
of a proper savage brownness. He finds himself quite disabused of
ideas concerning 'sloshiness' and commonplace gypsies, having
fallen in with some of the most extraordinary-looking people
conceivable. He found a very beautiful woman for what he wants,
fit for Cleopatra; she consented to sit for £5 an hour, but finally came
down to a shilling, and fixed a day to come. His Cleopatra asked
him for a pot of beer, over which she and a most hideous old hag,
her mother, made their bargain.[6]

Hunt used Stephens's head for the savage outside the hut, and William
Rossetti sat for the principal figure. When William called at Prospect
Place on 7 April to sit for the head and hands of Hunt's Christian
Priest, he reported: 'There remains now scarcely any uncovered
canvas: he has, however, a tremendous deal still to do for so short a
time, two or three heads requiring much yet. His frame with four
Bible-mottoes has arrived.'[7]

One of the associates of the Brotherhood most deeply concerned
with the production of *The Germ* was Walter Howell Deverell, who
contributed three sonnets under the title 'The Light Beyond' to the
second issue. Son of Walter Ruding Deverell, the Secretary at the
School of Design, Walter was born in Charlottesville, Virginia, where
his father was classical tutor to the university until Walter was two

years old. The boy's early ambition to take up a career in acting was thwarted by parental opposition, and he studied instead at Sass's Academy, where he met Dante Gabriel Rossetti. From his yellow-haired, ivory-complexioned, handsome father, and his black-haired mother Dorothy, who had Jewish blood, Deverell had inherited striking good looks. William Bell Scott, who met him through the Rossettis, described him as 'a youth, like the rest of them, of great but impatient ability, and of so lovely yet manly a character of face, with its finely-formed nose, dark eyes and eyebrows, and young silky moustache, that it was said ladies had gone hurriedly round by side streets to catch another sight of him.'[8]

In Scott's view, Deverell could have become one of the leaders of the English school of art, had he not become involved with the Pre-Raphaelite Brotherhood. During the early months of 1850, he was engaged on a picture from *Twelfth Night* for the Royal Academy, painting himself in the character of Orsino. The ever-obliging Gabriel sat for the Jester, but Deverell was desperate for a suitable model for his Viola. One day Deverell, who had a habit of dropping in on Hunt unexpectedly, turned up to tell him that his search for a suitable model was over: 'You fellows can't tell what a stupendously beautiful creature I have found,' he exclaimed. 'By Jove! she's like a queen, magnificently tall, with a lovely figure, a stately neck, and a face of the most delicate modelling; the flow of surface from the temples over the cheek is exactly like the carving of a Pheidean goddess. Wait a minute! I haven't done; she has grey eyes, and her hair is like dazzling copper, and shimmers with lustre as she waves it down. And now, where do you think I lighted on this paragon of beauty? Why, in a milliner's back workroom where I went out with my mother shopping. Having nothing to amuse me, while the woman was tempting my mother with something, I peered over the blind of a glass door at the back of the shop, and there was this unexpected jewel.'[9]

Deverell immediately asked his mother to invite this 'miraculous creature', whose name was Elizabeth Siddal, to sit for his Viola. Mrs Deverell promptly consulted Frith's daughter Isobel as to the appropriate rate for models, and discovered that the usual charge was seven shillings and sixpence a day. As a milliner's assistant, Lizzie was currently earning £24 a year, working from 6 a.m. until 8 p.m. It was not difficult, therefore, for this handsome young man and his mother to lure her away from Mrs Tozer's shop in Cranbourn Alley.

When Deverell went to see Hunt, he had already been trying to

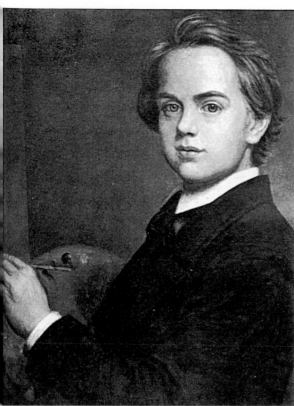

(Above) Portrait of Hunt's father, 1853

(Left) Self-portrait, at age 14

(Below) *Kitchen at Ewell*, with Hunt's mother at the sink

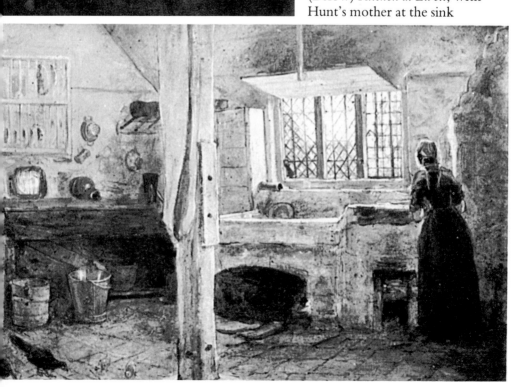

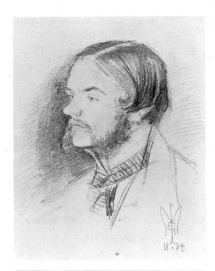

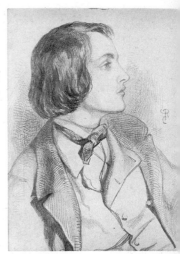

(Left) William
Holman Hunt by J.E.
Millais, 1854

(Right) W.M. Rossetti
by D.G. Rossetti, 1847

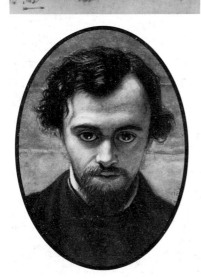

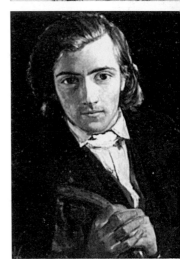

(Left) J.E. Millais,
1853

(Right) F.G. Stephens,
1847

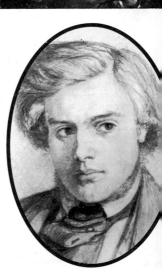

(Left) D.G. Rossetti,
1853

(Right) T. Woolner by
D.G. Rossetti, 1852

THE PRE-RAPHAELITE BROTHERS

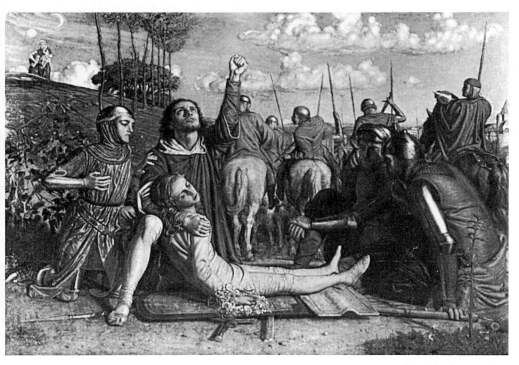

Rienzi, 1849. Models: D.G. Rossetti, J.E. Millais

The Hireling Shepherd, 1851. Model: Emma Watkins

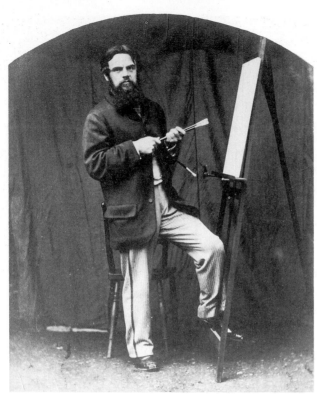

Photograph of Hunt
by Lewis Carroll

The Awakening Conscience, 1853.
Model: Annie Miller

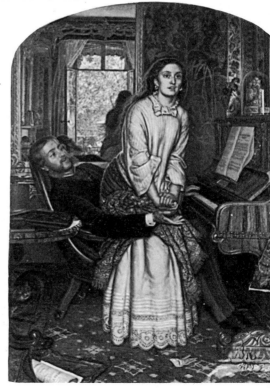

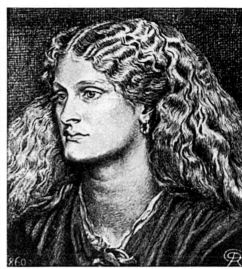

(Above) Annie Miller
by D.G. Rossetti, 1860

(Left) *Morning Prayers*.
Model: Annie Miller

(Below left) Thomas Combe, 1860

(Below) Martha Combe, 1861

The Scapegoat, 1854

Nazareth, 1855

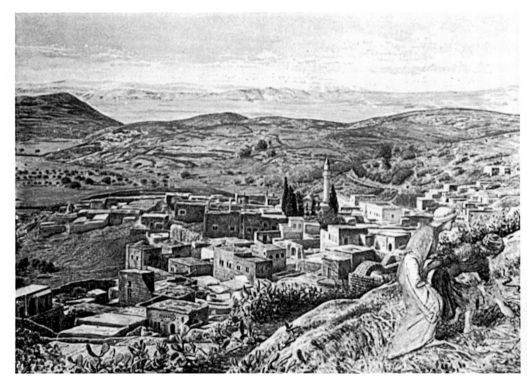

Mrs Wilson and her Child (Hunt's sister and niece), c.1850

The King of Hearts (Hunt's portrait of his nephew, Teddy Wilson) 1862

Mrs George Waugh (Hunt's mother-in-law), 1868

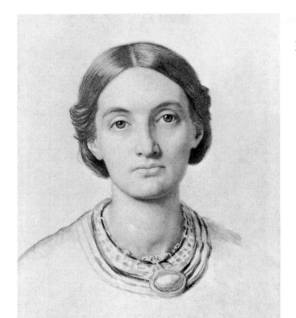

Hunt's first wife, Fanny, 1866

Hunt's son, Cyril

paint Lizzie, but had made a mess of the beginning. Now he invited Hunt and Gabriel to call at his studio to see her on the following day, adding, 'She really is a wonder; for while her friends, of course, are quite humble, she behaves like a real lady, by clear common sense and without any affectation, knowing perfectly, too, how to keep people at a respectful distance.'[10]

Hunt unfortunately had another engagement, but Gabriel duly went along to Deverell's studio and returned full of enthusiasm for the young model. Being himself in need of a model, he asked Lizzie if she would be willing to pose for him also, and having privately determined never again to return to Mrs Tozer's establishment, she gladly consented. It soon became clear that there would be ample work for Lizzie among the Pre-Raphaelite Brothers. Hunt, too, was urgently in need of a female model for his red-haired Celtic woman, and engaged her to sit for him. His picture was in no sense a true likeness of Lizzie, however, as he openly admitted: 'With my desire to give a rude character to the figure, and my haste to finish, certainly the head bore no resemblance to her in grace and refinement,' he wrote.[11]

Hunt's picture was now nearing completion. It was sounder in execution than *Rienzi*, and he had succeeded in mastering his material. The painting showed his developing feeling for tone and colour, and his successful representation of the natural effect of sunlight.

In March 1850, the third issue of the magazine was published, this time under the title *Art and Poetry*, which the Brothers hoped would bring in a wider readership. Interest among the contributors was beginning to flag, however, and some of the promised contributions failed to materialize. William was obliged to resurrect an old poem by Christina, called 'Repining', to fill up the space. They were unable to bring out an issue at all in April.

Gabriel's picture, *Ecce Ancilla Domini*, was now nearing completion. As before, his sister Christina had sat for the Virgin Mary, while Woolner had modelled for the archangel. The scarlet cloth which the Virgin had been embroidering in his earlier picture, *The Girlhood of Mary Virgin*, stands completed in the foreground, confirming the link between the two paintings. Once again Gabriel had had difficulties with the perspective of the floor tiles, and his archangel, with the woollen lilies in his hand (real ones being prohibitively expensive) unaccountably hovers a few inches above the floor.

Once again Gabriel decided to break ranks by sending his picture to the Free Exhibition, now occupying the Portland Gallery in Regent's

Street, and this time Deverell joined him, having purchased space for his scene from *Twelfth Night*, with Lizzie Siddal as Viola. This he was perfectly entitled to do, as although he was desperately anxious to join the Brotherhood, the membership was still restricted to the original seven. By the time the exhibition opened, Gabriel with his indiscreet tongue had betrayed them all again, this time by telling the sculptor Alexander Munro the identity of the Brothers, and the meaning of the enigmatic initials *PRB*.

Frank Stone, whose painting *Sympathy* Gabriel had savaged in *The Critic*, now saw his opportunity for revenge, not only on the young man himself, but on all his associates. When *The Athenaeum* came out on 20 April, it contained a scathing anonymous attack:

Ignoring all that has made the art great in the works of the greatest masters, the school to which Mr Rossetti belongs would begin the work anew, and accompany the faltering steps of its earliest explorers. This is archaeology turned from its legitimate uses, and made into a mere pedant. Setting at nought all the advanced principles of light and shade, colour, and composition, these men, professing to look only to Nature in its truth and simplicity, are the slavish imitators of artistic inefficiency.[12]

When Millais saw the article, he immediately realized that it had come from the pen of Frank Stone from an earlier conversation with him, in which he had introduced several of the observations in *The Athenaeum*. Vindictively, Stone, who had considerable influence, also aired his views as widely as possible, in order to manipulate the responses of other critics. Meanwhile, Munro had passed on Gabriel's ill-judged confidences to his friend Angus Reach, a gossip columnist who wrote for the *Illustrated London News*. In Reach's article, the Brothers were called 'Practitioners of "Early Christian Art" . . . who – setting aside the mediaeval schools of Italy, the Raffaeles, Guidos and Titians, and all such small-beer daubers – devote their energies to the reproduction of saints squeezed out perfectly flat.'[13]

On 2 April, Stephens wrote to William Rossetti: 'Have you seen the *Athenaeum* on Collinson and Deverell???? as PRBs . . . There is a notion abroad, I fancy, that the B—d [Brotherhood] is connected with "The Foreigners" and that we desire to alter the Established Church, which Johnny Millais is to propose to the Queen while painting her portrait. The first idea, which seems to have firm hold, may be much

weakened by getting Gabriel to cut off his moustaches and sacrificing himself to good pleb whiskers, such as our own . . .'[14]

In a letter to William Bell Scott, Gabriel said that the Brothers were already beginning work on their paintings for the following year, in expectation of astounding Europe: 'I have been guilty as yet of only two small pictures, one of which I had the luck to sell last year, while the second is at the present time exhibiting, still unsold. It has been a great deal abused. The *Athenaeum*, which blarneyed me last year, is now dreadfully impertinent . . . The RA will make a grand show this year. Millais and Hunt are really immense.'[15]

And indeed this was true. Even the slothful Collinson submitted a painting to the Royal Academy Exhibition of 1850. It was called *The Renunciation of Queen Elizabeth of Hungary*, whose story, under the title *The Saint's Tragedy*, had been published by Charles Kingsley in 1848. Though the events took place in the thirteenth century, the setting is a nineteenth-century Gothic revival church.

While Hunt was putting the finishing touches to his entry, *A Converted British Family Sheltering a Christian Priest from the Persecution of the Druids*, Millais came to his studio, bringing with him his latest protégé, Charles Collins, younger brother of Wilkie Collins, the novelist. Hunt was already slightly acquainted with the young man, whose father was William Collins, a distinguished Royal Academician. When Mr Collins died, in 1847, Wilkie had set aside his novel to write his father's biography, which was published in November 1848. Both Charles and Wilkie had been brought up to painting. Millais had spent most of the summer with Charles, perhaps because Hunt was mainly preoccupied with Gabriel. Under Millais's influence, Collins had abandoned his earlier manner, and while not accepted into the Brotherhood, had embraced the principles of Pre-Raphaelitism. His picture was called *Berengaria seeing the Girdle of Richard offered for sale in Rome*.

Millais, who was the most prolific of the Brotherhood, submitted three pictures to the Royal Academy in 1850, a Shakespearean subject, *Ferdinand and Ariel*, a portrait of a man and his grandchild, and *Christ in the House of his Parents*. The latter was painted in an Oxford carpenter's shop with genuine cedar planks, and wood shavings on the floor. A real carpenter posed for St Joseph, though the head was that of Millais's own father. Millais's sister-in-law sat for the Virgin Mary, and decisions about the composition and the setting were hammered out with the aid of the entire family.

Anticipating trouble ahead now that their secret was out, the Brothers anxiously submitted their work to the Royal Academy. All their pictures were accepted by the hanging committee. Hunt, who had not yet seen Millais's picture, spent the night at 83 Gower Street, and went with him first thing next morning to see it.

As Hunt stood studying *Christ in the House of His Parents*, Millais at first mistok his silence for disapproval, and said suddenly, 'It's the most beastly thing I ever saw. Come away!' At that moment two fellow students came up and laughed openly at it. Millais immediately put his hand on the shoulder of one of them, and told them that if they lived to be as old as Methuselah, they would be incapable of painting anything to compare with it. [16]

Frank Stone now launched phase two of his attack on the Pre-Raphaelites with another article in *The Athenaeum*, in which he wrote: 'Abruptness, singularity, uncouthness, are the counters by which they play the game. Their trick is to defy the principles of beauty and the recognised axioms of taste . . .' [17]

All the brethren were singled out for attack, but it was Millais who bore the brunt of it. 'Mr Millais' picture is, to speak plainly, revolting,' reported *The Times*. 'The attempt to associate the Holy Family with the meanest details of a carpenter's shop, with no conceivable omission of misery, of dirt, of even disease, all finished with the same loathesome minuteness, is disgusting.' [18]

Even Dickens, in *Household Words*, described Millais's boy Jesus as 'a hideous, wry-necked, blubbering, red-headed boy, in a bed-gown' and Mary as 'a woman so hideous in her ugliness that . . . she would stand out from the rest of the company as a Monster, in the vilest cabaret in France, or the lowest gin shop in England.' The Pre-Raphaelites were summed up as 'mean, repulsive and revolting.' [19]

Blackwood's Magazine was, if anything, even more scathing: 'We can hardly imagine anything more ugly, graceless, and unpleasant than Mr Millais' picture of "Christ in the Carpenter's Shop". Such a collection of splay feet, puffed joints, and misshapen limbs was assuredly never before made within so small a compass. We have great difficulty in believing a report that this unpleasing and atrociously affected picture has found a purchaser at a high price. Another specimen from the same brush inspires rather laughter than disgust.' [20]

Millais had indeed sold the picture, to a dealer named Farrer, but in view of the bad publicity, Farrer cut the price from £300 to £150. Understandably, Millais blamed the hostile reaction of the press to his

work on Rossetti. He was bitterly angry with Gabriel, and his whole family with him. Mr Millais said, with considerable justification, that Rossetti's work was medievalism, not Pre-Raphaelitism, while his wife poured out all her feelings of anger to Hunt, blaming the whole catastrophe on that 'sly Italian' Gabriel Rossetti: 'It's the forming yourself into so large a body that has done the mischief. I wish that you had never had anything to do with that Rossetti . . .'[21]

Art and Poetry was brought out for the last time in May 1850. Although it was advertised on sandwich boards paraded up and down outside the Royal Academy, sales remained poor. A meeting was called to assess the situation. On 10 May, George Tupper wrote to Stephens: 'We are to meet to overhaul the accounts on Thursday even next at 7 o'clock at Barge Yard. I trust you will manage somehow or other to be present for without a staunch *backer* (mind this is not a pun) in business matters like yourself, it will be impossible for me to prevent the meeting degenerating into a Poetico–spouting–railing–trolloping–mystifying–smoke–scandal – ergo – be Imperative – Present – I beseech you and you shall have my unmitigated prayers – now and evermore. Amen.'[22]

Now that public opinion had built up to stony hostility towards the Pre-Raphaelites and all that the movement stood for, the Brotherhood reluctantly decided that no further publications would appear. In financial terms the experiment had been disastrous, leaving a printing bill of £33 from Tupper outstanding. None of them had the money to pay, and for the time being at least, the unfortunate George Tupper was left to bear the loss.

With the furore at its height, Hunt took stock of his own situation. At least Millais had sold his picture for £150. Hunt was less fortunate. Dickens's criticism was all the more damaging to him because unless he sold his picture, Hunt could not afford to start another. Originally he had hoped to get £300, like Millais, but he now dropped the price drastically, in the hope of attracting a buyer. Even so, the picture remained unsold. The public scarcely glanced at it, dismissing it out of hand as 'PRB nonsense'.

Both Hunt and Rossetti were now in desperate financial straits. Rossetti had reduced the price of his picture to £50, but even this drastic reduction failed to attract a purchaser. To meet his obligations, he borrowed from his family, but Hunt knew that his father had too much difficulty making ends meet to be able to subsidize him. At one stage, Hunt was reduced to one half-crown, which he found in the

upholstery of an armchair. Only the kindness of William Dyce, the historical and religious painter, who was sympathetic to the work of the Pre-Raphaelites, saved him from going under. Dyce paid him £15 to make a copy of his painting *Jacob and Rachel*, which was in the Royal Academy. The work could only be done between 6 and 8 a.m., but Hunt was more than grateful for the commission.

During the course of the previous year, an older Academician called Thomas Creswick had asked Hunt to paint him a theme from Shakespeare for £50. Hunt now began working on the sketches for this commission, and took them to Creswick. To Hunt's dismay, Creswick said that the designs were hideous and denied all knowledge of the commission, which rested on a gentleman's agreement. Calling on Augustus Egg, who was always a sympathetic listener, Hunt poured out his troubles to him. Egg asked to see the sketches, and was so enthusiastic about them that he commissioned a single figure for £25, paying half in advance.

Egg's advance, modest though it was, enabled Hunt to carry on with his work. His next step was to seek permission to paint the background for his picture *Claudio and Isabella* inside the Lollard Prison at Lambeth Palace, and this was granted to him. The setting was redolent of the atmosphere of despair that he needed for this picture, which illustrates *Measure for Measure*, Act III, scene i, in which Claudio, in prison, begs his sister to purchase his life by sacrificing her own virtue.

By this time Hunt had completed the copying work for Mr Dyce, who was so well satisfied with the result that he invited him to clean and restore the murals by Rigaud at Trinity House for a guinea a day. The work on these bas-reliefs with their dingy sky-blue background was disagreeable in the extreme. Every day he worked on them with a scrubbing brush and flannel, but the ventilation was poor, and the walls reeked of suffocating white lead fumes. After a few weeks, when the cleaning was finished, Dyce agreed a new schedule for the restoration work, and increased the charges, at Hunt's insistence paying Stephens a guinea a day to work as his assistant. As Stephens was in financial difficulties, he was glad to accept the work. To him Hunt entrusted the flat shadings, which considerably speeded up progress, and in this way the work was brought to completion.

While Hunt had been thus engaged, Millais had been spending the summer in and around Oxford, in the company of Charles Collins, to whom he was becoming very deeply attached. Thomas Combe of the

Clarendon Press, the most important patron of Pre-Raphaelite art, and his wife had rescued the two young men from a frugal and un-inspired landlady, and had moved them into their own home. But though Millais was attached to Collins, he still worshipped Hunt, addressing him in correspondence as 'The President of the PRB', and losing no opportunity of singing Hunt's praises to his influential contacts in Oxford.

While Millais was commissioned to paint Mr Combe's portrait, Collins painted Mrs Combe's rich uncle, Mr Bennet, who one day confided to Millais his desire to buy a present for Combe. Millais immediately advised him to buy Hunt's *Druids* picture, and wrote to Hunt asking him to pack it up and sent it on approval. In the event, a quarrel broke out between the Combes and Mr Bennet, who left their house in anger, but Mr Combe bought the picture himself, and dispatched a cheque for £126 to Hunt by return.

The arrival of this cheque was a godsend to Hunt. He had numerous debts to settle, and was obliged to rescue his best suit and other possessions from the pawnbroker. His clothes were past repair and needed to be replaced. But at least, thanks to Millais and the Combes, he had for the time being weathered the storm, and could look forward to the work that lay ahead with renewed confidence.

CHAPTER 6

— ❀ —

The Light of the World

By the autumn, the Brothers had got over the initial shock of the hostile publicity and had begun to meet again as before. They had, however, lost one of their number. Collinson, who had been hovering uneasily between the Anglican Church and Roman Catholicism, had been finally and emphatically rejected by Christina Rossetti, who had broken off their engagement. Smarting under the double humiliation of the broken engagement and the outcry against the Brotherhood, he had written a letter of resignation to Gabriel:

> I feel that, as a sincere Catholic, I can no longer allow myself to be called PRB in the brotherhood sense of the term, or to be connected in any way with the magazine. Perhaps this determination to withdraw myself from the Brotherhood is altogether a matter of feeling. I am uneasy about it. I love and reverence God's faith, and I love His holy Saints; and I cannot bear any longer the self-accusation that, to gratify a little vanity, I am helping to dishonour them and lower their merits, if not absolutely to bring their sanctity to ridicule. I cannot blame anyone but myself . . . Please do not attempt to change my mind.[1]

Though they had liked Collinson well enough, nobody was particularly sorry to see him go. If anything, Millais rather welcomed his departure, for it gave him the opportunity of putting up his friend Collins's name for membership. For some obscure reason understood only by himself, Woolner bitterly opposed the nomination.

'Woolner himself fought the point savagely,' wrote William Rossetti, 'being of the opinion that Collins has not established a claim to PRB-hood, and that the connexion would not be likely

to promote the intimate friendly relations necessary between all PRBs.'

Lizzie Siddal continued to pose for the brothers, and was greatly in demand. In September 1850, however, Hunt was guilty of a little joke which turned her against him permanently. Gabriel explained the jest to William in a letter dated 3 September 1850: 'Hunt and Stephens have been playing off a disgraceful hoax on poor Jack Tupper, by passing Miss Siddal upon him as Hunt's wife. The Baron [George Tupper] was included as a victim. As soon as I heard of it, however, I made the Mad [Gabriel's nickname for Hunt] write a note of apology to Jack.'[2]

In October, Hunt and Gabriel went to stay at Sevenoaks, in order to paint backgrounds for their pictures in Lord Amherst's part at Knole. Hunt was working on *Valentine and Sylvia* from *The Two Gentlemen of Verona*, and wanted Lizzie to model for Sylvia. Lizzie, who had no sense of humour, and was still indignant about the Tupper joke, refused to sit for him, and declined to accompany them to Sevenoaks.

It soon became clear that, weatherwise, they had chosen the most disastrous fortnight of the year, for it rained torrentially throughout their visit. Gabriel had to write home to his mother for a change of clothing: 'I went out this morning with Hunt in search of an eligible spot, and found what I wanted . . . After an interval of extreme anguish, Hunt and myself were obliged to beat a retreat soaked to the bone. I find I shall never be able to get on without a change of nether garments, which article of dress proved this morning unable to withstand three hours' cataract. Will you therefore take the trouble to send me somehow my other breeches (the pair with straps) and to wrap in them any Italian grammar you can spare, as Hunt wishes to avail himself of my law [sic] in that language.'[3]

To Jack Tupper he wrote: 'Hunt gets on swimmingly – yesterday, indeed, a full inch over his ankles; I myself had to sketch under the canopy of heaven, without a hat, and with my umbrella tied over my head to my buttonhole – a position which, will you oblige me by remembering, I expressly desire should be selected by my statue . . . Hunt remarked – how disagreeable to enter one of your rooms for the purpose of delivering a soliloquy, and find a man there behind an easel, which was bobbish for Hunt. The cold here is awful when it does not rain, and then the rain is awful.'[4]

From time to time they were joined by other Brothers, and held regular meetings, to which all were summoned. Woolner, who failed to turn up, received the following:

At the town of Sevenoaks: County of Kent
This 27th day of October 1850
RESOLVED
by us the undersigned:

1st. That the conduct of Thomas Woolner PRB in failing to come hither on Thursday was ill-advised.

2nd. That the conduct of Thomas Woolner PRB in failing to come hither on this present Saturday calls for explanation, if not apology.

3rd. That the conduct of Thomas Woolner PRB should he fail to come hither on the Thursday or Saturday next ensuing will be wholly unjustifiable.

(Signed) W. Holman Hunt,
 Frederick G. Stephens
 Dante Gabriel Rossetti.

FURTHER RESOLUTIONS

1st. That the sonnet has thirteen lines.

2nd. That sensuality is a meanness repugnant to youth and disgusting in age, a degradation at all times.

3rd. That who will may hear Sordello's story told.[5]

Presumably Woolner responded by turning up at Sevenoaks, for on 8 November he was able to report in a letter to William Allingham: 'Most of the PRBs have been at 7oakes painting backgrounds for their next year's pictures. Hunt has succeeded in a remarkable manner with his, he has given the effect of a large rough forest on a small space better than I ever remember to have seen it before.'[6]

The novelty of painting from nature in such adverse weather conditions soon palled on Gabriel, who deserted Hunt and returned to town in the second week of November. His impatience made the Pre-Raphaelite principle of faithful representation of nature tedious to him, and was one of the main reasons why he was never truly at one with Hunt and Millais. Hunt stuck it out until the end of November, and then he, too, returned to London. On 2 December William found him painting fungi and dead leaves for the foreground of *Valentine and Sylvia*. Frith lent him some armour for the picture, which the 'slavey' who delivered it called a 'tin waistcoat and trousers'. Two young barristers, James Lennox Hannay and James Aspinal, modelled for Valentine and Proteus, but Hunt had still not found a suitable model for his Sylvia. Finally, in desperation, he wrote a conciliatory letter to

Lizzie Siddal, begging her to reconsider, and she finally agreed to sit for him. Hunt sat patiently, hour after hour, sewing beads on the dress which she was to wear.

Meanwhile, Hunt went every day to Lambeth Palace to paint the background for his *Claudio and Isabella*. The handsome Walter Deverell called regularly at Hunt's studio to sit for Claudio. Hunt's work was always slow and infinitely laborious, but he worked from early morning until late at night in a desperate attempt to increase his output. He was still acutely short of 'tin', and was relieved when he learned that between them, he and Stephens would get £54 for their work at Trinity House.

The resignation of Collinson from the Pre-Raphaelite Brotherhood left a vacancy which it was now proposed should be filled by Walter Deverell. The latter was so well liked, that everyone was anxious for his formal acceptance. A meeting was convened for this purpose on 2 January 1851, and Jack Tupper, in a letter to Stephens on the same day, included a postscript: 'Happy New Year to you! and PRB to Deverell, I suppose tonight, eh? You may interpret PRB "Penis rather better" – which to him is important!'[7]

Yet in the event, Deverell's election was deferred, mainly as a result of Hunt's intervention, and he was never formally elected. All his life Hunt was overpunctilious, and this was one of his more irritating characteristics. Although he fully approved Deverell's candidature, he was worried about the formalities, as his letter to Stephens explains: '. . . although, in itself, the form is of little consequence in this case, whatever system is followed now will be looked upon as a precedent . . . Tomorrow I will call on Gabriel and Johnny, to make sure of having a full meeting, be prepared with some rules to propose, and expect some stringent ones from me, have paper ready for the secretary and do not allow anything to occur calculated to interrupt the business character of the night until everything necessary is settled . . . Vivat PRB.'[8]

The meeting was held in Hunt's studio on 13 January, without Woolner, who was in the country. It was decided that new elections should be deferred until after the opening of the year's exhibitions, and that 'no rule affecting the PRB can be repealed, or modified, or any finally adopted, unless on unanimous consent of the members'. It was further resolved that a meeting of the Brothers would be held on the last Friday of each month. On 9 February, when they met again at Millais's house, Hunt proposed that any possible new members

should be re-elected annually, and would be expelled by unanimous vote. This was adopted.

Although the Brothers had no shortage of male models for their pictures, they were desperately short of female sitters. In their leisure hours they roamed out in twos and threes, on the look-out for pretty girls, but so far none of them had found a model to rival Lizzie Siddal. On 8 December 1850, William Rossetti went to Millais's studio to see his work in hand, but found that he had missed him: 'However, I met him almost immediately, parading Tottenham Court Road, together with Hunt and Collins, on the search for models. They found one or two women adaptable for Millais – the best being in company of two men; but did not muster face to address them, with the likelihood of a cry of "Police" . . .'[9]

Hunt was alone when he encountered a 'stunner' of his own for the first time. Annie Miller, a fifteen-year-old beauty with abundant fair hair, a lovely face and a perfect figure, lodged with her sister Harriet in Justice Walk, just behind Hunt's studio. Despite her youth she had already had a chequered career, having graduated from babysitting for a prostitute to clearing tables in the Cross Keys public house. Despite her natural beauty, she was dirty and illiterate, had a coarse laugh, and spoke the language of the gutter.

When Hunt introduced her to the Brothers, they all raved about her looks and wanted to use her as a model. Unfortunately, Hunt at this time could not afford to employ her, having recently fallen victim to a confidence trickster. A man called Warwick, claiming to be the heir to a large legacy, borrowed £15 from him. This was half Hunt's entire fund, and in making the loan, Hunt explained to him that he would have to have the money back five weeks before sending-in day, as if he could not pay for models and frames, he would lose a year's work. When the day appointed for repayment arrived, Warwick gave him what seemed to be a cheque for £60, which he said that Hunt must countersign, and present to a Jew called Soloman in Chancery Lane. Hunt duly signed the cheque, but when he presented it to Solomon, he refused to accept it. Puzzled and alarmed, Hunt went back to Warwick, who took the bill back, and promised to return with cash.

Fortunately, at this juncture, Hunt confided in his father, who realized immediately that he had been the victim of a confidence trick. Unless he got the bill back at once, Warwick would negotiate it, and after a while the holder of the bill would come to Hunt for the £60.

Hunt immediately returned to Warwick, and succeeded in getting the note back from him, but he never recovered his £15.

Hunt finished *Valentine Rescuing Sylvia from Proteus* just in time for the Royal Academy Exhibition of 1851. He was at Millais's home when Ford Madox Brown, who had not yet seen Hunt's picture, called at his studio to see it, and left the following letter for him:

My Dear Hunt,

 I could not pass this evening in peace if I did not write to tell you how noble I think your picture. I went up to see it after some resistance on the part of your landlady. I can scarcely describe the emotions I felt on finding myself alone with your beautiful work (quite finished and you out, *that* was something of a triumph), but certainly your picture makes me feel shame that I have not done more in all the years I have worked. You will now have one long course of triumph, I believe – well you deserve it. Your picture seems to me without fault and beautiful in its minute detail, and I do not think that there is a man in England that could do finer work; it is fine all over. I have been to see Millais. His pictures are wonders in colour and truth; in fine, admirable for all they intend, but I like yours better for my own use, although there are qualities in Millais which have never been attained, and perhaps never again will be. If Rossetti will only work, you will form a trio who will play a great part in English art, in spite of Egg's predictions. I mean to be much more careful in future, and try next time to *satisfy myself*. I wish I had seen you tonight, for I am full of your picture, and should like to shake you by the hand. I have had serious thoughts of joining PRB on my pictures this year, but in the first place I am rather old to play the fool, or at least what would be thought to be doing so; in the next place I do not feel confident enough how the picture will look, and unless very much liked I would rather not do it; but the best reason against it is that we may be of more service to each other as we are than openly bound together. I wish you all the success you deserve.

Yours,

Ford M. Brown.[10]

Millais had entered three paintings: *The Return of the Dove to the Ark*; *Mariana*, exhibited with a verse from Tennyson's poem; and *The Woodman's Daughter*, taking its theme from Coventry Patmore's

poem, 'The Tale of Poor Maud'. The work of the young Pre-Raphaelites contrasted so sharply with the paintings of their contemporaries that it needed to be grouped together to gain maximum impact of colour and effect. Because their pictures were separated, the work of Hunt and Millais suffered from lack of support. William Rossetti commented in the PRB Journal: 'Hunt's has been abominably shirked off into much the same position as his *Rienzi* of 1849.'[11]

Many artists admired their work, but some critics, including Frank Stone, could not be satisfied until they had destroyed the Pre-Raphaelites, and the storm of abuse was now a hurricane. The works of Collins and Brown were lumped together under the Pre-Raphaelite label, and came in for their share of the unjustified criticism. The *Times* article of 7 May 1851 was typical of the critics' responses to the exhibits:

> We cannot censure at present as amply or as strongly as we desire to do, that strange disorder of the mind or the eyes which continues to rage with unabated absurdity among a class of juvenile artists who style themselves PRB, which, being interpreted, means Pre-Raphael-brethren. Their faith seems to consist in an absolute contempt for perspective and the known laws of light and shade, an aversion to beauty in every shape and singular devotion to the minute accidents of their subjects, or rather seeking out, every excess of sharpness or deformity. Mr Millais, Mr Hunt, Mr Collins and – in some degree – Mr Brown, the author of a huge picture of Chaucer, have undertaken to reform the art on these principles. The Council of the Academy, acting in a spirit of toleration and indulgence to young artists, have now allowed these extravagances to disgrace their walls for the last three years, and though we cannot prevent men who are capable of better things from wasting their talents on ugliness and conceit, the public may fairly require that such offensive jests should not continue to be exposed as specimens of the waywardness of these artists who have relapsed into the infancy of their profession.
> . . . we can extend no toleration to a mere servile imitation of the cramped style, false perspective, and crude colour of remote antiquity . . . the authors of these offensive and absurd productions have continued to combine the puerility or infancy of their art with the uppishness and self-sufficiency of a different period of life. That morbid infatuation which sacrifices truth, beauty and general feel-

ing to mere eccentricity deserves no quarter at the hands of the public.

The only paper which did not join in the assault on the Brothers and their associates was *The Spectator*, which allowed William Rossetti to defend Pre-Raphaelitism. Every post brought rude anonymous letters. Hunt's father was laughed at in the City, and his relatives urged him to give up. One student of the Royal Academy wrote to Millais warning him that if he saw him in the street in future, he would cut him dead.

Ford Madox Brown, whose Pre-Raphaelite sympathies brought unjust abuse from the press, wrote to Lowes Dickinson:

As to the papers, I have had some fine criticisms and some violent abuse. They seem to smell a rat, and begin to know that if not an actual Pre-Raphaelite Brother, I am an aider and abettor of Pre-Raphaelitism, and under that impression they do not seem to know how to act. Many of the papers who abuse Hunt and Millais most violently pass me over in utter contempt, which is hardly to be looked at as sincere. *The Times* seemed to have a great inclination to abuse, but to hesitate and give it up. My picture [*Chaucer at the Court of King Edward III*] looked well in my studio, but in the Academy it is placed too high and shone all over, which hurt it; and then I find that our pictures are so totally unlike any of the others that they lose immensely from that very reason. We ought (to do them justice) to exhibit them quite apart.[12]

Shortly after this, Millais, in a mood of excitement, revealed to Brown a secret of Hunt's technique which the Brothers had adopted, and Brown, not realizing that the revelation was made in confidence, passed on the secret to Lowes Dickinson:

As to the pure white ground, you had better adopt that at once, as I can assure you, you will be forced to do so ultimately, for Hunt and Millais, whose works already kill everything in the exhibition for brilliancy, will in a few years force everyone who will not drop behind them to use their methods. Apropos of these young men, you must be strangely puzzled to know what to think of them if you see many of the English papers on the present exhibition. For the amount of abuse that has been lavished upon them has been such as

to impart dignity to a name which used to be looked on more as a subject of mirth and derision than anything else. You will remember that with all of us, whatever used to be thought of Rossetti's, Hunt's and Millais's talents, the words Pre-Raphaelite Brotherhood, or the letters PRB, used to be looked upon as the childish or ridiculous part of the business. But now, I can assure you, that I pronounce the words without hesitation as an ordinary term in the every day of art. The term will now remain with them, and, in the course of time, gain a dignity which cannot fail to attach to whatever is connected with what they do.[13]

Within the course of the next few years, Brown's predictions were fulfilled. Yet in the meantime, Hunt's picture, once again, remained unsold. He had been commissioned to illustrate an edition of Longfellow, and had produced three splendid drawings, but the publisher, afraid that the public would shun them, withdrew the commission and gave it to another artist. Nobody now wanted Hunt to paint his portrait, for the hope that it would rise in value as Hunt's reputation increased seemed likely to be unfulfilled. Gabriel had been deterred from ever exhibiting his work again, and had abandoned a half-finished picture from Browning. Things had never looked more desperate for the Brothers.

When everything seemed lost, help came from a totally unexpected quarter. Coventry Patmore, incensed by the critics' hostile attack on Millais's illustration of his poem, *The Woodman's Daughter*, and by the injustice of the storm of abuse heaped on the Brothers, went to John Ruskin and begged him to intervene. Ruskin obliged with two letters to *The Times*, the first of which was published on 7 May 1851:

Putting aside the small Mulready, and the works of Thorburn and Sir Walter Ross, there is not a single study of drapery, be it in large works or small, which for perfect truth, power and finish, could be compared for an instant with the black sleeve of Julia, or with the velvet on the breast and chain mail of the Valentine of Mr Hunt's picture; or with the white draperies on the table of Mr Millais's *Mariana*, and of the right-hand figure in the same painter's *Dove Returning to the Ark*. And, further, that as studies both of drapery and of every minor detail, there has been nothing in art so earnest or complete as these pictures since the days of Albert (*sic*) Dürer.

In a second letter a few days later, Ruskin stated that the chief fault of the Brotherhood was in the commonness of feature in some of the principal characters:

> In Mr Hunt's *Valentine and Sylvia* this is, indeed, the only fault. Further examination of this picture has even raised the estimate I had previously formed of its marvellous truth in detail and splendour in colour; nor is the general conception less deserving of praise. The action of Valentine, his arm thrown round Sylvia, and his hand clasping hers at the same instant as she falls at his feet, is most faithful and beautiful, not less so the contending doubt and distress with awakening hope in the half-shadowed, half-sunlit countenance of Julia. Nay, even the momentary struggle of Proteus and Sylvia, just past, is indicated by the trodden grass, and broken fungi of the foreground. But all this thoughtful conception, and absolutely inimitable execution, fail in making immediate appeal to the feelings, owing to the unfortunate type chosen for the face of Sylvia.

Hunt conceded that Ruskin had pointed to a genuine weakness in his picture, and later corrected it. In his delight, Hunt wrote a letter to Coventry Patmore:

> I am delighted to hear that Ruskin has taken the field in defence of Millais and myself, for I had almost despaired of overcoming the violent opposition to our style which the example of the *Times* and other influential papers are breeding. If they had merely confined their remarks to a just spirit of criticism it would have been all fair, but when they endeavoured to ruin our interest with the Academy and the patrons it was necessary that some notice should be taken, and to have that done by Mr Ruskin is of all things what I could most desire.[14]

Both Hunt and Millais wrote to Ruskin from Gower Street, thanking him most sincerely for championing their cause, and on the very next day he and his young wife Effie drove to Gower Street. Here they found Millais, and bore him off to their home in Camberwell where they kept him for a week. Unfortunately, Hunt, to his eternal regret, could not be found.

Under adversity, the Brothers and their intimate circle of friends were a tower of strength to each other. They were continually together, in each other's 'cribs' or studios, relaxing and talking about

their work and the state of the arts. A meeting at Hannay's crib on Saturday, 10 May 1851, of Hunt and the two Rossettis, was fairly typical. Hunt told them that Ruskin, whose defence of their work was still a major topic of conversation, had wanted to buy Millais's *Return of the Dove to the Ark*, but it was sold already to Mr Combe. When morning finally came, they were still talking.

'Having sat up at Hannay's till an advanced hour in the morning,' wrote William, 'Hunt proposed that we should finish the day with a row up to Richmond, to which Gabriel, Hannay and I agreed. We had a fine day; the lovely Spring variations of green in trees and grass were especially delightful. A bottle of champagne and a bottle of claret which we took with us from Hunt's served to drink the PRB and Tennyson and Browning in.'[15]

Hunt was again in such serious financial straits that for the first time in his life he was now seriously considering giving up painting altogether. Dyce had offered him a job as his assistant-painter, but Hunt could not stomach the notion of working on someone else's ideas. What he now had in mind was to spend a year with his uncle, William Hobman, at Rectory Farm in Ewell, to gain a good working knowledge of farming and cattle-breeding, with a view to emigrating to Canada or Australia.

Millais, however, was horrified at the notion of this waste of Hunt's genius, and his whole family shared his concern. From his own point of view, he was still heavily emotionally dependent on Hunt, who was very protective towards him in a way that Collins never could be. Having recently repaid a debt of £500 to his parents, Millais had no major outstanding commitments. He therefore talked the matter over privately with his mother and father, and with their full approval offered to lend money to Hunt. Amazed and touched by this generosity, Hunt gratefully accepted. There was now no more talk of farming in the antipodes.

Excitedly Hunt and Millais talked over their plans for the year ahead. Millais began the preliminary sketches for his *Ophelia*, and Hunt embarked on the outlines for *The Hireling Shepherd*, built up around a quotation from the Fool in King Lear:

> Sleepest or wakest thou, jolly shepherd?
> Thy sheep be in the corn;
> And for one blast of thy minikin mouth,
> Thy sheep shall take no harm.

At the end of June, Hunt and Millais took lodgings at Surbiton Hill, Kingston. These were far from ideal, being two miles from Millais's chosen site and four miles from Hunt's. Their landlady fed them a monotonous diet of chops and gooseberry tart, and they were martyred by the flies of Surrey, which were more muscular and with a greater propensity for probing human flesh than those of London.

'I sit tailor-fashion under an umbrella throwing a shadow scarcely larger than a halfpenny for eleven hours, with a child's mug within reach to satisfy my thirst from the running stream beside me,' wrote Millais. 'I am threatened with a notice to appear before a magistrate for trespassing in a field and destroying the hay; likewise by the admission of a bull in the same field after the same hay be cut; am also in danger of being blown by the wind into the water, and becoming intimate with the feelings of Ophelia when that lady sank to a muddy death . . .'[16]

No sooner were they settled in Kingston than Charley Collins came to join them. They accordingly moved to much larger and more comfortable lodgings at Worcester Park Farm, near Cheam. The farmhouse, built as a hunting box for one of the mistresses of King Charles II, was situated on one of the highest hills in the country, and approached by a splendid avenue of elms. The branches of these glorious trees were the nesting place of noisy broods of rooks.

According to Hunt, Collins was 'a remarkable looking boy with statuesquely formed features, of aquiline type, and strong blue eyes. The characteristic that marked him out to casual observers was his brilliant bushy red hair, which was not of golden splendour, but yet had an attractive beauty in it. He had also a graceful figure.'[17] He had asked Hunt to help him tone down the colour of his hair, which had always embarrassed him, and which he blamed for a recent disappointment in love. This same disappointment had driven him into a strange religious fervour, which was beginning to irritate his family and friends alike. His brother Wilkie was so disturbed by this that he begged his friends to do all they could to restore him to normality, for fear that he might damage his health.

'We all three live together as happily as ancient monastic brethren,' wrote Millais to Mrs Combe. 'Charley has immensely altered, scarcely indulging in an observation. I believe he inwardly thinks that carefulness of himself is better for his soul. Outwardly it goes far to destroy his society, which now, when it happens that I am alone with him, is tolerably unsympathetic . . . Collins scarcely ever eats pastry; he abstains, I fancy, on religious principles.'[18]

One day in September, when Millais had finished his background of dogroses, and river-daisies, lush meadowsweet and foxgloves for *Ophelia*, he started sketching a pair of lovers whispering by a wall, which he showed to Hunt. To his disappointment, Hunt was unenthusiastic, saying that in his view such a picture could not succeed unless linked to a powerful dramatic story.

That evening, when they met for dinner, Charley Collins irritated Millais by refusing a helping of blackberry pudding, which Millais knew was his favourite dish. Millais began to tease him for mortifying his flesh, pointing out that his health would suffer as a result, and jokingly accusing him of keeping a whip in his room for private flagellations. Eventually Collins went up to bed in a huff. Millais then turned his attention to Hunt, who, having finished his dinner, had been quietly sketching in the chimney corner.

'Why didn't you back me up?' said Millais. 'You know these unhealthy views of religion are very bad for him. We must try and get him out of them.'

'I intend to leave them alone,' replied the peaceful Hunt; 'there's no necessity for us to copy him.' A pause.

'Well,' said Millais, 'what have you been doing all this time while I have been pitching into Charley?'[19]

Hunt showed Millais some rough sketches on the back of an envelope. These were the outlines of *The Light of the World*, and a theme for Millais's two lovers, in which they belonged to opposing factions in the Wars of the Roses. Their discussions around this theme led Millais to his famous painting, *The Huguenots*, based on a scene from the opera of the same name.

In October 1851, Millais received a letter from Mr Combe, and replied:

Hunt and self are both delighted by your letter, detecting in it a serious intent to behold us plant the artistic umbrella on the sands of Asia. He has read one of the travels you sent us, *The Camp and the Caravan*, and considers the obstacles as trifling and easy to be overcome by three determined men, two of whom will have the aspect of ferocity, being bearded like the pard. Hunt can testify to the fertility of my upper lip, which augurs well for the undersoil. It therefore (under a tropical sun) may arrive at a Druidical excellence. . . . Hunt walked to his spot, but returned disconsolate and was wet through. Collins worked in his shed and looked most miserable; he

is at the moment cleaning his palette. Hunt is smoking a vulgar pipe.
He will have the better of us in the Holy Land, as a hookah goes with
the costume. I like not the prospect of scorpions and snakes, with
which I foresee we shall get closely intimate. Painting on the river's
bank (Nile or Jordan) as I have done here will be next to throwing
oneself into the alligators' jaws, so all water-sketching is put aside.[20]

This letter gives the impression of good-natured banter, rather than
a serious proposition to travel immediately to Syria. Gabriel, how-
ever, was thrown into a state of deep anxiety when he heard rumours
of the correspondence between Millais and Mr Combe, and wrote a
folorn appeal to Hunt:

Dear Holman,
 I have just heard from William, with great surprise, something
about you and Millais being commissioned by Mr Combes [sic] for
pictures to be painted in Palestine. Why did you not mention this
when I saw you on Sunday? Pray let me hear all about it as soon as
you get this. I hope to God – and I use the words most solemnly – as
concerning one of the dearest hopes I have – that you are not going
to start before the next exhibition, in order that I may at least have a
chance, by the sale of the picture I shall then have ready, of
accompanying you on your journey. Should your plans however
require an immediate departure, I could only trust, by an effort in
which I do not think I should then find it difficult to persevere, that I
might rejoin you within no long period. For indeed, should this not
happen at all, of which I have thought so much, I feel that it would
seem as if the fellowship between us were taken from me, and my
life rejected.
 I can trust you, my dear Hunt, for knowing much better than
these words express the reality which they have for me while I write
them, being indeed, I suppose, the most serious words I ever wrote
in my life.
 I shall think of nothing else till I hear from you on this subject,
remaining
Affectionately your PRB
D. G. Rossetti[21]

Rossetti's fears were totally unfounded. It was Hunt's dearest wish to
travel to the Holy Land, preferably in the company of his best friends,

to paint his pictures in the authentic setting of the Bible lands. This ambition had been with him from his early childhood, when his father read to him from the big illustrated family Bible, and taught his children from his own illustrated scrapbook. But the fact is that, far from receiving any ideal commission of this kind, Hunt was still engaged in the eternal struggle to make ends meet, and for the time being at least, his prospects of getting to the Holy Land seemed as remote as ever.

CHAPTER 7

— ✸ —

Strayed sheep

I N late October, Hunt and Millais went to London for the weekend
to see Robert Braithwaite Martineau, who on Millais's strong
recommendation had asked Hunt to accept him as a pupil. Mar-
tineau had already been through the Academy with some honours,
and Hunt was happy to take him on. It was the beginning of a
friendship which was to last until Martineau's death in 1869. While
under Hunt's tuition, he painted *The Old Curiosity Shop*, followed by
Kit's Writing Lesson. His most famous painting, *The Last Day in the Old
Home*, which was hung at the Royal Academy in 1861, shows a
young aristocrat who has gambled away the family fortune, drinking
his last glass of champagne, surrounded by his suffering family. This
painting with its moral didacticism clearly shows Hunt's influence.

On their return to Worcester Park Farm, they took Charley Collins
with them. Hunt was now deeply immersed in his new work, *The
Light of the World*, and still painting out of doors, though the weather
was bitterly cold. By day he was still working on his sheep for *The
Hireling Shepherd*, but every night from 9 p.m. until 5 a.m. he went out
to paint his moonlight, sitting in his little sentry-box made of hurdles,
with his feet in a sack of straw to protect them from the elements. At
first he tried to paint by the light of a lantern, but soon found that its
brightness obscured the subtleties of colour, and replaced it with a
candle. His site was near the elm avenue, which was reputedly
haunted. Until ten o'clock the servants came and went, and after that
his friends joined him for a chat while he worked. When they had
retired to bed, his only visitor was the village constable, who origin-
ally mistook him for a ghost, but afterwards fell into the habit of
smoking a pipeful of Hunt's tobacco and chatting to him for half an
hour or so every night.

On 4 November, Millais, who had been advised by Coventry Patmore to keep a diary, wrote:

Frightfully cold morning; snowing. Determined to build up some kind of protection wherein to paint. After breakfast superintended in person the construction of my hut – made of four hurdles, like a sentry-box, covered with straw. Felt like a 'Robinson Crusoe' inside it . . . Hunt painting obstinate sheep within call . . . This evening walked out in the orchard (beautiful moonlight night, but fearfully cold) with a lantern for Hunt to see effect before finishing background, which he intends doing by moonlight.

November 5th. – Painted in my shed from ivy. Hunt at the sheep again. My man Young, who brought another rat [for Millais's *Ophelia* picture] caught in the gin and little disfigured, was employed by Hunt to hold down a wretched sheep, whose head was very unsatisfactorily painted, after the most tantalising exhibition of obstinacy . . .

November 6th. – Beautiful morning; much warmer than yesterday. Was advised by Hunt to paint the rat, but felt disinclined. After much inward argument took the large box containing Ophelia's background out beside Hunt, who again was to paint the sheep. By lunch time had nearly finished the rat most successfully. Hunt employed small impudent boy to hold down sheep. Boy not being strong enough, required my assistance to make the animal lie down. Imitated Young's method of doing so, by raising it up off the ground and dropping it suddenly down. Pulled off an awful quantity of wool in the operation . . .

November 7th. – . . . Hunt was painting in a cattle-shed from a sheep. Letters came for him about three. In opening one we were most surprised and delighted to find the Liverpool Academy (where his *Two Gentlemen of Verona* picture is) sensible enough to award him the annual prize of £50 . . . During the day Hunt had a straw hut similar to mine built, to paint moonlight background to the new canvas. Twelve o'clock. Have this moment left him in it, cheerfully working by a lantern from some contorted apple tree trunks, washed with the phosphor light of a perfect moon – the shadows of the branches stained upon the sward. Steady sparks of moonstruck dew. Went to bed at two o'clock.[1]

Neither Hunt nor Millais appeared to show much concern for the unlucky sheep and rats, who were ill-treated in the cause of artistic truth. Yet Millais's diary indicates that they were not altogether indifferent to the suffering of animals:

November 16th. Sunday. – . . . Hunt and self went out to meet brother William, whom we expected to dinner. Met him in the park. He saw Hunt's picture for the first time and was boundless in admiration; also equally eulogised my ivy-covered wall. All three walked out before dinner . . . In what they called the Round-house saw a chicken clogged in a small tank of oil. Young extracted it, and, together with the engine-driver's daughter, endeavoured (fruitlessly) to get the oil off. Left them washing the fowl, and strolled home.
November 17th. – Small stray cat found by one of the men, starved and almost frozen to death. Saw Mrs Barnes nursing it and a consumptive chicken; feeding the cat with milk . . .
November 18th. – Little cat died in the night, also chicken . . .[2]

Towards the end of the year William Millais spent a few weeks with them, and painted a small landscape. Charley Collins, who was in their company almost continually, painted a background for a picture, the subject of which, characteristically, he could not decide. His painting consisted of a ramshackle shed with a broken roof, through which the sunlight streamed. Outside, glistening leaves fluttered in the summer breeze. He had various ideas for a theme, all of which he rejected. Finally he settled upon a legend of a starving French peasant and his family, who took shelter in a ruined hut and were looked after by a saint. He never finished the picture.

On 22 November Hunt went to London with Collins, having heard that Sir Austin Layard, the distinguished archaeologist who had excavated the ruins on the supposed site of Nineveh, required someone to draw for him. Millais gave the details in a letter to Mrs Combe:

Layard, the winged-bull discoverer, requires an artist with him (salary two hundred a year) and has applied for one at the School of Design, Somerset House. Hunt is going tonight to see about it, as, should there be intervals of time at his disposal for painting pictures, he would not dislike the notion. One inducement to him would be that there, as at Jerusalem, he could illustrate Biblical history.

Should the appointment require immediate filling, he could not take it, as the work he is now about cannot be finished till March.[3]

In the event, Hunt's application was too late, and he returned to Surrey disappointed. For a couple of weeks longer they continued their work at Worcester Park Farm, but the weather was now so cold and inclement that it was no longer possible to work out of doors. On 5 December they asked the landlady for the bill, which would have to take account of the many visitors they had received during their stay: Coventry Patmore, Wilkie Collins, Sir George Glynn, the Tuppers, the Combes, and many others. Millais's man Young came and presented him with a bottle of ketchup. On the next day they returned to London, little dreaming that they would never again live together.

One of Hunt's first tasks on his return to London was to organize the props for *The Light of the World*. His mother's best table-cloth, a family heirloom, was sacrificed for Christ's robe, but the tailor to whom Hunt took it to be made up mistook the instructions and turned it into a modern tail coat, which Hunt had to unpick and drape on the lay figure. Hunt also designed a special lantern, and took it to a metal worker, who made it up in brass. Somewhat to Hunt's dismay, the bill came to £7. Though pictorially it was exactly what he wanted, it had practical disadvantages. The oil lamp belonging to it gave insufficient light, but when he replaced it with gas-fittings, it became red-hot and smoked him out of his studio.

Elizabeth Siddal, who had softened somewhat towards him, allowed Hunt to make a study of the effect of light and shade on her copper-coloured hair. Christina Rossetti sat for the face, under the careful chaperonage of her mother. By moonlight he worked from tendrils of ivy pinned to an old board, and as the picture progressed, employed Henry Clark, who had business dealings with Hunt's father, to pose for the figure of Christ. Clark, who had lived at Aldermanbury in Hunt's youth, now occupied a house with a fine old garden in Homerton, and Clark posed here for Hunt, mostly at night, over a period of several months.[4]

During the daytime he continued to work on *The Hireling Shepherd*. While at Worcester Park Farm, he had found a servant girl who would be perfect for the young woman in the picture. He accordingly approached her mother and brother, a seller of groundsel, for permission to take her to London, where his landlady obligingly gave her a room. The young woman, Emma Watkins, was a great success

among the Brothers, and was nicknamed 'The Coptic' by Gabriel. When she was installed in Hunt's lodgings, he was teased without mercy by his friends, even though he explained that Emma was engaged to be married to a sailor. They delighted in hammering on the door, impersonating the angry sailor fiancé, and the joke was well known among their acquaintances. The Coptic sat for only one of Hunt's pictures. After her brief taste of the life of an artist's model, she went back to the country to marry her sailor.

On 12 December 1851 Millais wrote to Mrs Combe to report that he had sold his *Ophelia* for three hundred guineas. 'Hunt's prize picture of *Proteus* is sold to a gentleman from Belfast – which sets him (H.) up in opulence for the winter,' Millais added.[5]

Matters were not quite so uncomplicated for Hunt as Millais's letter suggests. Francis McCracken, the purchaser, was a Belfast shipping agent and merchant, who became well-known as a purchaser of Pre-Raphaelite art, acquiring work by Millais, Rossetti, Ford Madox Brown and others. He quickly gained a reputation among the Brothers for miserliness and hard bargaining. Gabriel wrote a parody of Tennyson's poem 'The Kraken' entitled 'MacCracken', which began:

> Getting his pictures, like his supper, cheap,
> > Far, far away in Belfast by the sea,
> His watchful one-eyed uninvaded sleep
> > MacCracken sleepeth . . .[6]

In a letter of 27 February 1896 to Mr Birkbeck Hill, Hunt said that *Valentine Rescuing Sylvia from Proteus* was the only one of his pictures which he sold to MacCracken. The latter claimed to be unable to get to Liverpool to see the picture, which had been awarded the £50 prize, 'and at last asked whether I would take a painting by young Danby as payment for £50 or £60 of the price, which was, I think, £157. (It might, however, have been two hundred guineas.) Eventually I agreed, and he paid me the money, part in instalments of £10 at a time. The picture was bought at Christies by Sir T. Fairburn for five hundred guineas, and he sold it about eight years since for £1000 to the Birmingham Art Gallery, where it now is.'[7]

In the *Contemporary Review* of May 1886, Hunt elaborated still further: 'When the dates for payment came, a letter invariably arrived

proposing to give instead of money, further paintings, so that the transaction became a continual torment to me.'

Hunt spent Christmas 1851 with the Combes in Oxford. It was his first visit to their house in the quadrangle of the University Press, of which Mr Combe was head. When Mr Combe had taken over the press, it was doing little more than printing Bibles and Prayer Books, and a few classic titles, at a considerable annual loss, but by broadening its scope Mr Combe quickly turned its losses into gains.

The exterior of the house was in Hunt's estimation somewhat plain, but he was enchanted by the garden, with its fountain and weeping willow, where peacocks wandered at will. Mr Combe's beautiful library of books, and the superb prints and drawings which lined the walls, greatly impressed him. In pride of place above the mantelpiece was Millais's lovely drawing of Mrs Combe. During the course of his visit, Hunt met John Hungerford Pollen, a don with artistic leanings, who had already decorated the ceiling of Merton College Chapel, and Dr Henry Wentworth Acland, the Regius Professor of Medicine who became honorary physician to the Prince of Wales, and was a distinguished amateur artist. Both men became his lifelong friends.

Hunt was now at the very centre of the Anglican High Church party in Oxford. Thomas Combe had endowed St Paul's, Oxford, a Tractarian church with whose vicar, the Revd Alfred Hackman, Hunt now came into contact. Obviously Hunt made a very favourable impression on the Combes and their friends, for at about this time he was commissioned by Mr Combe to paint the portrait of Hackman's curate, the Revd John David Jenkins. After Christmas, Hunt threw himself into his work with renewed vigour, but he found time to model for Ford Madox Brown, who had moved to a new studio next door to Bailey, the sculptor. Brown's current work was *Christ Washing Peter's Feet*, and several of the Brothers and their friends sat for the picture, including Hunt and his father, three Rossettis, and Charles Bagot Cayley, who succeeded Collinson as Christina's fiancé. Stephens, who despite his lameness was exceedingly handsome, and had modelled for Millais's *Ariel*, sat for the head of Christ. Although Brown's painting was impressive, Hunt felt that he was wrong to portray St Peter as a burly sixty-year-old, since he lived on for another thirty years afterwards.

In the evenings, Hunt and Millais often dined at the Collinses' home. Conversation was at its best when Wilkie Collins was there. Charles and Wilkie in their infancy had been dandled on the knees of

such notables as Romney, Constable, Leslie and Turner, whose patrons were Lord de Tabley and Lord Egremont. Wilkie and his mother never tired of talking of these men, who had opened up a whole new field of British art outside the realms of portraiture. Wilkie pointed out that these noblemen were exceptional, for most of the aristocracy cared nothing for the art of their country. Mostly they collected religious paintings of the past, caring nothing for native art. The men who opened up the way for English painters were manufacturers made rich by the industrial revolution, who suddenly wanted works of art that they could relate to personally, landscapes familiar to them, illustrations from books they had read and breathing national sentiment.

In April 1852 Hunt handed in *The Hireling Shepherd* at the Royal Academy. Stephens wrote of this picture: 'He was absolutely the first figure-painter who gave the true colour to sun-shadows, made them partake of the tint of the object in which they were cast, and deepened such shadows to pure blue where he found them to be so . . .'[8]

This was also the first of Hunt's paintings with a moral message. In a long letter to J. E. Pythian, written in January 1897, he explains the picture and his intentions:

> Shakespeare's song represents a Shepherd who is neglecting his real duty of guarding the sheep: instead of using his voice in truthfully performing his duty, he is using his 'minikin mouth' in some idle way. He was a type thus of other muddle headed pastors who instead of performing their services to their flock – which is in constant peril – discuss vain questions of no value to any human soul. My fool has found a death's head moth, and this fills his little mind with forebodings of evil and he takes it to an equally sage counsellor for her opinion. She scorns his anxiety from ignorance rather than profundity, but only the more distracts his faithfulness: while she feeds her lamb with sour apples his sheep have got into the corn. It is not merely that the wheat will be spoilt, but in eating it the sheep are doomed to destruction by becoming what farmers call 'blown'.[9]

At the opening of the Royal Academy Exhibition Hunt received many enquiries about *The Hireling Shepherd*, but to his disappointment, it remained unsold. He had almost despaired of finding a purchaser when he received a letter from an unknown person, Mr Maude of Bath, who said that he greatly admired Hunt's painting but could not

afford to buy it. He therefore wondered whether Hunt would be able to paint a picture containing sheep for him on commission. Hunt replied with alacrity, saying that he would be pleased to do so. Thus encouraged, Mr Maude wrote again asking whether his friend, a magistrate and naturalist called Mr Broderip, could buy *The Hireling Shepherd* in instalments.

'I have sold *The Hireling Shepherd* to Mr Broderip the magistrate for three hundred guineas,' Hunt wrote, 'he has not yet received the picture nor have I the money, they will be exchanged when certain necessary retouchings are effected on the first. It was not until the last day of the exhibition that he closed with me. He is a kind hearted man! and full of appreciation for PRBism. Maclise whom I do not know personally, behaved like a brick in the affair, and was evidently in great part, the cause of the picture's sale to Broderip, who referred to his praises of it. I always liked Maclise, he seems like a *man*, nothing more and nothing less and to be such appears to me to be more than most human beings are.'[10]

Hunt was overjoyed at the sale of his painting, and agreed the terms immediately, with the proviso that he should make some alterations to the face of the young woman, whose features Ruskin considered too coarse and vulgar. The sale of this picture meant that he could now repay his debt to Millais and for a time at least live in reasonable comfort without wondering how to scrape together enough money to get through the coming year. He decided that he would go to Fairlight, near Hastings, in the autumn and begin his commission for Mr Maude. He had decided to create an entirely new picture rather than copy a section of *The Hireling Shepherd*, as at first intended, despite the greater amount of time and effort involved.

In June 1852 Hunt went back to Oxford to stay with the Combes and work on his portrait of the Revd Mr Jenkins, who was a Fellow of Jesus College. Jenkins had a profound effect on Hunt, and the two men were constantly in each other's company. Like Hunt, Jenkins was eager to find a wife, and together they attended social functions and chatted to eligible young ladies, both with singular lack of success. Jenkins became Canon of Maritzburg in 1853, and was appointed Dean of Jesus College twelve years later. When he died in 1876, Hunt wrote, 'I never knew a man more pure in mind and deed than Canon Jenkins. It was a boon to have known him.'[11]

On 24 July 1852, Woolner, disillusioned by his struggle to make a decent living as a sculptor, stunned the Brothers by setting sail from

Plymouth for Australia, where he hoped to make his fortune. A group of other artists, including their mutual friend Bernard Smith, sailed with him. The *Windsor* was due to reach Port Phillip, Victoria, on 27 October 1852. Ford Madox Brown was one of the small party of friends who went to see Woolner off, and he was so moved by the experience that he began work at once on his famous painting, *The Last of England*. He later wrote of this picture: 'It treats of the great Emigration movement which attained its culminating point in 1865 . . . I have, in order to present the parting scene in its fullest tragic development, singled out a couple from the middle classes, high enough through education and refinement to appreciate all that they are now giving up . . . The husband broods bitterly over blighted hopes and all that he has been striving for . . .'[12]

Knowing of Hunt's desperate struggle to make a living, Deverell wrote and asked him whether he thought of following suit. Hunt replied: 'I have only a few men of our circle to keep my thoughts homeward. I do not know what I should do away from Rossetti. It is true, that I have not seen him for a long time, but I know him to be in the same land somewhere, and that at any time he can be found out and spoken with when necessary and this is enough, but to have the dark world separating me from Gabriel, Brown, Stephens and yourself, William R. for this life, is not what I will bring to myself rashly, for fear of the cold desolateness of the shadow of death's valley being anticipated by my soul's meanderings.'[13]

At this juncture, Hunt's pupil, Robert Martineau, approached Hunt on behalf of Edward Lear, who, having heard Martineau's enthusiastic comments about Hunt's teaching, wanted to become his pupil. As the two men had never met, Martineau took Hunt to Lear's home in Stratford Place, where Lear showed him large quantities of outline drawings with little delineation of light and shade. Lear had a habit of endorsing the drawings phonetically to explain what was not clearly apparent, labelling the various parts 'rox', 'ski', 'korn', etc. He asked Hunt whether he thought that it would be possible to use the drawings as a basis for oil paintings, but, predictably, Hunt told him that there was no substitute for painting direct from nature. As Hunt was going to stay in the Hastings area, to paint a background for his picture of sheep for Mr Maude, he suggested that Lear should go with him. Lear, who had lived in Italy for twelve years, was to give Hunt lessons in Italian in return for being allowed to watch him paint and receive his criticisms.

They took lodgings at Clive Vale Farm, near Hastings, where the landlady, Mrs Neeve, allocated them accommodation large enough for friends to join them if they wanted. William Rossetti decided to spend the first week with them. At the last moment Lear wrote to Hunt suggesting that they divide the house up into separate apartments. 'The unexpected guardedness of Lear's reception of us was amusing, but he gradually thawed, and by the end of dinner he was laughing and telling good stories,' wrote Hunt.[14]

The proposal to set up separate apartments became a joke. Lear, who despite being six feet tall with powerful shoulders, was pathologically afraid of dogs, feared that Hunt might turn up with a couple of dogs like the Newfoundland that belonged to the Martineaus, who lived near Hastings.

Soon after moving in, Hunt wrote to Stephens: 'When you go to my den will you please to look at the Coptic's head critically and tell me what you think of it? On leaving I had become so sick of it, and so fearful lest it should be a failure after all, that I was not bold enough to examine it . . . Lear is a very nice fellow but much too old to live with always – he is about forty . . .'[15]

Shortly afterwards he wrote to Stephens again, having been asked by Mrs Coventry Patmore to allow her to take Robert and Elizabeth Barrett Browning to his studio to see his pictures. The obliging Stephens was accordingly pressed into service to dust off the paintings and put them in positions where they could be seen without reflecting the window panes and bars. Hunt was unsettled at Fairlight, and wrote again to Stephens: 'I shall be glad when I can get back to town – everything tries my patience here, even good natured Lear who, being older than myself, I am obliged to humour.'[16]

Hunt soon revised his views of Lear as a companion, for he was witty and entertaining, fitting in easily with the Pre-Raphaelite Brothers. He was a great correspondent, often writing twenty or thirty letters before breakfast. After accompanying Hunt to watch him paint on the cliffs for the first ten days, Lear produced a canvas five feet long and began to work on *Quarries of Syracuse*. While he worked, he joked and composed nonsense rhymes which were later included in his books, and sang songs in a pleasing and tuneful voice, which was much in demand at parties. Although he was fifteen years older than Hunt, he referred to him always as 'Pa', or 'Daddy', and the other Brothers as his uncles.

In a long letter to Woolner, who was continually in his thoughts, Hunt wrote:

Since parting with you, my dear, good Braveheart, I have had no hour until now which could be applied to this noble purpose . . . I am writing this in a little farm house about a mile from Hastings where I have been lodging for the past three weeks, in order to paint a picture of sheep on the top of a cliff, which has yielded me about 48 hours fine enough to work, and so the progress of the work is by no means satisfactory seeing that each unpaintable day makes me take time later in the year for my Eastern voyage (not an anticipation to be delighted at in the depth of winter) . . . I have seen . . . [Ruskin] since you left, and was more pleased than I thought I should be altogether, in spite of meeting with the expected patronising tone. He draws with great ability, much more than I could think any would who admires the two Turners in his dining room. Turner's *drawings* pleased me very much, but not so much as to make me wish to have them by me always. I should tire of them after a fortnight I think. He seems to have forgotten the necessity for the constituent ugliness in works of Art: all abruptnesses are softened or removed from the scene painted, there is one instance of a mountain having been removed, while the drawing without it is still called by the same name as the town, where it exists. In the mists which annoy me so much here I frequently see effects like the dreamy parts of his works, and these I scarcely believed in the existence of an original to, so perhaps my faith may at last grow as large as a grain of mustard seed. Good jolly old Bernard! with the happy, life-enjoying, brave laugh, how I should like to see him! I think of you both every day, morning, noon and evening I sit on the high cliff and look over the great sea as I paint, and hear wave after wave beaten, and rolling back on the torn shingle: and the sun coming up from you to me and from me, again, to you, and no other link but *that*, of a material form, to be seen by both. By the bye, I have devised a means of causing this to make one other. This will reach you in less than three months, I suppose. December 10th, we will allow for accidental delays, say December 25th, Christmas Day (I shall then be in Beyrout) on that day at 7 o'clock p.m. *as time is with you* Bernard and you take a pipe and smoke, at the same time, we will calculate *for difference* of time, Stephens, William Rossetti, I, and some others, will take pipes in different parts of the world together.

What do you think of that? Gabriel cannot smoke, but he will join somehow. Hannay must be one, and whoever is with you that you may care to have. Perhaps you will have seen my brother by then, he left about a month ago, if so get him to join somewhere . . . Gabriel has been very ill with the 'thrush' but is now recovered and gone to see Scott of Newcastle. Stephens is going on steadily, he has lately attended the Academy and *is now making a drawing for the life.*★ I wish he would make some sudden step towards a more certain prospect than his present. Millais is working still at Hayes, in Kent. William Rossetti spent part of his holiday with me, and has now gone back contentedly to the Inland Revenue Office for another year. This is all I know about PRBs . . . Think! my good, dear Tom, through everything, what our first night will be after two or three years of separation, all bronzed to a Titian tint, sitting round a table, you with gold enough to buy England, perhaps, but all with some place in the world, if only gained by wrinkles and the sturdiness which comes by much battling with the crowd, or the possession of wives, payment of income tax, or a safe hold at last on public favour. We shall be men then, not boys as now, but firm and stern realities with big eyebrows, noses, chins and mouths, and loads of experience, wisdom etc. . . .[17]

After William Rossetti's return to London, they were joined by Millais, whom Lear had not yet met. He was avid for information about him, and asked Hunt whether he was inclined to Lord it over other people. Hunt replied that he was one of those good-natured individuals who have a knack of always making other people carry their parcels. Lear vowed that he would not carry Millais's things, and Hunt told him that he would be quite unable to refuse.

On Millais's arrival, they all went down on to the beach by Fairlight Cliff, where Millais, who was a keen amateur biologist, found some cuttlefish bones that he wanted to take home. Turning to Lear, he said, 'You carry it for me, King Lear,' and Lear could not find it in his heart to refuse. After this, 'He doesn't carry his own cuttlefish' became a proverb among the Brothers.

Lear was a great friend of the Tennysons, and kept up a lifelong correspondence with Emily Tennyson, to whom he wrote:

★ i.e. for the life school.

The man living here with me is Holman Hunt, the Pre-Raphaelite painter: he was the originator of the style and (let Mr R. [Ruskin] say as he may) the most original in idea, and the most thoroughly full of understanding concerning portions of nature and art of any young man I have of late seen. He is very plain and uneducated, except by his own exertions – and if all Tennyson's poems happened to be burned by a casualty he might supply their place as I really think he knows all. I am very much indebted to him for assistance in art.[18]

In spite of Lear's amiability, Hunt was often bored and frustrated, mainly on account of the weather and the various hitches that arose in regard to his work. On 22 November 1852 he wrote a long letter to Rossetti:

My Dear Gabriel,

It was a great delight to me, the receiving of your affectionate note. Albeit I always regard our friendship as of a less precarious nature, than those which require continual assurances from one to the other of the holders, and that I often refrain from sending you accounts of my little ways of life, because to do so would seem like playing the tattoo on a kettle drum, and because it is an unspeakable comfort to feel that there lies in reserve the most cared for love, as the most trustworthy band in a great battle; yet sometimes, when troubled or impatient, I am glad to call out to you, and to feel that comfort in your answer, which a child feels in the fearful dark, at knowing that he is not alone . . .

I am full of misgivings about my picture. I never expected it to give much satisfaction to myself, but nevertheless cannot but feel disappointed at its effect now that it is all filled in – I am half doubtful of showing it, even to the owner. I deserved more success; my perseverence in doing it, I regard as the one act of duty of my entire life.

At this moment the noise of the wind and rain are so confusing that I find the same difficulty in writing what I intend, which there would be, were I, under the same circumstances, writing from the half heard dictation of another person. And it is somewhat aggravated by have [sic] so little ink and no pen, but this, which provokingly runs through the paper at every curve . . .

Your brother
Holman.

Gabriel Dante [sic] Rossetti PRB[19]

On 1 January 1853 Gabriel wrote a letter to Woolner, full of news about the remaining Brothers:

I date this from my new rooms at Blackfriars, but it is written at Arlington Street, where Hunt and Stephens have just left, having dined with us, and spent the New Year's evening. Hunt has just returned from a Christmas at Oxford, jollier than ever, with a laugh which echoes one's own like a grotto full of echoes. Stephens smiles as of old, as cordially as the best but with a shade of nicety – the philosopher of reluctance. We have been amusing ourselves since dinner trying to sketch heads from memory. They are lying about the table – all more or less mulls.* Here is one of yourself which looks like a fire-fiend. Of course I do not mean this marginal one, which is William fallen asleep, while I write, in one of his usual anti-anatomical actions. The candle has just been gulped into its socket, and I wake him unrelentingly to ask him if there is another in the room. He says 'no' with benevolent self-possession, and falls asleep again. But he is wrong, for I have found one . . . Here is Hunt. It is one of William's queer portraits, but it has something of him. It looks like a fellow who would have a try at anything, even to making the sun stand still – and indeed he has done that, on his canvasses which are more vivid than ever. You have heard from him, and will know that he is at last coming into his rights, and, as Tennyson says, in his ode on the Wellington fever,

> Has found the stubborn thistle bursting
> Into glossy purples that outredden
> All voluptuous garden roses.[20]

In April, the Brothers met at Millais's house to make more sketches. Stephens wrote to Woolner:

I made an attempt at his [Millais's] most splendid head, but the failure was utter and in spite of all the tauntings he could pronounce, with proddings from Hunt, I viciously refused to proceed . . . However, Hunt, with his indefatigable affection for me, leaned over and altered it, so that it may be just recognisable for the handsome Johnny's head . . . Lear has a picture at the BI which is capital, he delights to acknowledge his obligations to Hunt for

* Mull: muddle or mess.

instruction while they were staying at Fairlight together. He goes everywhere saying that Hunt taught him all he knows and he has improved wonderfully . . . Hunt is becoming more established and acknowledged every day. People begin to see more in the old stunner than they were willing to do at first. He will get his right place at last I know.[21]

Gabriel drew a portrait of Hunt. He wrote to Woolner: 'My Hunt is universally pronounced to resemble Rush on his trial. I am therefore bound to say, that, while it was being made I distinctly remember Hunt's wishing he could hang Roland Hill, for increasing the burden of his correspondence through the penny postage. This may probably account for the murderous expression.'[22]

Hunt sent in three pictures to the Royal Academy Exhibition of 1853: *Claudio and Isabella*, Egg's commission which he had worked at off and on since 1850; *New College Cloisters*, the portrait of the Revd John Jenkins which he had painted in Oxford; and *Strayed Sheep*, originally entitled *Our English Coasts*, the sheep picture he had painted at Fairlight for Mr Maude. A black sheep has gone over the edge and stands bewildered, tangled in thorns. Others follow him blindly, while lambs frisk, oblivious of the danger. Stephens explains that the painting is 'a satire of the reported defenceless state of the country against foreign invasion',[23] a subject uppermost in many men's minds in the year the picture was painted. Later in the year the painting was awarded the prize of £50 at Birmingham. As a Pre-Raphaelite painting of an English landscape in full sunlight, it is unequalled.

At last money was beginning to flow into Hunt's bank account, and with the help of Mr Combe he was able to invest it wisely. His departure for the East was now a distinctly practical possibility. From now on he was determined to put his affairs in order and concentrate on finishing his two pictures for the next year's Royal Academy Exhibition. Gabriel, Johnny and Thomas Seddon, a friend and pupil of Hunt's, still talked of accompanying him, but whether or not they kept to these plans, Hunt was now resolved that no power on earth would now stop him from getting to the Holy Land.

CHAPTER 8

— ❀ —

For the East indeed

BESIDES working steadily at *The Light of the World*, Hunt was now beginning a second picture, commissioned by Thomas Fairbairn, a friend of Augustus Egg. The picture, called *The Awakening Conscience*, is set in a *'maison damnée'* where a wealthy seducer strums 'Oft in the Stilly Night' at the piano with his mistress on his knee. As she listens to the strains of the old song, she is overcome by the realization of the evil that has fallen on her, and starts up as if staring into hell. The seducer is like the cat on the floor, which has brought in a live bird to torture. The gaudy new furniture and flashy ornaments would reveal to a Victorian audience what the woman's early education had been. On the wall are allegorical designs of corn and vines of which Hunt said in a pamphlet published some twelve years later: 'The corn and vine are left unguarded by the slumbering cupid watchers and the fruit is left to be preyed upon by the thievish birds . . . The parallelism, it was hoped, might lead the spectator's mind to reflections beyond those suggested by the incidents connected with the scene portrayed . . .'[1]

The motto chosen by Hunt was 'As he who taketh away a garment in cold weather, so is he who singeth songs unto a heavy heart.'

The delectable Annie Miller, posing in a lace-trimmed nightgown, was the model for this picture. Hunt's sister Sarah warned him that Annie's attire would be too shocking for the public, who would be obsessed with the nakedness that lay beneath the thin nightgown. Another layer of clothing would be a necessary sop to public opinion. Hunt accordingly added the edge of a camisole at the neck, and a shawl about the hips.

With the aid of Mrs Combe, Hunt had been searching for a suitable wife to accompany him to the East. It appeared, however, that

respectable young ladies were rarely attracted by the prospect of trekking on mules through areas notorious for robbers, military unrest, and mosquitoes. The demure Miss Georgina Andrews, of whom he had entertained brief hopes, had preferred a husband who did not expect her to travel to a region where war might erupt at any moment. This refusal was a severe blow to Hunt's self-esteem. Like most of the Brothers, Hunt was shy in the presence of women, and he felt reluctant to approach any other eligible young ladies unless he received definite signs of encouragement.

As Hunt painted the subtle tints of Annie Miller's cheeks and the fire in her eyes, it occurred to him that Annie was well used to privations. He was more at ease with her than with the young socialites at Oxford and London, and he felt convinced that Annie would jump at the chance of marriage to him. If she could be educated sufficiently to eradicate the coarseness from her language and to give her a veneer of culture, she might well suit him as a wife.

The rescue of women from shame and degradation was dear to the Pre-Raphaelite heart. Gabriel had recently fallen under the spell of Elizabeth Siddal, who had been forsaken by the handsome Walter Deverell. Though Lizzie still hankered after Deverell, she acquiesced to Gabriel's advances, which at least kept her within the orbit of the Brotherhood, and saved her from having to return to Mrs Tozer's shop. Under Gabriel's tuition, Lizzie had begun to paint and write poetry. Her work looked like a pale imitation of Gabriel's own. Hunt entertained no hope of teaching Annie to paint, but he felt that he would be satisfied if she learned to speak properly, to control her unkempt hair and to behave well in company.

Annie greeted the news of Hunt's plans for her with less enthusiasm than he had expected, but after a few days she consented to the scheme. Clearly, marriage would have to wait until after his return from the East, and he would need a trusty friend to look after matters on his behalf while he was away. Fred Stephens was the obvious choice, having received so many favours from Hunt that he could hardly have refused. As usual, Stephens was desperately short of cash, and when Hunt placed £200 in his hands for Annie's education and support, he asked Hunt's permission to borrow from the fund until such time as it was needed. Mrs Bramah, the aunt of one of Stephens's friends, who belonged to a society for rescuing fallen women, was engaged to supervise Annie's education. While still continuing to sit for Hunt, Annie began her lessons in dancing and deportment. It was agreed that

when Hunt was in Syria, Annie could model for a few chosen friends who could be trusted not to take advantage of her.

Hunt was greatly relieved when these arrangements had been put in hand. Though he had formerly been an agnostic, his religious beliefs had dramatically changed in recent months since he had come under the influence of the High Church contingent in Oxford. As he worked on *The Light of the World*, a mood of religious fervour had swept over him. He now began seriously to question the morality of his relationship with Annie, and looked eagerly forward to the day when marriage would regularize the situation. Overwork coupled with anxiety caused a temporary breakdown of Hunt's health, and he went to stay with his Uncle Hobman in Ewell to recuperate.

Meanwhile, Millais was with John Ruskin and his wife Effie in Scotland, where he began his famous portrait of the great man. At first he was thrilled by Ruskin's companionship, but after a while he began to find his behaviour patronizing and tedious. As time wore on, he could not help noticing Ruskin's neglect of Effie, for whom he soon entertained the tenderest sentiments. Smothered in his mother's love from infancy, Millais was normally shy in the presence of young ladies, and only felt truly at ease with older women, like Mrs Combe and Mrs Collins. Though Effie was young and beautiful, she was mature for her years and enjoyed considerable social status as the wife of John Ruskin, who was old enough to be her father. Millais, with his notions of chivalry and honour, felt very protective towards Effie, and was thoroughly confused by the feelings he entertained towards the wife of his friend and patron.

All through the summer Millais corresponded with Hunt, begging him to join him in Scotland. The state of his health alarmed Ruskin, who cosseted him like a child. Johnny threw himself into his work, painting until his limbs were numb, eating erratically, going for long runs of seven or eight miles, and seeking solace in unaccustomed religious fervour. Hunt's impending departure for the East without him preyed continually on his mind, and he wrote a long letter pouring out his troubles to Hunt:

Now that there is almost a certainty of war will you still persist in going to the East? If so, I am sure you will be cut up and eaten by the Russians. I had a long letter from Mrs Combe yesterday – she speaks of your departure as inevitable and seems to think that she may accompany you, which would be splendid for you as she is a

wonderful person in sickness . . . My dear fellow, I can't tell you the depth of dull melancholy I have fallen to since I have been away. I quite hate the thought of your leaving me positively friendless (with the exception of Charley). I do believe you will never see me again if you stay away long. I have at night dreadful wakefulness and the most miserable forebodings. I wish you would not forget your original promise that you would write for me to meet you at Cairo after the first year. I don't think I could live in London somehow when you are gone. I have not any place to go to. You will think all this very weak but I don't profess to be otherwise . . . Here I am at 24 years of age sick of everything . . . I don't believe there is a more wretched being alive than the much envied J. E. Millais.[2]

As Hunt laboured to complete his paintings, a continual stream of visitors came to his studio. The Marchioness of Waterford called with her sister, Lady Canning, and afterwards wrote to ask the price of *The Light of the World*. Having promised first refusal to Mr Combe, Hunt wrote to him asking whether a price of 400 guineas would be acceptable, and a cheque for that amount was forwarded by return of post.

Shortly after this, Thomas Carlyle and his wife, Jane, called to see Hunt's latest work. Hunt afterwards wrote of the eminent man: 'His face, despite a shade of rickety joylessness, was one of the noblest I had ever seen. His large-orbited blue eyes, deep sunk, had upper lids drooping over the iris, the lower lids occasionally leaving bare the white below. The brow was prominent, the cranium domed and large, the hair shaggy. His nose and the lower part of his face were of a harmonious grandeur, and his figure, when unbent, had a dignity of its own.'[3]

A year previously, Jane Carlyle had written to Hunt that her husband considered *The Hireling Shepherd* 'a really grand picture! The greatest that he has seen painted by any modern man!'[4] Now, to Hunt's dismay, although he approved *The Awakening Conscience*, he described *The Light of the World* as 'mere papistical fantasy'. Perhaps for the first time, Hunt paused to consider whether this picture was in conflict with his Pre-Raphaelite ideals of truthful representation. If anything was needed to stiffen his determination to go to Syria, it was this. Once in the East, he would produce paintings with the authentic setting of the Bible lands. His work might then be the means of enlightening the faithful, and bringing converts to the true religion of

Christ. From this moment Hunt's struggle for authenticity in his paintings took on a new meaning.

As Carlyle turned to leave, his eye fell on a chalk drawing which was almost complete. Hunt described how he turned to him and asked:

> 'And who may that shrewd-looking man be with the domed and ample cranium? He ought to be a man of mark.' I said that it was my father, whom I regarded as a man of very exceptional intellect, though he had neither had the opportunity nor the ambition to care to make his voice heard beyond his own private circle.[5]

International events now posed a serious threat to Hunt's plans to travel to the East. With the wealthy Ottoman empire on the verge of collapse, the great powers were intent on capturing as large a share of the spoils as possible, and as they moved from one crisis to another, seemed likely to turn the whole of Europe and parts of Asia into a vast battlefield. While Britain strove to prevent Russian expansion in the Middle East, France sought to gain control of the Holy Places in Jerusalem. In August 1853, Hunt was, however, able to write: 'The Turkish affair has blown over for the present. I should not have been prepared to start in the teeth of a war extending itself, as it would have done, over the whole of Europe, and the part of Asia which is our land of promise. Now I see nothing to interfere with our main plan, and accordingly am working daily toward its accomplishment.'[6]

Originally Millais, Rossetti and Deverell had planned to travel with Hunt to the East, but Millais was now heavily involved with Mrs Ruskin, and Gabriel had become engaged to Lizzie Siddal, whose tantrums and illnesses were an increasing burden on him. Worse still, Deverell had become seriously ill with a kidney complaint, and Bright's Disease was diagnosed. Unfortunately there was no known cure at that time, and though the seriousness of his condition was kept from Walter himself, his friends were horrified at the news.

The tragedy was heightened by the recent death of Deverell's parents, as a result of which he had become responsible for his brothers and sisters, including a handicapped girl of eight. When he realized their friend's predicament, Hunt wrote to Millais and suggested that they should each contribute forty-five guineas to buy Deverell's latest picture, taking care to remain anonymous, in the hope that relieving

his anxieties might help in his fight against the disease. Hunt called personally to give Deverell the news that his picture had been sold, and drew a portrait of him as they chatted together. This gave Deverell great satisfaction, and he appeared to rally somewhat.

There was, however, another friend who was now determined to accompany him to the East, as Hunt explained: 'Thomas Seddon was an amateur friend of our circle. He had for years desired to convert his furtive indulgence in art into a professional pursuit of it, but being of value in his father's business, he had been indefinitely chained to it. He was about thirty-three years of age when, hearing of my Eastern project, he asked to join me, and thus by novelty of subject and my instruction make up in a measure for his tardy commencement. As I was not yet ready to start, he elected to go on before me to Cairo, in fear that otherwise he might further lose his freedom.'[7]

While Seddon began the tour alone, Hunt busied himself with equipment for the voyage, and consulted Layard, the discoverer of Nineveh, on matters relating to their journey. In a long letter to Seddon about their arrangements, Hunt wrote: 'I do not feel prepared at this moment to grapple with dates. I am never very strong in this matter . . .'[8]

This was a gross understatement. All his life Hunt was a great procrastinator, totally unable to keep to a timetable. He realized that this was enough to try the patience of a saint, but made no serious efforts at self-discipline. This was probably the greatest flaw in his character, and as time went on was to spill over even into his working habits, with disastrous consequences.

Of their mutual friends in the Brotherhood, he wrote: 'Gabriel is as unsociable as ever while Millais is as whimsical. Sometimes he is going into a monastery and at others only into the Academy.'[9]

There was a general outcry from Hunt's friends about his going away at what was seen by many as a turning point in his career and prospects. Augustus Egg argued that he risked losing his hard-won patrons, who might not follow him through radical changes of subject. Patmore showed that he had entirely missed the point of the journey by saying that the flora in the Bible lands would be nothing better than overgrown weeds, and that Hunt would be able to find natural beauty ten times more lovely at home in England. Russia declared war on Turkey, which once more raised the threat of international unrest. At the eleventh hour, Ruskin wrote to Hunt in a bid to make him give up the tour:

I can't help writing to you tonight; for here is Everett [Millais] lying crying on his bed like a child – or rather with that bitterness which is only a man's grief – and I don't know what will become of him when you are gone. I always intended to write to you to try and dissuade you from this Syrian expedition. I suppose it is much too late now, but I think it quite wrong of you to go. I had no idea how much Everett depended on you, till lately – for your own sake I wanted you not to go, but had no hope of making you abandon the thought – if I had known sooner how much Everett wanted you I should have tried. *I* can be no use to him, he has no sympathy with me or my ways, his family do not suffice him, he has nobody to take your place. His health is wretched, and he is always miserable about something or other; and his mind is really of too much value – as I think yours is also – that the health and life of both should be endangered because you must needs go to paint the Holy Land. You are not fit to do it yet – your own genius is yet *quite undeveloped. I say so the more positively because I think it is a great one – and the greater it is, the longer it will take to mature.* If you go to the Holy Land now, you will paint things that you will be ashamed of in seven years . . .[10]

Next morning Effie told Millais about Ruskin's letter, and he immediately wrote to Hunt telling him that Ruskin's concern about his health was exaggerated, and urging him not to alter his arrangements on his account. Hunt went on with his preparations, but on 20 October 1853 he received another gloomy letter from Millais in which he wrote:

I suppose you are right in leaving this country, which is getting more and more gloomy – relations and friends are dying so fast that I fear every fresh letter I receive contains the news of some other death . . . Scarcely a night passes but what I cry like an infant over the thought that I may never see you again. I wish that I had something to remember you by, and I desire that you go to Hunt and Roshell and get yourself a signet ring which you must always wear . . . I should like to go to sleep for a year and awake and find everything as it was when you lived in Cleveland Street when you were straightened for food, and we all went nightly to disclaim against Rubens, and the Antique – those were happy times to these . . .[11]

On 7 November 1853, Hunt wrote again to Seddon:

> I am progressing very quickly with my picture and am hoping to be quite free by the 15th and perhaps on my route, but from the thousand interruptions of bad light, social duties etc. I can not feel certain enough to ask you to wait anywhere for me. In fact, I feel that the 18th will be the better day for me especially as I have discovered the necessity for attending my dentist who may not be able to perform his operation of stopping in one sitting . . . I am in the midst of such confusion . . . I must try your patience very much with my delays . . .[12]

The new year arrived and still Hunt lingered in England. In the end his departure was a scrambled affair. He needed only one more bright day to finish *The Awakening Conscience* before setting off to join Seddon. Friday, 13 January 1854, was just such a day. At four o'clock in the afternoon he put the finishing touches to the picture, before touring in a taxi to say goodbye to his friends. As it happened, Millais arrived in London that very day.

'The dear old Millais was astonished when I said I was going that night on the mail train,' wrote Hunt. 'Jack came back with me and helped me to pack. Some bachelor friends rallied round me, saying that they should go and dine leisurely and come on to my lodgings later. When they arrived I had gone, and Millais had accompanied me to the station. As I had not had time to dine, Millais rushed to the buffet and seized any likely refreshments he could, tossing it after me into the moving carriage. What a leave-taking it was with him in my heart when the train started! Did other men have such a sacred friendship as that we had formed?'[13]

On Hunt's finger was the little gold and sardonyx ring with their initials entwined, that Millais had given him. He wore it until his dying day. Framed and carefully wrapped, he also carried with him Gabriel's parting gift, a daguerreotype of his painting, *The Girlhood of the Virgin Mary*, with the two sonnets he wrote describing it, and some lines from Taylor's *Philip van Artevelde*:

> There's that betwixt us been, which men remember
> Till they forget themselves, till all's forgot,
> Till the deep sleep falls on them in that bed
> From which no morrow's mischief knocks them up.
> <div align="right">from D.G.R.</div>

In Paris, Hunt booked in at an ancient hotel in the Rue Jean Jacques Rousseau, recommended by Seddon, and immediately made contact with an English artist named Brodie, whom he had met five years earlier when he was in Paris with Gabriel. Brodie was working on a picture called *The Murder of Prince Edward*, but nevertheless found time to take Hunt about the city. Hunt was constantly reminded of Deverell, who was to have been his inseparable companion on this tour, and the thought that he would never see his friend again continually tormented him. He was convinced that his hotel was haunted, and had a recurring nightmare in which he awoke with screams of 'It's death, it's death, it's death!'[14]

Three days of this were enough to make him quit Paris, and travelling to Chalon, he took the Saône steamer to Lyons, where he spent the night before descending the Rhône. The following day brought him via Avignon to Marseilles, where he went to the Château d'If before embarking for Alexandria. The first stop was Malta, and Hunt went ashore to meet the governor, Henry Lushington, to whom Sir Austin Layard had given him a letter of introduction. He also posted a letter to Gabriel, one of many to the Brothers, which were passed from one to another and greatly treasured. When Gabriel received it, he wrote to Woolner: 'I had a long letter yesterday dated Malta, from the glorious old boy . . . William's letter, accompanying this, will tell you how Hunt, the world's great man at last, is off "for the East indeed," – and of what pictures he has painted, celebrated already before the town has even seen them, – and how during his last months here he had become such a swell that he regarded the great Millais as a mere tyro in that particular, and used to be severe on his imperfections . . .'[15]

Hunt hated Egypt, with its monotonous low sand dunes, on sight. He despised the 'house called a hotel', where people clamoured incessantly for attention, and when he transferred to a dirty steamboat in the canal, he complained that the crewmen were wild and rude. Just before sunset, they landed at Boulak, where all the luggage was handled by a grizzly old sheikh and his six sons. A bus drawn by donkeys conveyed them through a dense jungle of sugar canes. Gazelles quietly munching were almost as frequent a sight as the cows and asses tethered in the fields, and by the roadside a motley assortment of jugglers and snake charmers plied their trade.

In this way he eventually reached Cairo, with its bustle and confusion, where water carriers shouted in the name of the Prophet, while

the spasmodic trumpeting of donkeys vied with the loud laughter of the jackass, and hawks circled overhead, occasionally swooping into the middle of the crowd to carry off their defenceless prey. Soon he was safely installed in the Williams' Indian Family Hotel, where Seddon was waiting for him. Edward Lear, who had begged to be allowed to join Hunt's expedition, had reached Cairo on 30 December 1853, but had left shortly before Hunt's arrival, on a Nile expedition with a group of English people, leaving word with Seddon that he hoped to see Hunt on his return.

Seddon shared Hunt's lack of enthusiasm for the Egyptian land-scape. To Millais, Hunt wrote:

> The country is very rich and attractive, but I am inclined to mislike it on that account, for I have no patience with the Fates when they tempt me to become a *paysagiste*. The Pyramids themselves are extremely ugly blocks, arranged with imposing but unpicturesque taste. Being so close at hand, it is difficult to refuse making a sketch of them. With some effect and circumstance to satisfy the spec-tator's expectation and the charm of past history, it might be possible to gather a degree of poetical atmosphere to repay the patience one would expend; but I would rather give the time otherwise. Their only association that I value is that Joseph, Moses, and Jesus must have looked upon them. There are palm trees which attract my passing admiration. Without these, in places, one might as well sketch in Hackney Marsh.[16]

In practical and social terms, Hunt's life was quickly organized, partly thanks to Seddon, who wrote to his fiancée, Emmeline Bulford, on 11 February, 1854:

> Hunt and myself dine today at Mr Bruce's, [the Hon. F. Bruce, British Consul General] and tomorrow we are going with him to call on the Shekh-el-islam, the head of the Mohammedan religion here. It appears that his house is one of the handsomest in Cairo.
> I have changed boys a few days ago, and have now rather a character, known as 'Hippopotamus Jack' as my running footman. I complained of the extreme simplicity of his attire, which he apolo-gised for, saying that his wife had run off with all his clothes to Dongola, up the country. He went to England with the hippopota-mus, and among other virtues, is a snake-charmer . . . His stock of

English is limited; and when he does not know a word, he says, 'Me no got him.'[17]

Seddon dressed Hippopotamus Jack in a blue blouse and white Turkish drawers. He also had his head shaved, and made him use soap. Hunt had decided reservations about him nevertheless, as he explained to Millais: 'His vocation is that of serpent-charmer . . . This recommended him to Seddon's attention, who has such an unqualified love for the inhabitants of this quarter of the globe as to covet specimens of all the noxious reptiles that dwell here.'[18]

Hunt also objected to Seddon's unfortunate habit of wearing native dress, and of being too friendly with the local inhabitants. As far as Hunt was concerned, it was the sacred duty of every Englishman to draw a sharp distinction between himself and foreigners at all times, and to maintain English standards of dress and etiquette. To Gabriel he wrote: 'His devout admiration of the Arabs is perfectly exasperating. They are the meanest sneaks in the world and he never tires of praising them. His adoption of the costume is simply amusing in the result, for somehow the wind and other little circumstances disturb the arrangement with a familiarity never assumed towards a native.'[19]

He, too, needed a running footman, and hired a man called Gabrien for thirty shillings a month in town, where he could pick up additional baksheesh, or fifty shillings in the desert. Board and lodging at the hotel cost Hunt seven shillings a day, but in the desert he and Seddon were able to economize by living simply and shooting plovers and snipe for the pot. Such economies were attractive, but there was another reason why Hunt liked the idea of living under canvas in the desert: 'I find a good deal of difficulty in living in quiet here, for there are four or five other Englishmen in the hotel, some of them very pleasant fellows: but I want solitude for my work, and it is impossible to feel secluded enough even when Seddon is away. When he is present, serious devotion to thought is often shattered with intolerable and exasperating practical jokes, and by his own unbounded risibility at the same . . . I hear no news here but what hoarse-throated donkeys shout. These loquacious brutes are the only steeds one can get here without purchasing a horse . . . They are themselves veritably one of the burdens of Cairo. One is never free for a second from their wanton braying.'[20]

A short while after Hunt's arrival, he and Seddon decided to camp for a while near the Sphinx. On 11 February, Seddon wrote to

Emmeline: 'We intend, in seven or eight days, to take a tent and two camels, with their drivers, and a servant to cook, and camp out by the Pyramids, and move quietly to Sakkara. By this plan we shall economise our hotel bill . . .'[21]

For this expedition they used a double-pole tent, with a double roof, which prevented it from becoming intolerably hot. It was twenty feet long, and the centre pole marked the divide between Hunt's territory and Seddon's. Both men slept on the floor, and dined at an 'Arab table', a circle of black leather, with a string laced round the edges. At meal times this was opened out on the floor, and afterwards was drawn up into a bag containing all the crumbs. One night there was a violent windstorm: 'You would have laughed to have seen Hunt and myself rushing out in our night attire,' wrote Seddon, 'he looking grave and holding on like grim death to the skirts near him, while I was roaring with laughter, and holding on at the ropes outside.'[22]

Hunt was not amused. After a few days he returned to the Williams' Indian Family Hotel in Cairo, where Edward Lear joined him, while Seddon stayed on, encamped near a tomb in which an Englishman, named Nicholson, lay dying. Although Nicholson was merely a casual acquaintance, Seddon refused to leave him, and spent many hours at his bedside, reading to him from the Bible or Prayer Book. He was with him when he died, and commented afterwards: 'It is very painful to see a man dying among strangers, far away from all his friends.'[23]

After Nicholson's death, Seddon was persuaded to take over the tomb, which was far more comfortable than the tent. In a letter to Ford Madox Brown, he wrote:

Old Hunt came to join me yesterday, for I have spent the principal part of the last two months in a tomb, just at the back of the Sphinx, away from all the petty evening bustle of an hotel. We began in a tent, but a week's experience showed that the tomb possessed in comfort what it lost in picturesqueness. It is a spacious apartment twenty-five feet by fourteen feet and about six feet high. My end is matted, and I recline, dine and sleep on a sumptuous divan consisting of a pair of trestles with two soft boards laid across them . . . Since Hunt came I have not quite followed your advice, and have done no sketches here, but at Jerusalem I intend to do so, and leave any parts which can be done in England to finish there. Poor Hunt is half bothered out of his life here in painting figures; but, between

ourselves, I think he is rather *exigeant* in expecting Arabs and Turks in this climate to sit still (standing) for six or eight hours. Don't tell anyone this, not even Rossetti. I think the thing is easily done if one were residing here and with patience.[24]

The wife of the English missionary told Hunt that it would be virtually impossible for him to get models, but Hunt wrote: 'There are beautiful women here. In the country the fellah [peasant] girls wear no veils and but very little dress, and these in their prime are perhaps the most graceful creatures you could see anywhere.'[25]

One day Hunt saw a group of *fellahin* sweeping sand away from the Sphinx. Among them was a slim, beautiful young woman with large eyes, whom he managed to persuade to model for him for a picture which he called *The Afterglow in Egypt*. There were considerable difficulties about working in colour, because of the strong wind blowing sand everywhere, which made painting a time-consuming business, and in the end he was forced to compromise on his principles and finish it in England.

Back in Cairo, Hunt was mooning about in the bazaar when he saw a tradesman paying court to a young girl. Custom prevented the lover from raising her veil to see her face, and he resorted to pressing the fabric close in order to make out the outline of her features. This glimpse of a human little scene captured Hunt's imagination and inspired his new picture, *The Lantern-Maker's Courtship*. Selecting a suitable young man, he paid him to sit for the lover, and on the first day all went well. Next day, however, he failed to turn up, having been told by his friends that Hunt would sell his picture to the devil.

'I wish my attempts to get models had been encouraging in the result,' he wrote. 'Bedouins may be hired in twenties and thirties, merely by paying them a little more than their usually low rate of wages, and these are undoubtedly the finest men in the place; but when one requires the men of the city, or the women, the patience of an omnibus-man going up Piccadilly with two jibbing horses on an Exhibition-day is required.'[26]

Gabrien, ever eager to please, took Hunt to see some prospective female models, who one by one were reluctantly persuaded to lift their veils.

'The shy "daughter of the full moon" squinted,' wrote Hunt, 'and on turning to others, I discovered that Nature had blessed each with

some such invaluable departure from the monotony of ideal perfection. "The evening star" had lost her front teeth, "the sister of the sun" had several gashes in her cheek, while "the mother of the morning" had a face in pyramid shape. I told my man to express my regret that heaven had not bestowed on me enough talent to do justice to that order of beauty . . .'[27]

At around this time news reached Hunt of the death of Walter Deverell. Rossetti described his end in a letter to William Bell Scott:

Deverell's complaint, which had long been called disease of the kidneys, had lately declared itself as dropsy, and he had to take to his bed just at the time he was to have come to me. He was, as you know, very reckless of his health . . . I saw him a week before his death, when he was congratulating himself on some (what he thought good, but, as I heard afterwards, really most dangerous) symptoms. He said to me however, 'I must not halloa before I am out of the wood.' On Thursday morning he was told that he could not live through the day, which he heard quite calmly, only saying that he wished they had told him before, but that he supposed he was man enough to die. At four o'clock his end came: he was conscious to the last, without special pain.[28]

In April, Hunt and Seddon left Cairo, as Seddon wrote:

You will, perhaps, be surprised to hear that our plans are changed, but the fact is, that Hunt discovered, two or three weeks ago, that when Jacob left his father's house he was a middle-aged man of forty, which has stopped him from painting a picture of him in the wilderness, as he had intended to have done at Sinai; so that, not being a landscape painter, he thought he could not spend a whole summer there . . . so we start in a few days for Damietta, a branch of the Nile little visited by travellers, and thence by ship to Jaffa and Jerusalem; whence we shall go, as soon as the heat is great, to Lebanon . . .
At the hotel I found Lear and Hunt done up. Our bedrooms, which are in front, and to windward, were unbearable . . . Today my boy's mother came to me, and asked me to write a paper to prevent her husband's beating her . . . I wrote, 'I hereby order Abdallah Ebu Kateen not to beat El bint l'el Zobeid, his wife, under pain of

my heavy displeasure; and if he persists, I shall send the Howager Hunt to settle him.'[29]

Despite Seddon's faults, he was an excellent tour manager, and bargained for a diabeyah to take them down the Eastern branch of the Nile. The journey was very pleasant and leisurely. Aboard the diabeyah they finished their water-colours and prepared future work. Hunt now determined that his next picture would be *The Finding of the Saviour in the Temple*. In the heat of the day, when they could no longer work, he and Seddon defied the crocodiles and plunged into the waters of the Nile. Unlike Hunt, Seddon was not a strong swimmer, and usually stayed close to the boat. One day when Hunt had been swimming for ten minutes or so, he realized that the boat was picking up speed, and that Seddon, who had already clambered aboard, was laughing and motioning the sailors to go faster. As the boat disappeared round a bend in the river, Hunt, who was almost naked and had bare feet, was obliged to scramble up a twenty-foot bank covered with thistles and brambles. He was not amused at this stupid practical joke, which could have had a very unlucky outcome. On the following day, Hunt saved Seddon's life, which underlined the dangers of their situation. Neither of them referred to either incident again.

At Damietta they discovered that their coasting vessel was a smack of about 40 tons, loaded to the gunwale with rice, with no deck and no cabin accommodation. For several days it lay close to the estuary, but when the wind changed, the cargo was unloaded and a dozen native passengers came on board. Affronted, Hunt insisted on being separated from these in some way, and was allocated a dinghy, where he and Seddon were tolerably comfortable. By and by it came to the notice of the crewman at the tiller that Hunt was sketching, which aroused all his superstitious fears. He accordingly left the helm, and nobody else was willing to take his place. Eventually the vessel drifted into Jaffa, but the crewmen insisted that Hunt should turn out the contents of the dinghy before allowing anybody ashore.

Immediately they set foot in Jaffa, they were sharply aware of the difference between Syria and Egypt. Whereas in Egypt, the patterned dresses were brown and red, or green and pink, or blue and orange, combinations which neutralize each other at a distance, here they were azure and pink, or indigo and white, or yellow and vermilion. These prismatic combinations, Hunt concluded, were suggested by the sky and by the amethystine colour of the mountains, which were pure in

their pristine hues. Simply being in Jaffa with its rich classical legend was exhilarating for Hunt. From the rooftops he could see the remains of Caesarea, where Paul appeared before Festus, and where Herod Agrippa sat resplendent in his golden robes before the multitudes in the amphitheatre. He looked along the sea coast towards Acre, Tyre and Sidon, and saw the snow-capped peak of Mount Hermon, glorious in the afternoon sun.

At dawn on the following day they set out again, through fields where the reapers were at work, and ate their simple lunch of dried fruit and bread in the shade of a sycamore tree. The air was hot and stagnant as they wended their way along a tortuous track up the hillside and down into the valleys, over polished and slippery limestone.

Suddenly their horses stopped, and they saw before them a panoramic view of the city of Jerusalem. It was a moment filled with emotion for both men. The ancient fortresses towered above the battlements, fir trees clustered to the south and a few graceful cypresses pierced the rounded outline of the city. The mountain sloped down to the deep valley of Jehoshaphat; domes and minarets rose against the Mount of Olives, and in the far distance they could see the Mountains of Moab, all amethyst and azure.

'The afternoon sun was already beginning to glow with the softness of amber,' wrote Hunt, 'the breeze from the sea had awakened the birds, and the windmills turned with a music as of new life . . . There was an unspeakable spirit of secrecy in the air . . . I turned to my companion, and he, habitually jocose, was now leaning forward with clenched hands upon the pommel of his saddle, swaying his shoulders to and fro, while copious tears trickled down his cheeks . . .'[30]

CHAPTER 9

— ❀ —

The vision of desolation

I N Jerusalem, where there was no hotel, Hunt and Seddon spent two weeks at the Casa Nuova Monastery, where the Holy Brothers provided them with clean beds and simple fare. When it was time to move on, Hunt rented a furnished house with two servants, one of them a Jew from Tripoli, and the other an Abyssinian. One night, soon after moving in, Hunt was looking out over the high wall of his house and sketching the distant view, when his neighbour angrily accused him of spying on his wives. Hunt assured him that nothing was further from his thoughts, but he refused to be placated, being obsessed with an overwhelming fear that the sight of a younger man might alienate his wives' affections.

Shortly afterwards Hunt received news from home of the fate of his pictures at the Royal Academy Exhibition of 1854. His name was on everybody's lips that year. Predictably, Frank Stone was scathing about *The Light of the World* in *The Athenaeum*. 'The face of this wild fantasy, though earnest and religious, is not that of a Saviour,' he wrote. 'It expresses such a strange mingling of disgust, fear, and imbecility, that we turn from it to relieve the sight. The manipulation, though morbidly delicate and laboured, is not so massive as the mute passion displayed in the general feeling and demands. Altogether the picture is a failure. Mr Hunt's second picture is drawn from a very dark and repulsive side of modern domestic life, but we need scarcely say is treated, in spite of strange heresies of taste and commonsense, with an earnest religious spirit and with a great though mistaken depth.'[1]

Hunt's work met with a varied response from the public. Harriet Collins, the mother of Charles and Wilkie, was at an exhibition with Mrs Combe when a Royal Academician asked her, 'Is it true – I'm sure

you can tell us – that Holman Hunt has found some fool to give him four hundred guineas for that absurd picture which he calls *The Light of the World*?'

'It's quite true,' replied Mrs Collins affably, 'and allow me to present to you my friend, Mrs Combe, whose husband happens to be "the fool" to whom you refer.'[2]

The *Morning Chronicle* described *The Awakening Conscience* as 'an absolutely disgraceful picture', and said: 'Both Hunt and Collins appear to have retrograded during the past year. Their pictures have more of their particular mannerisms and less of their intrinsic excellence than heretofore.'[3]

Gabriel wrote to William Allingham: 'He [Hunt] is at Jerusalem now, where he has taken a house, and seems in great ravishment, so I suppose he is not likely to be back yet. Have you seen the lying dullness of that ass Waagen, anent *The Light of the World*, in *Times* last week? There is a still more incredible paragraph, amounting to blasphemy, in yesterday's *Athenaeum* . . .'[4]

Waagen's offending letter in *The Times* of 13 July 1854 ends: 'The smallness of the head in proportion with the figure is probably attributable to that ambition to imitate the early masters, even in their defects . . . For the green shadows in the hand, though the picture is otherwise most carefully painted, the painter himself must be held responsible, as this is a defect which cannot be laid to the account of those early masters whom he may have studied.'[5]

Ruskin had come to Hunt's defence in two splendid letters to *The Times*. In the first letter he said of *The Light of the World*, 'For my own part, I think it one of the very noblest works of sacred art ever produced in this or any other age.'[6] In the second letter he commented on *The Awakening Conscience*: 'Examine the whole range of the walls of the Academy, . . . there will not be found one [painting] powerful as this to meet full in the front the moral evil of the age in which it is painted, to waken into mercy the cruel thoughtlessness of youth, and subdue the severities of judgment into the sanctity of compassion.'[7]

Despite his practical jokes, Seddon had a serious side to his nature, and was deeply influenced by Hunt, not only in regard to his painting techniques, but also in matters of religion. In a letter to his sister Mary, Seddon wrote: 'I want to know what you think of Hunt's pictures. He is a thoroughly worthy excellent fellow, and in other respects than painting it is a great privilege to have been with him. Tell John [his

brother] it has worked some of my pooh-poohing all scepticism out of me.'[8]

One of the first expeditions made by Hunt and Seddon was to the Mount of Olives, which was wild and desolate, like the surface of the moon. Next day, they made a pilgrimage to Bethlehem, armed to the teeth for fear of attack. After this Seddon decided to go off and live under canvas by himself for a while, for he was essentially a landscape artist, and he wanted to paint the valley of Jehoshaphat. Hunt, however, was preoccupied with people and costume, and with social and religious customs, and stayed on alone in Jerusalem in the house of a missionary who was out of town for a few months. Every Saturday he went to the synagogue to watch the religious service. Whenever he went out into the streets, he was hounded for baksheesh and called a 'Christian pig' if he did not respond generously. Often he was threatened with violence, but being well-versed in the art of self-defence and brave as a lion, he refused to be intimidated.

On one occasion when he was sketching alone by the Pool of Siloam, a band of *fellahin* led by the Sheikh of Siloam attacked him. Hunt vigorously defended himself with his fists until a powerful-looking *fellah* started to brandish a long horse-pistol, with which he proposed to put an end to the unequal contest. At this moment Hunt drew a cheap revolver, bought as an afterthought with Millais on his last night in London, and used it to disarm his opponent. Then he marched them all back to Jerusalem and took them to the British Consul, as a result of which they were jailed. Later, however, Hunt checked out his revolver in the garden of his house. 'The weapon was a cheap one,' Hunt wrote, 'a merit which as the last of my disbursements for the voyage was a consideration to me . . . To my consternation the hammer, when I pulled the trigger, was raised only half an inch, and then no strength of finger would stir it.'[9]

After this episode, Hunt was treated with considerably more respect both in the city and in the surrounding countryside. He was, however, regarded as utterly mad by the *fellahin*. His household servants, who saw him doing nothing but draw, paint and write, and setting a high value on authenticity, regarded him as a great Howagah who could afford to gratify his whims at any trouble or cost. In a letter to Seddon, he related how his servant, having been sent to fetch him some salt and to lay it out for him to paint from, turned to the landlord and said: 'Did you ever see such a strange Howagah? He does nothing but play from the moment he gets up to the moment he goes to bed like a child.'[10]

Immediately on their arrival in the city, Hunt and Seddon had made contact with the Protestant Mission. The English Mission to the Jews in Jerusalem had been established in 1833, and the Bishopric had been founded in 1841 as a strategy to force Turkey to recognize Protestantism as a valid religion. It was funded by an annual grant of £600 from the King of Prussia matched by a similar sum raised by the London Society for Promoting Christianity among the Jews. The funding authorities alternately nominated the Bishop of the United Church of England and Ireland in Jerusalem, and the Turks reluctantly agreed to recognize the new Bishop, provided that he did not attempt to gain converts from among the Muslims or from other Christian sects. This effectively limited the Bishop's evangelical field to the native Jewish population. At the time of Hunt's arrival, the Bishop was a man called Gobat, nominated by the Prussians. As there were virtually no Protestants in Jerusalem, Bishop Gobat's congregation consisted of the employees of the mission and a handful of Jewish converts. In an effort to obtain more converts, the missionaries resorted to bribing the native Jews, and their activities brought down on the Mission the wrath of the European Jews, headed by the Rothschilds, who sent a man called Cohen to sort out local affairs.

On 25 June 1854, Seddon wrote to Emmeline explaining the situation as he and Hunt originally saw it: 'Most of the English are more or less occupied here in the mission to the Jews, and they seem to be doing a great deal of good. They have boys' and girls' schools on a large scale, and an admirably arranged hospital, making up about thirty beds. There are not many converts yet, though there are some; but the people seem to feel that their intentions are friendly, and the Children all read both the Old and New Testaments. The elder men and rabbis show no disinclination to listen and discuss matters; many are wavering, and a great change seems to be anticipated shortly.'[11]

This was an opinion that both men were soon to revise, as Seddon wrote to his aunt: 'I spoke in my earlier letters very hopefully of the mission but further experience makes me modify my opinion very much and I cannot but think that a great deal of their funds is expended in maintaining an extremely bad system of idle beggary. The money that has in so many years proved of so little effect here would have kept almost millions of our own poor from ignorance and vice.'[12]

When Mr Cohen, the Rothschilds' envoy, arrived in Jerusalem, he forbade the Jews to accept any employment from Christians. This meant that Hunt's Jewish models, patiently recruited and essential to

his work, immediately refused to sit for him again. Seddon explained matters to Emmeline:

> We have come here just at a crisis when the European Jews, alarmed at the proceedings of the mission, have sent over a Mr Cohen to examine matters. His first step was to lay a heavy curse upon any Jew who held any communication with Christians; and Hunt, who had spoken to some about sitting to him, was put under a special curse. He called on Cohen, to explain that he had no connexion whatever with the missionaries, and that his object was purely an artistic one; and that, even if he wished, he could not convert any, because he could not speak a word that they could understand. But long before he could say all this, Cohen burst into a most ungovernable passion, and stamped, and railed against Christians till he was breathless. The effect has been, that not a soul has dared to come near the house, which has made him lose the whole of a month.[13]

It was not until August, when Hunt was on the verge of despair, that Cohen left, and Hunt's sitters began drifting back to him. Even so, Hunt needed all his patience to get new models.

'I go every Friday and Saturday . . . to see the Jews worship', he wrote to Millais. 'I also take every opportunity to get introduced to them in their homes. They are polite, and I can study their characteristic gestures and aspects; but for special attendance at my house I can scarcely get them at all. When by the exercise of great interest one is brought, he looks about like a scared bird, and if he sees any piece of carpentry – a window sash, or a border of a panel – that looks in his suspicious eyes like a cross, away he flies, never to come back any more . . . My subject picture is in the most unsatisfactory, higgledy-piggledy state, with many disjointed bits begun and not completed.'[14]

Most of Hunt's social contacts in Jerusalem were associated with the staff or congregation of the Mission. His chief friend there was James Graham, the Lay Secretary of the Jerusalem Mission to the Jews, an office which he had held since December 1853. Prior to this he had been a director of a Glasgow bank which failed, and as a major shareholder, he had lost everything. He had taken the post in Jerusalem in order to avoid being a financial liability to his friends. As early as 1854, only three years after Frederick Scott Archer had perfected the collodion wet plate, Graham was an enthusiastic amateur photographer. Hunt wrote of him: 'He was a Churchman with a

strong tendency to Presbyterianism; he was good-nature itself, but prosy, and an incorrigible procrastinator. Tall, fair, and brawny, riding beautifully, and having a deliberate polite gait and manner, he took rank at once as a person of distinction.'[15]

Another important friend was Robert Sim, a surgeon who worked at the Mission Hospital, and who frequently accompanied Hunt on his expeditions into the desert until in a mood of patriotism he went to the Crimea to become an army surgeon. He was an expert marksman, and after Seddon returned to England, he shot a magnificent eagle, four feet high, with a wing-span of eight feet, which he packed up and sent for him to paint. Sim's colleague, Dr Edward MacGowan, was also one of Hunt's friends, and later spoke out against Bishop Gobat's conduct of diocesan affairs.

Seddon was nearing the end of his tour when he set out with Hunt, Graham and Sim for Hebron. At the last minute Graham had to return for his gun, promising to catch up with them as soon as possible. On the way, they stopped for breakfast at Artass, a village set in a long, winding valley, with a stream from Solomon's Pools running through it. The vegetation was luxuriant; figs and grapes were abundant, and peaches the size of a double fist were on sale at a penny a pound.

Here they made the acquaintance of an eccentric Canadian fruit-grower called Henry Wentworth Monk, who impressed Hunt with his incredibly detailed knowledge of the Bible. Monk's life's ambition was to abolish war by uniting Christendom under a supreme central parliament, with an army to enforce law and order. In this ideal world, heroic minds would be used not for death and destruction, but for humanitarian purposes. Later he sought to raise funds for the gradual purchase of tracts of land in Syria, but he failed to persuade Hunt to become one of the shareholders. Hunt regarded him as a complete madman, but this did not prevent him from painting a fine portrait of him, dated 1860, featuring his magnetic eyes and long, flowing beard.

From Artass they moved on to Solomon's Pools, which used to supply Jerusalem with water, until the *fellahin* broke holes in the aqueduct, to save the trouble of taking their cattle to water. The Hebron Valley was very beautiful, and was covered with vineyards. They visited the mosque at Hebron, which housed the tomb of Abraham, Sarah, and Jacob, but to their great disappointment the Muslims did not allow free access to the building, and they saw very little.

Meanwhile, Graham failed to turn up with the tent in which they

were to have slept, and so they lodged overnight in the freshly whitewashed house of a local Jew. Next morning they found Graham waiting for them with the tent under Abraham's Oak, where he had spent the night, having mistaken the rendezvous. The tree was 60 feet high and 24 feet in circumference. Though its connection with Abraham may have been mythical, it was an impressive landmark, and Seddon made a sketch of it. Finally they climbed the hill and from the summit, in the rays of the setting sun, looked out over the Plain of Sharon to the sea. Throughout the day, Graham had been active with his camera. Seddon wrote of his photographs: 'They are extremely valuable, because perfectly true as far as they go; however, they will never supplant the pencil.'[16]

Next morning Seddon and Sim returned to Jerusalem, leaving Hunt and Graham still busy with pencil and camera. They were scheduled to leave at midday, but Hunt was not ready until four, when Graham decided to go into the village to get some small change. Loading the photographic paraphernalia caused them endless trouble, and they tried to balance it on the donkey with bunches of grapes. It was 6.30 p.m. when they eventually left, with an Arab to guide them, but they lost their way in the dark.

'They . . . looked for the North Star,' wrote Seddon; 'but here there was a difference of opinion; one chose Jupiter, which happened to be due south, and the others each took a pet of their own. Fortunately, Graham had a small compass, but they had no little difficulty with a flint and steel getting a light to see it. At last they got to Bethlehem at three in the morning, slept there two hours, and arrived at Jerusalem at seven, just as we had finished breakfast.'[17]

As Seddon began winding up his affairs in preparation for his return to England, he sought further advice from Hunt about his work, which was unfinished. Hunt urged him not to return home until he had completed his paintings, but Seddon was in love, and anxious to get married. As far as he was concerned, this took precedence over all other considerations. He had previously worked on unfinished pictures in his studio, but Hunt regarded this as unsatisfactory. 'Remember however that away from nature itself this can only be effected by removing or at least confusing features that you have marked down; before nature the simplifying is done by adding . . .' he wrote.[18]

In the event, Seddon left Jerusalem on 19 October 1854, but Hunt helped him out of a difficulty by completing a water-colour sketch for

him after his departure. This has been identified as either *The Well of Enrogel* or, more probably, *The Mountains of Moab*.[19]

Hunt's influence on Seddon had been profound, and in a revealing letter, Seddon wrote: 'I am sure that there is a great work to do, which wants every labourer – to shew that Art's highest vocation is to be the handmaid of religion and purity, instead of mere animal enjoyment and sensuality. This is what the Pre-Raphaelites are really doing in various degrees, but especially Hunt, who takes the higher ground than mere morality, and most manfully advocates its power and duty as an exponent of the higher duties of religion. Indeed, I think our intimacy is a most valuable and useful lesson to me, for which I may thank God, and by which I hope to profit much myself; for he has the courage to say openly what he thinks is right.'[20]

Every Sunday, Hunt was in the habit of assessing the week's progress, and comparing it with what he had set out to achieve. He now realized that it would be impossible to complete *The Finding of the Saviour in the Temple* in time for the Royal Academy Exhibition of 1855. He therefore decided for the time being to concentrate on another subject, which he described to Millais in a letter dated 10 November 1854:

In Leviticus xvi, 20, you will read an account of the scapegoat sent away into the wilderness, bearing all the sins of the children of Israel, which, of course, was instituted as a type of Christ. My notion is to represent this accursed animal with the mark of the priest's hands upon his head, and a scarlet ribbon which was tied to him, escaped in horror and alarm to the plain of the Dead Sea, and in a death-thirst turning away from the bitterness of this sea of sin. If I can contend with the difficulties and finish the picture at Usdoom, it cannot fail to be interesting, if only as a representation of one of the most remarkable spots in the world; and I am sanguine that it may be further a means of leading any reflecting Jews to see a reference to the Messiah as He was, and not (as they understand) a temporal king.[21]

Hunt had recently bought a white goat for his picture, and his need to find a suitable background coincided with the arrival in Jerusalem of several other people who wanted to go with him into the wilderness. These included Mr Porter, the author of Murray's *Guide to Syria*, who had arrived from Damascus, and William Beaumont, a young Fellow

of Trinity College, Cambridge, whom he had met in Cairo, as well as Beaumont's father, who had recently joined him. As the group left the city by the Jaffa Gate, slaty clouds covered the sky, thunder murmured in the distance, and lightning quivered from east to west. When they reached the first height beyond Hinnom, Hunt decided to ride on ahead with Issa, Graham's servant, to get accommodation for the party in the Quarantine Building. The rest of the group were horrified at the potential danger to Hunt, but he simply laughed at them, revelling in the situation, and set off at a brisk trot, pumping water out of his carpet saddle as he went. Somewhat reluctantly they eventually followed him. When they reached the bottom of a deep valley, their strongest mule fell down, and they were unable to get the animal to its feet again until they had unloaded all the supplies from its back. Meanwhile the storm continued unabated, and Hunt later recalled: 'The lightning was kindled in the east, and played along the gamut of the cloud-clavier as if with the touch of an almighty hand, advancing note by note along the extending range, until in the west it closed like an angry fist, and descended on the plain as though to single out the object of its wrath.'[22]

After a while they realized that they were lost, and hearing the barking of dogs, Hunt led them to a village. At their approach, the men, who were sleeping around their fires, started up, while the women and children, too, looked dismayed but fierce. Hunt asked for the sheikh, who appointed one of his men to guide them to the Quarantine Buildings, which they reached in the early hours of the morning. Just as they came in sight of their objective, Hunt's horse stepped on to a loose mass of rock and fell. Hunt threw himself clear, pushing his gun into a safe direction, for it was loaded and half-cocked. The horse rolled heavily down the incline, and was scarcely able to get up again, while Hunt escaped with a badly bruised leg. Hobbling to the Quarantine Building, Hunt knocked loudly, but nobody answered, so that eventually he had his baggage stowed under the portico, selected some dry matting and went to sleep. Next morning he awoke to find himself surrounded by curious men, women and children, who watched him while he drank his coffee before riding out alone to work on a sketch which he had begun on an earlier visit.

After he had finished sketching, Hunt rode to Abraham's Oak, where the tent had been pitched. The rest of the party had not yet arrived, and he ate a solitary meal of grapes and bread, thinking

nostalgically of his friends at home in England. In his pocket he had the latest letters from Millais and Mike Halliday, an amateur painter who worked in the House of Lords. He was a friend of the Brotherhood, and Millais had recently been advising him on his painting, as a result of which he had attained a high standard of proficiency. Lying under the great tree in the middle of the afternoon, Hunt re-read the letters. Then, rolling Halliday's envelope into a cigarette, he smoked it as a kind of ritual while he remembered his absent friends. 'I could remember Winchelsea so clearly,' he wrote to Millais, 'all our walks there together, and our meal at the inn, and I could imagine you and jolly Halliday working there within sight and sound of the sea. And how I could have joyed to be with you, to talk together for a few hours! Some day again I hope to see you, and not long hence. A few months, and I shall look for spring and England together.'[23]

When the sun went down, the remainder of the party had still not arrived. In the middle of the night a great storm arose, and while the lightning flashed and thunder rumbled overhead, the wind rushed past Abraham's Tree like massive waters. Luckily Hunt's tent was sheltered from the elements by the enormous girth of the tree, and when the storm eventually passed, the stars shone down through a dramatic blood-red sky. It was a solemn moment for Hunt, who realized that he stood on the very spot where Abraham received the promise of the future greatness of his race.

On the following morning, Beaumont and his father arrived at Abraham's Oak, and reported that the rest of the group had returned to Jerusalem. Beaumont, however, had refused to leave Hunt in the lurch, and brought with him Graham's tent and his servant, which he had left behind for Hunt. Having restocked their canteen at Hebron, they went on to their next encampment, led by a party of Arabs. Next day they followed the shores of the Dead Sea to Oosdoom: '. . . the whole scene was a vision of desolation and deceitful phantasy,' wrote Hunt. 'Before the sun rose every rock appeared like a weird monster, in the cave itself were white stalactites and rocks, which to our eyes, dazed by the sun, appeared as threatening genii, and to the ear the effect was no less magical, for as we shouted, "Remember Lot's wife," round every hill and cranny were the words murmured in confusing mockery, until distinct in every syllable, "Remember Lot's wife" was returned to us.'[24]

The heat was intense, and their water stocks exhausted when they came upon a stream in the desert. Beaumont fell upon it and began to

slake his thirst, but Hunt recognized the danger immediately, and warned Beaumont not to drink, for the water was pure brine. In the end, he and Beaumont's father had to drag him away. A few miles further on, their servants awaited them in a wadi with an excellent fountain.

'It was a journey of inconceivable delights,' wrote Hunt; 'its daring nature only added zest to the adventure.'[25]

Nevertheless, Hunt failed to find the background he wanted for *The Scapegoat*, and when he returned to Jerusalem, he learned that the whole of Southern Syria was in a state of unrest, as the sheikhs massed their forces in an attempt to oust the Turks. All too frequently, patriotic endeavour degenerated into lawlessness, and peaceful travellers now ran increased risk of violence and robbery. It was enough to daunt even the bravest, and few people now left the city. Even Hunt quailed at the prospect of facing the wilderness. Only his strong sense of personal mission and his indomitable courage induced him to set forth on his perilous adventure, as he explained in a letter to Mr Combe:

> Before leaving here I had all manner of arguments and weaknesses to overcome, or rather fly in the face of, in making my preparations and setting off, no frank had ever been in the place for more than a few hours hitherto, it was notorious – for the wildness of the few inhabitants, then the many deaths by fever that had occurred to people who had spent any time in the atmosphere of the pestilential lake and many other facts were represented to me to dissuade me until finding my judgment yielding I remembered that I had already determined the course and that it could not be changed.[26]

Having negotiated with Omar Beg, the mukkary master, Hunt returned to the Dead Sea, taking with him an Arab named Nicola Beyrouti to take charge of his animals. Wherever they went, the bleating of the white goat aroused the dogs in the villages they passed, leaving Nicola in terror of attack. They were constantly aware of the presence of brigands, and Hunt travelled with his gun held high and the trigger cocked. At one point the mule carrying their gear fell, and Hunt had to keep guard while it was unloaded and raised to its feet again. It was after midnight when the mukarry said that they were lost, and they had no alternative but to spend the night beneath the terrace of a hill. Next day they set out again, and Hunt wrote:

Every fresh hill brow drafted us lower into the wilderness of Ziph, nowhere was there a trace of landmark, road or any sign of life. As the sun rose towards the zenith, the shadows of the rocks disappeared, and the want of even their shelter made the wanderer feel more of an outcast; the bare earth grew wilder as though new from the Creator's hand; and yet I felt a novel joy in life. I looked around to account for my exhilaration of spirit, but there was only a sweet purity in the very barrenness of the scene before me; it was a pleasure to inhale the living breeze wafted from the distant Mediterranean, perfumed by forty miles of aromatic hillside and plain.[27]

In the afternoon Hunt reached the encampment of Sheikh Abou Daouk. The English Consul wished to make a gift of a coat to the sheikh, and asked Hunt to present it on his behalf. Hunt asked the sheikh if he would allow two or three of his men to accompany him during the next few weeks while he painted his picture, and the sheikh readily consented, but said that in view of the dangers involved, he would need a hundred men. The cost of their services would be £500. After the usual haggling, he finally agreed to accept 800 piastres (about £7), plus 300 piastres for the sheikh himself.

Heir to the sheikh was a twenty-year-old man called Soleiman, who accompanied him on the expedition, and was so taken with Hunt that he begged him to allow him to become his son. Even with Soleiman as guide, the route was fraught with danger. For three or four days they had seen no sign of vegetation. At one point Hunt went forward alone in search of a suitable site, and immediately sank into a pit of slime. Fortunately he had the presence of mind to throw himself down at once and literally crawl on his belly until he reached the safety of a firm ridge. By this means he literally saved his own life.

At last he found the view that he had been looking for, on the shores of the Dead Sea, at Oosdoom. It was in this wilderness of silica and limestone that Lot was thought to have ascended when he escaped from Sodom. When Hunt arrived at the southern end of the Dead Sea, he was appalled at the desolation of the landscape, and wrote in his journal: 'I can understand the use of Art in thinking how interesting a picture of such a scene would be, and in thinking that I was doing right morally in undertaking a work of similar value in conveying important knowledge I commended myself to God's merciful protection from all the dangers by which I had ventured to challenge in this

pursuit. I believe if I had not had the comfortable assurance of his presence and defence of me, that I should have been overcome and cried like a child at the misery of my solitary position.'[28]

After searching for a suitable spot to set up his camp, Hunt chose a site by a dry watercourse, where he pitched his tent. Every day he went down to the margin of the Dead Sea, accompanied by Soleiman, who sat minding the ass while Hunt painted until sunset.

'The water was sometimes blacker than London porter and the bread like a mud pie,' he wrote to Seddon. 'There were many gazelles and Bedens there but I had no time to lie in wait or track them.'[29]

One day, when Hunt was in a particularly happy mood, he seized his gun as a partner and waltzed along the shore with it, to the utter amazement of Soleiman and his companions. Later Soleiman begged Hunt to demonstrate his 'dervish dancing' to his friends, and was disappointed when Hunt refused. He wanted Hunt to marry the Sheikh's daughter and be Sheikh before him, and was unable to understand why Hunt declined.

Every day Hunt went on steadily with his work, despite a bad attack of diarrhoea, which he shook off with difficulty. On one occasion as he painted the inhospitable landscape, a band of robbers appeared on the horizon. The group consisted of three horsemen armed with long spears, and four on foot armed with guns, swords and clubs. Soleiman warned him to retreat immediately, but Hunt, characteristically, insisted on going on with his painting with apparent unconcern. The robbers were somewhat nonplussed by this, but eventually left when Soleiman told them that Hunt would not hesitate to shoot them with his double-barrelled shotgun. After they had gone, Hunt's men insisted on cutting short the tour, and he had no option but to pack up his belongings and return to Jerusalem. On the journey, the white goat took sick, and had to be carried on the picture case. Sensing that its end was near, the vultures circled overhead. Hunt poured water into its mouth but despite all his efforts to revive it, the unlucky beast died.

On the way back, he stopped at the Quarantine Building, and found that it was under attack from Abderrachman with 6,000 *fellahin*. A band of armed men apprehended Hunt, mistaking him for a Frank. Nicola was convinced that they were about to be killed. Fortunately, however, it transpired that the leader of the group was Abderrachman's brother, who was his sworn enemy, and Hunt was therefore allowed to proceed along a path between the two armies. Bullets were flying in all directions, and he was glad to reach Jerusalem alive, with

all his paraphernalia intact. He now had to reconcile himself to the impracticality of finishing *The Scapegoat* on the shores of the Dead Sea, as he admitted in a letter to Seddon: 'I am humbled you see in having to do my Dead Sea work almost entirely without Nature. I have painted the Mountains and the sea, and some of the foreground, but the others, the sky etc. I have to do from the top of Sim's house, or otherwise I must just throw the picture away according to my first impulse.'[30]

Hunt was still in Jerusalem painting *The Scapegoat* in January 1855. Outside in the streets of the city the snow lay some two or three feet deep. It had not been easy to replace the white goat, and he had had to send a man over the Jordan, where he had found a fine animal at a high price. Unfortunately the goat died after Hunt had had it for only two days. It was mid-February before he managed to get another. Shortly after this he received a letter from Gabriel, who wrote: '. . . I am beginning this at Albany Street where Christina . . . has just charged me with a charge to you to bring home an alligator (an allegory on canvas not to be accounted a fair substitute), in which she also proposes that a few of your select friends should be allowed to take shares, after which its sudden presentation to the Zoological Society should make the fortunate Joint Stock Company members for life of that dismayed Institution.'[31]

To this Hunt replied, 'Alas! your sister's commission has come to the wrong place. Very willingly would I sidle up to a basking alligator with "pretty! pretty! did he then" and so on and so on, until by gentle patronage I had obtained a good hold of the scuif [sic] of his neck, and could thus capture the unwary animal for the grand object in idea but he is not here, not nearer than Higher Egypt in fact which is much farther south than I have any intention of going this journey. So I am afraid the scheme must be regarded at present only as an intention. Of course a profoundly secret one too, until my next journey gives me an opportunity of securing the honour of the scheme to the lady who invented it.'[32]

Gabriel also informed Hunt that he planned a new picture, about a peasant taking a calf in his cart to market when he sees his lost sweetheart, who has turned to prostitution. He was fearful that Hunt might feel that he had stolen his own subject, but Hunt replied:

I could wish we were all employed about such subjects if there be any power in a simple representation by Art of such terrible

incidents when the guilty see the angels sorrowing for them to lead the unstained to guard their innocence. I can't tell why you think people can suppose it to follow in the wake of my last year's picture. If so, I should never be able to paint another picture for I believe you have designed subjects bearing on every art, science, feeling and virtue that exist in the world. Surely it is enough to illustrate a moral with a different incident from that of another's. I believe that good can not be done by a single exposure of the vice particularly this vice as men would see nothing but a pretty sentimental vanity in one illustration of the evil, when I believe many would hesitate in a mad career if they were led to consider the sin denounced by a class of men who till this time have been thought excused for some licentiousness.[33]

Hunt told Gabriel that he now had no hope of finishing *The Scapegoat* in time for the Royal Academy Exhibition of 1855, and added:

I don't know I should have thought the subject demanding immediate illustration had I not had the opportunity of painting this extraordinary spot as background from Nature, and had not the Jewish conceptions of the Messiah which they have formed without attention to types and prophecies, such as this, been brought so often before my eyes. I should like to show it to you yet I have that horrible feeling of dissatisfaction with [sic] urges me to put it by, and trust to my next work as my hope of using my little strength to some purpose. My other picture I paint at as Russians are kept at the guns and bayonets. I compel myself to labour despite frightful suspicions of its never coming to anything. I could never tell you what a full equivalent the beauty of this country is to any bothers I suffer from . . . Even with all hideous domes and minarets the city is the most purely poetic sight on earth I am convinced. Every hill about here is covered with a delicate green which makes the country heavenly beyond all hopes description. I shall be dreadfully sad in leaving the place with so very little of its countless beauties on canvas.[34]

CHAPTER 10

——— ✸ ———

The Hanna Hadoub affair

ALONE in the East, Hunt constantly thought of the small band of friends who had once shared his ideals. So many of his cherished dreams had vanished beyond recall. The Pre-Raphaelite Brotherhood was no longer in existence. Collinson had resigned and Woolner had gone to seek his fortune in the gold mines of Australia. William Rossetti and Fred Stephens had both turned to criticism for a career, and Gabriel was too preoccupied with Lizzie Siddal and his new acquaintances, Jones and Morris, to be interested in PRB affairs. Millais was absorbed with Effie, Charley Collins had abandoned art for literature, and Walter Deverell was dead. To Hunt, it often seemed that he was fighting a lone battle; and sometimes, despite his love of the East, he was homesick. On 24 January 1855, he wrote to Millais: 'I wonder how you all go on in London. No Pre-Raphaelite Brotherhood meetings, of course. The thing was a solemn mockery two or three years past, and died of itself . . . I shall be glad to leave this unholy land, beautiful and interesting as it is. Never did people deserve to lose their empire so thoroughly as these Arabs. If they were left alone for a few years, they would complete the work themselves.'[1]

Back in England, Seddon walked into Ford Madox Brown's studio and reported on his adventures with Hunt. In his diary Brown noted:

Yesterday Seddon came back after more than twenty months of absence, looking thinner and genteeler than ever and in high spirits . . . His pictures are cruelly PRB'd, I was very sorry to see he had made less than no progress. The places are not well selected nor adapted and the high finish is too obtrusive. However, they present

qualities of drawing and truthfulness, seldom surpassed but no beauty, nothing to make the bosom tingle. Could I but have seen them in progress – I will do all I can to make him improve them yet, but it is late. Hunt, he tells me, gave him no advice at all, he has been prepossessed against him I fear . . . Hunt used to be in agonies about his joking propensities and lecture him and get mighty sulky if things did not go right – and tell him secrets of great worth for his getting on in the world, and expect him to do all the housekeeping, which he declined after a time, and indulge in many whims incompatible with the locality and circumstances. But Seddon entertains a high opinion of his worth and gallantry. Hunt knocked an Arab down and they afterwards stood with pistols cocked at each other a space of time.[2]

Easter 1855 saw a large influx of European visitors to Jerusalem, including the Duke of Brabant, heir to the Belgian throne. On the Saturday of the Greek Easter, Hunt saw for the first time the ceremony of the Miracle of the Sacred Fire at the Church of the Holy Sepulchre, in which thousands of gullible believers thronged the sacred building to light their candles from the flame, supposedly sent from Heaven. The scene made an indelible impression on Hunt, who was to take up the theme in a major painting many years later.

Hunt had long wished to gain admittance to the Temple in Jerusalem, but the regulations strictly forbade this, and he had almost despaired of realizing his ambition, when the Duke of Brabant's arrival unexpectedly paved the way for him to enter the sacred building. As a special privilege, about thirty Europeans, including Hunt and his friend, Dr Sim, were allowed inside the Temple with the Duke and his entourage. Though the visit was a fleeting one, Hunt took his sketchbook, and succeeded in recording the details, and inspecting the Beautiful Gate.

Meanwhile, Hunt's relationship with Bishop Gobat was rapidly worsening, and reached rock bottom when he lodged a formal complaint about the Bishop's dealings with a man called Hanna Hadoub. These deeply affected the family of Issa, the servant of Hunt's friend Graham.

Hanna Hadoub was one of Jerusalem's most disreputable characters, having been initiated in vice by his parents from his infancy. Although he had been excommunicated by Bishop Gobat for felony, he had built up a substantial fortune from the immoral earnings of his

mother and sisters, and of his first wife, who died of venereal disease in
1850.

After her death, Hanna Hadoub returned to the Roman Catholic
Church in order to marry his second wife, being readmitted to the
Anglican Church in 1853, although he was excluded from Holy
Communion. He now lived off the immoral earnings of his second
wife, until her death from syphilis in 1854. In the winter of 1854–5, he
paid court to Sophia Nicola, Issa's fourteen-year-old sister. Sophia
was well-known to the congregation at the Mission, having been
brought up in the Bishop's school, although she had not yet been
confirmed. Early in 1855, Sophia entered the service of Lady Napier,
wife of the British Minister to the United States of America, who was
on an extended visit to Jerusalem. As their father was dead, Issa was
the girl's legal guardian, and when he heard of Hanna Hadoub's
intentions towards Sophia, he bitterly opposed the courtship. Their
mother, however, connived at Hanna Hadoub's plan to marry Sophia,
and encouraged premarital relations between the couple. Sophia's
younger brother promptly reported their activities to Issa, provoking
a fierce family quarrel.

In March a contract of marriage between Sophia and Hanna Hadoub
was drawn up, but Issa refused to sign it, and Dr Sandreczki, the
Secretary of the Church Missionary Society, accordingly tore up the
document. Pressure was then brought to bear on Issa, and the banns
were called on 1 April. The second publication of the banns did not
take place, but on Sunday 15 April, the banns were read as if for the
third time. After the service, Hunt followed the Bishop into the vestry
and remonstrated with him, pointing out this irregularity, and draw-
ing his attention to the man's infamous reputation. Later he signed a
protest, jointly with Dr Sim and the Revd W. C. Cotton, thereby
effectively halting the marriage. Subsequently a similar document was
drawn up and signed by virtually every family associated with the
Mission.

Feeling ran very high about the girl's welfare, but it was Hunt who
acted as the mouthpiece of the community, and the Bishop now set
out to make life as difficult as possible for him, insisting on full
documentation of all the evidence against Hanna Hadoub, and draw-
ing an unrealistic deadline. Hunt, who was desperately busy with his
own work, and urgently needed to supplement his failing financial
resources, was now compelled to devote time which he could ill afford
to drawing up the evidence.

In the midst of all his worries about his work, Hunt received news from home that his portrait of his father, the only picture which he had been able to enter in time for the Royal Academy Exhibition of 1855, had been rejected. Brown's three pictures were also turned down. On 3 May, Seddon, now at home in England, wrote in his diary:

> The Academy opens on Monday; not a remarkable exhibition, I believe. The hangers were of the old school, and they have chucked out everything tainted with Pre-Raphaelitism. My Pyramids, and a head in chalk of Hunt's, and all our friends, are stuck out of sight, or rejected. Millais's picture was put where it could not be seen . . . He carried his point by threatening to take away his picture and resign at once unless they rehung him, which they did. He told them his mind very freely, and said they were jealous of all rising men, and turned out or hung their pictures where they could not be seen.[3]

Millais, meanwhile, wrote to tell Hunt of his impending marriage to Effie Ruskin, saying that it made him feel 'desperately melancholy'. He described it as a 'fearful risk' taken 'in desperation'. The marriage took place very quietly at Bowerswell, Perth, on 3 July 1855. In her journal, Effie wrote of her bridegroom: 'I had to give him all my sympathy. He cried dreadfully, said he did not know how he had got through it, felt wretched; it had added ten years to his life, and instead of being happy and cheerful, he seemed in despair.'[4]

The Scapegoat was finished on 15 June 1855. Hunt rose early, and left Jerusalem by the Jaffa Gate with Sim and Graham, with the picture carefully packed up, ready for dispatch to England. This visit to Jaffa was to mark Hunt's farewell to Sim, who had enlisted as an army surgeon and was now bound direct for the Crimea. They had a delightful ride through the cornfields, arriving at Jaffa at 4 p.m. His leave-taking with Sim was not without emotion. They had lived through wonderful experiences together, and not a little danger.

When Hunt had passed his picture through customs and had taken it on board ship, he was free to enjoy himself with Graham for a few days in Jaffa. He had been looking forward to this, having been somewhat ill from the effects of overwork. In the event, however, Issa came to them with disturbing rumous of new developments in the Hanna Hadoub affair, as a result of which they decided to return at once to Jerusalem.

The rumours were well-founded. No sooner had Issa left Jerusalem

with Hunt and Graham, than Bishop Gobat dispatched Sophia and Hanna Hadoub to Nazareth, in the charge of Jacoub, the Dragoman of the Church Missionary Society. Here, on the direct instructions of Bishop Gobat, they were immediately married without banns.

Hunt was furious when he learned the direction events had taken, and complained bitterly to the authorities. Bishop Gobat wrote a note to the Revd John Nicholayson, the Head of the Mission to the Jews, alleging that the evidence collected by Hunt as to Hanna Hadoub's character was false. It later emerged that Hanna Hadoub had paid a large baksheesh to Jacoub, the Dragoman, and had bribed Gobat himself, for arranging the marriage. Hunt's forebodings as to Sophia's fate quickly proved to be well-founded. Early in 1856, Hanna Hadoub was sentenced to life imprisonment for robbery, and Sophia and her mother, who had suffered deplorably at his hands, went to the Bishop begging for a divorce. The Bishop turned them away from his door.

James Graham shared all Hunt's criticisms of Bishop Gobat. One of his complaints was that Gobat had imported a semi-literate German soap-boiler, married him off to his own head nurse, and made him Headmaster of the Diocesan Boys' School. As second master he had imported a man called Hanna Yuseph from Malta, and married him off to his own household servant. Under such unqualified persons the school was in severe danger of foundering, and academic standards were abysmally low. What was worse, homosexuality was rampant, and Jewish converts removed their sons to avoid the 'contamination' to which they were exposed from intercourse with the Arab boys. Hunt felt that Bishop Gobat was scornful of the English, despite the fact that they contributed half his salary. Gobat also had scant regard for Dr John Nicolayson, the Head of the Mission to the Jews and Dean of the English Church of the Mission, though he was a man of considerable literary and linguistic accomplishment, who could speak fifteen languages.

Apart from his problems with Bishop Gobat, Hunt remained ecstatically happy in Jerusalem. James Graham had fitted up a little square stone tower like a feudal castle, near the top of Mount Olivet, as a summer retreat, and here Hunt often stayed with him when the weather was hottest. Its window overlooked the Valley of Jehoshaphat, the Garden of Gethsemane and the slopes of the city. A telescope was mounted on the window-sill, and on moonlit nights Hunt loved to sit gazing out over the city, and listening to the caller to prayer chanting the *Kuteb Mueddin*. 'The caller to prayer, with hands

on the parapet, began his chant with a voice like a resonant bell across the homes of hidden men who at the sound bent in prayer and praise,' he wrote. 'The voice lingered and soared aloft; it was the chant of the Kuteb Mueddin, declaring itself emphatically in every fresh outburst, warbling, carolling, and exclaiming in ecstasy, till it expressed the fullness of thanksgiving and joy. It awakened the rapture with which I had heard the nightingale thrilling in his listening copse . . . From a further tower a second psalmist responded, increasing his voice, and there echoed around a refrain of melody, a strophe, and antistrophe, and as the chant swelled, a fuller height of rhapsody was attained; then by intervals the exalted strain slowly descended into a tender chorus and ceased.'[5]

Towards the end of the summer, Hunt began a water-colour of the Pool of Gihon, from outside the walls. He had extended his stay in Syria far longer than he had originally intended, and was now working desperately hard, in order to accomplish as much as possible before returning to England. One Sunday morning he accompanied Graham to Artass, where Graham often conducted matins. They had not gone far before Hunt began to feel ill. Despite the heat of the day, he arrived in an icy condition, and shivered outside in the hot sunshine until the service was over. Returning to Jerusalem, he found his icy coldness replaced by a violent burning, accompanied by severe oppression in the head. Next morning the doctor was summoned, and diagnosed an attack of tertiary fever, or malaria, a disease that was to dog him for the rest of his life. He advised Hunt to spend a period of convalescence, and then to return to England as soon as possible.

When Hunt was sufficiently recovered to think again of work, his friend, James Graham, told the Pasha's secretary of Hunt's great desire to go into the mosque alone, and to Hunt's great delight, permission was given. On the appointed day he went up on to the roof of Assakreh and sat alone sketching for a whole hour.

Still Hunt lingered in Syria, despite the threat to his health. Stephens, who had written him regular bulletins of Annie Miller's progress, sent him disquieting news of her sitting for artists who were not on Hunt's 'approved' list. Annie was restless, for the understanding between herself and Hunt had never been formalized. Filled with forebodings, and fearful lest in this mood of restlessness she might renege on their unwritten agreement, Hunt wrote making Annie a definite offer of marriage. Even so, there seemed no certain prospect of his returning to England, and his friends became increasingly

alarmed on his behalf. Finally, Dr Sim wrote an urgent letter to Halliday, with whom Hunt planned to share a studio on his return to London, and begged him to come and fetch his friend home. Sizing up the situation, Halliday immediately wrote to Hunt and arranged to meet him at Pera, near Constantinople.

On 17 October 1855, Hunt at last dispatched his boxes and paintings, etc., to Mr Combe in Oxford, and left Jerusalem with James Graham and a geologist named Poole, who had been advising the Sultan of Turkey on mining possibilities. As they left the city, there was a minor earth tremor, which the three men felt quite distinctly. They rode to Nazareth via Samaria, and on to Jenin, where Hunt painted a coloured landscape. Poole now left them, but at this juncture, Graham fell ill, and to make matters worse, they learned that Tiberias, their next stop, had been evacuated by its inhabitants because of an outbreak of cholera. They therefore decided instead to continue on up the ridge to Tabor.

'Clambering among the rich tree growths,' wrote Hunt, 'I reached a height where the old wall joined a fortification still undemolished enough to form, with the trunks and branches of trees, a frame in the distance. Below the farthest horizon, amid amethystine variation of grading tints like those of a prism spectrum, lay a mirror, oval and unbroken in border, which reflected the turquoise sky so perfectly that it looked like a portion of the heavens seen through the earth. It was the Sea of Galilee.'[6]

At Safid, Hunt finally took leave of Graham. The two men had grown very close during the last eighteen months. They had seen many wonderful sights together, and had faced numerous difficulties and dangers in each other's company. They parted unwillingly, and Graham insisted that Issa travel with Hunt to Beirut. On the journey, Issa, as always, proved himself invaluable. On one occasion he put up Hunt's tent as usual, and brought him two buckets of water, with which he began his ablutions. Suddenly Hunt became aware of a heated altercation outside, and called to ask Issa the meaning of all the noise. Issa explained that the local people, hearing that Hunt was taking a bath, had turned out in force to peer through a hole in the canvas.

'. . . They can't all see at once, and I want those who were here at the beginning to go away, and make place for others, but they won't, and those behind are laughing and quarrelling with those in front, and I threaten that I will turn them all away if they can't agree,' he said.[7]

When Hunt arrived in Beirut, he sent Issa back to Jerusalem, and boarded the Messagerie boat, *Le Tancred*, which took him to the Crimea. The decks were overcrowded with five hundred pilgrims returning from Mecca. To his astonishment, he also encountered Nicola Beyrouti, who had looked after his animals in Syria, and who had joined the land transport corps in the Crimea. His travelling companions were 105 bashi-bazouks, who caused consternation by starting a mutiny on board ship. When Nicola complained to Hunt that one of his friends, who was innocent, had been put in irons, Hunt interceded on his behalf. The captain was hostile to all Syrians, however, and Nicola was put ashore to be transferred to a Turkish vessel.

In January Hunt travelled from the Crimea to Constantinople, where he stayed for several weeks, during which time news of the armistice broke. For the first five days he was the guest of Admiral Sir Edmund Lyons, the commander of the British naval forces in the Crimea. The admiral allocated his personal cabin to Hunt, and lent him his horses, and his nephew as guide in Sebastopol. Later he went to Balaclava for several days, returning to Constantinople after four days in a small steamer, which was buffeted by the worst storm of the year.

Eventually Hunt caught up with Halliday in Pera, and together they sailed via Malta to Marseilles in a ship crowded with officers returning home from the war. From Marseilles they made for Paris, where they lingered briefly, finally reaching London in February 1856. His first task was to write to let Mr Combe know of his safe arrival: 'At last my guardian angel has brought me home in safety. On Sunday morning I arrived in Marseilles. Some week beyond my time by reason of the negligence of the commanders of the "Thabor", on board which I quartered myself for a direct passage from Constantinople – so that we were shipwrecked in the Dardanelles and had to leave the vessel and find our way to our destination in a slow ship through Malta.'[8]

Hunt now began gathering up the threads of his life again, dealing with business matters and calling on old friends. He and Halliday took a house at 14 Claverton Street, Pimlico, where there was a studio for each of them and an upstairs room which they let to Martineau, who urgently needed Hunt to advise him on his work. Hunt was amazed at the progress that Halliday had made under Millais's tuition. When Hunt had left for Syria, Halliday had been no more than a gifted amateur, but he was now an accomplished artist, and while at

Winchelsea with Millais, had finished a fine painting, *Measuring for the Wedding Ring*, which was hung in the Royal Academy Exhibition of 1856.

During Hunt's absence, his father had been seriously ill, and was now in a very frail condition which gave cause for considerable concern. There had been a certain amount of family feuding, of an undisclosed nature, which had been carried on by letter. At Hunt's request, Seddon had advised his own father not to become intimate with the family, to whom Hunt wrote by every post. Emily Hunt, who had been a great favourite of the Millais family, had been attending a school of art, and Hunt now agreed to supervise her work. Millais was still in Scotland with Effie, and Gabriel was out of town. During Hunt's two-year absence from England, the Pre-Raphaelites had not met once, even for night excursions or boating expeditions. Though there had been no official winding up, the Brotherhood was now clearly defunct.

Eager for news of his old friends, Hunt made an early visit to the studio of Ford Madox Brown, from whom he learned that Gabriel was now in Oxford, with the University at his feet. Elizabeth Siddal was not his fiancée, as had been commonly supposed, but his pupil, of whose work he was intensely proud. Even the famous Dr Acland and his wife had entertained Lizzie in their home, and everyone in Oxford was enchanted with her. Brown was no longer interested in propitiating the Royal Academy, being disgusted with the treatment that he and his friends had received, and with its management of its affairs. The Rossettis shared this opinion.

Though Hunt himself had not yet realized it, certain of his friends were not quite as eager to see him as he might have expected. Annie Miller was the cause of their embarrassment. While Hunt had been painting goats in Syria, he had expected Annie to work hard to fit herself for her role as his future bride. She had indeed taken to dressing like a lady, and had learned how to tame her unruly auburn tresses. She could now read and write, though she rarely made the effort, and she had little taste for books; but she had learned how to capitalize on her stunning good looks, and took to dancing like a duck to water. Several of Hunt's friends, like Stephens, Halliday and William Rossetti, took Annie dancing in the Cremorne Gardens, or on the river, under the pretence of looking after Hunt's interests; but George Boyce and Gabriel Rossetti entered into a relationship with her of a much more intimate nature, vying with each other for the privilege of drawing

her. Inevitably it was Gabriel who triumphed, and his conduct soon gave rise to scandal, for he made no effort to conceal the connection. They were repeatedly seen together in public, and for a time Annie was openly installed in his studio at Chatham Place, where she acted the part of hostess to his friends.

Stephens had an uneasy conscience where Annie was concerned, for he had borrowed heavily from the fund which Hunt had allocated for Annie's education and maintenance, and had not been able to repay his debt. Annie had not actually gone short of money, for she had lived well on the proceeds of modelling, and had probably realized that in not approaching Stephens for 'tin', she had in effect gained a hold over him. But for this, Stephens might have told Hunt what many of his friends already knew: that Annie had formed a dangerous liaison with a member of the aristocracy.

Lord Ranelagh was a notorious rake, and Annie was dazzled by his luxurious life-style, revelling in her position as his mistress. Thanks to the money which Hunt had poured into her education, she was able to capitalize on her good looks and to behave creditably, though she must have realized from the outset that she had no hope of ever becoming Lady Ranelagh.

Hunt was unaware of all this, yet he sensed a certain coldness in her attitude towards him, and was disappointed at the lack of progress in her education. Clearly she saw no reason for gratitude, nor had she worked as hard at her lessons as he had expected. For the time being, he had to concentrate on his work, but he decided that he would say nothing more of marriage until he saw evidence of serious endeavour on Annie's part.

All Hunt's friends gossiped about his romantic affairs, even the faithful Jack Millais, who as a newly married man, extolled the joys of marital bliss. Celibacy was an unnatural state for a healthy young man, he remarked to Brown, who recorded in his diary: 'Walked with J.M. to the R.A. he conversing much about babies and the advantages of marriage, the disgustingness of stale virginities etc, in allusion to Hunt. He said he supposed the reason of Hunt's being able to be so long virtuous was that before doing anything whatever he always held a sort of little council with himself in accordance with which he acted. This is very true I believe.'[9]

During Hunt's absence abroad, Mr Combe had looked after his business interests, but although he had written to all Hunt's previous clients, he had been unable to find a purchaser for *The Scapegoat*. He

now drew Hunt's attention to the need to get more 'tin', advising him to concentrate on 'pot-boilers' in the short term, to avoid cashing in his remaining investments. In common with Millais and Rossetti, Hunt had been approached by the publisher, Moxon, who had offered them £25 a picture for illustrations for his edition of the works of Tennyson. Hunt accordingly worked steadily at his quota, and quickly completed all six drawings.

Meanwhile, Rossetti and Brown, who was so hard up that he had been forced to pawn his cutlery, got up an exhibition in Charlotte Street, to which Hunt contributed some Eastern landscapes. Rossetti put eight of his own works on display, and Brown exhibited a dozen paintings. At the private view, Gabriel led Hunt over to look at Lizzie Siddal's pictures, which he described as 'stunning'. Hunt remarked that they were very like Deverell's work, at which Gabriel indignantly insisted that they were a thousand times better than anything Deverell had ever done. Clearly the issue was a sensitive one. Hunt pretended ignorance; yet he was well aware of the true relationship between Gabriel and Lizzie, and knew of her former amorous association with the handsome Walter Deverell. Doubtless Hunt, having been hurt by Gabriel's behaviour towards Annie, was in a vengeful mood.

Hunt also learned that Gabriel had not sent in any illustrations for Moxon's Tennyson, and called on him to find out the reason. Gabriel seemed piqued, and said that he had only been interested in *The Lady of Shalott*, which Hunt had taken. Hunt reminded him that he had made a drawing of 'The Breaking of the Web' four years previously, which Gabriel had known about. He had apparently forgotten that they had discussed the subject in correspondence early in 1855, when Hunt was in Jerusalem. 'By the bye,' Rossetti wrote, 'I have long had an idea for illustrating the last verse of *Lady of Shalott* which I see marked to you. Is that a part you mean to do, and if not and you have only one design in prospect to the poem, could I do another?'[10]

'I am not able to get on with Tennyson's designs for want of models,' Hunt replied. 'I leave them for the most part to do in Europe . . . and I hope you will take the subject you spoke of from the *Lady of Shalott* . . .'[11]

At the Royal Academy Exhibition of 1856, *The Scapegoat* was hung on the line, but it was given a very mixed reception, and in general was much criticized and misunderstood. Ford Madox Brown went to see it, and wrote in his diary:

Hunt's *Scapegoat* requires to be seen to be believed. Only then can it be understood how, by the might of genius, out of an old goat, and some saline incrustations, can be made one of the most tragic and impressive works of art. In pictorial composition the work sins, however, the goat being right in the middle of the canvas, and the two sides repeating each other too much, which is always painful, and gives a studied appearance, a defect arising from lack of study. The background also is, at present, hard in colour, and eats up the foreground.[12]

Hunt had set a price of 450 guineas on the picture, but the only offer he received was from Sir Robert Peel, whose offer of 250 guineas Hunt declined. Finally, on the last day of of the exhibition, B. G. Windus, a retired business man who had inherited a fortune and built up an impressive collection of Pre-Raphaelite art, bought it for the original asking price. Meanwhile, Hunt had sold the engraving rights for *The Light of the World* to Gambart for £200, and also succeeded in selling the original sketch for *The Flight of Madeline and Porphyro*. Paradoxically, it now appeared that the public only wanted copies of Hunt's earlier works which they had originally greeted with derision a few years previously.

When the exhibition closed, Hunt went to stay with the Combes in Oxford, where he completed his original small sketch for *The Light of the World*. He found the town in the middle of an election campaign, for Neale, the Member of Parliament for Oxford, had recently been unseated. Thackeray, whom Hunt often met at the Cosmopolitan Club, of which Hunt was a member, had decided to stand as Liberal candidate. Though the Combes were staunch Conservatives, they liked and admired Thackeray, and Hunt therefore wrote to the novelist suggesting that he might like to call on them during his election campaign. As it happened, the Combes were not at home when he and Neale called, and Hunt was working alone in the studio. Thackeray asked to see *The Light of the World*, and Hunt took the two men to see it. For a long time Thackeray stared at the painting.

'Ah me!' he pondered aloud, 'I assume we must regard this painting to be your *magnum opus*,' Hunt wrote afterwards, confessing that he was not sorry when Mr Combe voted Conservative, and Thackeray's rival was elected.[13]

On his return to London, Hunt was introduced to G. F. Watts, and visited him at his studio in Little Holland House, the home of Thoby

Prinsep and his formidable wife. Watts was at this time engaged on a portrait of Miss Emma Brindling, a famous beauty worshipped by Charley Collins, who was devastated when she became Lady Lilford. From this point on, Hunt became very friendly with Watts, who gave him a portrait sketch of Emma Brindling. Hunt also modelled for the head of King Alfred in a fresco which Watts painted in Lincoln's Inn, and a study of Hunt which he did for this work was also on the canvas of the famous beauty. Any friend of Watts was automatically a friend of Mrs Prinsep, and Hunt was continually invited to her elegant receptions. 'In respect of his fulness of rendering the human form, I was fain to regard Watts as an ideal Pre-Raphaelite,' wrote Hunt.[14]

Millais was also a regular visitor to Little Holland House on these glittering social occasions, though his wife could not accompany him, in view of the circumstances surrounding the annulment of her first marriage. Woolner, who was still an eligible bachelor, haunted the premises and was a great social success. Soon afterwards Hunt introduced Gabriel to Mrs Prinsep, and he was a frequent visitor until he became bored with the other guests.

Mrs Prinsep was one of the seven extraordinary Pattle sisters, who were a feature of Victorian society. Another sister, whom Hunt met at Little Holland House, was Mrs Julia Margaret Cameron, the famous photographer. Mrs Cameron was a lionizer who was constantly on the look-out for famous people who could be inveigled into posing for her soft-focus photographic portraits, and Hunt eventually fell victim to her lens a few years later. Her object was to make a profit by selling her work to the public, but she assured Hunt that she was unlikely to be able to do so in his case. 'I can't say I took interest enough in my own face to look at the portrait very closely, but my impression certainly was that it made my face less ugly than I was accustomed to see it in the glass,' he wrote to Stephens.[15]

In describing himself, even semi-humorously, as ugly, Hunt did himself a great injustice. He was tall and well proportioned, with engaging blue eyes, a shock of camel-coloured hair and a reddish-gold beard. The overall impression was of manly vigour matched to a pleasant disposition, though he was still extremely shy in the presence of eligible young women.

Mrs Cameron doted on Tennyson much as Mrs Prinsep worshipped Watts. One day Mrs Cameron invited Hunt and Woolner to her house at Roehampton, where he met the poet for the first time. 'The man I met was markedly unostentatious and modest in his mien,'

wrote Hunt, 'as though from the first courting trustfulness; his head was nobly poised on his grand columnar neck, rarely held erect, but inclined towards whomever he addressed with unaffected attention; he was swarthy of complexion, his black hair hanging in curls over his domed head; he had a great girth of shoulder, resembling certain Syrian Arabs I have met.'[16]

During the course of the summer, Hunt was invited to go with Gabriel to dine with Mr and Mrs Robert Browning. Hunt was suffering from a recurrence of his malaria, but he shared Gabriel's veneration for the couple and decided that the opportunity was too good to miss. Afterwards he went away to Hastings to convalesce. 'Poor fellow! He works too hard,' commented Brown in his diary.[17]

Meanwhile, Hunt continued to see Annie Miller. She paid many visits to his studio, which she could reach easily by boat from her lodgings in Chelsea. Realizing that something was going on between Annie and Gabriel, Hunt became increasingly jealous. He was not exactly in love with Annie, but anger and humiliation increased his desire, and he was determined to marry her. On 6 July 1856 he went to see Brown and poured out his troubles to him. Brown recorded the details in his diary:

> Hunt . . . told me about the Bishop of Jerusalem who seems to be one of the meanest scoundrels not yet in hell . . . then about Annie Millar's [sic] love for him and his liking for her, and perplexities, and how Gabriel like a mad man increased them taking Annie to all sorts of places of amusement which he had implied if not stated should not be. Annie sat to him for that picture of the swell and his mistress and since that Hunt has promised to be like her guardian and she should never sit to any [but] him or those he would name lest poor Annie should get into trouble, and having allowed her to sit to Gabriel while he was away Gabriel has let her sit to others not in the list and taken her to dine at Bertolini's and to Cremorn where she danced with Boyce, and William takes her out boating forgetful it seems of Miss R. [Henrietta Rintoul, his fiancée, daughter of the founder/editor of the *Spectator*] as Gabriel, sad dog, is of Guggum [Lizzie Siddal, called 'Guggums' by Rossetti]. They all seem mad about Annie Millar [sic] and poor Hunt has had a fever about it. I told him I could not speak to Gabriel about it as I did not see him, there being a coolness between us.[18]

Ten days later Brown wrote: 'Emma called on Miss Sid yesterday who is very ill and complaining much of Gabriel. He seems to have transferred his affections to Annie Miller and does nothing to [but] talk of her to Miss Sid. He is mad past care.'[19]

Brown also described a visit to Hunt on 28 July 1856 in his diary:

Seddon took me away to Hunt's, to go boating, by agreement, but dinner was laid, and Hunt made no mention of the boat, and Seddon was afraid to remind him. Saw Hunt's *Lanthorn Maker* which is lovely colour and one of the best he has painted, but, like much he has done of late, very quaint in drawing and composition, but admirably painted. Anny Millar was there, looking most syren-like, Hunt went off to put her on board the boat to go home to Chelsea, and I went with him, not understanding dinner was served. When we came back Halliday and Seddon had begun, as it appears Hunt makes a rule of running out for something just as dinner has been waiting ten minutes, much to Halliday's disgust.[20]

In time, the affair between Annie and Gabriel had burnt itself out. Gabriel had never intended to leave Lizzie for Annie Miller, but the relationship had caused endless trouble between them. When it was all over, Gabriel received a letter from his poet friend, William Allingham, in which he enquired how things stood between them, and answered: 'My rapports with that "stunner" stopped some months ago after a long stay away from Chatham Place, partly from a wish to narrow the circle of flirtations, in which she had begun to figure a little; but I often find myself sighing after her, now that "roast beef, roast mutton, gooseberry tart", have faded into the light of common day. "O what is gone from them I fancied theirs?"'[21]

That year, on the advice of Mr Combe, Hunt applied again for associate membership of the Royal Academy and was rejected. His bitterness was increased when he learned that only one vote had been cast in his favour, and he vowed never to apply again. The Academy's decision seriously affected the marketability of his work, for few people were now willing to risk investing in it. He now had difficulty in obtaining commissions, even for pot-boilers.

In September Hunt travelled to the annual exhibition in Liverpool, and Brown joined him there. Though Hunt was himself urgently in need of commissions, Brown's diary reveals that he spoke up vigorously on Woolner's behalf. One of Hunt's great qualities was his

kindliness in helping his friends, and his own experience of adversity made him doubly anxious to encourage true merit. Brown recorded that they sat up so late after supper at Hunt's hotel talking about dreams, that the boots put out the gas and locked them in, so that Brown was obliged to take the first empty room.

When the season drew to a close, Seddon called on Hunt for advice about his return visit to the East. Now married, and with an infant daughter, Seddon was desperately anxious to succeed as an artist, and was much more mature in outlook than on their earlier expedition together. He was only too happy to undertake one or two small tasks for Hunt, who was in continual need of costumes and accessories for his models.

It was at about this time that Edward Burne-Jones met Hunt for the first time. Burne-Jones, who was twenty-three years old, wrote to his father:

> A glorious day it has been – a glorious day . . . one to be remembered by the side of the most notable ones in my life; for whilst I was painting and Topsy [William Morris] was making drawings in Rossetti's studio, there entered the greatest genius that is on earth alive, William Holman Hunt – such a grand looking fellow, such a splendour of a man, with a great wiry golden beard, and faithful violet eyes – oh, such a man. And Rossetti sat by him and played with his golden beard passing his paint-brush throught the hair of it. And all evening through Rossetti talked most gloriously, such talk as I do not believe any man could talk but him.[22]

In the late autumn, Hunt's parents decided to go to Folkestone for a holiday. Mr Hunt travelled ahead of his wife, who was to join him on the following day. Soon after he arrived, a ship was driven on to the rocks in a thunderstorm, and Mr Hunt rushed to the clifftop, where he stood for several hours in torrential rain, watching the progress of the rescue attempts. When he finally returned to his hotel, he was shivering with cold, but refused his supper and went straight to bed. Next morning when Mrs Hunt arrived, she found that he was suffering from a fever. Inflammation of the lungs was diagnosed.

Though Mrs Hunt took him back to London, and sent immediately for Sir Richard Quain, an eminent physician, it was soon apparent that the case was hopeless. Hunt was summoned, and undertook his share of nursing the patient, with his mother and sisters. In a letter to Seddon

he poured out all his anxieties about his father. During the many hours spent at the bedside, his father owned that despite his initial fears, he had finally realized that Hunt had been right to become a painter.

On 3 November 1856, Seddon, who had undertaken to obtain some costumes of a particular design and colour which Hunt wanted for his models, wrote to him from Old Cairo: 'After being to all the silk and cotton markets, I cannot see what you want; my only idea is to have a caftan made as a pattern, and for you to have it copied in England. I do not know whether you remember the mania the Cairo people have for dull arrangements of colour . . . I was very sorry indeed to hear of your father's serious illness, and the consequent weight of anxiety thrown on you.'[23]

In the early hours of the morning on 16 November 1856, after his mother and sisters had gone to bed, Hunt kept vigil alone in his father's room. Seeing that the patient was at last sleeping peacefully, Hunt took the candle and moved over to the table, where he began writing a reply to Seddon's letter. After a while, his mother and sisters woke spontaneously and came into the room to sit by the bedside. Moments afterwards, Mr Hunt drew his last breath.

A few days later he was buried in Highgate cemetery. The funeral cortège by a coincidence passed by Seddon's house, and even in the midst of his grief, Hunt's thoughts were with his friend. That very night, Hunt's little nephew died, and Hunt's sister fell into a death-like swoon which lasted for two hours, so that the family were in fear for her life also.

In Cairo, unbeknown to Hunt, his friend Thomas Seddon had fared badly. Only a few days after he had written the letter about the caftan, he fell ill with dysentery. At first the symptoms, though serious, did not unduly alarm him, but after an improvement, he suffered a relapse. He felt that God had sent the illness as a punishment, because he had not kept the sabbath. On the very day of Mr Hunt's funeral, when Hunt was with him in thought, Seddon died.

It now remained for Seddon's friends to do what they could for the widow and orphan. Brown finished one of Seddon's paintings. Hunt, who had already worked on a water-colour for him in Jerusalem, came to the conclusion that none of the other uncompleted works could be finished in England. Gabriel busied himself trying to sell Seddon's paintings, and a public fund was set up, which raised £600. This enabled Seddon's picture of Jerusalem and the Mount of Olives to be purchased for four hundred pounds. Thomas Seddon was only thirty-

five years old at the time of his death, and though his use of colour tended to be somewhat harsh, he might have accomplished much if he had lived. It was curious that Seddon, who had stayed with Nicholson, a stranger, in the desert, reading the Bible by his bedside so that he should not die alone in an alien land, should himself have met a similar fate.

CHAPTER II

— ✸ —

The awakening conscience

UNDER the strain of his father's last illness and death, Hunt's health broke down, and he consulted a number of eminent physicians, all of whom recommended him to move away from the river to higher ground. Having promised his father on his deathbed to take care of his sister Emily, and to supervise her career as an artist, he now regarded this as a sacred trust. As their present house was too small to accommodate Emily as well, he and Halliday began looking for a larger house in a more salubrious area. Meanwhile, having selected the Crystal Palace Alhambra as a background for *The Finding of Christ in the Temple*, he went to stay temporarily in Sydenham.

It was at this precise juncture that Annie Miller, restless and feeling neglected, decided that their relationship must be more precisely defined, and wrote to Hunt asking him when they were to be married. Hunt replied rather curtly that marriage could not be discussed until her education was complete. He was far from satisfied at her rate of progress, but was prepared to pay for her to attend a suitable academy for young ladies. She would have to live in, and this would hopefully enable stricter control to be exercised over her activities.

Annie was angered by Hunt's letter, and refused to entertain the idea of entering an academy. Though this was a blow to Hunt, he determined not to capitulate, and gave her an ultimatum to reconsider. As the days slipped by without response, Stephens was pressed into service to interview Annie and encourage her to do as Hunt wished, without committing him to matrimony. Yet despite his firm stance, Hunt went through agonies over the outcome, as he revealed in a letter to Stephens: 'To be at all anxious about her decision is very stupid – whether "yes" or "no" I am convinced that it will be fruitless to

persevere but I will go on for years against all conviction rather than be the first to give up the attempt – which might have such a happy issue if she would determine to give up wretched false pride, and a fatal indolence.'[1]

After the interview, Stephens reported that Annie cared nothing for Hunt and his painting, and exhibited a hardness which shocked him. 'Your note makes me uneasy about you,' wrote Stephens; 'it is useless, I am sure to warn you against the utter hopelessness of your entering into a more sincere engagement with her unless she shows some sort of stability of character . . . You will have cleared yourself of all responsibility by your efforts to serve her . . .'[2]

'Of course I expected to hear what you said,' replied Hunt, 'perfect indifference on her part either in refusing or accepting an offer of assistance. I wonder what particular sin of mine it was that brought me into contact with such a girl.'[3]

Nevertheless, Hunt called at Annie's home, and in her absence had a long discussion with her aunt, who said that Annie was now prepared to continue her education as a day pupil. Thus a compromise was reached, and temporarily at least, his quarrel with Annie was patched up.

In the new year Hunt, Halliday and Martineau moved to Tor Villa, Campden Hill, a rented property which satisfied Hunt's medical advisers and was large enough to enable Emily Hunt to occupy rooms of her own. Fortunately Hunt had just sold the copyright of *Claudio and Isabella* for £200, and for the first time in his life he was able to spend money on furniture. Revelling in the task, he went about it with extraordinary care.

His first important item was contributed by Augustus Egg, who, remembering a past favour, gave him a magnificent Regency sideboard with legs inlaid with ivory or bone, which had originated from Kensington Palace. Standard Windsor chairs served for ordinary seats, but Hunt chose an armchair in an Early English style, with his initials on it, embellished with scrolls. He designed a chair based on an Egyptian stool in the British Museum, and had all these items made up for him by Messrs Crace. Later he added a fine old English chest, and a superb ivory cabinet. When Hunt showed off his new furniture to his Pre-Raphaelite friends, they were enthusiastic, and the idea of customized furniture spread. Brown set a carpenter to work on a set of Egyptian chairs, and designed a table, which Hunt had made up with slight modifications. From these small beginnings sprang the fashion

for fine, handcrafted furniture which led to the launching of 'the Firm' by Morris, Rossetti, Brown and others.

After Millais had forfeited Ruskin's patronage by marrying Ruskin's ex-wife, Hunt's own amicable association with Ruskin had lapsed, from embarrassment caused by his status as Millais's friend. Rossetti and Elizabeth Siddal between them were the beneficiaries, and Ruskin even paid Lizzie a generous annual stipend in return for all her art work. Now that Rossetti was at the centre of a new movement which had donned the mantle of Pre-Raphaelitism, Millais and Hunt felt distinctly alienated. Nevertheless, when Rossetti began work on the project to decorate the Union Building in Oxford, in which he was joined by Morris, Burne-Jones and others, he invited Hunt to participate. Pleading overwork, Hunt declined. Jealousy was perhaps at the root of his refusal. He was baffled by the relationship between Gabriel and Lizzie, and in March 1857 wrote to Edward Lear: 'I hear that Rossetti is going to be married, but I hear from friends of the lady that everyone else can see what he does not notice that she is dying – he has left it too long!'[4]

Brown was now busy collecting pictures for a proposed Pre-Raphaelite exhibition, to be held at 4 Russell Place, Fitzroy Square. Hunt, Millais and Rossetti all agreed to contribute. The exhibitors paid £10 per share, and Hunt showed three pictures: *The Haunted Manor*, which he had begun at Worcester Park Farm in 1851, *Cairo Sunset*, and *The Sphinx, Gizeh*, all of which were much admired.

For some time Brown had dreamed of founding an artists' colony in which each could have a studio and living quarters for wives and children. Gabriel was filled with enthusiasm. Tudor House, Chelsea, was identified as an ideal site, and Hunt, Burne-Jones and Morris were all invited to participate. All were excited by the prospect, especially Gabriel, who had been having difficulties with Lizzie, and hoped that the prospect of moving into Tudor House as a Pre-Raphaelite bride would encourage her to marry him without further delay. At first she seemed to take to the idea, but as soon as she realized that Hunt was to be included, she flew into a rage. The sudden realization that Annie Miller, as his future wife, would live there as well, angered her beyond belief. She knew all about Gabriel's affair with Annie, and felt bitterly humiliated by it. In a white rage, with strident tones, she gave Gabriel an ultimatum that unless Hunt and Annie were excluded, he must withdraw altogether from the scheme. Though desperately unhappy

at the turn events had taken, he told Hunt that Lizzie's objections made it impossible for them to live amicably together.

Seeing through Gabriel's thin excuses, Hunt realized that something serious lay at the bottom of Lizzie's behaviour, and insisted on a full explanation from Annie. Sulkily, she told him the sordid details. He had been hurt when he realized that Gabriel had carried on an idle flirtation with Annie, but when he discovered that the relationship between them amounted to a full-blown affair, he was furious.

Strangely enough, when the matter was brought out into the open, and Hunt had given vent to his anger, he and Annie were on better terms than ever, and throughout the summer of 1857, they were idyllically happy. Gabriel's offence was harder to forgive, and although there was never any confrontation between them, the relationship between the two men never recovered. There were other storm clouds gathering, for Hunt was still unaware of Annie's affair with Lord Ranelagh.

Hunt was unable to complete any work for the Royal Academy Exhibition of 1857. The hapless Charley Collins was in the same predicament, as Hunt explained in a letter to Lear: 'Poor Carlo broke down on the last day but one with tic-doloreux. I am very sorry that he did not get done, his poor Mother frets about it very much – and he has been obliged to promise to exert himself for popularity – and get elected within five years.'[5]

Now that Ford Madox Brown's scheme of founding an artists' colony had fallen through, he invited Hunt to join the newly founded Hogarth Club. This provided a regular meeting-place where the tendency to disruption in the ranks would be checked, and where its members' paintings could be exhibited. Stephens became honorary secretary to the Club from its inception until 1861, when he became art critic to the *Athenaeum*. Rossetti sent in two excellent oil paintings to the first exhibition.

'He had now completely changed his philosophy,' wrote Hunt, 'which he showed in his art, leaving the monastic sentiment for Epicureanism, and after a pause, which was devoted to design in water-colour, he had again taken to oil-painting. He executed heads of women of voluptuous nature with such richness of ornamental trapping and decoration that they were a surprise, coming from the hand which had hitherto indulged itself in austerities.'[6]

At the Committee's insistence, Hunt applied to Mr Fairbairn for permission to exhibit *Valentine Rescuing Sylvia from Proteus*, but as

soon as it was hung, Rossetti took his own work down. Brown was also angry at the placing of his own paintings, and arriving one morning at breakfast time, he took them all down and drove off with them in a cab. In this way the club which had been founded to check disruption bred further ill will, and was soon disbanded. To Hunt's surprise, Brown openly accused him of causing the break up of the club, by making it plain that he considered its activities of little interest.

Brown seemed to be hypersensitive, at least where Hunt was concerned. During the summer of 1857, the Combes turned up in London unexpectedly, and Hunt, who never failed to try to interest art patrons in the works of his friends, took them to call on Brown, whom they had never met. Unfortunately Brown was out, and his daughter took them into the studio to see his picture, *Work*, which the Combes greatly admired, although it was not the kind of painting which appealed to their particular taste. When his daughter told him of the visit, Brown was annoyed, and wrote to Hunt: 'As I have never derived anything but disgust (except in the case of personal friends) from artistic meetings, I mean to keep at home and never talk of art or show my pictures except to those who I know come to buy. I am obliged to tell you this, because I have now made a strict rule in the house, that no one is ever to be allowed in my studio when I am out.'[7]

Shortly after this episode, Hunt and Brown were walking home together after an evening at Coventry Patmore's, when Brown confided to Hunt that he wanted to include Carlyle in *Work*, but was having difficulty in getting him to sit for him. As Carlyle had already agreed to sit for his portrait when Hunt was free, Hunt offered to use his influence with Carlyle on Brown's behalf. A few days later, however, Brown wrote to him: 'I must now beg a favour that you will not mention the subject to him [Carlyle]. I should have doubts of the success of your mediation, and indeed, from the step that you have taken, you must be aware that the chances of my ever getting him to sit for the portrait of him in my large picture are now smaller than ever . . . Your practice has been *a leetle too sharp* in this case considering the stake I had in the matter.'[8]

In June Hunt went to Oxford to stay with the Combes, and while he was with them, he painted their portraits. He poured out all his troubles to them, and as always, they were sympathetic. It clearly worried them that Hunt still planned to marry Annie, but they sympathized with his desire for a wife, and did their best to guide him

in the direction of eligible young ladies. He was still desperately short of 'tin', and though he wanted above all things to get on with *Christ in the Temple*, he was obliged to concentrate on pot-boilers. Such was his benefactor's confidence in him that before he left Oxford, Mr Combe offered him a loan of £300, completely unsecured, to enable him to finish *Christ in the Temple*. Hunt was overwhelmed with gratitude, and promptly accepted.

Since their reconciliation, Annie had been modelling regularly for Hunt at Tor Villa. It had always been Hunt's habit to produce nude studies of his models, male and female, before clothing them for the finished picture. He made many such studies of Annie, which he gave to her after the pictures were complete. As the summer progressed, Annie absented herself because of alleged ill-health, and at Hunt's insistence, consulted Dr Sanneman, who gave an adverse report, and hinted that consumption could not be ruled out. Hunt immediately feared the worst. 'I am afraid it is very serious,' he wrote to Stephens, '. . . I hope she can be saved.'[9]

Hunt immediately took Annie to see a specialist, who found her lungs to be weak but not diseased. Nevertheless, Hunt decided that more suitable lodgings must be found for Annie, and asked Stephens to recommend a respectable landlady with a decent room to let. As a result, Annie was moved from her hovel behind the Cross Keys public house in Chelsea to the genteel Pimlico establishment of Mrs Stratford, whose husband occupied a humble position in the civil service. Among Mrs Stratford's other lodgers was a retired school-mistress called Miss Prout, who was hired to give Annie her lessons.

Meanwhile, Hunt, who even at this stage did not feel himself irretrievably committed to marriage, and who never desired Annie more than when she repulsed him, continued to enjoy a singularly active social life. He and Woolner were among the most eligible bachelors in town, and were in great demand by society hostesses of the day. Mrs Thoby Prinsep never omitted them from her guest list, and they haunted her soirées at Little Holland House.

One of Hunt's most engaging characteristics was his eagerness to speak out for his friends. During the course of the summer, he went to stay with Thomas Fairbairn at his home in Manchester, and seized the opportunity of mentioning Woolner's newly completed bust of Tennyson, and his rapidly growing reputation. On the strength of his recommendation, Mr Fairbairn commissioned Woolner to do a sculpture of his children, and was so pleased with it that he followed

this up with orders for busts and medallions of Rajah Brooke, Sir William Fairbairn, a noted engineer, and others.

The Tennysons also wrote to Hunt and invited him to Farringford, their home in the Isle of Wight. Bayard Taylor, the American translator of *Faust*, who also stayed with the Tennysons in June 1857, described the scene that greeted him on his arrival:

> As we drew near Freshwater, my coachman pointed out Farring-ford, a cheerful gray country mansion with a small thick-grassed park before it, a grove behind, and beyond all, a deep shoulder of the chalk downs, a gap in which, at Freshwater, showed the dark blue horizon of the Channel . . . I walked to the house, with the lines from *Maud* chiming in my mind. 'The dry-tongued laurel' shone glossily in the sun, the cedar 'sighed for Lebanon' on the lawn, and 'the liquid azure bloom of a crescent of sea' glimmered afar.[10]

Anne Thackeray Ritchie described the inside of the house in *Records*:

> The house at Farringford itself seemed like a charmed palace, with green walls without, and speaking walls within. There hung Dante with his solemn nose and wreath; Italy gleamed over the doorways; friends' faces lined the passages, books filled shelves, and a glow of crimson was everywhere; the oriel drawing-room window was full of green and golden leaves, of the sound of birds and of the distant sea.[11]

Tennyson delighted his guests with his utter informality. He spent hours walking in the countryside, where not a single flower passed unnoticed. He loved working in the garden, and was often seen digging or mowing the lawn in a wideawake and spectacles. Hunt was particularly impressed by the writhing monsters which Tennyson had painted on the window panes with remarkable taste and judgement. After dinner he liked to withdraw with his male guests to his little smoking-room at the top of the house. The garret windows looked out over one of the finest views of the island, and hanging on the wall was a picture of the view which his friend Richard Doyle, the illustrator of *The King of the Golden River*, had painted for him. On the lowest shelves of the swinging bookshelves near his writing table were volumes of Greek and Latin: Homer, Aeschylus, Horace, Lucretius,

Virgil, etc. In the evening he loved to translate Virgil's *Aeneid* aloud to
Emily Tennyson, and often they read Dante together.

Moxon had just brought out his edition of Tennyson's poems, with
illustrations by Hunt, Millais and Rossetti. On 24 July 1857, Ruskin,
claiming for himself the title PRB, had written to Tennyson:

> I wanted to congratulate you on the last edition of your poems.
> Indeed it might be and I hope will be some day better managed, still
> many of the plates are very noble things, though not, it seems to me,
> illustrations of your poems.
> I believe in fact that good pictures never can be; they are always
> another poem, subordinate but wholly different from the poet's
> conception, and serve chiefly to show the reader how variously the
> same verses may affect different minds . . . But we PRBs must do
> better for you than this some day. [12]

Tennyson took issue with Hunt on his illustration of *The Lady of
Shalott*, asking why he had depicted her with her hair floating wildly,
for which there was no authority in the poem. In his view, an
illustrator had no right to incorporate any ideas of his own, but should
confine himself strictly to what was stated in the text. Hunt later wrote
of Tennyson:

> I was profoundly impressed by the unpretending nature of this large
> thinker and consummate poet, who, deeply conversant with the
> character and forms of preceding singers of all Races and time, yet
> adopted for his themes the scenes, moral feeling, and science of his
> own day and country. His simplicity of manner was by some dwelt
> upon as childish; there was a truth underlying the comment, for his
> frankness of speech was like that of a child, whose unembarrassed
> penetration surprises the conventional mind. My holiday brought
> balm and health to me, and I went back to my work with renewed
> zest. [13]

Although Hunt's relationship with Ruskin had been broken off since
Millais's marriage to Effie, they corresponded from time to time.
Ruskin still had Hunt's interests at heart, and cautioned him not to fall
into the trap of spending too long over a single picture. Ruskin's good
advice fell on deaf ears, and Hunt replied: 'What you say about the
imprudence of remaining at work very long at one picture might be

met by the fact of Leonardo da Vinci's working for seven years at the *Last Supper*. Don't let the apparent conceit of this provoke you to severity. To me my "Finding" is as important [as] Da Vinci's *Last Supper* was to him.'[14]

It would have been better for Hunt if he had taken Ruskin's advice to heart, for he was already beginning to display the symptoms of a flaw in his character and his approach to painting that was to place his career in jeopardy and recur to hamper him again and again throughout his working life. In his early days as an artist, sheer hunger and the inexorable knock of the landlord at the door for the rent had urged him on to completion of his paintings, and had forced him to resolve his difficulties as they occurred. The comradely meetings of the PRB had provided relaxation to lighten the nervous tension which attacked him when he worked too hard, and the brotherly interest of Millais, Rossetti and the others had given him moral support when his spirits were low. But as soon as he had a little capital laid by, carefully husbanded by Mr Combe, and a small but reliable income from his investments, he lost that vital will to survive at all costs which had previously driven him forward. Now he began to labour unproductively, imagining problems where none existed. In the East he had become accustomed to solitude. His friends Sim and Graham had provided social contacts, but there had been nobody at hand who truly understood his needs as an artist. Though he had good friends in Halliday and Martineau, as well as the faithful Stephens, they were pupils and disciples. What Hunt needed was an equal, whose advice would carry weight with him, and who could help him over the obstacles in his path. Probably Millais was the only person who could have influenced him, but marriage, admission to the ranks of the Royal Academy and differing pursuits had removed him to another social sphere.

The new year of 1858 found Hunt desperately trying to prepare his family for his marriage, while trying to cover up all evidence of Annie's shady past. Models were inevitably regarded as loose women, and if word got around that Annie had been a model, she would be ostracized by society. This could lead to a reluctance among his patrons to purchase his work.

In January 1858 he and Martineau called unexpectedly on George Boyce, for whom Annie had sat on several occasions. Boyce had first met Hunt at Gabriel's crib in January 1853, and had taken to him immediately. 'Hunt struck me as a thoroughly genuine, humorous,

good-hearted, straightforward English-like fellow,' he wrote in his diary.[15]

Explaining to Boyce that he intended to educate and then marry Annie, Hunt said that he wanted to destroy any pictures in which she could clearly be recognized. Boyce's picture was the only direct study of her head, and Hunt therefore asked Boyce as a special favour to let him have the portrait in return for one of his. Boyce was not keen to give away the picture, which he particularly prized as the best he had ever done, but when he saw that Hunt was in deadly earnest, he did as he was asked.

While Hunt was still hotly involved in all this, he received word from the Combes that Henry Wentworth Monk, the Canadian religious eccentric whom he had met in Syria, had descended on them unexpectedly, and wanted to come and stay with him in London. Hunt, though hardly in the mood for a visit, replied that he could put him up for a few days. Apparently Monk stayed with him for a considerable period, for while he was there, Hunt painted a striking portrait of him.

In April 1858, Wilkie Collins opened his copy of *Household Words*, the journal owned and edited by Charles Dickens, and read a story by Robert Brough called 'Calmuck'. This featured a turbulent young artist called Mildmay Strong, with a passion for realism in his paintings, whose followers spent all their time posing for him in strange, uncomfortable attitudes. While painting a background for *As You Like It* near Sevenoaks, he recruited a wench to go to London with him to model for the character of Audrey. Fancying that she looked like a Tartar, his followers nicknamed her the Calmuck. Modelling for Mildmay Strong turned out to be so disagreeable that the Calmuck revealed that she was already married to a sailor. His followers amused themselves by banging on the door and pretending to be the husband. Unperturbed by all this, Strong calmly finished his picture, and sent the chastened Calmuck back to Sevenoaks.

Collins was horrified. He recognized at once that this was a satirical account of Hunt's brief relationship with Emma Watkins, christened 'the Coptic' by Gabriel, who had posed as the shepherdess in *The Hireling Shepherd*. It was well known that Dickens was a friend of Frank Stone, and hostile to the Pre-Raphaelites, but Brough's satirical little tale was an infamous libel. Taking up his pen, he promptly wrote to Hunt advising him to send a strong letter of protest to Dickens.

Meanwhile, Uncle Hobman, at his home in Ewell, read the story of 'Calmuck' and realized at once that his nephew was Mildmay Strong. He was shocked at this exposure of his nephew's apparently lascivious relationship with a field girl. Emily Hunt, already annoyed by Hunt's relationship with Annie Miller, had gone to stay with Uncle Hobman to paint backgrounds, and wrote an angry letter in which she said that Hunt's true character was now common knowledge.

Emily's letter arrived simultaneously with the one from Wilkie Collins. Aghast, Hunt read the offending article and wrote to Dickens. In reply, Dickens claimed to have been unaware that the article satirized Hunt, and invited him to call and discuss the matter. But Hunt was now obsessed with the extraordinary notion that Bishop Gobat, in Jerusalem, would read it and associate him with the hero of the story. Dickens was prepared to print a full apology, but advised against such a step on the grounds that it would draw attention to the libel, which he felt sure would have passed unnoticed.

Hunt accepted Dickens's advice against all his inclinations. He was desperate not to be discredited in the eyes of Bishop Gobat, particularly since his object was now to return to Jerusalem as soon as *The Finding of the Saviour in the Temple* was completed.

It was probably the unfortunate 'Calmuck' affair and Hunt's positive obsession about the news reaching the Mission in Jerusalem that decided him, more than three years after leaving Syria, to publish his account of the Hanna Hadoub affair, together with the supporting statements. *Bishop Gobat in Re Hanna Hadoub* by William Holman Hunt was published in London in 1858. At the same time Hunt's friend James Graham, whose position as Lay Secretary to the Jews Society in Palestine had been abolished in June 1856, published a booklet, *Jerusalem: Its Missions, Schools, Converts etc. under Bishop Gobat*, in which he made claims of improper appointments of staff, uncontrolled homosexuality among the pupils of the boys' school, etc.

The Jerusalem Diocesan Missionary Fund could not ignore these serious published allegations, but having read them, the Committee decided to support Bishop Gobat. As an appendix to their 5th Annual Report, published in 1858, they issued in the form of an appendix an 'Authorised Statement in vindication of the Anglican Bishop in Jerusalem from the accusations of Mr James Graham and Mr Holman Hunt'.

It seems unlikely that Hunt's pamphlet did any good at all, but in

publishing it he gained some powerful enemies. Graham had already paid the price of speaking out against Bishop Gobat, for he had been dismissed from his post. This was allegedly because he was redundant, but in reality his dismissal was a punishment. Hunt, being his own master, could not be punished in the same way. Yet all his life he was convinced that he in fact paid a high price. The Patron of the Jerusalem Diocesan Fund was none other than the Archbishop of Canterbury himself. In questioning Bishop Gobat's fitness for office, Hunt was directly criticizing the Primate's judgement, and it is likely that the Archbishop was vexed. It was certainly remarkable that Hunt, though the foremost religious painter of his era, never received any form of official church commission, and he may well have been right in attributing this to his part in the dispute.

With the Hanna Hadoub affair finally behind him, Hunt expected to be able to get on with *The Finding of the Saviour in the Temple* in relative tranquillity, but unfortunately, yet more trouble lay ahead. Since Annie had moved into her new lodgings, Hunt had been making her a monthly allowance to cover Mrs Stratford's rent money and Miss Prout's teaching fees, as always using Stephens as his intermediary. Unknown to Hunt, Annie had been spending the money instead of paying the bills. Matters came to a head when Mrs Stratford called at Rochester Row Police station and reported Annie for non-payment of rent. When questioned by the police, Annie gave Stephens's name and address, with the result that an inspector called on the unlucky Stephens without warning and took him to the police station. After a long interview, Stephens referred the police to Hunt, and wrote immediately warning him that he, too, could expect a similar visit.

Hunt wrote to the inspector, and explained matters to him. Meanwhile, he used the hapless Stephens to enquire into exactly what had been going on. Patiently Stephens dredged up the sordid details, and reported to Hunt that Annie had behaved with wilful frivolity throughout the time she had been in her lodgings in Pimlico. She had bribed Miss Prout to turn a blind eye to her missed lessons, squandered her allowance from Hunt on fancy clothes and an extravagant life-style, and haunted numerous places of amusement with various male companions. When questioned, Annie maintained that she had not been physically unfaithful, and though she was found to be lying in every other particular, Hunt believed her protestations.

Hunt's resolve to save Annie from a life of sin and degradation was never stronger than when she refused to be saved, and she now began

returning his gifts and cheques, refusing to sit for him, and turning him away from her door. Only the other inhabitants of Tor Villa, and one or two intimate friends knew that anything was amiss between Hunt and Annie. Stephens and Millais both begged him to reconsider, but when, after months of rejection he called on Annie and found her looking radiant, healthy and expensively dressed, his customary caution crumbled, and he proposed to her.

Revelling in her power over him, Annie said that she would let him know her decision in due course, but weeks went by without a word from her on the subject. Emily, who hated Annie, moved out of Tor Villa in disgust. As Halliday and Martineau were also away, Hunt now found himself alone in a fourteen-roomed house. He was wretchedly lonely.

Seeking refuge in work, Hunt tried to blot out his personal worries. In his view an artist needed above all things to go on with the task in hand, no matter what problems beset him. A letter which he sent to Brown, who was considering going to America as a picture hanger in an exhibition at about this time, brings out this point: 'I am really very glad that you have given up the task of hanging pictures in America. It would have lost you much time, and an artist in the unavoidable troubles of life has quite enough interruption to his work. I often think the game of success is dependent on *production*, regular production, *as much* as on any other card, and in your case as requiring it particularly at this time.'[16]

On 10 June 1858 an important meeting was held at Hunt's house, to which Boyce was invited. He described the event in his diary:

To Hunt's. He was hard at work on some drapery in his 'Christ and the Doctors' picture, which is a noble and wonderful work and intensely expressive and realistic. Every single head full of meaning and worthy of study. The head and legs of the boy Christ not finished. All the flesh had first been modelled in bright blue.

At 7.30 we came to dinner, and found in the room Wallis, Halliday, Martineau, Barwell and Miss Hunt. After dinner came Prinsep, Jones, Brett, Egg, Stephens and Stanhope. We took tea on the grass outside bespread with carpets. Boxing was the principal topic discussed, and Hunt communicated the doctrine that it was on account of our ancestors' pugnacity and warlike disposition that England had become great. Now we were degenerating into a nation of milksops. He and several of the other men were arranging

boxing lessons to be taken of a man of the name of Reid. Hunt told some interesting stories relating to his experiences in the East. After some time he mooted the subject which was the subject of the gathering, viz., the importance of supporting the Old Liverpool Academy. All adhered, Wallis alone rather throwing cold water on the project. R. took down the names of those who would send and the number of works promised. I promised two, and two for Joanna [his sister]. In the dining room were three of Hunt's fine eastern drawings and a chalk head by him of Lear.[17]

During the course of the summer, Edward Lear's arrival in London helped to remedy Hunt's loneliness. He had just returned from Corfu, and being equally solitary, moved temporarily into Tor Villa. His three-year visit to Corfu had not been the idyll that he had hoped. Lear was pining for the love of his life, Frank Lushington, who probably never realized the full nature of Lear's feelings until after Lear's death. Frank had been too preoccupied with work and other friends to spend much time with Lear, and they had quarrelled frequently. From Corfu Lear had written to Hunt, pouring out his troubles: 'I have, alas! too present a feeling of the want of all kind of sympathy not to find one of your letters most welcome. Perhaps to irritable natures of my temperament, my unsettled early life makes me more susceptible to what devours me here – isolation and loneliness, and sometimes drives me half-crazy with vexation.'[18]

As far as his painting was concerned, Lear valued Hunt's advice, and continually turned to him for assistance. 'You see, Daddy, you took an awful load of responsibility on yourself when you adopted me as your son . . . you are so solid and distinct in going on constantly in doing what is right; I am so fluffy and hazy, and never know what is right and what isn't.'[19]

Though the two men met only at breakfast and in the evening, they got on admirably together, and at one stage even contemplated making it a permanent arrangement. Simply being in the same house with Hunt was a comfort to Lear, who felt that Tor Villa was pervaded by Hunt's mind, which he described as 'active and truthful'.

Curiously, Hunt seems to have stepped into the paternal role which Lear jokingly referred to, while Lear, for his part, had a certain childlike dependence on the younger man, who patiently listened to his troubles and helped direct his thoughts away from his brooding and towards his work. 'One thing is a fact,' wrote Lear in a letter to his

friend Fortescue, 'living with Daddy Hunt is more a certain chance of happiness than any other life I know of.'[20]

The relationship brought benefits to Hunt as well as to Lear. When he managed to throw off his mood of depression, Lear was a sparkling companion. Though he had had little more formal education than Hunt, he had rapidly acquired an immense learning and culture. Hunt, forced from an early age to go out to work for his living, had far less leisure, but had acquired an education by avid reading in his spare time. Years later, he wrote to Lear: 'I am indebted to you for the amount of culture that I have got since the time I first met you.'[21]

As to Lear, he never had any reason to revise his high esteem for Hunt, of whom he wrote: 'Daddy Hunt's head would cut up sufficient for ten men, and his heart for two hundred at least. God bless him.'[22]

CHAPTER 12

Blighted hopes

O N 16 January 1859, Tommy Woolner, who like Hunt was still a bachelor, wrote a long letter to Emily Tennyson:

> On Thursday evening I went to Leatherhead in Surrey to meet a great beauty whom I have long been promised a sight of – my friend who mentioned her having thought she would do for my Trevelyan Lady. Although it certainly was an awful bore leaving my work yet I was munificently repaid for the lady, Miss Waugh, was one of the grandest creatures I ever saw and her face is not far from what I want for my Lady: I hope to get her to sit . . . I did her a great deal of good, for I converted her to Browning – almost – of course not quite – almost made her look with suspicion upon that schoolgirl poet Longfellow . . . I should not have taken so much trouble with her mental development had she not been so majestically beautiful . . .[1]

Fanny Waugh was the eldest of the eight beautiful daughters of George Waugh, a wealthy chemist with a shop and substantial blocks of property in and around Regent Street, an elegant house in Queensborough Terrace, and a country house in Leatherhead. At twenty-six years of age, Fanny had striking good looks coupled with intelligence, easy grace and natural refinement. Woolner soon began to court her in earnest.

On 19 June 1859, Woolner wrote to Fanny, enclosing a ticket for an exhibition at the Hogarth Club, and recommending her in particular to look out for Hunt's *Valentine Rescuing Sylvia from Proteus*. He added:

> Would you and your sister like to see Holman Hunt's great picture which he has been engaged on for the last five years? If you would

like to see it and would not mind a few parts being unfinished, and would let me know which day would be most convenient I would call and accompany you to his house: but if you are too proud to accept my escort I would meet you there at any time you please to appoint and introduce you to him . . .

I should advise you strongly not to miss the opportunity as you are fond of works of art, for this picture is incomparably the greatest work ever done by an English artist and so many great judges have said that they knew of nothing either old or modern painting, taking all qualities into consideration, that can be pronounced equal to it: of course he being an intimate friend I do not like to say so much as this, but I do confidently say that I have seen nothing in modern art so good. There will be such swarms of people going to see it when finished, which will be about three weeks from now, that it will be difficult to get a sight of the picture then, and the advantage of going before he lets the public in upon him, is that he will have the opportunity of explaining all about it; for you may suppose that a work which contains such a vast amount of thought and labour cannot be read off in a few minutes.'[2]

Hunt, meanwhile, despite his entanglement with Annie Miller, had begun courting a certain Miss Strong, who had been introduced to him by the Combes in February 1859. He actually got as far as making a proposal of marriage, but Miss Strong, who had no desire to start married life in Syria, turned him down out of hand. Once more Hunt's ego was deflated, and in July he returned to London, where he called again on Annie Miller.

This time Annie received him warmly, and even consented to sit for him again. He painted her in a relaxed, becoming pose, with the accent on her flowing hair and fine clothes, and called the picture *Il Dolce Far Niente*. This time there was no typological symbolism, and no morals were pointed.

Hunt's reconciliation with Annie was brief. One day he called at her lodgings in Mrs Stratford's establishment, and noticed a letter, with a Belgian stamp, on the mantelpiece. He thought that he recognized Boyce's writing, and questioned Annie about it. Snatching the letter, Annie claimed that it was from a woman friend. After a brief altercation, Hunt stalked out, and Annie promptly burned the letter.

A few days later, having received a gift of wine from Millais, Hunt invited a few artist friends, including Boyce, to dine with him at Tor

Villa. When the wine had been flowing freely for a while, William Allingham, not realizing that Hunt had re-established relations with Annie, expressed the opinion that Hunt was well rid of her, and remarked that as Lord Ranelagh had now abandoned her, she was doubtless in desperate financial straits. Hunt, who was a master of self-control at all times, gave no indication of the inner turmoil occasioned by this hapless remark, but on the following day set out to verify the information. This turned out to be all too true.

Noticing that Hunt was showing signs of strain, Martineau persuaded him to go with him to his family home at Fairlight, where they spent several weeks together. Hunt bombarded Stephens with letters of instruction. He seemed obsessed with fears that the whole miserable affair would be reported in the national press, and became paranoid about the personal columns of *The Times*, which he believed carried enigmatic coded messages from Annie. Eventually he wrote to Stephens: 'I have nothing further to propose to aid the poor devil but I must thank you for your kind and complete attention to this last effort as in all previous ones to save the silly fool.'[3]

Returning to London in late September, Hunt resolutely set aside *Il Dolce Far Niente* and took up *Christ in the Temple* again. He now recognized that marriage to Annie was impossible, but he was still infatuated with her and though he made no efforts to approach her personally, he let it be known, through Stephens, that he would be willing to help her establish herself in some suitable way of life.

Annie ignored these hints. She had no intention of working for a living, and preferred to return to modelling. Before long she had started posing for Gabriel again, and on 22 December George Boyce wrote in his diary:

Miss Annie Miller called on me in the evening in an excited state to ask me to recommend her someone to sit to. She was determined on sitting again in preference to doing anything else. All was broken off between her and Hunt. I pitied the poor girl very much, by reason of the distraction of her mind and heart.

Called on Hunt in the evening to tell him of her visit and that, finding that she was resolved on sitting again, I should ask her to sit to me instead of to any stranger. He said it seemed now as if she could do nothing else for she rejected (naturally enough) all his efforts to find her employment through friends. Finding he could not get her to do what he wanted to make her a desirable wife for

him, nor wean herself from old objectionable habits, he had broken off the engagement; but the whole affair had preyed on his mind for years. The interview was friendly throughout.[4]

It was a relief to Hunt to escape from London to the Combes for Christmas, taking Woolner with him. It was Woolner's first visit, and Mr Combe wrote to assure him of a warm welcome: 'It gives Mrs Combe and myself such pleasure to hear from our mutual friend Mr Hunt that you assent to accompany him to Oxford on Saturday next. Hunt is not famed for his punctuality, we shall be glad to see you as early in the day as is convenient.'[5]

Once more Hunt threw himself into a hectic round of socializing as an antidote to hard work and to take his mind off his problems with Annie. He and Woolner were socially much in demand, being handsome, cultivated, well turned out, and above all eligible. Hunt now got his clothes from Mr Poole, a Savile Row tailor, and was always a model of sartorial elegance.

Lear, meanwhile, had abandoned the idea of living permanently with Hunt. Hearing that a Derbyshire landowner whom he had known since his days at Knowsley, and who had stayed with him in Corfu, was going to Rome, he decided to travel with him and settle there. On 16 February 1860 he wrote a letter to Woolner, beginning with the salutation, 'O my Deerunkel', in which he sent a message for Hunt: 'Tell my pa [i.e. Hunt] he is a nasty unnatural old brute of a parient, as lets his own flesh and blood pine and fret away in furrin parts, without his never writing nothink to them. I am immensely glad you give such a good account of dear Daddy – and long to hear of the picture being finished. I approve of both your dancings . . . a couple of little apes as you both of you be! For all that I wish you were both of you here . . .'[6]

Hunt's great masterpiece was now in its final stages, and was eagerly awaited by the public. It was widely rumoured that this painting was truly remarkable, and those who had already seen it in preparation spoke of it with awe. One artist, John Ballantyne, considered it was such a landmark in the history of English art, that he even painted a picture of Hunt at work on it in his studio. As was his usual custom, Hunt had designed a special frame for his picture, which he had made up for him. Henry Holiday, an associate of the second wave Pre-Raphaelites, Morris and Burne-Jones, wrote: 'He [Hunt] told me a good story of his frame-maker, old Green. When he had finished the

frame for *The Finding of the Saviour in the Temple*, Hunt, who had designed it himself, went to see it and told him it was quite satisfactory; "Ah," said Green, "but you will see the picture will set it off amazingly."[7]

Finally, in April 1860, Hunt laid aside his brush and announced that *The Finding of the Saviour in the Temple* was finished. It had taken him six years to complete. At this juncture, Hunt paid a visit to his friend Wilkie Collins, who was invariably glad to see him. As a host, Collins was impeccable, and Hunt wrote: 'No one could be more jolly than he as the lord of the feast in his own house, where the dinner was prepared by a chef, the wines plentiful and the cigars of the choicest brand. The talk became rollicking and the most sedate joined in the hilarity; laughter long and loud crossed from opposite ends of the room and all went home brimful of good stories.'

Collins's sitting room was decorated with his father's fine paintings, including two beautiful pictures of the Bay of Naples· which Hunt much admired. Wilkie's own painting, *The Smugglers' Refuge*, which had been hung in the Royal Academy Exhibition of 1849, hung alongside his father's work.

On this occasion Hunt confided to Wilkie Collins his dilemma over the price that he should ask for the painting. Collins had immense faith in Charles Dickens's expertise in matters of business, and knowing that Dickens had long wished to make amends for the unfortunate 'Calmuck' affair, suggested that Hunt should seek his advice. Hunt accordingly called to see Dickens at his home in Tavistock Square, and was immediately impressed by Dickens's ability to establish the principles and form an accurate and impartial judgement.

Dickens began by asking Hunt how long he had worked on the painting, how long he had been in Jerusalem, and what the expedition had cost. He then asked what revenue the dealer who bought the painting might expect.

'He will be able to exhibit it at his gallery in London;' explained Hunt, 'we may average as much as £20 or £30 a day, taken at the door. The rent at the best season is of course heavy, and he has a canvasser paid partly on results, and a toll-keeper. I should calculate that a fifth of the revenue should suffice for this. The canvasser will take the names of all people willing to subscribe for the plate; the impressions will bring £3, £5, and £8 each. He will have to pay the engraver, say £800 or so, for his work, and then there will be the cost of printing and

distribution. When this had been done he would get the price of the sale of the picture itself.'[8]

After a few mental calculations, Dickens delivered his verdict: that Hunt should charge 5,500 guineas for the picture and the copyright, in instalments; £1500 as a down payment, a further £1000 after six months, and the balance over 2½–3 years. Hunt was overawed by the sum, for no English artist had ever demanded such a price; yet in all justice, having regard to the amount of labour and expenses involved, the quality of the picture and the dealer's scope for profit, he saw that this price was not unreasonable, and resolved to do as Dickens suggested.

When the painting was ready, Sir Charles Eastlake, the President of the Royal Academy, and his wife called to see the painting in Hunt's studio. This singular honour was brought about because word had reached the President that Hunt did not intend to send his picture to the Royal Academy after all. He now promised Hunt that if he would agree to submit it, his picture would have the place of honour in the exhibition, with a special rail to protect it from the crowds of people who would come to see it.

Here at last was Hunt's great opportunity of returning to the Royal Academy in triumph after all those years in the wilderness. Had he done so, the way ahead might have been easy for him for the rest of his life. But Hunt was a proud and inflexible man. He could not forget all that he had suffered in the past, nor his deeply-rooted objections to the whole rotten system. After years of humiliation at the hands of the Royal Academy, it must have given Hunt some satisfaction to be able to decline. Yet in his refusal there would have been a degree of sadness as he remembered his early hopes, and how much he had once longed for recognition within the Academy.

Although Hunt had promised Ernest Gambart, the Belgian art dealer, first refusal of the picture, he would not discuss the price in advance. When Gambart heard that it was finished, he invited Hunt to dinner, and Hunt explained his terms in detail. Gambart said that such a price was out of the question, but when he realized that the price was not negotiable, he accepted Hunt's terms.

The Reverend Charles Lutwidge Dodgson, a lecturer in mathematics at Christ Church, Oxford, saw the picture in April 1860. Hunt had been introduced to Dodgson in June 1857, when he and Charles Collins were entertained in Christ Church Common Room by the Precentor, Alfred Hackman. Dodgson, who as 'Lewis Carroll'

published *Alice's Adventures in Wonderland* in 1865, described seeing the picture in a letter to his sister Mary:

> I was at Mr Cundall's, . . . when he happened to mention that Holman Hunt's great picture, *Christ in the Temple*, was on private view (being open to the public on Wednesday) and thought that if I told them I was going on to Oxford the next day, they might possibly admit me. I tried, but the doorkeeper was inexorable: as a last resource, I sent my name in to Mr Hunt, remembering that I had once been introduced to him, and he most kindly admitted me, and I re-introduced myself. There were very few people there, so that I saw it capitally, and had also the treat of talking to the artist himself about it. It is about the most wonderful picture I ever saw.[9]

Dodgson was so impressed by the picture that, after a second viewing, he wrote a long poem about it called *After Three Days*, which Edmund Yates published in *Temple Bar*. It contained the lines:

> Gazers came and went –
> A restless hum of voices marked the spot –
> In varying shades of critic discontent
> Prating they knew not what.
>
> 'Where is the comely limb,
> The form attuned in every perfect part,
> The beauty that we should desire in him?'
> Ah! Fools and slow of heart!
>
> Look into those deep eyes,
> Deep as the grave, and strong with love divine;
> Those tender, pure, and fathomless mysteries,
> That seem to pierce through thine.[10]

On the first day of the exhibition, Millais accompanied Hunt to the gallery, and when he saw the painting, described it as 'a jewel in a gorgeous setting'. On 4 May he wrote to his wife: 'Hunt's exhibition is a tremendous success, and I believe Gambart is to give him £5,000 for his picture. The public are much taken with the miniature-like finish and the religious character of the subject. The Royal Academy are tremendously jealous of the success of the picture, and his pocket-

ing such a sum; but he has been seven years at it, and he says it has cost him £2,000 painting it.'[11]

Writing to William Bell Scott about the price Hunt obtained from Gambart, William Rossetti wrote: 'This is a miraculous draft of loaves and fishes, though I have little doubt that Gambart, being a wide-awake man, will pay himself splendidly for the outlay by exhibition and engraving, and finally by resale of the picture, which will have accumulated a huge reputation meanwhile. A little time ago the receipts at the door were thirty pounds a day, and a very easy sum in arithmetic will show what this will come to throughout the year.'[12]

Every day between eight hundred and a thousand people fought their way into the gallery to see Hunt's great painting. The Prince Consort called at the gallery unannounced one morning to see Hunt's masterpiece, and was recognized by an attendant as he vainly tried to see over the heads of the people in front. Before leaving, he asked if the painting could be sent to Windsor for the Queen to see. Gambart duly obliged, and the Queen much admired the painting, returning it to the gallery with a note of sincere appreciation.

Gambart now engaged Signor Morelli to make a black and white drawing for the engraver, and Hunt usually arrived at the gallery at 5.30 a.m. to make the tracing for him. This was tedious for Hunt, but the work had to be finished before the public were admitted each day, and Hunt would allow no hand but his own to touch the painting. The care taken was, however, well worth while, for with Hunt's help Signor Morelli succeeded in making an exact and very elaborate transcript.

Although Gambart asked Hunt to write the story of his life for a pamphlet, he was too modest to do so. Stephens, however, was very glad to oblige, for a fee of £30, and his little book was so much in demand that within a few days it was sold out. Hunt now visited the Combes in Oxford, and was able to repay Mr Combe's loan of £300. With characteristic generosity, Mr Combe declined to take the money, but asked Hunt to pass it on to Woolner as an indefinite loan. At that time Woolner was working on his statue of Lord Bacon for the Oxford Museum. Of Hunt's picture, Woolner wrote to Emily Tennyson: 'You must have heard of the prodigious success of Hunt's picture in a popular sense, nothing like it in modern times.'[13]

Lear, whose attempt to settle in Rome had proved something of a disaster, was back in his old home in Stratford Place. He, too, wrote to Mrs Tennyson about the success of Hunt's picture: 'My father I have

seen several times, and am as glad of his success as if I had got double myself. He is a blessed old parient he is. The best criticism I have yet heard on his picture was last week, when a very fine gentleman objected to the "commonplace air" of the Virgin and added "No well-bred woman would ever enter a room in such a *fussy* manner".'[14]

There was no word from Gabriel, who had other things on his mind. On 13 April he wrote to his mother: 'I write you this word to say that Lizzy and I are going to be married at last, in as few days as possible . . . Like all the important things I ever meant to do – to fulfil duty or to secure happiness – this one has been deferred almost beyond possibility. I have hardly deserved that Lizzy should still consent to it, but she has done so, and I trust I may still have time to prove my thankfulness to her. The constantly failing state of her health is a terrible anxiety indeed . . .'[15]

The wedding nevertheless had to be put off because of Lizzie's illness. In a letter to Ford Madox Brown, Rossetti wrote: 'She has seemed ready to die daily and more than once a day.'[16]

Finally, on 23 May 1860, Rossetti wrote to his mother to tell her that the wedding had taken place: 'Lizzie and I are just back from church. We are going to Folkestone today, hoping to get on to Paris if possible but you will be grieved to hear her health is no better as yet.'[17]

When news arrived about the outbreak of war between France, Piedmont and Austria, it was widely feared that England, too, might be invaded. The nation appealed for able-bodied men to join the volunteers, and in the summer of 1860, the Artists' Volunteer Corps was formed. Urged on by Leighton, Hunt attended the first meeting, along with Millais, Morris, Rossetti, Richmond, Swinburne, Burne-Jones and many others. Being fond of outdoor activities of all kinds, keen on self-defence, and above all an ardent patriot, Hunt threw himself into the work of the Corps with enthusiasm. In June 1860, Lady Trevelyan wrote to William Bell Scott: 'Holman Hunt spent an evening here very well and jolly. He is finishing up odds and ends that have been put aside for the great picture, and is very diligent at rifle-drill.'[18]

Marriage, it seemed, was fashionable in PRB circles. William Morris had just married Jane Burden, and Ned Burne-Jones was about to tie the knot with Georgiana Macdonald. Charley Collins, who had drifted into journalism with his brother Wilkie's encouragement, had abandoned painting and had already had a number of articles

published in *Household Words*, of which Dickens was editor. Wilkie wrote: 'Charley continues to spin madly in the social vortex, and is still trying hard to talk himself into believing that he ought to be married.'[19]

As a contributor to *Household Words*, Charley was thrown more and more into the company of Dickens and his family. He often visited them at their new home, Gad's Hill Place, near Rochester in Kent. On his first visit, he wrote to Hunt describing the house: 'This is a delightful place about a couple of miles from Rochester, a house of about the period of George III, red brick with a belfry; and from the high ground one sees the ships working up the estuary of the Thames. It has the oddest effect to see the ships apparently moving through the fields, for one cannot see the water always, and just now I saw a cutter, to all appearances sailing on the top of a green hill.'[20]

Anxious to appear to the best advantage among his new friends, Charley began taking a great interest in his personal appearance. Hunt, whose sartorial elegance now exceeded even that of Millais, recommended him to visit Poole, his Savile Row tailor, and shortly afterwards received the following letter:

My Dear Hunt,

I take the opportunity of having nothing to do to write and express (most inadequately) the deep sense of gratitude which pervades my whole system when I reflect on what I owe to you in the matter of Poole.

Why, it's a new sensation. I am unrecognisable, I am astonished at myself. I see life under a new aspect since the mighty genius of Poole has become known to me. I no longer dislike modern costume. But my dear fellow, why have you not long ago taken me in a cab without telling me what you were going to do, and placed me in the hands of this profound artist? However, it's better late than never, and I am content.

Always yours,
Charles Allston Collins
Gadshill Place,
Higham, by Rochester[21]

Before long Charley proposed to Dickens's daughter, Kate, and to everyone's surprise, she accepted him. It was generally felt that, but

for the break-up of Dickens's marriage, she would not have felt driven to matrimony. The wedding took place at Gad's Hill on a sunny day in July 1860, and Hunt was best man. A special train from London Bridge conveyed the guests from London.

'All the villagers had turned out in honour of Dickens,' wrote John Forster, 'and the carriages could hardly get to and from the little church for the succession of triumphal arches they had to pass through. It was quite unexpected by him; and when the *feu de joie* of the blacksmith in the lane, whose enthusiasm had smuggled a couple of small cannon into his forge, exploded upon him at the return, I doubt if the shyest of men was ever so taken aback at an ovation.'[22]

After the service the guests played games on the lawn and later drove into Rochester, where they toured the castle. Hunt drove with Mrs Collins and John Forster, whom he had not met before, and enjoyed a long debate with him about literary responsibility and the false influence of so-called poetic justice. Later all the guests went on to Chatham to hear a band concert. The programme was signed 'W. Collins, Bandmaster', which gave rise to a number of jokes at Wilkie's expense. Hunt, who stood next to Dickens, remarked that throughout the proceedings he seemed a little sad. When the bride and groom set off on their honeymoon, Charley was deathly pale and Kate cried bitterly on her father's shoulder. After the guests had gone, his eldest daughter found Dickens alone in Kate's room, with his face buried in her wedding-dress. 'But for me Kate would never have left home,' he said.[23]

At the end of July, Wilkie Collins finished writing *The Woman in White*, which Dickens had been publishing in serial form in *All the Year Round*. It was now scheduled for publication in book form, and to celebrate the launch Wilkie gave a party to a select group of friends, including Hunt, Augustus Egg and E. M. Ward. 'We dine here at half past six on Thursday to drink success to the book in England, America, Germany and Canada, in all which places it will be published this month. Will you come? No evening dress – everything in the rough . . . cast respectability to the winds and write me a line to say you will come,' wrote Collins to Ward.[24]

On 18 August 1860 Tennyson set off from Oxford for a walking tour of Devon and Cornwall. 'I started off alone,' he wrote in his journal, 'and I believe that in a week's time Holman Hunt, Val Prinsep and Frank Palgrave will join me at Penzance. Woolner, like a good fellow, followed me here yesterday that I might not feel lonely.'[25]

Palgrave duly arrived at Tintagel on 25 August, but characteristi-
cally, Hunt, accompanied by Val Prinsep, did not turn up in Penzance
until 7 September. Finding that Tennyson and Palgrave had gone on
to the Scilly Isles, they followed in the packet boat to St Mary's, and
met up with them at the inn. They spent most of their time wandering
in the gardens. 'There are West Indian aloes here 30 feet high, in
blossom, and out all winter, yet the peaches won't ripen,' Tennyson
wrote; 'vast hedges of splendid geraniums, a delight to the eye, yet the
mulberry won't ripen. These islands are very peculiar and in some
respects very fine. I never saw anything quite like them.'

Returning to Penzance, they put up at an inn called the Three Tuns
at the Lizard. Palgrave was working on his *Golden Treasury* at the time,
and the party had long discussions about English poetry. Tennyson
had a bad foot, and Palgrave ordered a dogcart, riding with Tennyson
while Hunt and Prinsep followed on foot. Tennyson was obsessed
with the fear that he might be recognized and mobbed, and insisted
that his name should not be used. At the inn, when ordering the wine,
Palgrave accordingly referred to him as 'the old gentleman', which
annoyed him. In the event, it was Hunt who, recognizing some
acquaintances, let slip that Tennyson was with them, though luckily
there were no repercussions. In her book, *Memories of Old Friends*,
Caroline Fox recalled meeting the party:

Holman Hunt and his big artist friend, Val Prinsep, arrived, and we
were presently on the most friendly footing. The former is a very
genial, young-looking creature, with a large square, yellow beard,
clear blue laughing eyes, a nose with a merry little upturn to it, and
dimples in the cheek, and the whole expression sunny and full of
simple boyish happiness. His voice is most musical, and there is
nothing in his look or bearing, spite of the strongly marked
forehead, to suggest the High Priest of Pre-Raphaelitism . . . Hol-
man Hunt is so frank and open, and so unspoiled by the admiration
he has excited; he does not talk 'shop', but is perfectly willing to tell
you anything you really wish to know of his painting, etc. He
laughed over the wicked libel that he had starved a goat for his
picture, though certainly four died in his service, probably feeling
dull when separated from the flock. The one which was with them
by the Dead Sea was better off for food than they were, as it could
get little patches of grass in the clefts . . . Speaking of lionising, he
considers it a general sin of the age, and specially a sin because

people seem to care so much more for the person doing than for the thing done.[26]

After a few days Tennyson grew weary of Palgrave's fussy ways, and decided to go on alone to Falmouth. He left Hunt and Prinsep hard at work at the Lizard, but to his annoyance, Palgrave insisted on returning with him. In the event it emerged that Palgrave had been secretly charged by Emily Tennyson not to let her husband out of his sight in view of his poor eyesight, and Palgrave had nobly kept to his promise.

Meanwhile, Hunt and Prinsep remained behind, each producing a water-colour of Asparagus Island. Hunt had almost finished his picture when a gust of wind carried it away. It caught on a tuft of grass at the very edge of the precipice, and Hunt was just able to retrieve it with the help of his umbrella.

Soon after Hunt returned to London, Annie Miller's landlady, Mrs Stratford, called at Stephens's home in Lupus Street and demanded payment of Annie's debts. Stephens immediately contacted Hunt, who received this unwelcome news with his customary sang-froid. Asking Stephens to handle the negotiations as usual, he offered as before to defray Annie's expenses for training in some respectable career. This time he also offered to pay her passage to Australia, where she could start a new life if she so desired. Mrs Stratford was to be asked to produce her accounts for inspection, and when Stephens had finished his negotiations, he was to hand Annie an envelope containing money but no letter.

Annie was displeased with the outcome of Stephens's visit and asked for time to consider Hunt's proposals. Eventually, since she seemed unable to accept his suggestions, Hunt paid Mrs Stratford £5 in final settlement of her account.

Having failed in her attempt to extort more money from Hunt, Annie went to Lord Ranelagh and threw herself on his mercy. Being far too worldly to be taken advantage of by the likes of Annie Miller, he suggested that she should sue Hunt for breach of promise, or failing this, make use of the letters and valuable drawings in her possession to bargain with him. Lord Ranelagh's cousin, Thomas Ranelagh Thomson, was present at the interview, and took the opportunity of getting better acquainted with the delectable Miss Miller. Surprisingly, Annie was quite impressed by the gentleman, who was sympathetic to her cause.

Shortly after this, Mrs Stratford called on the unlucky Stephens as Annie's emissary. She made thinly disguised threats concerning the large quantity of letters and drawings of Hunt's that were in Annie's possession. Stephens informed Hunt that it was now a question of blackmail.

For the first time Hunt now took action on his own account, by calling on Lord Ranelagh. Perhaps surprisingly, Lord Ranelagh made no attempt to cover up his relationship with Annie, and freely admitted that she had been his mistress for years. She was simply one of many, and he had never been foolish enough to promise marriage. His attitude to Hunt was quite courteous and understanding.

When he left Lord Ranelagh, Hunt went immediately to Annie's lodgings and confronted her. He asked whether she knew Lord Ranelagh, and when she denied it, he gave her a detailed description of him. Annie then said that a person of that description had been following her about the streets during the last couple of weeks. Hunt left abruptly. On the way out the Stratfords presented him with a bill for several months' board and lodging for Annie Miller.

Hunt was utterly distracted by the day's events. His usual panacea for dismay and frustration was sheer hard work, but he was now sick with worry, and began to behave in a manner that was entirely out of character, spending hours dredging up discreditable material to use against the girl. Stephens was deluged with sordid details, and instructed how to proceed in the battle of wits with her. He was also authorized to approach Annie with an offer of £7 in return for all Hunt's letters and drawings. This was quite useless. Annie had no intention of parting with the material for such a derisory sum. She had other plans for the future. Leaving Mrs Stratford's establishment for good, she went off secretly with her aristocratic new lover: Thomas Ranelagh Thomson.

CHAPTER 13

— ❀ —

The happy bridegroom

ON a raw winter day early in 1861, *The Finding of the Saviour in the Temple* was nearly destroyed by fire at Gambart's German Gallery in New Bond Street. A canopy had been erected to prevent the clothes of the spectators from being reflected in the glass, and in winter when the daylight was insufficient a row of gaslights was used to illuminate it. One day the gaslights set fire to the canopy and it collapsed in flames beneath the painting. The gallery was crowded at the time, but the viewers were able to escape unhurt into the next room. The flames spread fast, however, and there was only one fire bucket whose contents were not frozen. Lady Trevelyan, who happened to be in the gallery, took off a valuable Indian shawl and threw it to a man to smother the flames, a spontenaous act which undoubtedly saved the painting from total destruction. The painting was discoloured in places, but luckily Hunt was able with patient care to restore it to its original condition, and it was back on display within a week.

Hunt was now restless, and eager to return to the East. He desperately wanted a wife to take with him, but was once more confronted with the old problem, that he was interested only in well-born ladies with a degree of refinement. Whenever he found an attractive and agreeable young woman, and outlined his plans for living in primitive conditions in Syria, the young lady invariably deserted him. He had brief flirtations with a number of young women, including Mrs Cameron's beautiful niece, Julia Jackson, to whom he had proposed and, like Woolner before him, been rejected. Julia ultimately married Leslie Stephens, and was the mother of Virginia Woolf.

Hunt's unfortunate efforts at educating Annie Miller discouraged him from ever repeating the experience with another girl of humble

origins. He envied Woolner, who had been courting Fanny Waugh for two years, though he had not yet proposed to her. Hunt often went with him to visit the Waugh family. The two young men were both popular with Mr and Mrs Waugh, as well as with their eight beautiful daughters.

In May 1861, Woolner asked Mr Waugh's permission to propose to Fanny, who was then twenty-eight years old. It was no secret that Fanny was Mr Waugh's favourite, and he was notoriously jealous of her. He liked Woolner, and gave his consent, but knew in his heart that Fanny would turn him down. Events proved him right; yet in rejecting him in her own gentle manner, Fanny begged Woolner to continue his visits, for he had become a dear friend to all the family.

Meanwhile, Hunt was preoccupied with more mundane domestic affairs. Susan, his old servant, was leaving to get married, and he was desperate to find a replacement. Susan had managed the house and done all the cooking as well, the only other servant being a little girl to run errands. He wrote to Mrs Coventry Patmore, asking if she could help him in his search for someone suitable, at a wage of £13 per annum, rising to £16. The outcome is not on record, but a letter to Stephens in January 1865 shows that he was still having staff problems: 'This morning I received a note from an anonymous correspondent informing me that in my absence my servants were playing mass diversions at my establishment, having visitors male and female night and day, females with hats and feathers of a kind highly displeasing to correspondent, it seems rather hard that I should be debarred from the fun . . . Don't say anything for I am laying a trap for them.'[1]

In August 1861, being in great need of rest and relaxation, Hunt went to stay with Richard Monckton Milnes at Fryston Hall, Ferrybridge, in Yorkshire. Other guests, many of whom were drawn from the members of the Hogarth Club, included Richard Burton, the translator of *The Arabian Nights*, Wilkie Collins, and the poet Swinburne, who stayed for a fortnight. While gossiping with Ford Madox Brown, Hunt spoke of having been informed that procuring abortions was an everyday amusement to Gabriel Rossetti. Brown, believing Hunt had named Swinburne as the source of this piece of gossip during their stay at Fryston Hall, felt that Swinburne ought to be restrained from such slander in future. He consulted Edward Burne-Jones, who urged him to tell Gabriel. Brown accordingly blurted out the whole unfortunate tale to Rossetti, who accused Swinburne of slander.

Swinburne vehemently denied the allegation, being prevented only with great difficulty from confronting Hunt.

Up to this point, neither Gabriel, nor Burne-Jones, nor even Brown, doubted for one instant that Swinburne had made the alleged remark. Swinburne, who was of a very inflammable temperament, now threatened to see Hunt and have the matter out with him. All concerned agreed unanimously that such a confrontation should be avoided, and it was therefore decided that Brown should sound Hunt out again to see how he reacted.

To Brown's complete mystification, while Hunt agreed that he had passed on the gossip, he claimed that Swinburne was not his informant. The source was in reality Annie Miller, who had an intimate knowledge of Rossetti's private life, and may even have called on his services on her own account. Swinburne had been unjustly accused, and was entitled to an unreserved apology. Retractions and apologies now flowed freely between the various parties, but not before solicitors had been consulted by all concerned. Brown assured everyone that he had not meant to stir up trouble, and regretted having spoken out, though he felt that he was morally in the right. Gabriel, in the end, was magnanimous about the whole affair, but it was unfortunate that lawyers were consulted in a dispute between men who had once been so intimate.

Hunt now had the canvas for *The Afterglow in Egypt* enlarged to take a life-sized form, and worked intermittently on this picture. At around this time Henry Holiday called on him, and later wrote:

> On one occasion when he was at work upon an Egyptian girl carrying corn upon her head, with pigeons pecking at it, I was struck by the extreme purity of his colour, never a trace of muddiness or opacity, qualities which predominated often to the exclusion of all others in the pictures seen on the walls of the RA, and I said it looked as if he never got into a mess. 'Oh, but I do. Sometimes on leaving work for the evening with a satisfied feeling of having really done something good, I find on coming to it in the morning, not merely that it is unsatisfactory, but that it is so bad that I could deny any Royal Academician to equal it.'[2]

Hunt also completed his small study for Mr Combe, changing it slightly for the sake of variety. Ernest Chesneau, in *The English School of Painting*, wrote of *The Afterglow*: 'I am in the personification of

modern Egypt. In the dull, black eyes, as frigid and lustreless as a lifeless coal; in the ominous stillness, and in these trappings suitable to a slave or a courtesan, I find a symbol of Egypt, deposed from the splendour of her ancient civilisation.'[3]

Hunt was now preoccupied with the International Exhibition in London. His patron, Sir Thomas Fairbairn, who had been a prime mover in the Manchester Loan Collection of 1857, was a guarantor, and came on a long visit to London. Preparations for the exhibition were interrupted on 14 December 1861 by the death of the Prince Consort, and although the exhibition went ahead as planned, an air of sadness clouded the opening ceremony.

Both Hunt and Millais were well represented at the exhibition, and Hunt derived much satisfaction from the public attention given to Woolner's marble busts, which were exhibited for the first time. Morris, Brown and Rossetti exhibited the work of Morris and Co., demonstrating publicly that it was appropriate for artists to be involved in the design and production of furniture and household utensils.

When Sir Thomas Fairbairn was looking for a competent writer to produce a guide to the exhibition, Woolner suggested Francis Palgrave, who shared his house at 29 Welbeck Street, and Palgrave was given the commission. The historic part of *A Handbook to the Art Collections in the International Gallery* was excellent, but Hunt saw at once that Palgrave had severely criticized all the sculptors except Woolner, who received fulsome praise. Woolner's great rival Marochetti was ridiculed for producing a human figure which looked like a round lump of brawn, while the unfortunate Alexander Munro had sculpted a group of figures with eyes like 'squinting cauters', 'the work of an ignoramus, grotesque and babyish'. Yet of Hunt's work he wrote: 'Hunt's pictures burn with a kind of inner fire which extinguishes almost all other men's work; the sun's heat seems within the *Cairo*; the pure crystal day itself in the scene from Shakespeare; the hazy silver of the morn mixed with the stealthy influences of starlight and dawning, and subtle flashings from gem and dewdrop have been harmonised in the *Light of The World*, by we know not what mysterious magic . . .'[4]

Hunt saw at once that he and Woolner were bound to suffer adverse comment as a result of these laudatory remarks. The subject was immediately taken up in the letter columns of *The Times*, by a correspondent who signed himself 'J.O.', who disclosed that Palgrave

was a clerk in the office of the Privy Council. Attempts were made to suppress the guide, but these were unsuccessful. Immediately the letter was published, Hunt realized that 'J.O.' was a giant of a man called Higgins, 6 feet 8½ inches tall, who was a personal friend of the sculptor Marochetti. His principal object in making this attack was to gain for Marochetti the commission to sculpt the statue of Macaulay at Cambridge.

'There is a novelty and vigour in the slang of art criticism in which he indulges which is very remarkable; he does nothing by halves; those whom he praises – and he praises some very obscure people – he praises to the skies; those whom he condemns – and he condemns a large number of very distinguished men – he damns beyond the possibility of further redemption', he wrote. As for the criticism of Munro's work, he commented, 'Pleasant for Mr Munro, is it not? How truly grateful he must be to the Commissioners for having first borrowed the statues for the exhibition and then considerately discovered in Mr Palgrave a critic competent to appreciate them.'[5]

Of Woolner, J.O. wrote: 'There is one on whom he lavishes pages of high-flown praise which would have made a Phidias blush: that sculptor is Mr Woolner . . . The object of this is evidently to fill Mr Woolner's pockets at the expense of his fellow labourers.'[6] Hunt immediately published a reply in *The Times*, saying: 'Mr Woolner and Mr Palgrave, it is true, within the last two months have taken up their abode in the same house. Is there anything suspicious in this fact to any but "J.O."? . . . The public will, I think, regard his attempt to use the interest which he has engaged for this question to the injury of a talented and honourable gentleman in a very different light.'[7]

In publishing this letter, Hunt alienated 'J.O.', Marochetti, and also Landseer, whose paintings had been summarily dismissed by Palgrave. Munro, who was an amiable but sensitive man, never recovered from Palgrave's attack, but crawled away to Cannes and died in humiliation. Everyone criticized by Palgrave now assumed that Hunt shared his opinions, and Hunt suffered as a result. Woolner was probably an innocent victim in all this. Nevertheless, Hunt's popularity in the Waugh family was enhanced, and in due course Woolner won the coveted Cambridge commission.

During the early part of 1862, Hunt finished off his original study for *The Finding of the Saviour in the Temple*, taking a certain pleasure in altering some of the colouring. His sister Emily, having finally forgiven him for the 'Calmuck' incident, was once more installed with

him at Tor Villa, and Martineau still lodged with him intermittently. At the end of May, Hunt was prostrated with a severe attack of bronchitis, which alarmed Emily so badly that she sent for Stephens.

Later in the year, Hunt went to stay with the Lushington family at Oakham Park, Ripley, in Surrey, having been invited by Vernon Lushington to paint his father's portrait. Vernon Lushington had initially decided on a naval career, but had given it up when he witnessed the ill-treatment of the men by their officers. He had then gone to Cambridge to study law, and had become involved with Morris and Burne-Jones in the *Oxford and Cambridge Magazine*. He had acted as unpaid secretary to Carlyle when he was working on *Frederick the Great*, was a friend of the Pre-Raphaelites and was described by Burne-Jones as 'one of the jolliest men I know.'

His father, Stephen Lushington, was then 82 years old, and was a retired high court judge of considerable repute. He had a vast fund of stories and was an entertaining companion. Hunt began by making a chalk drawing, before painting him in oils. 'The good old Doctor has not the virtue of being a steady or patient sitter – he in fact does not sit at all, and I could not wish him to do so for once or twice when I have for a minute kept him in one position his whole expression has become so different that I have not been able to go on,' Hunt wrote.[8]

Hunt was going through a difficult phase with his work. Once again he was suffering from a shortage of 'tin', yet he seemed unable to bring any of his projects to an early conclusion. 'I *can't* get anything finished,' he complained to Stephens. 'I work and work till I feel my brain as dry as an old bit of cork but completion slips away from me.'[9]

As light relief, Hunt was working on a portrait of little Teddy Wilson, his nephew and godson, who was born in 1857. Teddy posed in the garden of Oakham Park, legs astride, in an ermine cloak, like Henry VIII in the famous Holbein portrait. The picture was called *The King of Hearts*. Later, Charles Dogson (Lewis Carroll) recorded a visit to Hunt's studio at Tor Villa: 'I found him at work on the great picture he has been at for six or seven years – an Egyptian girl carrying a wheat-sheaf and surrounded by pigeons. His little nephew was in the room, (the original of the *King of Hearts*, a child dressed up as Henry VIII) and we soon adjourned to the garden for a game of croquet, as it was getting too dark to paint.'[10]

Woolner, like Hunt, was in a mood of black depression, and wrote to Hunt in January 1863: 'I do not know if it be our own faults or the fault of the world, but certainly in some way life is made a hard road

and a bitter draught to some of us. I suppose one ought to be reconciled, and in clear moments I am; but my common feeling is that I have been, after fighting a stiff battle, beaten.'[11]

As usual, he and Woolner were both still desperate to find a suitable wife. In a letter to Palgrave, Woolner wrote: 'Mrs Fairbairn says that she takes more interest in seeing Hunt, you and me well married than in any other friends of hers.'[12]

Seeking relief from this unnatural celibacy, Woolner got himself enmeshed with a poor girl named Amelia Henderson who lived near Regent Street. This was uncomfortably close to George Waugh's sphere of business interests, but in the disappointment of being rejected by Fanny Waugh, it hardly seemed to matter. Gradually, however, as he accepted the Waugh family's continuing invitations, his eye fell on Alice, the youngest daughter. Suddenly he began to want to free himself from all taint of disreputable associations, and asked Hunt to have Amelia Henderson discreetly shipped off to Australia. Hunt quietly made the necessary arrangements, and sent Stephens to see her off, with a golden guinea to comfort her on the voyage.

The health of Hunt's old friend Augustus Egg had been giving concern for some time, and he had for some time been living in Algiers, where the climate was beneficial to him. In 1863, Hunt learned that he had died and been buried in Algiers, and hurried to Wilkie Collins with the bad news. 'He was quite broken down,' wrote Hunt, 'and rocked himself to and fro, saying, "And so I shall never more shake that dear hand, and look into that beloved face! And Holman," he added, "all we can resolve is to be closer together as more precious one to the other in having had his affection."'[13]

Shortly afterwards Hunt received a letter from Dickens in which he wrote: 'The dear fellow was always one of the most popular of the party, always sweet-tempered, humorous, conscientious, thoroughly good and thoroughly beloved.'[14]

Throughout the summer of 1863, the whole country was preoccupied with preparations for the marriage of the Prince of Wales. When the great day arrived, Hunt went to see the decorations. Temple Bar was splendidly festooned with gold and silver tissue, and London Bridge was decorated with masts and crimson banners. Hunt made sketches of the scene, and next day set to work to record them in colour on canvas. Interpreting the crowd with Hogarthian humour, he included himself, the Combes, Millais's father and brother

William, Martineau, Thomas Hughes the author, and Millais's son in the picture.

When it was finished, *London Bridge on the Night of the Marriage of the Prince and Princess of Wales* was exhibited with *The Afterglow in Egypt* in a gallery in Hanover Street. Martineau was also represented, with *The Last Day in the Old Home*. During the course of the exhibition, the Prince of Wales visited the gallery and took a great interest in Hunt's picture. Hunt described their conversation:

'Where is the Princess? Where am I?' he inquired in looking on the motley scene. I explained that the picture only dealt with 'London Bridge by Night on the Occasion of the Marriage', crowded by the mob viewing the illuminations. Looking at it from point to point, our Royal guest asked many questions about it, but suddenly singling out Mr Combe's figure, which I had introduced into the crowd, with face no larger than a sixpence, the Prince exclaimed, 'I know that man! . . . I have seen him in the hunting field with Lord Macclesfield's hounds! He rides a very clever pony about 14 hands high, and his beard blows over his shoulders . . . Yes, I remember, Combe, of course!'[15]

Though Mr Combe usually only bought pictures with a religious subject, he promptly bought this painting. Perhaps it was because the Prince of Wales was so delighted with this little incident that he later agreed to allow the engraving of *The Afterglow in Egypt* to be dedicated to him. The painting itself was sold for 1,300 guineas, exclusive of the exhibition rights and copyright. The money was to be paid in instalments, 600 guineas on delivery of the painting, and the balance by 30 November 1864. On the whole, however, Hunt and Martineau decided that the exhibition was not a success in financial terms, and were not tempted to repeat the venture.

Meanwhile, Hunt was at last making real progress on his portrait of Dr Lushington, and wrote to Stephens from Tor Villa on 25 August 1863:

. . . Before I left town I worked for about three days on Dr Lushington's portrait and made it at last really a creditable work. I *think* it the best painted portrait of modern times, an opinion of more value than it might be because I have an increasing conviction that all the while I am at work in life sized portraits till the very last

that I am a born idiot at drawing and painting on that scale. I am steadily persevering however in the hope of producing a facility in such work – amongst other things I did a drawing of a beauty with strong peculiarities at my last staying place – certainly I did not do it very glibly.[16]

His eccentric friend from Syria, Henry Wentworth Monk, had also turned up again, and Hunt added, 'Monk is here, waiting for the commencement of the seven thunders.'[17]

Monk's arrival only served to stimulate still further Hunt's hankering for the East, and his search for a wife was becoming even more desperate. While staying with the Combes in November 1863 he wrote to Palgrave:

I am ready to give up hunting in exchange for matrimony but as far as I can see I have no choice. Throughout the whole year season after season I never find a single opportunity of speaking a single word to any single young woman . . . I am driven to conclude their fathers and mothers conspire to prevent me from having a single opportunity of making their daughters the victims of my matrimonial designs. You would say I ought to apply to the parents. My reply is I have an instinctive aversion from that course. I should like the girl herself to give me some indication of her interest in me first.[18]

Hunt was almost beginning to face up to the prospect of returning to the East in his bachelor state. He had a long discussion about the journey with Lushington, who advised him to take Boswell's *Life of Johnson* with him, a suggestion with which Hunt was in hearty agreement, for he feared above all things losing his sense of national identity: '. . . The great advantage of it will be in the interest it will give me in my own country and the power of keeping me from becoming an oriental, as many long residents in Egyptian and Syrian latitudes do,' he wrote.[19]

It was also his heartfelt wish not to get mixed up in any fighting this time. Syria was in a slightly more settled condition than in the turbulent days of his first visit: 'I shall nevertheless take a six shooter with me and if necessary draw it – but I hope to God I may not have to fire it at any human being or in any case that if I do it may only be to save life, that is to save other and better lives than that of my antagonist,' he wrote.[20]

On 1 June 1864, Woolner became officially engaged to Alice Gertrude Waugh, who was only sixteen years old. 'Sweet, gentle, self-effacing, although lovely, devoid of personal vanity and jealousy, she was always absolutely unworldly. She was hardly more than a girl at the date of her engagement, but her future husband at that age had realised her nature, and held in true reverence her "lofty young soul",' wrote her daughter in later years.[21]

Carlyle wrote offering congratulations. He and his wife were 'delighted to hear of your getting an eligible young Wife – which we are aware is the crown and keystone of all comfortable *Housekeeping*, and expect will be a very great improvement to you, in that and all other respects.'[22]

The couple were married on 6 September 1864, and once again Hunt found himself standing before the altar in the role of best man. He was in a curious emotional state, and shortly before the wedding, wrote to Stephens:

> I have in fact no intention of matrimony at all now. Two mistakes in a life do not leave a man of my slow nature in that state of faith which is essential to serious love-making with conditions of cold-blooded strategy fixed as they are by fathers and mothers in this day – if you brought a lady to my study and left her with me alone for a day the chances are that I should end by declaring myself in love and be either rejected or accepted – but as it is I have to make my calculations coolly and these do not encourage me to take any such steps. I have not made a reasonable sort of income for the last four years. I have been drawing for the whole of that time upon my capital not of course for a very large proportion of my expenditure but for enough to make it clear that I ought rather to diminish than increase my outlay. My eyesight is not so good as before – my health is not so good as to make me see any long period of life before me. I have already a fixed weakness in my throat which means bronchitis . . . My spirits are not up to the old mark – and so I look forward to the quiet sleep with a feeling of something nearer to contentment than I have for any other prospect in the world. The only thing that disturbs me in this outlook is the evidence that sometimes forces itself upon my attention that my passions still burn within me, and the fear that these, having no lawful hope, should burst out by contact with unlawful tinder into an unholy flame. When I have to reflect on some danger of this only just

escaped I would do much to encourage a legitimate passion, but not anything like the sort of thing Woolner is going through now . . . To be hampered with the arrangements of the family in all my movements for three – four or six months before I married would be just impossible to me. You may say that had I been successful in my suit I should have to be doing this now. Very true! But two or three months experience of a disappointment of such importance makes a difference in one and I am another person now to what I should have been had I met with another fate.[23]

After Woolner's wedding, Hunt went to Burton Park, Petworth, the Sussex estate of Thomas Fairbairn. The object of the visit was to paint a picture of Mrs Fairbairn with the five youngest of her seven children. Life at Petworth was frankly dull, and Hunt was still there in March 1865. In April he returned to London, where Charles Dodgson found him still working on the picture, which was almost life-size. Dodgson suggested a title, *The Children's Holiday*, which Hunt adopted.

Less than a year after Hunt's letter to Stephens, repudiating all thoughts of matrimony, his intentions had completely changed, and he had begun to woo Fanny Waugh. A letter to Fred Stephens, dated 25 June 1865, explains the state of his feelings:

I am making assiduous court to Miss W and I am encouraged by the darling to persevere although she has not yet pronounced definitely in my favour . . . She thought of taking her beautiful self un-embraced to Heaven and she cannot readily reconcile herself to the great change of life I propose . . . I had no choice – by a curious chance – but to tell Mrs W all the history of the A.M. affair. She was shocked beyond measure at it, and at my part in it, really regarding it as very perverse and shameful. Mr W is now ill in bed, he is a good old fellow but awfully jealous of me with his daughter . . .[24]

Hunt was impatient to get matters settled, and complained to Woolner that at the present rate of progress he was unlikely to get Fanny to name the day by the end of the century. Nevertheless, on 18 August he was able to write: 'You will be glad to hear that all is concluded in my favour and my engagement to Fanny Waugh may be spoken of publicly. It makes me more truly happy than I have been for many years . . .'[25]

Stephens now had to admit to Hunt that he had made himself

ineligible to be best man by secretly marrying a young widow, Clara Charles, who was completely illiterate. Undeterred by Hunt's experiences with Annie Miller, he had educated Clara himself, and she could now read and write, and behave properly in company.

On 28 December 1865 Hunt married Fanny Waugh at Christ Church, Lancaster Gate. The service was conducted by the Reverend Richard Maul, with Mr Combe and William Rossetti as witnesses. Hunt's intention was to take his bride off to the East as soon as he could settle one or two outstanding business matters.

Being ruled in all such matters by his head rather than his heart, Hunt was not the sort of man to fall madly in love. But now, matrimony had released the brake on his pent-up passions. Every day that passed he seemed more deliriously happy than ever, and he worshipped Fanny with all his heart. He had reached the pinnacle of happiness, for the days of loneliness were at an end, and it seemed to him that nothing could assail his new-found bliss.

Yet after six weeks of happy married life, Hunt's tranquillity was unceremoniously shattered by a threatened eruption of the Annie Miller affair. In 1863 Annie had secretly married Lord Ranelagh's cousin, Thomas Ranelagh Thomson. Perhaps, finding that Annie was now becoming a nuisance, Lord Ranelagh had paid his cousin to take the girl off his hands. Annie's husband was not a rich man, and, being now pregnant, she was in need of cash. Hearing of Hunt's marriage, she decided to make a further attempt at blackmail. Hunt was totally unaware of Annie's marriage. Under this new threat, he turned once more to the faithful Stephens, who managed the negotiations on his behalf. It seems likely that in the end Hunt paid up for the return of his letters and drawings, which Stephens kept on his behalf, but on this occasion the matter was finally settled, and there were no repercussions.

Ever since *The Light of the World* had gone on public exhibition for the first time, Hunt had been plagued by requests for his autograph. In April 1866 he received such a request from Mrs Lorina Liddell, wife of the Dean of Christ Church. He replied in the formula that he had devised as a means of revenge: 'Having heard of your extraordinary beauty I am exceedingly anxious to obtain your photograph prepaid by return of post.'[26]

In return, Mrs Liddell wrote him a letter full of charm and courtesy, enclosing a photograph, not of herself, but of her daughter Alice, who, though only fourteen years old, was celebrated for her beauty.

Alice had frequently been the subject of photographs by C. L. Dodgson, the shy Oxford don who, under his pseudonym 'Lewis Carroll' had celebrated his friendship with her in *Alice's Adventures in Wonderland*. Hunt replied from Tor Villa on 11 April 1866:

> I am somewhat ashamed at finding that my note of last week – which I wrote without any idea that it would leave the room in which it was dictated – has reached a lady kind enough to deserve a much better one. I can scarcely however profess very sincere repentance for my part in the passing joke seeing that it has procured me a portrait of so interesting and graceful a young lady as your daughter. I make a rule to demand a photograph of each lady that applies to me for my autograph but I am sorry to say that many take no notice whatever of my claim, a fact which leads me to the conclusion that most autograph seekers are very dishonest people – or very indifferent in enthusiasm which prevents me from attending to other collectors as I should do.[27]

Among the paintings which Hunt finished before his departure for the East was the ill-fated *Il Dolce Far Niente* for which Annie Miller had modelled in 1860. Though the elegantly gowned figure and the crimped, reddish gold hair had been virtually finished, the face remained blank. Hunt now decided to use Fanny as a model for the face, though her strong features and dark complexion seem incongruous against Annie's hair. Emily Hunt, who had refused to move out of Tor Villa after the wedding, had begun a picture of the dovecote in their garden, which Hunt had devised for her. She had quickly lost interest in it, and Hunt, who had done nearly all the work himself, decided to finish it before leaving for the East. It was a decision he came to regret, as he told Lear in a letter: 'This pigeon picture each day becomes more of a trial to me. If I had not had to do it I should have realised the £1500 which I find it will be necessary for me to raise before I can leave England . . . The Hanover Street experiment lost me £1000 and the failure of the Consolidated Bank the day after I saw you played the devil with £1083 more.'[28]

In the same letter, he referred to the possibility of a quarantine at Jaffa, and added: 'Fanny is fortunately most heroic in her way of meeting difficulties.'

Hunt and his wife finally embarked on their long and dangerous journey to the East in August 1866. Their departure caused great

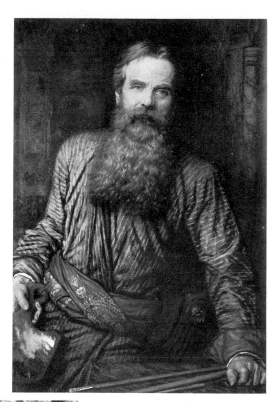

Self-portrait, 1875

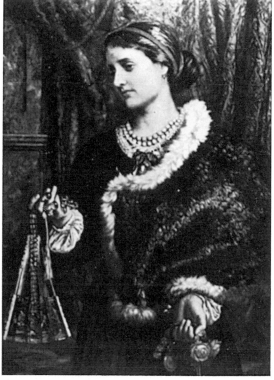

The Birthday (Hunt's second wife, Edith), 1868

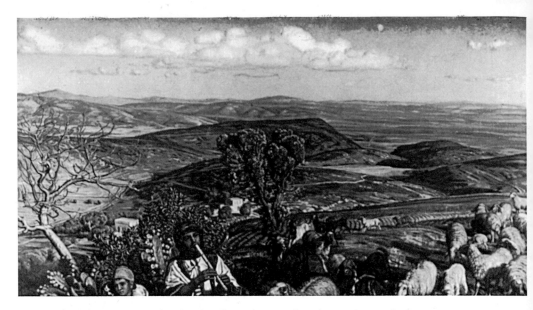

The Plain of Esdraelon from the Heights above Nazareth, c.1876

The Beloved, 1898

First portrait of Hunt
by Sir William Richmond, 1878

The Triumph of the Innocents, 1887

Miss Flamborough (Hunt's daughter, Gladys), 1882

The Tracer (Hunt's son, Hilary), 1886

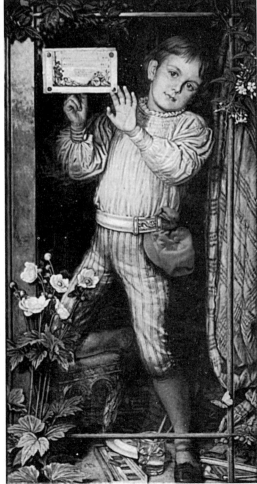

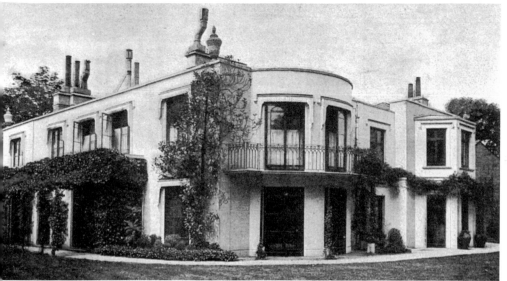

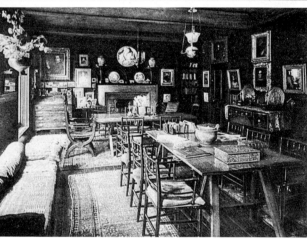

(Top) Draycott Lodge
from the lawn

(Above left) The
entrance to Hunt's
studio

(Above right) The
Dining Room at
Draycott Lodge

(Left) The Drawing
Room

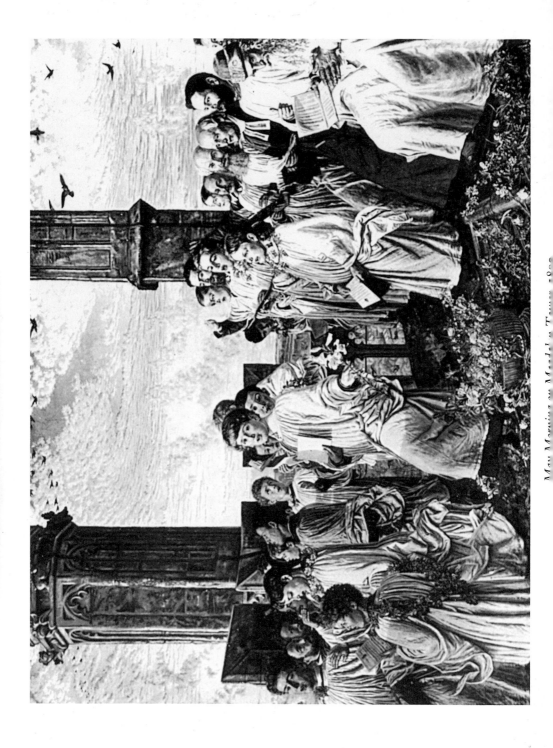

May Morning on Magdalen Tower 1890

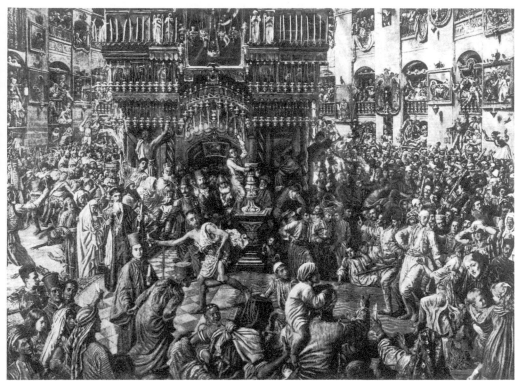

(Above) *The Miracle of the Holy Fire*, 1899
(Left) *The Pearl*, 1890
(Below) Second portrait of Hunt
by Sir William Richmond, 1900

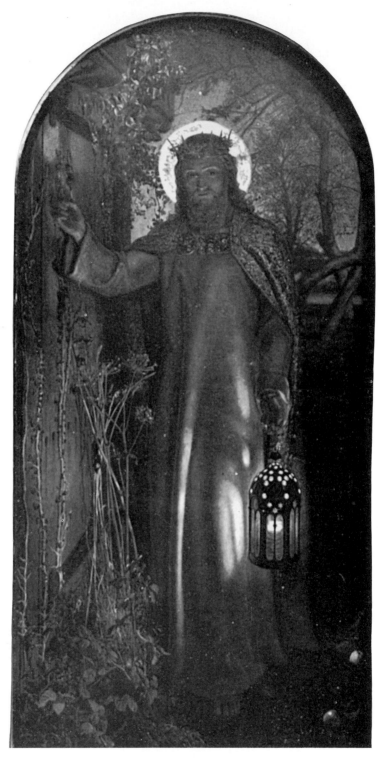

The Light of the World, 1853

anguish in the Waugh household, for Fanny was now five months pregnant. She was, however, a strong-willed young woman, and being deeply in love with her husband, had no intention of remaining in England while he went off without her. The journey was fraught with difficulty. At Marseilles they were unable to take the boat to Alexandria as planned, because of an outbreak of cholera. However, as the secretary of the P & O Line assured them that the next boat would be allowed in, they decide to wait for it. When it eventually arrived, they learned that the ban had not been lifted. Undaunted, they crossed the Maritime Alps to Florence, hoping to reach Egypt via Malta from Leghorn. To their dismay, they discovered that a similar ban had now been imposed at all Italian ports.

There now seemed no choice, in view of Fanny's condition, but to remain in Florence until after her confinement. Having secured lodgings at 32 Via Montebello, Hunt began looking round for a studio, and began work on a portrait of his wife. Posing for the picture placed a great strain on Fanny, who stood for many hours at a time in the merciless heat of an Italian summer.

Despite his love of the art and architecture of Italy, Hunt was unimpressed with its citizens. In a letter to Stephens, he wrote:

These Italians here are not on this slight acquaintance a very satisfactory set, they are the filthiest people I ever knew. Such stinks meet you on the street and wake you up at night that it seems Pestilence must be on the threshold with destruction for the whole city and yet I live in the most cared for part of the town. What do you think of a boy of fifteen or sixteen in the blazing sunlight at one o'clock on Sunday in Kensington Gore say, taking his breeches down for a necessary purpose which he performs while he still goes on with his game of pitch and toss with seven or eight companions some two years older who remain in a circle about two or three yards round him. Then again to an old gentleman of the utmost respectability (Mr P. Wildsmith say) walking across the road at the Duke of York's column and taking down his black cloth breeches for the same purpose.[29]

When Hunt was not painting they scoured Florence for fine pieces of furniture, for glass and majolica, and *objets d'art* to decorate the studio. Hunt felt strongly that an artist should surround himself with

beautiful things, and said that these were in any event bound to appreciate in value.

As October neared its close, Fanny went into labour. She suffered terrible pain, and the danger to her life was so great that forceps had to be used. Hunt reconciled himself to the loss of the baby, a boy born on 26 October, but miraculously he survived, despite severe head injuries.

'If you had seen him within five or ten minutes of his birth lying nestling up in his mother's breast, and moaning in a confiding way, you would have thought that already by some instinct he had recognised her as his natural protector and was complaining of the ill-treatment he had received . . . Poor Fanny has had to lie at the very gates of death many and many an hour. Now I bless God it is thought she is out of imminent danger altho' she is sadly wasted and v[ery] feeble,' Hunt wrote to Stephens.[30]

Nevertheless, on 20 December 1866, exhausted with all her suffering, Fanny died of a miliary fever, to which Florence was especially subject. Distracted with grief, Hunt called the child Cyril Benone, which means 'child of sorrow'. That same day Woolner wrote to Stephens: 'The dreadful telegram has come at last – poor Hunt has lost his angel wife at half past ten this morning and she is to be buried tomorrow evening. I scarcely know which is saddest, to lose one so perfect from this little world we live in, or to think of the deep sorrow the poor fellow will live with for years to come if not for his whole life.'[31]

Stephens called on William Rossetti with the news of Fanny's death. Like a true friend in need, William wrote to Hunt next day offering to leave immediately for Florence if it would be any satisfaction or convenience to him. He replied that he might ask at a later date, though he never did.

The Waughs, in their despair, wanted to take the baby and bring him up in England. Hunt's sister Emily made a counter-claim, and turned her back on him for ever when he insisted on keeping the child near him in Italy. Instead his friends the Spencer Stanhopes, who had settled in Florence, took Cyril in and engaged a wet nurse to look after him.

Tommy Woolner went out to Florence to help Hunt with practical matters arising from Fanny's death and funeral, but nothing could console Hunt, who had idolized his wife. Less than a year of idyllic happiness had passed since he had stood with Fanny before the altar.

'I am alone now – more tragically solitary than ever I knew a man in this world could be,' he wrote to Stephens. '. . . I cannot divest myself of the belief that I am more constantly afflicted than many other men and that such frequent trials are much more than my feebleness can bear . . . I cannot say "thy will be done" and bless God for this affliction . . . It is my one comfort that she loved me beyond all measure, that she valued this affection for me so highly that I was her first thought in the hope that her life might yet be spared to her . . . the still silence makes me dread that she knows all my unworthiness and despises me. I will however gather all my strength to be worthy of her – she shall not see me worse than she knew me if the God in whom I trust will not humiliate me.'[32]

CHAPTER 14

— ❀ —

The lonely widower

'I saw Carlyle at Mentone . . . He was deeply grieved at the terrible loss of poor Hunt and said it contained all the elements of a tragic event,' wrote Woolner to William Allingham on 9 February 1867. '. . . Hunt was plunging deep down into work hoping to keep the hard fixed sorrow at a kind of bay.'[1]

On his return to England Woolner called on Rossetti, who recorded the visit in his diary: 'He says Hunt is much overcome, and greatly wrapped up now in his infant, who seems ominously delicate. He proposes to send it to Mrs Waugh, and to go on himself in course of time to Jerusalem.'[2]

Poor Cyril Benone's tenuous hold on life was threatened by the activities of the wet-nurse, who starved and neglected him. When she was dismissed, she stole a shawl and various articles belonging to the baby. Hunt called the police, and it was then discovered that she had also helped herself to Fanny's valuables, which she claimed Fanny had given to her on her deathbed. Her relatives claimed to be witnesses to the 'bequest', and threatened to kill Hunt if he secured a conviction. As if these problems were not enough, there was an outbreak of scarlet fever in the Spencer Stanhopes' house, and Cyril Benone had to be removed.

Hunt sought relief from his grief by busying himself with his wife's monument, which he designed himself. He also began to combine two pictures which he had painted of Fanny into a single work, *Isabella and the Pot of Basil*. His only pleasure was in the correspondence which he conducted with his friends. On 26 May 1867, he wrote a long letter to Millais, urging him to exhibit at the 1868 Art Exhibition in Paris:

Of late I have been feeling very strongly indeed the responsibility which every man, and especially remarkable and successful men, are under to do the utmost that is possible with their talents, and I believe that for this it is essential that they should know of everything, as far as possible, that others are doing in the same branch of work. Of course you will not suppose that I mean a great man should bother his little life, or any of it, in trying to get medals and twopenny honours in future competitions, but he should see and judge with all his steadiest powers that he is leaving none of his heaven-entrusted talents he has within him unused and uncultivated. All the Italian journals here are speaking of the English pretensions to a place in the Art world as meaner than those of any other nation. It may be concluded, of course, that national prejudice and vanity blind this race of patent geniuses, but at the same time we should have to admit the possibility that our own higher estimate of the English claims may be affected by the weaknesses which influence the Italians; and at this distance, calling upon my memory of the pictures we English painters have produced in the last ten years, I must admit that while in little pictures we have exhibited certain artistic merits not possessed in the same degree by any other country, in seriousness and importance of subject we are far behind where we should be, seeing that we have about eight or ten really great painters, amongst whom J. E. Millais has the highest powers of all. You must not be testy with me that I revert to this subject. Remember that lately I have had many reasons to think of the perennial interests of life. In a few days we shall both be lying in our dark bed under the growing flowers, and the naked soul of us will have no riches that we have not already laid up in heaven; and these must surely be composed of (amongst other things) the intellectual advance which the energy and modest scrutiny of man have enabled him to make in his life on earth. You may say that I should first do something great myself, but I might lose time in waiting.[3]

As time went on, he turned his thoughts again to collecting beautiful things for his studio. Though there was a certain sadness in continuing what he and Fanny had undertaken so light-heartedly together, he knew that he must go on building for the future for the sake of his art and for Cyril Benone. The most important of his purchases that year was a painting which he bought from an Italian family who had lost

197

almost everything they possessed in a disastrous flood. It was called *Madonna and Child with Saints Jerome and Ambrose*, and they represented it as a late Giovanni Bellini. The picture had been damaged by the perpetually burning candle in front of it, but he paid them eight hundred pounds for it and repainted the hands. Hunt was convinced that the picture was worth more than this, and wrote to Stephens, 'If I croak, don't let it go for under a thousand.'[4] The picture was not a Bellini, but turned out to be a good Cariani.

In September 1867 Hunt decided to return to England, taking Cyril with him, and engaged a buxom new wet-nurse to travel with them. *En route* they stayed in Paris, for Hunt was eager to see the Great Exhibition. On arrival Cyril appeared slightly unwell, and Hunt assumed that this was the result of the strain of the journey; but after a couple of days, he appeared positively ill. Cutting short his visit, Hunt decided to go on to London as quickly as possible, and seek the help of the Waugh family.

When Mrs Waugh saw the baby she realized that he was starving to death. A doctor was called in immediately and on examination of the wet-nurse, discovered that she had no milk at all – indeed it was doubtful whether she had ever had any. The Italian was immediately dismissed and sent back to Italy, and a young woman with an ample supply of milk was engaged in her place. Once installed in the Waugh household, Cyril began to thrive at last, and Hunt was free to come and go as he pleased. Among the first of his friends to receive a visit was the ever faithful William Rossetti, who reported that Hunt looked thin and fagged.

During the course of 1867 Millais had renewed his efforts to persuade Hunt to apply for election to the Royal Academy, even going so far as putting Hunt's name forward without asking his permission.

'I am well assured that you put my name down on the Academy list with the kindest intentions,' wrote Hunt. 'I should, however, I must avow, have been unhappy had I been elected, for I should have had to do so disagreeable a thing as to retire after having been elected. Many good friends of mine are in the body, and these would not have understood my objection to remain, and if I stayed it would only be doing violence to my conscience, which will not allow me to see in the institution as at present constituted anything but a power most injurious to the true interests of Art . . . For my own personal interest I know I am unwise in my views. I may lose in professional gains, but I hope to meet with enough success to allow me to do my own work in

my own way; and with this secured to me I have no excuse for considering more about the morrow . . .'[5]

Though Hunt's feelings could not have been clearer, Millais still pressed him to reconsider, and with good reason, for Hunt was again experiencing difficulties in the marketing of his work. He had sold his picture of the pigeon house to Colnaghi's, who attempted to sell it at Christie's in 1867 without success. Hunt now decided to buy it back himself for the sum of £367.10s., because he was worried to see his work changing hands at such low prices.

On 17 January 1868, William Rossetti recorded in his diary: 'Dined at Stephens' with Hunt. The latter has been solicited lately by Millais to stand for ARA. He consulted Brown about the matter the other day, and seems to have made up his mind not to stand on this or any future occasion.'[6]

In his desperation for some tangible link with his wife beyond the grave, Hunt turned to spiritualism. On 11 February William wrote:

Called on Hunt to see his picture of *Isabella and the Pot of Basil*, a work somewhat deficient in beauty, but eminently fine and able. He is doing, for his little boy, portraits of himself and Mrs Waugh (and I think others are to come) – very forcible (not as yet softened down) and painted with brushes of great length, so that he stands a good way off the canvas, and finds he can thus give features better as a general whole . . . Hunt (with Tebbs etc.) went lately to a spiritual seance at Mrs Guppy's. The principal thing was the production (apparently on the spot and in a very short time, but in total darkness) of two drawings, of a griffin, bird and angel and of a crane, sea etc. Hunt says these were certainly good performances up to a certain point – would have done credit to a very clever and competent amateur; and the short time of their production (if really thus produced) beyond what he can account for.[7]

Three weeks later William Rossetti saw Hunt at a party looking very worn and ill, having been told by the doctor that his illness was not asthma, as at first thought, but a recurrence of his Syrian ague, or malaria. On 9 March William dined with the Waughs, and reported that Hunt was looking much improved. The doctor had prescribed tonics, to be taken seven times a day, and advised him to eat meat separately from bread and vegetables.

In the spring, George Waugh commissioned Hunt to paint a portrait

of his daughter Edith, whose twenty-first birthday was approaching. Edith resembled Fanny more closely than any of her sisters, but whereas Fanny had been handsome in a Junoesque way, Edith was young and very beautiful. While Hunt was painting her portrait in the conservatory at Leatherhead, Edith confessed that she had always been in love with him. Suddenly Hunt realized that he, too, was falling in love all over again. On the frame which he devised for the portrait was inscribed a quotation from *Romeo and Juliet*:

> My true love is grown to such excess,
> I cannot sum up half my sum of wealth.

Unfortunately as the English law stood at that time, there was no way in which a man could marry his deceased wife's sister. As the realization came to him that this was a forbidden relationship, Hunt decided that he and Edith must part, and that the subject must never again be mentioned between them. Gambart had bought *Isabella and the Pot of Basil* and had put it on display all by itself. Cyril was in excellent hands with the Waughs, and there was nothing to detain him in England. He therefore decided to put as many miles as possible between himself and Edith Waugh. In July 1868 he left for Florence.

Back in Italy, Hunt painted *The Tuscan Straw-Planter*, and also four water-colours in the hills, principally in order to spend as much time as possible in the pure fresh air. In his studio in Florence, he painted *Bianca*, using a voluptuous American woman, Miss Lydiard, as his model. Beginning in tempera, he traced out the design in light and shade like the old masters, finishing in oil and amber varnish. The result was very striking. Edith got to hear of it, and was consumed with jealousy. In spite of the law, she was determined that one day she and Hunt would be married.

For a while Miss Lydiard was a distinct threat to Edith, though Hunt tended to dismiss the idea. Though he rather played down the importance of his relationship with the American, this was largely out of respect for the feelings of the Waugh family. In fact now that the immediate shock of Fanny's death had receded somewhat, his desire for a wife to take with him to Syria was as strong as ever. Hunt was as diffident with women as formerly, yet he actually discussed the possibility of marriage with Miss Lydiard. When he discovered that she was not prepared to go to Syria with him, even for a short tour, he dropped the idea immediately. The qualities he looked for in a wife

were willingness to accompany him to the East, physical beauty, and social acceptability, in that order. He was not prepared to tolerate a wife who expected to wait for him in Europe. After this fresh disappointment, he wanted only to see the completion of Fanny's monument before returning to Syria.

While he was waiting for the marble mason to complete his work, he went to Naples to see his old friend Dr Sim, and spent a few weeks in Salerno and Ravello making drawings. On his return to Florence, he designed a lectern for his friend W. J. Beaumont, who had been appointed to the living of St Michael and All Angels, Cambridge. Beaumont, who was Cyril Benone's godfather, had asked Hunt to decorate the interior of his church. An artisan was now set to work to make up the lectern, which was to be inlaid with ivory. Sadly, before the lectern was finished, Hunt learned that Beaumont had died of fever while returning from Mount Athos. In the end, Hunt kept the lectern himself.

Hunt had still not been able to shake off the traumatic effects of his bereavement, and he was even lonelier in Italy than he had been in England. In a letter to Mr Combe he wrote: 'I seem like a ghost here wandering about with nothing in common with the people I touch against but an interest in the place I walk in – every man with his wife or children about him – everyone but me.'[8]

Back in England, Clara Stephens had given birth to a little boy. Hunt was godfather, and the child was baptized Holman, though he was always called Holly. To celebrate the birth of his friend's son, Hunt sent a cheque for £13, a most handsome sum, which bound Fred Stephens to him in love and gratitude even more closely than before.

Hunt's interest in collecting art treasures was something which he shared with Tommy Woolner, who had for some time been using his skill and expertise to acquire and deal in paintings and sculptures. Hunt often sought his advice on the subject, and on 17 November 1868 Woolner wrote to him:

The notion of any living person having got a Leonardo is well nigh enough to take one's breath away; but I believe that with a moderate purse, a quick eye, patience, diligence in search, and constant residence in Florence a man might pick up a priceless knot of treasures . . . I should look out for some of those nice little old Florentine bronze figures, that fetch such high prices in London – no one but a sworn collector or millionaire can ever hope to obtain

possession of more than a specimen or two . . . Masaccio is the man I should like to get a specimen by; but this I suppose is impossible! I thought so of Memling a short time back and yet for a not extravagant sum I got two angels by him . . .⁹

A month later came hints of unfortunate disputes with Woolner in a letter from Hunt to Stephens: 'His indignation at my presuming to know more of my own particular subject than he is one of the most ridiculous things I ever heard of – and certainly his course lately has proved to me that he scarcely knows anything at all did I not know how greatly collecting things blinds a man to the faults of the objects he meets.'¹⁰

It is curious, in the light of these remarks, that Hunt fell into the very pitfalls of which he was so conscious. While in Italy he acquired a pair of dark *Miracles of San Rocco* which he believed to be by Tintoretto, but these proved to be copies. Another of his acquisitions, 'Tintoretto's portrait of his daughter Lavinia', was a fake. The most elementary research on his part would have revealed to him that Tintoretto had no daughter Lavinia. In 1869 he bought a drawing of Adam and Eve from a family in Assisi, believing it to be by Mantegna. In the event it proved to be by the most important Sienese artist of the fifteenth century, Francesco di Giorgio Martini.

If the test of a good collector is the ability to identify antiques and works of art and their sources, Hunt was an almost total failure. Undoubtedly he paid far too much for many of the items he bought. But Hunt was not particularly interested in capitalizing on his own powers as a connoisseur. His object was to surround himself with beautiful things that would enhance his life, appreciating steadily in value over the years, as a hedge against financial adversity and an ultimate benefit to his heirs. In this object he was entirely successful, for he had an instinctive eye for beautiful and collectable items.

Meanwhile, progress on Fanny's monument was almost at a standstill, and Hunt in frustration finally decided that he would take up the tools and finish the carving himself. He was still occupied with this work on 16 April 1869, when William Rossetti and Jack Tupper, newly arrived in Florence, called at his studio. Only three days after their arrival, Tupper was taken ill with spasms, and Hunt had to send for the doctor. Next morning, when William was administering the medicine, the unfortunate Tupper was seized with a spasm so violent that both he and Hunt thought that their poor friend was about to die.

By a miracle, he survived the attack, and on 1 May William took him back to England.

In June, having finally completed Fanny's monument, Hunt decided to visit Venice and Rome, before leaving for the East. Quite by accident, he ran into Ruskin in St Mark's Square in Venice. The two men had rarely communicated since Millais married Effie Ruskin. Now, all petty embarrassment was forgotten in their pleasure at seeing one another again. Hunt noted with satisfaction that Ruskin, at fifty, was now more conventionally dressed, though he had not greatly changed in other respects. A valet followed a few paces behind him, carrying a copy of his book, *Modern Painters*. By common consent they took a gondola to the Church of St Rocco. Standing in front of Tintoretto's *Annunciation*, Ruskin took out his book to see what he had said about it twenty years ago, and read the text aloud: 'Severe would be the shock and painful the contrast if we could pass in an instant from the pure vision (Fra Angelico) to the wild thought of Tintoretto. For not in meek reception of the adoring messenger, but startled by the rush of his horizontal and rattling wings, the Virgin sits, not in the quiet loggia, not by the green pasture of the restored soul, but houseless under the shelter of a palace vestibule ruined and abandoned . . .'

When he had read the passage to the end, he turned to Hunt and congratulated himself on the justice of his remarks. Hunt was fully in agreement with him. Together they went through his descriptions of the *Adoration of the Magi*, the *Flight into Egypt*, and the *Baptism*, and agreed that they were as valid now as when he first wrote them.

That evening while dining at Danieli's the two men were in a mood for confidences, and talked with remarkable lack of reserve about their most intimate problems. In matters of religion they could not agree, for Ruskin was an atheist, yet in spite of this they had much to learn from each other. When they went their separate ways a few days later, it was with warm friendship and increased understanding.

In Rome Hunt had another chance encounter, this time with his old friend Captain Luard, whom Halliday had introduced to him in the Crimea. He had left the army to take up art, and Millais had been his guide and mentor. Every day Hunt swam with Luard in the Tiber, though the current was so strong that after struggling for a hundred yards or so they were completely exhausted.

On 31 August 1869, Hunt finally reached Jerusalem again after an absence of nearly thirteen years. Here he took a three-year lease on the

former residence of the Mexican consul, a decaying house in the Muslim quarter, which was in an elevated part of the city. Rumour had it that the house was haunted, but it was spacious and cheap. The entire ground floor formed a stable. The living room was upstairs, and the bedrooms and servants' quarters surrounded the courtyard. There were other rooms above, and an open roof.

Hunt had already decided that his next picture would be of Christ working in the carpenter's shop. While his house was being renovated and its windows enlarged, he went to Bethlehem where he stayed for many weeks, working on the roof in the sunshine. Later he went to Nazareth to paint fresh verdure. From his camp site below the town he had a splendid view of the fields in the valley, which were cultivated by the Nazarene farmers, and of the hills beyond.

When his house was ready, he returned to Jerusalem. In a letter to William Bell Scott he described his house and his way of life:

> You should see how grand I am in my desolate house here; it is about large enough for a family of ten or twelve, and I walk in dismal dignity about the unfriended rooms. Two servants attend upon me, and sometimes a country man or woman is staying here as a possible model. I assure you at first starting, even with my old experience, it required no ordinary perseverence and energy to get to work. The house was the first difficulty, and the model-finding. The difficulties were all the greater to me because I had altogether forgotten my Arabic at first. Little by little I am getting about as forward as I was when I left nearly fifteen years ago, and as I pay well, the procuring people to sit does not promise to be such a bother as formerly.[11]

A handsome Abyssinian called Gabriel did all Hunt's marketing for him, and an old Bethlehemite called Miriam El Megnoona ('the crazy one') kept house for him. Hunt had engaged her for her honesty and for her huge collection of drapes which were useful for modelling, but she had a habit of sweeping up in his studio the instant his back was turned, and rearranging the drapes. Patiently Hunt explained the harmful effect of the dust clouds she raised, but she proved quite incorrigible.

The painting on which Hunt was now engaged was *The Shadow of Death*. It portrayed Christ in the carpenter's shop, with arms outstretched after his toil. His shadow falls upon the wall, where

carpenter's tools are arranged in a rack in the form of a cross. Mary, on her knees as she goes about her work, sees the shadow and realizes its significance.

Hunt went to great trouble to get all the details of the interior accurate, using real tools from Nazareth, and authentic costume, but the work did not go smoothly. He had enormous difficulty with the head of Christ, which was too large. Deciding eventually that he would have no option but to do it again, he found that the proportions were still wrong. He was also determined not to make the mouth of Christ a great yawning gap, as the old masters had done, but he had trouble getting the teeth correct.

All these problems added to his despondency. To Millais he wrote:

Life here wants something to make it bearable. Having no sort of counter-interest, my work becomes the most frightful anxiety to me, and sometimes I am sure I have lost a great deal of labour from nursing all manner of fears about it. When a notion once gets into my head it goes on worrying me until I see everything by its light, and I am tempted to change back again. When I began my work I had very ambitious hopes about it, but (like Browning's man, who in infancy cried for the moon, and in old age was grateful for the crutch on which he hobbled out of the world) I should be glad now to find it only done in any way. There are peculiar difficulties in the subject I have devoted my time to – such serious ones that, had I only foreseen them, I would have left the subject to some future painter; but I tried to console myself by thinking that other pictures I have in my mind to follow will go more easily and be a great deal better.[12]

In May, 1870, Edward Lear, who was in Cannes, wrote to Woolner:

I have had a long letter from Daddy . . . In the last letter I had written to him I find I have knocked my head against a wall; for supposing that he was – as he used to be – of what you and I should call 'advanced or liberal principles' in religious matters, I had spoken about the increase of rationalistic and antimiraculous thought, and hoped his future pictures would paint or express such progress. Whereas, I find that I never made a greater mistake, and that on the contrary, he is becoming a literalist about all biblical lore, and has a

holy horror of Darwin, Deutsch . . . meanwhile if he should paint Balaam's Ass or Gideon's Fleece it would not surprise me.[13]

Increasingly Hunt took refuge in introspection. His interest in the supernatural increased. 'The world into which he believed his Saviour had withdrawn was very real to him, to whom the spiritual was the actual,' wrote one old friend.[14] Religious argument occupied all his thought, and he was preoccupied with the physical problems of the resurrection of Christ. 'Since we are told that condensation of gases in the atmosphere can make a solid body like a thunderbolt, it is competent for us to imagine that His body was resolved into its original elements, to be reorganised at a later time,' Hunt wrote.[15]

Living in the vast house Hunt soon learned why it was thought to be haunted by spirits. At night the wind had a habit of bursting open the casements and extinguishing all the lamps. He kept a loaded gun by his bed, and often had to shoot deadly snakes, or kill scorpions that invaded his chamber as he slept. One night he heard a noise on the stairs, and lighting a candle, went to investigate. To his horror he saw an army of rats advancing towards him.

Though he took all such difficulties in his stride, his real problem was desperate loneliness. Fanny should have been by his side, with Cyril Benone to provide welcome relaxation from the stresses and torments of his work. The enjoyable social life in which he had revelled on his earlier visit had disintegrated. His old friends Sim and Graham had moved on, and Seddon and Beaumont were dead. In the course of 1869 news filtered through to him that Halliday and Martineau had both died. His brother-in-law, George Waugh, was drowned while swimming in the sea in the darkness, only a few yards from a holiday cottage that Stephens had rented. When Alex Waugh went to fetch his brother's body home, he was so ill that the family feared for his life also. With so much grief in his life, it was not surprising that Hunt fell into moods of black depression.

'I am like you in loving my Art very intensely now, the more it seems that I am denied all other love,' he wrote to Millais. '. . . My love for Art pains me – it hurts me sleeping and waking; there is no rest from it . . . If I had my life over again (which offtimes I should crave God for some reasons to spare me) I might (if fools could be kept from hindering), out of the raw materials I started my days with, make a satisfactory painter; but this life is made so that riches and wisdom come too late. The prizes that boyhood sighs for come when toys are

no longer in request; those which youth covets are withheld till youth is flown; and so on to the grave. One must continue one's journey minus the means and weapons which carelessness or over-confidence rejected at one's place of outfit – the tale of the foolish virgins again, who, in going back, came at last too late. One must go on now, trusting that the oil will last to the journey's end, though the lamp may not be so brilliant as it should be.'[16]

A Jew called Ezaak, recruited in Bethlehem, was Hunt's model for the figure of Christ. He quickly attached himself to Hunt and was constantly at his side. When they went on excursions, Ezaak rode like a centaur, with his knees up to the horse's shoulders in the Syrian manner. Together they made a formidable pair.

One day, Ezaak having failed to return after a short holiday, Hunt received a message that he had been arrested for murder. There was something deeply incongruous about his Jesus-model being held on such a charge, and Hunt could not believe that he was guilty of the crime. He accordingly went to the Pasha to find out the facts of the matter, and was given an order for Ezaac's release. When he arrived at the prison, he found that the courtyard was filled with Bethlehemites crying out for the release of their relatives. Hunt handed over the Pasha's order and was incredulous when he was told that there were still certain obstacles, in the form of expenses, to be overcome. Suddenly all became clear. Hunt handed over a gold sovereign, and Ezaak was let out immediately. He was entirely innocent, having been with Hunt at the time when the murder took place, and his arrest was a ploy on the part of a corrupt official to extort money. The crowd of people in the courtyard were on a similar mission, and their relatives were as guiltless as Ezaak.

Miriam 'El Megnoona', in some of her famous drapes, was Hunt's model for the Virgin Mary. She was almost more trouble than she was worth. Once when Hunt was in the WC, she brought a stranger into the house and began shouting for Hunt. In what he referred to as his 'ridiculous western fastidiousness' he did not reply. Hammering loudly on the door for Hunt, she then stationed the visitor with his back to the door of the WC, telling him to wait there until Hunt came out.

Eventually Miriam's loud quarrels with the Abyssinian servant were more than Hunt could stand, and when she took leave of absence without permission, he took her to task severely, and threatened to dismiss her unless these noisy altercations ceased.

A visit from Captain Luard, who was on his way to India, was a welcome break for Hunt, who went to Jaffa to meet him. Luard spent a month with him in Jerusalem, bringing news of the Franco-Prussian War. Hunt gloated over the defeat of the French, and said that afterwards the French at the Consulate no longer made their daily promenade in broad daylight, but came out dejectedly after dark. 'What could be expected from a set of immoral braggarts like the French soldiers against a set of vigorous husbands and healthy lads with honest sweethearts behind them – as the Prussians are,' said Hunt.[17]

Captain Luard was an excellent raconteur, with a fund of stories about the Indian Mutiny. His father, who had been an amateur artist, had served at Waterloo. At the time of the captain's visit, Syria was in the grip of a serious drought, for which the local population claimed that the opening of the Suez Canal, in 1869, was responsible. Fortunately Hunt suffered from no shortage of water, for he had excellent wells in his garden.

Desperate loneliness, and the longing to see his little boy, eventually drove Hunt to write to Mrs Waugh and ask her to send Cyril out to Jerusalem. Edith was only too willing to escort him on the journey, but Mrs Waugh flatly refused to allow Cyril to leave the country. Hunt's thoughts turned again to remarriage as the only solution to the problem. 'I am rather frightened at this idea for to marry a woman near my own age would be impossible,' he wrote.[18]

Nevertheless, he sent a letter to Stephens, asking what had become of Miss Lydiard, the American who had modelled for *Bianca*, who he thought might be a prospect, if still unmarried. To his friend John Bradley, professor at the Royal Academy of Fine Arts in Florence, he wrote: '. . . Though I dearly admire particular women it is only with the staid and unjealous feeling of a painter not with the fervour that at a particular moment makes one ready to leave every place and prospect for the sake of paying one's court to someone . . . At forty-three the "blood is cold and waits upon the judgment".'[19]

Meanwhile, his work was not progressing as fast as he had hoped. To William Bell Scott he wrote:

This picture of mine treats me so severely that I am a miserable slave, with no time for anything but just the attempt to sustain life and strength enough to wrestle with my work, which plays the part of a tenacious foe . . . I thought in the middle of the summer it

would be the death of me. I got but about four hours sleep each day, and these were scarcely any rest, for my feverish anxiety went on through the night, and I dreamed of nothing but newly-discovered faults – of paint drying before it could be blended, of wind blowing down my picture and breaking it, etc. – until my eyes sank so deep into my head, and I became green, and my body seemed such a heavy, stiff and unelastic corpse that I thought the next stage would be coffinward. And now that it is past, people tell me they thought me a doomed man.[20]

Many of the difficulties which faced Hunt in his work were self-created. He was rapidly becoming incapable of taking the simple course in anything. All his life he had been a fighter, and half the pleasure in tackling any subject was in overcoming all obstacles. To Millais he wrote:

The one fact that continually perplexes me is how the confidence of youth carried me through difficulties that now quite bring me to a standstill. I had no fear then of the distant royalty of my mistress [Art], but bit by bit I have learnt the width of the gap between us; and the very sense of her greatness paralyses my hand in attempting the simplest service. It is very imprudent to confess all this, for the world will never believe in anyone who does not have unbounded confidence in himself, and will, on the contrary, accept any humbug who declares himself infallible; but you are not *the world*, but an old fellow-servant, who knows too well what sincere service is to be prejudiced against my work because I confess the trouble it gives me.[21]

When *The Shadow of Death* was finished, Hunt allowed the Pasha to see it. The local people now clamoured for the same privilege, and he finally gave in, admitting them to his studio in small groups. In their simplicity, they begged to be allowed to see the back of the canvas, expecting to see Christ's back and Mary's front.

The completion of this picture marked the end of a period of despair in Hunt's life, and he was thankful to be able to lock up his house in Jerusalem and wend his way towards England. Yet he was so certain of returning before long that he left behind his artist's materials and the sketch for a new picture, *The Triumph of the Innocents*, which he felt would be his most significant work to date. On 21 July 1872 Hunt

shipped *The Shadow of Death* back to England from Jaffa, and made his way to Trieste. The Franco-Prussian war had closed most European routes, but he found his way to Paris, where he was shocked by the damage done by the *Communards*. There was no incentive to remain in Europe amid so much change and devastation, and three weeks after leaving Jaffa he was back on English soil.

Mrs Waugh, accompanied by a servant, brought Cyril to Victoria Station to meet him, without revealing to the boy the object of the visit. Hearing the servant calling Cyril's name, Hunt saw a dancing five-year-old, with long, straight, golden hair, and recognized his son by the blue veins at his temples. Cyril was at first incredulous when Hunt told him that he was his father, but when his grandmother confirmed that this was true, he rode home merrily on Hunt's knee.

Installing himself at 2 Wilton Terrace, Campden Hill, Hunt availed himself of the loan of Millais's studio, as he was fishing in Scotland. Cyril remained with the Waughs at Queensborough Terrace, but every day Hunt took him riding or swimming. The boy, though tall and straight, was somewhat pale, and benefited from these outdoor pursuits and the society of his father.

The Shadow of Death and the first study for the painting were bought by Messrs Agnew for £11,000, payable in two equal instalments. Hunt now had to produce a quarter-size elaborate copy for the engraver. The original painting was placed on exhibition in London and Oxford. It was condemned out of hand as blasphemous by the extreme Church Party, but the Queen asked to see the picture at Buckingham Palace and was so moved by it that she later asked Hunt to repeat the head for her. This was a great personal triumph for Hunt, but what gave him even more satisfaction was that humble working men throughout the length and breadth of the country subscribed week by week for the prints. Several years elapsed before Hunt was able to paint the picture for Queen Victoria. He called it *The Beloved*, and the Queen, who was delighted with it, had it hung in the Chapel Royal.

At the beginning of November Hunt received news of the death of his friend and patron, Thomas Combe. From his early days as a struggling artist, Mr Combe had taken an interest in him that was almost paternal, and Hunt felt his loss deeply. He dropped everything to go at once to Oxford and spend the day with Mrs Combe, and returned there again a few days later for the funeral.

Initially on his return from the East, Hunt in pursuance of his original resolve had steered clear of Edith Waugh as much possible.

During his absence Edith had never wavered in her love, nor in her resolve to win him for herself. Disappointed at being continually shunned, Edith finally wrote to tell him that life without him had been lonely and wretched, and that she would follow him anywhere in the world.

Hunt was flattered but horrified. His decision had been made three years ago, and with the passage of time he had long since ceased to desire Edith. He was still anxious to remarry, and was continually seeking a suitable young woman whom he could grow to love. Worn out with the endless dinner parties, weakened by bouts of malaria, and haunted with guilt about the suffering he had inadvertently brought to Edith, he finally began to consider Edith's continual proposals seriously.

'It saddens me to think how much pain I have cost her,' he wrote to Stephens. '. . . I am unfortunate in having to go to many dinner parties now. I can scarcely bear these but the number of guests forces one to put on a show of bravery, although as I emerge into the street I weep like a whipped child.'[22]

In the winter of 1872 Edith precipitated matters by telling her family that she intended to marry Hunt. Though such a union would be illegal in England, it would be possible on the Continent. This news caused immediate consternation among the Waughs, who summoned Hunt to a family conference and demanded an explanation. George Waugh had been fairly supportive of his son-in-law until this point, despite a nagging belief that Hunt was really responsible for Fanny's death. Now it appeared that this was not enough, and that the man was about to bring shame and degradation to another of his daughters. He refused to have anything further to do with Hunt, and what was perhaps even worse, Tommy Woolner and his wife Alice also turned against him.

One day in April 1873, Charley Collins called to see Hunt and Millais. He had been ailing for several years, and as long ago as 1864, Dickens had expressed the fear that Kate would be left a young widow. Most of Charley's friends assumed that he was consumptive, and he and Kate had lived in the warm climate of the Mediterranean for some time, in the hope that his health would be restored. Now he was suffering from gastric ulcers, appearing noticeably weak and very sad.

Only a few days after this visit, on 9 April, Wilkie Collins was summoned suddenly to his brother's bedside. When Wilkie arrived,

Charley was already in a coma, and died soon afterwards. At Wilkie's request, Hunt took on the melancholy task of drawing his portrait in death. Lying on the bed beside him was the canvas, removed from the stretcher, which Charley had painted at Worcester Park Farm twenty-one years previously, and never finished. It was a powerful symbol of unfulfilled ambitions and talents misapplied. Hunt made a gift of the portrait to Wilkie, who said of his brother: 'His ideal was a high one; and he never succeeded in satisfying his own aspirations.' Dickens's friend John Forster wrote of him '. . . that no man disappointed so many reasonable hopes with so little fault or failure of his own, that his difficulty was always to please himself, and that the inferior mind would have been more successful in both the arts he followed.'[23]

In the months that had followed since Edith's revelations to her family, she had staunchly withstood all their opposition, and had continued to write to Hunt letters of undying love. On 2 May 1873 Hunt received a letter from her which without warning shattered all his expectations. He wrote immediately to Stephens:

> I have got an answer from Edith and it is to say, what do you think? that she cannot be my wife since the law would not recognise the marriage as tho' she had not been writing to me all this while, and had not called me back from wooing elsewhere with the repeated declaration that she did not care for the law when opposed to God's written will . . . I must now try and get interested in some other woman for the disquiet and untrusted longings of this last mistake of mine must go on no longer.[24]

Hunt wondered whether Miss Lydiard, the American lady, might now be willing after all to tolerate a year or two in Syria. Perhaps it was because she got wind of Hunt's intention to look elsewhere for a wife that Edith began to waver yet again. Hunt now made enquiries as to whether they could be married in America, but found to his disappointment that such a marriage would be invalid. Finally on 20 June 1873, Hunt wrote to Clare Stephens, telling her that this time the marriage was definitely on, and asking her to take Edith in if her situation at Queensborough Terrace with her family became intolerable.

The conflict among the Waughs was worse than ever and Edith took advantage of Clare's hospitality. On 27 August word came that Edith's father, George Waugh, had died. Edith had just left the

Stephenses' home in Lupus Street, Hammersmith, and it was left to Clare to bring Edith the painful news. Edith's mother never forgave her. Though Mr Waugh had been ill for years, Mrs Waugh held Edith responsible for his death.

Hunt removed Cyril from Queensborough Terrace, and took refuge with Uncle Hobman at Ewell. Here he began painting Cyril's portrait. However, when news of Hunt's intentions leaked out, the tranquillity was rudely shattered, and Hunt left, vowing never to return. At first Uncle Hobman cut him out of his will, but he was a kindly, sympathetic old man and before long he reinstated his nephew in his heart and his will.

Despite everything that had happened, Hunt seemed in no real hurry for the marriage to take place. In the following year, Hunt painted Edith's portrait, though he complained often that nothing would persuade her to smile. Until they were married, she could not be happy. In the summer of 1875, Edith went to Switzerland, where she revelled in the scenery and busied herself with her sketchbook. She had made great progress since her early childish daubs, done as a girl of sixteen in Kensington Gardens. Now she was able to record accurately with pen or brush the sights that she wished to preserve for future memory. Hunt joined her in Andermatt and Ragaz for a brief holiday from his work in hand. It was not until November 1875 that the couple finally left England to get married. Characteristically Hunt kept putting off the day of departure. He had innumerable boxes of painting materials, etc., which he packed at the last minute. Probably through his own fault, the van which he had arranged through a London firm to collect and transport them did not arrive until after his departure, and as usual Stephens was left to take care of things on his behalf.

Edith, meanwhile, slipped quietly out of England in the company of Dinah Craik, the authoress of *John Halifax, Gentleman,* and her daughter. Mrs Craik was a sister of Hunt's great friend, Tom Mulock, who had died tragically young. They met up with Hunt at the Hôtel du Lac in Neuchâtel. He reported to Stephens that Mrs Craik was always good-tempered and made light of any difficulties. Her little daughter was a 'jolly little puss'.

There was no impediment to the marriage under Swiss Law, and the civil ceremony took place on 8 November 1875. Next day Edith's dream of a white church wedding came true, and afterwards the couple travelled to Berne through a storm of wind and rain to escape

from publicity. They found the Hôtel Belle Vue so comfortable that instead of staying for two days, they lingered for five. Edith so loved the view from the window that she persuaded Holman to draw it for her. When they moved on to Interlaken, Hunt wrote that she had wonderfully recovered her happy looks and appearance of good health.

From Switzerland they went on to Venice, picking up Cyril *en route*. Continuing down the Adriatic coast, they crossed to Alexandria, and finally took ship to Jaffa. It seemed that all Hunt's troubles were now over, and he had reached the happiness that he had always longed for.

CHAPTER 15

—— ❀ ——

Return to Jerusalem

ARRIVING in Jerusalem with his new bride, Hunt was dismayed to find that his house was uninhabitable, and that most of his artist's materials were spoiled. Luckily the sketch for *The Triumph of the Innocents* was intact. Installing his family in a hotel temporarily, he looked for a plot of land where he could build himself a new house with a large studio.

Meanwhile, the cases containing all Hunt's painting materials which Stephens had forwarded on his behalf had not arrived, though Stephens assured him that they had been duly dispatched. Hunt would have gone to Alexandria to buy replacements, but there were rumours of possible attempts to massacre the Christians in Jerusalem, and he was afraid to leave his family. Finally he bought some linen in the bazaar, and used it to paint a small picture, which he called *The Ship*, and as this proved satisfactory, he decided to risk using it for a larger painting. Unfortunately when he pulled it taut, the linen tore, so he had to stop short of the usual tension. Though the texture meant that work on the painting was more laborious, the linen seemed to serve the purpose.

When spring came, Hunt decided to go to Philistia in search of verdure to paint. He was about to set out when he received a telegram to say that a large unlabelled trunk had arrived in Jaffa which might be his. It was too large to carry by mule, the only form of transport. Though he was expecting three boxes, not one, he went directly to Jaffa to inspect it. On 13 March he wrote to Edith that the boxes were inside the case. 'A more profitless expenditure of intelligence than the whole thing both in superintendence and workmanship it would be impossible to find. The case is a marvel of good workmanship with a good lock and *no key to open it*. The screws were numerous and so

215

deeply driven into the wood that had I not been there the too perfect case would have been broken to pieces over and over again. As it was it took me more than an hour to move the lid. I forget how many cases came out of it but there were 28 parcels in addition to cases.'[1]

Next day he wrote to say that his mare had gone lame on the journey, and he had had to walk for at least three miles. He enclosed a cheque for Edith to fill out with the necessary amount for the purchase of their plot of land, but advised her to pay the deposit only at this stage. Edith, meanwhile, had moved out of the hotel and into a temporary house as a surprise for his return. Hunt wrote to Stephens: 'Edith had pluckily broken away from the hotel before all the furniture was ready. The house notwithstanding all difficulties looked very comfortable.'[2]

Three weeks later, Hunt wrote again, breaking the news that Edith was pregnant, and asking for baby clothes. He had now bought three-quarters of an acre of Holy Land, for which he had paid 200 napoleons. 'It is the first piece of this planet except for a small parcel at Highgate Cemetery [his father's grave] that I ever held . . . Edith went with me down to the Jordan – a tent life in the blazing sun of two days and a half. All hard riding and no mistake and she behaved like a heroine.'[3]

On his return to Jerusalem a letter from Sir Charles Dilke finally caught up with him, asking for his observations on the constitution of the Royal Academy, and what changes were needed. Hunt replied: 'The majority of the men in such a body are naturally men who have strained all their interest to become members and having little or no other strength, are interested in outvoting the men of talent who form the minority.'[4]

Hunt said that his remedies would be to limit membership to ten years, no past member being eligible for re-election; that the duties should be to analyse artists' materials and guard against adulteration, and to manage the schools, appointing a supervisor in the full vigour of his faculties; that elections should be made not by the body itself but by every exhibitor of three years' standing; and that the title should signify simply that the person was an important and respected member of his profession.

Sir Charles Dilke was so impressed by Hunt's observations that he sent him a little volume of his parliamentary speeches, with a letter of warm appreciation. In thanking him for the book, Hunt elaborated on his own experiences in a damning indictment of the Royal Academy:

The Institution would not allow me as a boy to make my own efforts. I had no intention of warring with it. I merely wanted to try my way – if I failed the penalty would be mine, and that of those who with me made the assay. Sixty men rose up against me. Sixty grown, established, and influential men used every art they had to ruin me. They courted the press to help them, they spoke against me at dinner tables, they delivered lectures on purpose, they damned my works with faint praise, they used their arts to separate fellow workers from me when they found that which we did could not be stopped, but in the meantime there is no saying what the difficulty to which they reduced me was in extremity – had not a good friend come in an unexampled way, lent me money I should have had to emigrate as a farmer . . .[5]

Now that Hunt had good, strong canvas from England, he should have begun *The Triumph of the Innocents* again, but he was unwilling to waste several months' work, and so decided to persevere with it. As soon as the plot of land had been purchased, Hunt engaged a German builder, who constructed a house to Hunt's specifications. They were soon able to move in, but when the rainy season began, water poured through the ceilings, and the precious picture had to be protected with tarpaulins.

When things were restored to normal, a party of local women asked to see the studio, and Hunt agreed. They were delighted with his lay figure, and asked him to explain the full significance of the picture. He was greatly impressed by the questions. Until that moment, it had never occurred to him that Arab women could be intelligent.

On 20 September 1876 Edith gave birth to a baby girl. Hunt wrote to Brown: 'There is a delightful little daughter born to me, who is the admiration of all who have seen her . . . At first she was like Socrates but now she is exactly like Tintoretto. She has a thick soft brown wig which it is quite a pleasure to rub. She has blue eyes, is as fat as ripe fruit, is as solid as apples, and has beautiful hands. I delight to add that my dear wife bore the shock bravely, and that she is now getting quite herself again. Cyril delights in his sister . . .'[6]

The child was called Gladys Mulock, the second name being a compliment to her godmother, Dinah Craik, née Mulock who had accompanied Edith to Neuchâtel for their wedding. In the following year he wrote to Brown again, describing his difficulties in registering Gladys's birth:

> Although I regard Christianity as the best system for the training of the world I regard its priests in a body as most pernicious in their exercise of authority . . . Men in authority are so sure to dogmatise and tyrannise I love therefore all resistance and freedom. I am in a row now which will probably be published in the newspapers about the refusal of the English Consul here by instructions received only three months before to register my baby as a British subject. It was probably the same fanatical official who got the order passed that I and other offenders against the table of prohibited affinity in marriage should be punished by this impression of their condemnation.[7]

Realizing that a foreign national who had married his deceased wife's sister could become a naturalized British subject, and that the marriage would be recognized as valid under English law, Hunt now proposed that he and Edith should change their nationality, and then become naturalized British subjects. This he was told, however, would not be permitted, on the grounds that he would be denaturalizing and renaturalizing himself in order to break the law of his original country.

On 15 January, 1877, *The Times* announced: 'Mr Holman Hunt is making good use of his newly-built studio in Jerusalem in preparation for the important picture which is to occupy all his energies.' The source of this little item of information was Hunt's friend Stephens, still loyally serving Hunt's interests by keeping his name before the public.

Early in the new year Hunt planned to leave his new studio for a while and ride out in search of the genuine Emmaus, partly in response to a query from Brown, and partly for his own satisfaction. 'I always like to gather what is known of any question which my pictures may raise that I may be prepared to prove to the knowalls that the course adopted in its treatment was not altogether from grovelling ignorance or stupidity but from considerations which in my mind I preferred to regard as weighty,' he wrote to Brown. 'I send you my scribble merely to put you into the position for meeting the cackling geese of the Art World.'[8]

Meanwhile, however, the political situation seemed to grow more serious every day.

> I feel that the whole of Europe might be in war one state with another or with Turkey before I know it. I have too much at stake

here to be cautious until this is proved to be necessary and while I hesitate I feel I may be cut off in my retreat with my family. If I knew that war were coming I should take my wife and son and daughter to Italy and return here to work alone until I could see something settled but this would be losing all chance of appearing this season in the Exhibition World. My notion of British policy in the East is that it is stupid and wicked . . . The Turk is an utterly hopeless protégé, he is an incurable devil of indolence cruelty and dishonesty with the most plausible tongue in the world. The *notion that he could be driven* out of Europe *is a delusion.* I am thoroughly persuaded it is based upon the notion that Arabs are Turks. The first could not of course be expelled but nobody should wish to get rid of him for he is the one sufferer of all others from the Turkish rule.[9]

Hunt's idea of the solution to the problem would be for the British Government and its allies to transport an army of some 4,000 men by sea to Syria and march on Jerusalem. In his view, the capital would capitulate with scarcely any resistance. A letter to Stephens written on 1 February 1877 indicates that fears for his family are still uppermost in his mind: 'We are full of consultations now as to the flight we are likely to be obliged to make. I have been sticking to my work like a slave foreseeing some such finale but I have not got the principal work forward enough to be taken away . . . Our Government and Consul are too idiotic and idle to have any instructions to give but the tenor of the advice from the Government will help me to see whether to make our start at once or to wait and see a new crusade. If I go it will be to place my wife, and Cyril, the baby and nurse with Mr Himmelruck at Malta. I shall go as far as Alexandria and then hurry back to guard my pictures.'[10]

Edith and the children remained in Jerusalem until early May, when Hunt sent them to Jaffa. Shortly after her arrival there, he wrote to her: 'I am very comfortable in the thought that you [are] away from here for although I think it probable nothing will occur in the nature of an onslaught against the Christians, I am sure it is by no means a complete impossibility.'[11]

His letters were full of practical advice. He suggested that it would be prudent for Edith to wean Gladys, in case her milk supply dried up, and warned her of the danger of fleas and lice. 'Red precipitate of Mercury, a powder, like vermilion, rubbed into the skin is the sovereign remedy,' he wrote.[12]

A few days later he wrote to her: 'While it is safe I am much more content that you should be at Jaffa rather than in Italy for one thing because the journey to that place with you and the showing you the delights of Naples I look to as a special pleasure in our honeymoon which I don't consider half finished which in fact I intend shall never finish.'[13]

For Hunt and his wife the honeymoon never did end. Whenever they were apart, he continued to write to Edith in terms of romantic endearment for the rest of his life. He addressed her as 'My dear One', 'Darling Contentment', or 'Darling Wife', and signed himself 'Your devoted lover Holman'. From the very beginning their marriage brought him immense joy and deepest satisfaction. Edith was a woman of remarkable courage and strength of character. She was in every sense of the word a true helpmeet to her husband, taking over all those trying little details of daily living that had so irked him and distracted him from his work. She had the good sense never to attempt to interfere with his painting, though in other spheres she tended to rule him. He was, in fact, somewhat afraid of her displeasure, and was mostly content to go along with her wishes. Although as she grew old she became somewhat eccentric, she remained unswerving in love and devotion to her husband. They were like happy children who walked hand in hand through the world, even when they reached old age.

Though the dreaded attack never materialized, Hunt had great problems with his work. The centre of the canvas was so irregular, that he had great difficulty with wrinkling of the cloth. Rumours reached England that he was seriously ill. On 22 October 1877, *The Times* printed a denial: 'The story that Mr Holman Hunt has been suffering from 'black fever' (whatever that may be), if we are to understand that he has experienced a recent severe attack of illness of any kind, is not true. At least, the artist is not aware of the attack. He has suffered greatly from the dangerous illness of his little daughter, which has delayed his return to England.' The paragraph was signed 'Athenaeum', Fred Stephens's usual pseudonym.

Gladys was twice at death's door. The doctor diagnosed inflammation of the stomach, and unfortunately just as the condition was beginning to clear up, a careless servant gave her some bad soup which started it up again. Incredibly, as she began to progress towards normality, another servant gave her figs and other fruit, with disastrous consequences.

Meanwhile, as Hunt's difficulties with the picture increased, he

blamed the unlucky Stephens more and more as the author of his misfortunes. But for his blunder in enclosing his boxes in a single giant case, he maintained, his materials would not have gone astray, and he would not have used local linen. For nearly thirty years Stephens had patiently run Hunt's errands for him, even when they brought unfortunate consequences to himself, as in the Annie Miller affair. He did not forsee the delay that would be caused by his minor deviation from Hunt's instructions. Hunt failed to see that he had only himself to blame for rashly using local linen for such a large and important work of art, and for persisting with the linen when it became obvious that it was unsuitable. Perhaps most important of all, had it not been for the flaw of unpunctuality and procrastination in Hunt's own character, he would not have departed without personally supervising the dispatch of his impedimenta in the first place.

Despite his denials about the state of his health, Hunt was in fact continually beset by various ailments. Towards the end of November he was crippled by a large carbuncle on his left leg, which the doctor lanced when he visited Hunt on 21 November. With his anxieties about his painting bordering on the neurotic, his health broke down in the early months of 1878. As his condition began to improve, he decided to take his picture to England, and see whether a picture liner could remedy the problem of the wrinkling canvas. On 22 March 1878, *The Times* reported: 'We are glad to announce that Mr Holman Hunt is in a fair way of recovering from his late illness. He will return to England at Easter, and will bring with him an almost completed picture which will be the most important work he has yet produced.'

Hunt thus returned to England with only one half-completed picture to show for two and a half years' work. He and Edith took up residence temporarily at 5 Berkeley Gardens, Campden Hill, and on 19 May 1878, gave their first dinner party. The guests were William Rossetti and his wife, William Bell Scott and Hunt's nephew and godson, Teddy Wilson. Fred and Clara Stephens were not invited because they were still on holiday. Scott recalled the occasion in his memoirs:

The dear, serious, successful and yet in some degree disappointed man I found, after his long absence, the same as ever. No change could possibly take place either in his art or himself, except the change of years: on myself I could not detect the effect of advancing age, but I saw it on all my friends . . . He was more than ever an

221

anxious man – spoke of going again for a month or two to the East to finish his picture; meanwhile he had taken a studio here, and began struggling with certain difficulties resulting from the canvas, a Syrian cloth, on which he unfortunately began his picture.[14]

Not long after his return, Hunt received a letter from his old friend Lear, reminding him of old projects, and replied:

Ah the Tennyson illustrations! how they take one back – 27 years by Jupiter! when we neither had a gray hair – and there seemed plenty of time for regenerating oneself and the world by display of powers yet unknown . . . It used to strike me as very preposterous that while I met scores of millionaires – male and female who rightly or wrongly glorified my works as a sort of revelation from Heaven I was at the time wearing away my powers in doing miserable pot boilers sitting up half the night scraping glittering copper to illustrate some rubbishing book.[15]

During the months that followed, Hunt finished a picture of Nazareth, overlooking the plain of Esdraelon, for the new Grosvenor Gallery, founded by Sir Coutts Lindsay, an artist with a large fortune. The building was to be 'an entirely independent picture gallery, where distrust of originality and imagination would not be shown, delicate workmanship would not be extinguished, and the number of pictures exhibited would not be too large for the wall-space.'[16] All pictures would be hung where they could be seen, care would be taken to hang pictures in a favourable light, harsh contrasts of style and colour would be avoided, and there would be no ordeal of passing a committee.

Ruskin criticized the new gallery on the grounds that the upholstery was too bright, and the lighting unsuitable, but it was a great success with the public, and on Sundays and private view days it was always crowded. The Prince of Wales was often to be seen there, and this alone was enough to ensure its popularity. It was the kind of gallery that the Pre-Raphaelites had always dreamed of, yet, surprisingly, they made little use of it. Millais, safely established within the Royal Academy, had no need of other outlets. Hunt was eager to exhibit, but had only minor works ready. Edward Burne-Jones, like Hunt, was happy to submit his work, but surprisingly Brown declined. So, too, did Rossetti, though Burne-Jones wrote hoping that he would change his mind: 'I should have liked a fellow-martyr – that's natural – as it is I

shall feel very naked against the shafts, and as often as I think of it I repent promising, but it doesn't really matter – the worst will be temporary disgrace, and one needn't read criticisms.'[17]

The succession of paintings which Hunt exhibited at the Grosvenor Gallery included a portrait of his son Cyril, *Amaryllis* and *Miss Flamborough*. He also exhibited his portrait of Sir Richard Owen, described at the foremost man of science of his day, wearing the robe of Harvey, who discovered the circulation of the blood. *The Times* described the picture as 'perhaps the finest portrait in the Gallery among so many that are very fine . . . The flesh of the face is that curious reddish yellow with purple shadows in which the artist delights, and it is painted with all the sculptured accuracy that is familiar to us in Mr Hunt's religious subjects.'[18]

In the meantime, however, his problems with *The Triumph of the Innocents* were increasing, the picture-liner having failed in his attempt to straighten the canvas. With these anxieties preying on his mind, he went on a visit to Paris, and as a result, caught typhoid, which brought him near to death. But for the timely intervention of Sir William Gull, he would probably have died. Stephens wrote to inform Millais of his condition, and he replied: 'I am very much grieved to hear that my dear old friend Hunt is stricken down with so serious a malady. Please let me know how he goes on, if we may not send ourselves to enquire. He has had a good innings of health, and I am not altogether surprised to hear of the attack. I myself very nearly died of the same fever some years ago, when Gull also attended me . . . Let me know soon of Hunt's state, and tell his wife how sincerely I sympathise with her in her anxiety.'[19]

As it was, the illness laid him up for ten weeks, and he was then forced to take a recuperative holiday, before being fit to resume his interrupted work. For a while he went to stay with Dinah Craik and her family at their home in Bromley, and made the children laugh with his stories of life among the Arabs.

When Hunt eventually returned to the studio, he was assailed with doubts, and asked Millais to come and look at his picture, to help him decide whether or not he should abandon it. Millais was shocked at the condition of the canvas, but knew someone who he thought could repair it. Hunt duly sent the picture to this man, and was initially quite pleased with the result, continuing to paint on it for another eight months.

He now began to be increasingly obsessed with the notion that he

was being persecuted by the Devil, who, aware of the Christian message in his picture, was determined to prevent him from finishing it. This obsession reached a climax at Christmas 1879, as he explained to William Bell Scott:

The story about the unaccountable noise, you will remember, I gave as an illustration of the degree to which the difficulty with my picture has distressed me. For four years this torment has been going on, wasting my life and health, and powers, just when I believe they should be at their best, all through a stupid fit of temper on the part of a good friend. I don't like to hold him responsible, although his agency caused the beginning of my difficulties, but I have got into the way of thinking that it is one of many troubles during these seven years (balanced by much joy of my last four years) which the Father of Mischief himself only could contrive. What I told you is only a good story, as my impressions give the experience. It is not evidence, remember, one way or the other, although I give the exact truth. I was on Christmas Day induced to go and work at the studio [7 Trafalgar Studios, Manresa Street, Chelsea] because I had prepared a new plan of curing the twisted surface, and till I could find it to be a practicable one, it was useless to turn to work when I had engagements to take up on the following days. When I arrived it was so dark that it was possible to do nothing, except with a candle held in my hand along with the palette, I laboured thus from about eleven. On getting to work I noticed the unusual quiet of the whole establishment, and I accounted for it by the fact that all other artists were with their families and friends. I alone was there at the group of studios because of the terrible and doubtful struggle with the devil, which, one year before, had brought me to the very portals of death; indeed, almost, I may say, beyond these, during my delirium. Many days and nights too, till past midnight, at times in my large, dark studio in Jerusalem, had I stood with a candle, helping to surmount the evil each hour, and the next day I had found all had fallen into disorder again, as though I had been vainly striving against destiny. The plan I was trying this Christmas morning I had never thought of before the current week, but it might be that even this also would fail. As I groaned over the thoughts of my pains, which were interwoven with my calculations of the result of the coming work over my fresh preparation of the ground, I gradually

saw reason to think that it promised better, and I bent all my
energies to advance my work to see what the later crucial touches
would do. I hung back to look at my picture. I felt assured that I
would succeed. I said to myself half aloud, 'I think I have beaten the
devil!' and stepped down, when the whole building shook with a
convulsion, seemingly immediately behind my easel, as if a great
creature were shaking itself and running between me and the door. I
called out, 'What is it?' but there was no answer, and the noise
ceased. I then looked about; it was between half past one and two,
and perfectly like night, only darker; for ordinarily the lamps in the
square show themselves after sunset, and on this occasion the fog
hid everything. I went to the door, which was locked as I had left it,
and I noticed that there was no sign of human or other creature
being about. I went back to my work really rather cheered by the
grotesque suggestion that came into my mind that the commotion
was the evil one departing, and it was for this I told you the
circumstances on the day of your visit. I do not pretend that this
experience could be taken as evidence to support the doctrine of
supernatural dealings with man. There might have been some
disturbance of the building at that moment that caused the noise
which I could not trace; indeed, I did not take pains to do this. Half
an hour afterwards I heard an artist, who works two studios past
mine, come up the stair, and before he arrived by my door he said to
someone with him, 'It is no use going in, it is as dark as pitch,' and
they went down again. This was the only being that came to my
floor during my whole stay, which was till three thirty. I perhaps
should have taken more pains to explain the riddle, but while I quite
accept the theory of gradual development in creation, I believe that
there is a 'divinity that shapes our ends' every day and every hour.
So the question to me is not whether there *was* a devil or not, but
whether that noise was opportune, for I still hope that the wicked
one was defeated on Christmas morning about half past one. Thus,
you see what a child I am![20]

Scott further explained: 'The friend he alludes to in his letter was his
friend of many years, F. G. Stephens, who had simply made the mis-
take of using too large a box, which he jocularly called Goliath. This
large box could not travel by any means of transit known to the stony
roads in Palestine; its address and key had both been lost, and it was laid
away at the seaport till by accident Hunt saw it after nearly a year.'[21]

Early in the new year, Hunt heard again from his old friend, Henry Wentworth Monk, who had spent his whole life trying to found a new 'Society of the Faithful' to own and inhabit the Holy Land. Monk now sent Hunt a copy of a circular letter, urging him to give one tenth of his possessions to a fund to purchase the sacred soil. Hunt declined, but Ruskin, who had been visited by Monk, had signed a declaration of his intention to do so. When Hunt heard what Ruskin had done, he persuaded him to withdraw from the scheme.

In February 1879 the Hunts moved to a more suitable house at 2 Warwick Gardens. Among its advantages was greater proximity to the Stephenses' home in Lupus Street. Hunt was full of solicitude on the Stephenses' behalf. While they were still in Syria, Clara had been seriously ill, and Hunt had suggested that she should come out to them for a holiday. Soon after his return to England, he had noticed that Fred had been unwell, and offered to pay for him to go on holiday. Now, he remarked that he thought Clara needed a holiday, and offered to put her up for a while so that she could have a complete rest from domestic responsibilities.

Unaccountably, however, Hunt's attitude began to change. His neurosis about his picture was now so extreme that his anger against Stephens and the box named Goliath increased. He had now developed what amounted to a persecution complex, and saw the unfortunate Stephens as one of those who campaigned for his downfall. Nothing could have been further from the truth. For thirty years Stephens's regard for him had amounted almost to worship. Hunt had shared with him all his intimate secrets, and Stephens had without complaint carried out innumerable commissions for him, many of them causing him acute embarrassment.

Edith ought now to have discouraged these absurd fantasies, but she was a jealous woman who tended to resent her husband's close relationship with his old friends. For many years, Stephens had been the most important of these, more so even than Millais, who loved Hunt as much as ever, but was separated from him by his life-style, his success and his geographical remoteness. Despite the personal kindness and support she had received from Fred and Clara, especially in the dark days before her marriage, it now suited Edith to foster, rather than to discourage, her husband's suspicions regarding Stephens.

Matters came to a head after the birth of Edith's second child on 6 May 1879, a boy baptized Hilary Lushington, his second name being a

compliment to his godmother, Jane Lushington. Stephens sent Hunt a cheque for thirteen pounds to be used for Hilary's benefit. Hunt, who had sent exactly the same sum for Stephens's boy Holly, interpreted this gesture as a deliberate slight because of the secret grievance which he imagined that Stephens had against him. Stephens, wounded by this suggestion, immediately returned the thirteen pounds that Hunt had sent for Holly. At this stage Hunt seems to have paused for thought, realizing that their longstanding friendship was crumbling. He invited Stephens to take the money back, and when he refused, he passed the £13 to Henry Wentworth Monk as an investment for Holly in the Kingdom of Heaven. Stephens accused Edith of stirring up Hunt against him, and probably this was true. Edith could be a tigress when angry, and never more so than when she thought that her influence with her husband was threatened.

Life was not altogether untroubled among the members of the Hunt household either. In the early days after Fanny's death, Edith had clung to Cyril Benone and lavished her love on him as the one sure link between herself and Hunt. Theoretically the transition from loving aunt to stepmother ought to have been smooth, but in fact Edith soon became jealous of the relationship between Cyril and her husband, and was relieved when he was banished to boarding school. Gladys adored Cyril, who was a hero in her childish eyes, and never stole the limelight from her. She was the pet of the entire family until the arrival of Hilary, and she never got over her jealousy of him. As they grew older, they quarrelled continually, to the annoyance of both their parents, who in reality loved them both.

In the early months of 1881, Edith was occupied with a creative project of her own, a little book which she wrote and published under the title *Children at Jerusalem: A Sketch of Modern Life in Syria*. A picture by the authoress of the interior of an English home in Jerusalem formed the frontispiece, and the dedication read:

To Our Children
Cyril Benone Holman Hunt
and
Gladys Mulock Holman Hunt,
I Dedicate This Book
In Remembrance of Many Hours, Sad and Happy
Grave and Gay,
Spent Together in Jerusalem.

In the autumn of 1881, Hunt bought Draycott Lodge, a large, old-fashioned house, at Fulham. It was a fine, Regency house with a distinguished history, having once belonged to Horace Walpole. In a letter to his mother dated 31 October 1881 shortly before they moved in, he wrote: 'She [Edith] is now incessantly busy in arranging the new house – we have moved all our stores into it and she is quite longing to see all our long hidden treasures in their proper places – They will we think look quite magnificent.'[22]

The large, intercommunicating rooms of Draycott Lodge gave a wonderful feeling of spaciousness. Soon they were decorated with William Morris wallpaper, and Hunt's Italian Old Master paintings looked down from the walls. Sumptuous carpets, a relic of his visits to the east, covered the floors, and Jacobean four-poster-bed hangings, which decked his ornate cabinets, were a reminder of the Pre-Raphaelite interest in embroidery. The furniture and *objets d'art* all represented Hunt's highly personal choices. His taste was truly eclectic, yet it was Edith who organized them into a home of dignity, elegance and charm. Though she was inclined to be a hoarder, her husband's opinions disciplined her into keeping everything in order. She prided herself on her ability to manage with the minimum of domestic help, and made strict rules of behaviour designed to lighten the burden of work which she posted up about the house.

While Edith organized their home, Hunt was once more free to concentrate on his work. Obsessed, as always, with accuracy, he tried to buy the carcass of a donkey at the knacker's yard, so that he could assemble the skeleton in his studio. Being unable to get a donkey, he had to make do with a horse, which was hacked into enormous joints and delivered to his house in a cart. These gruesome hunks were carried through the house, leaving a grisly trail on the precious carpets in the parlour, and laid out on the grass in the back garden.

Next, Hunt bought some bricks and an old copper from a building site, and with Edith's help, trundled them through the streets of Fulham on a barrow to his home. Having put as much of the meat as they could in the copper, and covered it with countless jugs full of water, they began the grisly task of boiling all the meat from the bones. It rained incessantly, and damp wood kept putting out the fire. The stench was appalling, and after several days of fruitless remonstrances, a neighbour called the police, which caused aggravation and embarrassment all round.

Finally the skeleton was reassembled in the studio. The whole

exercise was singularly pointless, for the figure of the donkey was largely concealed by the figures of the Innocents. Valuable time was once more lost, and Hunt remained as neurotic as ever. At this stage a failure in the picture-liner's work revealed itself. The soft composition over which he had smoothed the wrinkled linen gave way. Eventually he decided that the only sensible thing to do was to start all over again, this time using new and sound English double canvas. Hearing of his problems, Millais came to his studio and gave him a hand. This was a great psychological boost, reminding him of the days of their youth, when they helped each other out, working side by side in Gower Street. After this he worked on steadily, and soon the great painting was nearing completion.

On 9 April 1882, Gabriel Rossetti died. His health had been undermined when his wife, Lizzie, died of an overdose of laudanum twenty years before. Chronic insomnia had led him to take ever increasing doses of chloral, and in 1872 he had had a breakdown so serious that his brother William had written: 'On 2 June 1872 I was with my brother all day at No. 16 Cheyne Walk. It was one of the most miserable days of my life, not to speak of his. From his wild way of talking – about conspiracies and what not – I was astounded to perceive that he was, past question, not entirely sane.'[23]

Though he had recovered from his breakdown, he was never again in robust health, and drug and drink dependency finally resulted in renal failure. In times of lucidity he had possessed all the old magic, but his final years had been marred by quarrels with most of his dearest friends.

When he had heard of Gabriel's failing health, Hunt, whose bitterness towards Rossetti had vanished with the passing years, contacted William and asked whether he felt that a visit might be welcome, but in view of Gabriel's violent changes of mood and temper, William advised against it. Now that this friend of his youth was gone, Hunt felt unutterably sad. To Scott he wrote:

Rossetti's death is ever on my mind, for all my old thoughts turn up in order to be fresh marked with the painful fact. I had long ago forgiven him, and forgotten the offence, which, in fact, taken altogether, worked me good rather than harm; indeed, I had intended in recent times to call upon him, but the difficulties arising from my Jerusalem canvas had already humiliated my spirit so much, that when the visit was in question I felt the need of

conquering the task before I went, and awakened memories of early days, when, partly by the noisy blundering of followers, we were driven to stand as though we were reckless in our challenge of the whole world of self-seeking fools.[24]

Perhaps it was Gabriel's death with its inevitable reminders of the early days of Pre-Raphaelitism that turned Hunt's thoughts again to Ruskin. On 4 July 1882 Hunt sent Ruskin a letter which he had written to him in November 1880 but had kept back, wondering whether or not to send it, because it dealt with such intimate feelings. In it he wrote: 'I hope you will never have any doubt that I wish to remember you as my first soul's friend, and I am anxious the more to say it because I have been in my awkward sense of honour and pride hitherto prevented from saying it distinctly . . . When I was getting to manhood I had read most of the easy sceptical books and was a contemptuous unbeliever in any spiritual principles . . .'

Describing how a fellow student lent him *Modern Painters* he commented: 'It was the voice of God . . . these first books of yours which I met with were a real treasure, and all of your later books have been the more precious from my remembrance of the benefit which you conferred on me at first.'[25]

Three days later Hunt took Ruskin to see *The Triumph of the Innocents* at his studio, and afterwards entertained him in his home. Ruskin gave a glowing account of his visit:

> I had an entirely happy afternoon with Holman Hunt, entirely happy, because at his studio I had seen, approaching completion, out and out the grandest picture he has ever done, which will restore him at once, when it is seen, to his former sacred throne. It is a 'Flight into Egypt', but treated with an originality, power and artistic quality of design, hitherto unapproached by him . . . Then we drove out to his house at Fulham. Such Eastern carpets – such metal work! such sixteenth century caskets and chests, such sweet order in putting together – for comfort and for use – and three Luca della Robbias on the walls! with lovely green garden outside and a small cherry tree in it before the window, looking like twenty coral necklaces with their strings broken falling into a shower.[26]

The intimacy between Hunt and William Bell Scott also increased during this period, and when Scott published a volume of verse, called *A Poet's Harvest Home*, he sent a copy to Hunt. 'My first thought on

getting your little volume is to envy you,' wrote Hunt. 'I wish so much that I could write poetry! I tried a little in early youth, but then, as with music at a still earlier time, and for somewhat similar reasons, i.e. that I had almost more than I could do to avoid being driven from painting, I was discouraged, and lost the chance, if I ever had one, of training my ear in the melody of sweet sounds.'[27]

Scott even grew bold enough to offer a criticism of *The Triumph of the Innocents*: 'I have thought a great deal about your picture and cannot help coming to the conclusion that it will be a perfect success. This is a very bad day, otherwise I would venture to call on you and offer you, or press upon you, it might be, a criticism of the lighting of your picture, particularly the angels . . . You have lighted them not by any natural means, as they are brightly lit when all the rest of the scene is in partial moonlight, but in a preternatural way . . .'[28]

To this Hunt replied:

It was good of you to write to explain your impressions of the points in my picture which invite reconsideration.

The first question about the light on the supernatural figures I debate thus: The children must be so treated that they shall not be mistaken for infantine angels of heaven or amoretti, which previous illustrations of the subject would lead people to expect them to be. The beings I want to represent really differ in this, that they have only just left this life instead of having got altogether established as celestial creatures. Some of them, if not all, may indeed scarcely have altogether lost the last warmth of mortal life. It seems desirable therefore, to avoid a treatment which would make them like the angels who regard the face of our Father in heaven. A support to this view I find also in the desirability of avoiding to distinctly pronounce the figures to be either subjective or objective. I wish to avoid positively declaring them to be more than a vision to the Virgin conjured up by her maternal love for her own child, the Saviour, who is to be calling her attention to them. Having got so far in my reading of the conception, I rely for the next step upon what, to use a presumptuous phrase, I will call my experience of the embodiment of ideal personages. These develop in solidity and brightness by degrees, and I imagine the Virgin to have seen these children at first, scarcely discerning that they were not natural figures under the natural light which illuminates the surrounding objects, until, with longer examination, and recognition of the

individuals as the neighbouring babies of Bethlehem, the more distinctive parts of each figure become lighted up with the fullest light, and as a full consolidation, she sees the glory of their new birth. The division of the two – the natural and the supernatural illumination – cannot be avoided, but when the picture is completed, I think the light on the duller parts will be more ethereal in effect, and therefore less separated from the brighter.[29]

Even with a new canvas, work on the picture did not proceed smoothly. Hunt was dogged by ill-health and troubled by the state of his finances. For some years the strength of his investments had cushioned him from the effects of taking so long over a single painting, but now he fell into the hands of an unscrupulous financial adviser called Neil with disastrous effects. In July 1883 he consulted Theodore Watts-Dunton, Rossetti's writer-friend, who was a practising solicitor. 'Neil must now be made to bind himself to supply us with stock for his debt – at low prices – or we must proceed against him for the money,' Hunt wrote.[30]

Two years elapsed before the matter was resolved, though Hunt's financial difficulties were not yet over. In a letter to Watts-Dunton, he referred to the account for 'services which you and Mr Mason rendered to me in my dire confusion and need when caught in the meshes of Mr Neil, and which I may say by the legal judgment exercised did much to save me from being overwhelmed by the flood of difficulties which beset my affairs . . . Ten years failure to earn a farthing with great expenses, and the losses which came from the desperately mad attempt to repair the threatened catastrophe have left me with the health of my bank book as well as my body seriously demanding rest.'[31]

Nevertheless, in spite of these problems, he maintained apparent cheerfulness, and was socially still much in demand. In his memoirs, Charles Rowley wrote of him: 'Nobody was more agreeable than Holman Hunt. I was always a greedy listener to his delightful talk, and he apparently liked my poor chatter . . . The varied experiences of life and work made Hunt one of the richest and fullest of men. He was brimful of keenly observed matter, both at home and abroad; nothing escaped him. No wonder that many less gifted ones thought his line, his colour, his facing of truths, too keen . . . He was most loyal and helpful to his contemporaries, especially to those who had an ideal they clung to in season and out.'[32]

In August 1883, Hunt was touched when he received a letter from Scott, telling him how he had heard a parson describing *The Light of the World* in a sermon in a ruined church. He replied:

My Dear Scott,
Your letter, with its scene of the congregation on the hillside and its beautiful background, came in due course, but the recipient was and is a great invalid about fourteen hours a day with what is decided to be spasmodic asthma, brought on by hard work and incessant long-continued anxiety . . . Many times I have been comforted by hearing of persons who knew not the painter's name, and troubled themselves not at all about the manner of its production, or the artistic question, speaking of the picture as one that had haunted them and given them hope – the hope that makes death have no terrors. It is not egotism that makes me pleased at this . . .[33]

In the same letter Hunt also spoke of his spiritual conversion while painting *The Light of the World*:

The figure of Christ standing at the door haunted me, gradually coming in more clearly defined meaning, with logical enrichments, waiting in the night – ever the night – near the dawn, with a light sheltered from the chance of extinction, in a lantern necessarily therefore, with a crown on His head bearing that also of thorns; with body robed like a priest, not of Christian time only, and in a world with signs of neglect and blindness. You will say that it was an emotional conversion, but there were other influences outside the sentiment.

At last there were indications that the long saga of *The Triumph of the Innocents* was almost over. In November 1884 he was visited by his old friend, G. F. Watts, and afterwards, in his obsessive quest for perfection, he wrote to Watts: 'The long detention on the same composition may have rendered me liable to great blindness as to defects of drawing, and indeed, of design in all respects. If you can recall any of these to your mind and would set down in a few lines your feelings I should be truly grateful to you, and this I could exhibit by my finishing touches. It was good of you to come and see me. I value the faces of old friends more and more as the day goes on towards the time of retrospection and harvest.'[34]

233

In 1882 the French art critic Ernest Alfred Chesneau (1833–1890) published a book called *La Peinture Anglaise*, which credited Ford Madox Brown and Gabriel Rossetti with founding the Pre-Raphaelite movement. The book was translated into English and published in 1884 under the title *The English School of Painting*. Ruskin wrote an introductory chapter, and had some correspondence with Hunt on the subject, feeling that he had been unjustly dealt with by the book. At the time, Hunt was disinclined to take up the cudgels on his own behalf, as he explained in a letter to Ruskin dated 15 June 1884:

> Generally indeed I have determined verbally to avoid claiming any priority in the attempt of our youth to make a revolution in Art . . . He [Chesneau] has established a kind of protective kinship with good old Madox Brown, who now has a chance of fairly and favourably representing himself at Manchester . . . Well F.M.B. with a good stock of facts – when seen alone – really believes himself to be through Rossetti the true father of the set of wild blundering madcaps and narrow minded geniuses who founded PRBism. W. M. Rossetti is too shrewd to go as far as this, but being in the family he leaves it to find its own level, and I wish to do so too.[35]

On 6 August 1884, Hunt invited Mr and Mrs Gladstone to his studio in Manresa Road to see *The Triumph of the Innocents*, which he said that he had now finished transferring to the new canvas. It was exhibited at the Fine Arts Society gallery in Bond Street, where visitors who knew the artist's family might have recognized Edith's features in the Virgin Mary. The infant Christ was Hilary, whose earliest recollections were of posing without any clothes for the picture. A small girl examining a tear in her dress in the foreground is Gladys. Scott, who saw Hunt soon after the painting was completed, wrote to Vernon Lushington saying that he was surprised to see how healthy and happy Hunt now looked: 'I say surprised because for two years at least there has been on his countenance, so well known to me for so long a time, something of a *lost* undercharacter of expression that has made me unhopeful about the picture. Now he has toned the whole surface into unity and got the pervading moonlight excellent, so that one wonders why, when he could do it at all, he did not do it at once, instead of showing the crude effect for so long.'[36]

Meanwhile, Hunt finally got the picture liner to cut out the defective centre from the version on Syrian canvas, and afterwards finished

this also. The painting which he had first begun in Syria was finally sold to the Liverpool Art Gallery in 1891.

On 24 June 1885 Gladstone wrote to Millais from 10 Downing Street to inform him that a baronetcy had been conferred on him. Hunt was delighted at his friend's success. Discussing the early days of their friendship, Millais said to Hunt: '"We made a great mistake in accepting others to form a brotherhood with us, when we knew little or nothing of their abilities and dispositions . . . You taught Gabriel to paint and I kept back no secret from him. We brought out our very precious guineas to start *The Germ*, in which the writers published their poems and articles; and we did etchings in addition. Did they ever do anything for us? No!" '[37]

In the autumn of 1885 Hunt's health broke down again, and for a time he lay at death's door. Ruskin was one of many who feared that this time Hunt might not survive, but on 21 October 1885 he wrote from Brantwood: 'My dearest Hunt, I never was more thankful for anything than for this letter of yours, assuring me of your recovery from the deadly strain, and being able to look forward to this world still, as well as the next. Every word you say of your illness shows me that you have rightly understood its warning and gives me the best and brightest hope for your future.'[38]

Perhaps it was this brush with death that made Hunt want to set the record straight about the origins of Pre-Raphaelitism once and for all, for despite what he had previously said to Ruskin on the subject, he began to record his version of events. This took the form of a set of three lengthy articles entitled 'Pre-Raphaelitism: A Fight for Art'. These articles were published in the *Contemporary Review* in the numbers for April, May and June 1886.

The publication of Hunt's articles caused a great deal of indignation, principally among Gabriel's friends, and members of the Brotherhood whose relationship with Hunt had cooled. Stephens, now permanently alienated from Hunt, never lost an opportunity of adversely criticizing his former friend. Woolner had not spoken to Hunt or to Edith since their marriage. Brown, who had idolized Gabriel while fully realizing all his failings, objected to what he saw as Hunt's attacks on his former friends, though he was not a man to bear a grudge, and their friendship was not permanently broken off. William Rossetti, though bound to his brother in love and loyalty, appreciated Gabriel's frailties all too well, and realized the justice of Hunt's assertions. But Millais, as always, came down fairly and squarely on Hunt's side. His

love and admiration for Hunt had remained unchanged since their youth, and nobody else could ever take Hunt's place in his estimation or his affections.

That same year an important exhibition of Hunt's work took place in the rooms of the Fine Art Society. *The Light of the World* was sent to Hunt in preparation for the exhibition, and was found to have suffered appalling damage, due entirely to the carelessness of the Keble College authorities. Many years later, Hunt's daughter, Gladys, vividly re-called his shocked reaction when he opened the box and saw the condition of the famous masterpiece.

'After gazing at it in silent stupefaction for a few minutes, he replaced the lid, and left the studio without a word,' she wrote.[39]

Hunt spent a month repairing the picture without charge, and Mrs Combe paid for it to be relined.

The exhibition of Hunt's work aroused considerable public interest. Ruskin contributed criticisms to the Catalogue. In it he wrote:

> To Holman Hunt, the story of the New Testament when once his mind entirely fastened on it, became what it was to an old Puritan, or an old Catholic of true blood – not merely a reality, not merely the greatest of realities, but the only reality. So that there is nothing in the earth for him any more that does not speak of that; – there is no course of thought nor force of skill for him, but it springs from and ends in that.[40]

CHAPTER 16

— ❀ —

Last journey to Jerusalem

ON 13 July 1887, Hunt unveiled the memorial fountain to Rossetti on the Chelsea Embankment and delivered an address. It was a melancholy duty for Hunt, who recalled vividly their early days together, and having long since forgiven Rossetti for his betrayal with Annie Miller, still cherished him in his heart. The patriarchal Ford Madox Brown, who had worshipped Rossetti despite all his failings, ornamented the fountain, which was designed by John Seddon. The memorial did not win universal admiration. On the day before the ceremony, Arthur Hughes, who thought that a simple plaque in front of Rossetti's house would have been much better, wrote to William Bell Scott: 'I hope it will be long enough when Hunt speaks! I feel I must go, but I dread seeing the Fountain, the model of which I dislike much.'[1]

After labouring so long on his great religious painting, Hunt turned for a time to small, non-didactic works. *The Bride of Bethlehem*, a study of the Virgin's head in *The Triumph of the Innocents*, and *Sorrow* were exhibited in the Fine Art Society's Rooms, and Hunt remained in London while Edith went to Dieppe with Gladys and Hilary. Her holiday was marred by a bad fall, which caused Hunt considerable anxiety.

In September, Hunt asked Arthur Hughes to come and look at his two versions of *The Triumph of the Innocents* side by side and to compare them. One was bound for Melbourne and the other for America on exhibition. To Hunt's great disappointment, both remained unsold.

'He told me a sorrowful tale of having lost money by some bad speculation on the advice of a trusted broker friend,' wrote Hughes; 'being so put back and put back by the everlastingness of the *Flight into*

Egypt, he wanted money to go with it, and without leaving it to paint anything else for money, so was induced to go into something that went smash, and induced to put the little more remaining, to turn the tide and make the first pay and come right, and then that went too . . . Privately, my own wonder is, that he had any savings left to lose, considering how long he has been laboriously and expensively engaged with these two pictures.'[2]

On 21 October 1887 Hunt's favourite uncle, William Hobman, died at 53 Studley Road, Clapham. He had outlived his wife, and had no children, but there were numerous nephews and nieces and their offspring, all of whom were remembered in his will. His very first bequest was the much-cherished portrait of himself which Hunt had painted at Ewell many years before. This he left to his only surviving brother, Alfred Thomas Hobman. Hunt received the standard nephew's portion of £500, while Cyril got £200, and Gladys and Hilary £100 each. Hunt also received the famous Hobman chest, an early sixteenth-century Italian bridal chest decorated with elaborately carved scenes. This was not actually a bequest in the will, which was drawn up in May 1885, and had probably already been given to him by his uncle when he and Edith moved into Draycott Lodge. Alternatively Hunt might have obtained it by arrangement with his sister, Elizabeth Ann Hunt, who inherited all their uncle's furniture.

Less than a month later, Edward Lear wrote to Hunt asking him to be his executor at his death, and Hunt promptly agreed. He was nevertheless stunned and saddened when Lear died on 29 January 1888 at San Remo. Lear was buried in the English cemetery there, and none of his friends was at the funeral, for even Frank Lushington, his principal beneficiary, arrived too late. Hunt's portrait of Lear, dated November 1857, shows all the sensitivity and loneliness of the man who brought laughter to people of all ages. Lear never did bring out his illustrated edition of Tennyson's works, which he had planned more than thirty years ago when he was staying with Hunt at Fairlight, but the Tennysons published it posthumously with some of his pictures as a memorial to him.

Hunt was now occupied with a Tennyson theme of his own, *The Lady of Shalott*. It was a most exciting project, and he threw himself into it with enthusiasm. But during the summer of 1888 he set it aside temporarily for another work, *May Morning on the Magdalen Tower*. During the course of the year he received a degree of public recognition as a collector, for his Donatellos and Della Robbias were

exhibited at the Old Masters exhibition in Burlington House. Lately he had been somewhat preoccupied with Cyril's education, for his son was about to embark on his final year at Cambridge, and Hunt was anxious that he should not waste his opportunity of getting a good result in his finals. Meanwhile, having packed Edith and the children off to Dieppe for their summer holiday, he went to Oxford by himself to start the new picture. '. . . this subject at Magdalen I have set myself to seems to me an important one for me to have painted next year,' he wrote to Edward Clodd, 'when as I calculate my *exasperating* piece will be a picture of the Lady of Shalott . . . Now I come upon the Magdalen singing scene as really one without offence in it . . . and the public may even look at my other pictures with more toleration . . . It is hard work to get up at a quarter to four and wind my way up the narrow and steep stairs of the tower, and paint till half past eleven or twelve without regular breakfast, but I have got a deal of my scene done and soon I shall begin on the figures.'[3]

Clodd, who was Secretary to the Joint Stock Board, had first met Hunt in July 1880, at the home of Robert Hannah, Hunt's neighbour in Warwick Gardens, Kensington. Hannah was a portrait artist, who entertained them that evening to supper and a game of bowls. By a curious coincidence, Clodd at the age of sixteen had been a city clerk and had known old Hannah, with her basket of apples and nuts, whose portrait Hunt had painted as a young man in the City. Hunt took an instant liking to Clodd, and before long the two men were close friends.

In December, Hunt, who had been allocated a studio in the new building at Magdalen, wrote to tell Edith that he was having problems with his picture. He had obviously underrated the public's capacity for taking offence, for some people were saying that the traditional St Swithin's Day ceremony was little regarded now. Others objected to one of the characters in the foreground, who was clearly recognizable. In a close community like Oxford, petty jealousies abounded. 'There is a manifest strong feeling against my picture because I have filled up so many places and cannot put Oxford or Magdalen notables for the figures,' he wrote.[4]

New Year's eve, 1888, found Hunt still in Oxford. To Clodd he wrote: 'I am kept here with my picture, but the people are most pleasant and the dons at Magdalen help me to the utmost. In a week I may, perhaps, be beginning to think of moving, and when I come home I shall feel that part of the work which of necessity has been

trying has been overcome and I shall enjoy the delights of home not without a sense that I have earned them.'⁵

Before he left Oxford, Hunt went to see Mrs Combe. In taking his leave of her, he presented her with a picture which he had painted especially for her, entitled *The Sleeping City*. During the course of his visit, she told him that she was still dissatisfied with the arrangements for *The Light of the World*, and very much regretted separating it from the other pictures which Mr Combe had bequeathed to the Taylor Building. It seemed both to Mrs Combe and to Hunt himself that the authorities at Keble were indifferent to the picture, and this caused them both considerable distress. She said that she had made provision in her will for a chapel to be built at Keble College especially to house the picture. Perhaps, as she explained all this to him, she had a premonition that she would never see him again.

Characteristically, Hunt had grossly underestimated the length of time needed to complete his paintings, and there was no prospect of their being ready for exhibition during 1889. Hilary, whom he had painted in a charming picture as *The Tracer*, now made his appearance as one of the choirboys on the Magdalen Tower. He was well used to modelling for his father, having been pressed into service from his infancy. Soon after *The Tracer* was finished, Millais had seen it, and though much admiring it, felt that it needed a touch more colour. Taking up his brush, as in the old days when he and Hunt had helped each other out, he had added stripes to the trousers, and a red cap tucked into the belt. The finished result shows all too clearly how Millais had fallen from his early Pre-Raphaelite ideals, producing work of great fluency but without the fine detail which had once characterized his work, and which was still a vital part of Hunt's technique.

Like his step-brother and his sister, Hilary was a remarkably handsome lad, and already promised, like them, to be exceptionally tall. Cyril was 6 feet 4 inches, and Hilary was eventually almost as tall, while Gladys reached an Amazonian 6 feet 1 inch in her stockinged feet. Hunt doted on all his children, and was an indulgent father, who did all that he could to smooth away difficulties and make life easy for them. Cyril had seen all too little of his father in his formative years. Though Edith had been glad enough to make use of the child in her struggle to win Hunt for herself, the successful outcome of her long campaign had rendered him superfluous to her. Indeed, at times she seemed almost hostile towards him, resenting anyone with a claim to

Hunt's affections, and inevitably favouring her own children. It was not surprising that Cyril went abroad at the earliest opportunity and remained proudly independent for the rest of his life.

A huge age gap separated Hunt from the children of his second marriage. He was nineteen years older than Edith, and was fifty-two when Hilary was born. His patriarchal appearance, with full flowing beard which turned silver with his advancing years, tended to accentuate the difference in age, even though an active life-style and boundless physical energy had helped him to maintain his strong, wiry physique. Though Hilary's sporting prowess delighted him, he found him a bit of a handful, and it was with some relief that he sent him off to Rugby, and later to Wellington College. Gladys, meanwhile, was educated at home. She had inherited artistic talent, and received her tuition from Hunt.

On 30 June 1889 Wilkie Collins suffered a paralytic stroke, and his general physical condition gave him little hope of recovery. He rallied for a while, and in August was allowed out of bed for short periods, but on 23 September his life slipped peacefully away. On 27 September Hunt attended the funeral at Kensal Green Cemetery, along with Charles Dickens junior, Edmund Yates, Hall Caine, Oscar Wilde and many other figures from the world of literature and art. According to a contemporary report: 'There must have been at least a hundred of these unwholesome creatures who call themselves women, who seem to live in graveyards. When the coffin had been lowered into the bricked grave there was a general rush of these people who craned over into space, and clawed the wreaths of flowers, and pulled about the cards which were attached to the wreaths, and laughed and cried and chattered until they were moved on by the graveyard police.'[6] In his will Wilkie bequeathed to Hunt the chalk portrait which he had made of his brother, Charles Collins, on his deathbed.

One Sunday in early August 1890, Millais visited Hunt and looked at his picture of *Christ in the Temple*, and at *May Morning on the Magdalen Tower*. He was filled with enthusiasm for Hunt's work, and said that the *May Morning* was a lovely composition, reminiscent of Holbein. Afterwards they strolled together along Bishop's Walk, and called to see Charles Keane, the *Punch* illustrator, who was terminally ill. Edith, as usual at this time of the year, was on holiday, and on 20 August Hunt wrote to her, 'At last yesterday I did get the *Christ Among the Doctors* finished and I sent the man off with the frame while I went in a cab with the picture to get it photographed . . . The question is

about price. If anyone cared for my pictures in less than forty years they would see that this is about the cheapest picture I have ever done for it has an enormous deal of work in it and now it is most completely finished – this last work having taken [sic] almost unintelligible extent of thought and labour.'[7]

Hunt decided to ask 1,100 guineas for the picture. A few days later he learned that molten lead had fallen on one of his paintings at an exhibition, and received a telegram from Lloyd's asking him to report urgently on its condition. Fortunately, when he inspected the picture, he concluded that the injury was minor and could be repaired in a few minutes with a little paint.

'As no sales of subject pictures ever take place with me now, I feel that it is impossible to go on painting more,' he wrote to Edith. 'I shall finish those in hand, and then I shall do some portraits, and fancy heads – or give up altogether painting, for I am not sure that to do work with only limited invention would not be very dispiriting.'[8]

Less than a fortnight later he wrote to her from the Woolpack Hotel in Warwick, where he had come in the hope of working from figures on a tomb in the Beauchamp Chapel. Unfortunately as the Earl of Warwick was away and nobody seemed to have authority to allow him to work from the Beauchamp tomb, he was frustrated in his objective.

During Hunt's early years as an artist, he had relied heavily on the advice of Mr Combe in the matter of his investments. Gradually he had acquired an expertise of his own, so that in time he was able to manage his own financial affairs. A few close friends had come to look to him for advice, including Stephens, though this had died with their friendship. On 14 November 1890 he wrote to his artist-friend and former pupil, Frederick Shields, telling him that a few years pre-viously he had invested in a nominal amount of shares in a Cornish mine which now promised to do exceedingly well. Though he was not at present able to invest more money, he thought that Shields might be interested. He mentioned that he had himself been in the clutches of swindlers a few years before – presumably a reference to the Neil affair of 1883 – and added: 'Don't write to acknowledge this in any case because my wife would be angry if she thought I had advised you in such a matter.'[9]

Undoubtedly Edith's instincts were right in this instance, but it is interesting that Hunt, whose only motivation was to do Shields a

good turn, should feel driven to deception in the matter. Clearly Edith's wrath was terrifying and best avoided.

William Bell Scott died on 22 November 1890. Their friendship had lasted since the early days of the Pre-Raphaelite Brotherhood, when Gabriel had brought him to Hunt's studio, but the bond between them had strengthened in recent years. Scott had remembered Hunt in his will, with a generous bequest of £800.

Writing to Shields in January 1891, Hunt gave a catalogue of minor misfortunes. He had been poorly again and the house was 'knocked up'. The pipes were frozen, the range wouldn't work, and there were no baths. Gladys had gone down with measles, and to cap it all, the stove in his studio had scorched his picture.

May Morning on the Magdalen Tower was placed on exhibition in the spring, and Arthur Hughes, who attended the private view, reported that Edith, who had so often seemed worn out of late, now looked wonderfully youthful and well. Gladys, at fourteen, was already as tall as her mother, while Cyril was giving a good account of himself as a tea-planter in Ceylon. Hughes said that Hunt's picture was very fine, and more true to nature than most of his later works.

'It seems very real and true,' wrote Hughes, 'and there is a beautiful sky, very Hunty, of streams of beautifully composed cloudlets flushed with warm gold and violet. It is a difficult picture to have done.'[10]

The absence of a purchaser for *The Triumph of the Innocents* continued to disappoint Hunt, but in 1891, an artist called Harold Stewart Rathbone, who was a great admirer of Hunt's work, organized a subscription list to purchase the picture for the Walker Art Gallery in Liverpool. Rathbone was an interesting man who had studied painting in Paris before becoming a pupil of Ford Madox Brown, and when he met Hunt the two men liked each other on sight. Later Hunt painted his portrait. In 1893 Rathbone founded the Della Robbia Pottery at Birkenhead. Its speciality was the production of architectural embellishments, for which there was now a considerable demand. Hunt took a great interest in the project, and became a member of the council set up to control its activities.

During the course of 1891, Hunt was invited to a banquet given by the Lord Mayor of London to leading personalities in the world of art and literature. Millais was seated next to the Lord Mayor himself, and Brown was opposite. Hunt suggested to Brown that they might sit together, but Brown declined, and sat silent all evening. He was now a lonely and disappointed man. His son Oliver had died in 1874, and his

wife Emma in 1890. For years he had been slaving over a series of important murals depicting local history in Manchester Town Hall, for the paltry sum of £300 a year. He never seemed to escape from the poverty trap, or to gain the recognition that he deserved. Before the series was finished, he suffered a stroke and his painting arm was affected, but he managed to work on, using his left hand.

In the winter of 1891, Shields organized a collection to buy some of Brown's works without his knowledge. Surviving correspondence with Shields shows that Hunt, who had a great affection for Brown, made a generous contribution of £30. The secret leaked out when a newspaper publicized it, and when Brown read about it, he felt deeply humiliated. His immediate reaction was to send a furious letter to Shields claiming that he had been insulted. A few days later he wrote and apologized, withdrawing all his remarks. Part of the money was used to buy *Christ Washing the Disciples' Feet*, which was presented to the National Gallery.

In September 1891 Edith took Gladys and Hilary on holiday to Brittany. Shortly after their return, Hunt handed over the supervision of his daughter's painting lessons to Frederick Shields, and set out on his fourth journey to Syria. Edith, loyal and courageous as ever, went with him. They reached Alassio on 19 December, and travelled on through Italy to Greece. Returning to Naples, they proceeded to Cairo, which Hunt now found quite unrecognizable. Edith made a pictorial record of their journey with diary entries, and as they travelled up the Nile she busied herself with her sketches.

'Assint is one of the oldest and still most prosperous towns on the Nile,' she wrote. 'Our steamer is seen as a speck on the distant river. A funeral party is making its way to the modern cemetery, below the ancient Rock Tombs of the old Lycopolis, from where the sketch is taken.'[11]

They reached Luxor on 12 February, and the Temple of Edfou on the following day. At Gebel, Edith recorded that the temperature was ninety degrees in the shade, and when, a few days later, they stood before the statue of Rameses, Edith was moved to write a poem of unremarkable quality, ending in the line 'Rameses! I love thee.'

In March 1892 they finally arrived in Jerusalem. To their disappointment, their own house was in a very dilapidated condition, and as it was impractical to repair it, they booked into Howard's Hotel. Though his materials were a week late in arriving from Jaffa,

Hunt was soon able to devote his attention to designs for Sir Edwin Arnold's poem, *The Light of the World*.

While staying in Jerusalem, Hunt received a letter from Alfred Fripp, inviting him to send work to the great Munich Exhibition, but he declined, saying: 'My own convictions . . . are strong against the advisability of sending to International Exhibitions for at present I regard the Art in the Continent as simply abominable, and it seems to me that contact with it has already injured English Art.'[12]

In the weeks following their arrival, they toured the surrounding countryside, visiting the Valley of Jehoshaphat and reaching Bethlehem on 29 March. But Hunt's principal object in returning to Syria was to work on a new picture which had begun to take shape in his mind on an earlier visit, *The Miracle of the Holy Fire*. The Easter ritual which formed the basis of his picture drew thousands of pilgrims every year to the Church of the Holy Sepulchre in Jerusalem. The pilgrims were people of child-like faith who had accumulated the means for the sacred journey by years of self-denial. The 'miracle' of the Holy Fire was to the faithful an indication of the supremacy of their religion, but to Hunt the deception by the priests was an abomination which he intended to satirize in Hogarthian fashion. At Easter he obtained a gallery position from which he had an excellent view of all that went on, and translated it on paper in a series of lightning sketches.

At the climax of the ceremony, the Greek Patriarch produced a candle supposedly lit by divine miracle, and the mob inside the church surged forward, each one intent on lighting his own candle from the sacred fire. The heat became intense, and the smoke stifling, like an inferno. Gradually the flame was passed from hand to hand, until the church blazed with candles, while a huge pall of smoke hung overhead. At a given signal, each man kissed his neighbour and extinguished his candle, wrapping it carefully for use at his own funeral. When the heat and smoke were at their worst, the mob fought for the only exit. Many of the faithful collapsed, overcome by the heat and fumes. Stampedes, in which many were trampled underfoot, were common, and sometimes the fatalities ran into hundreds. When the flame appeared through an aperture in the shrine, a priest took it to the Jaffa Gate, where it was shipped to Odessa to be distributed to churches throughout Russia.

After the ceremony, with the aid of his sketches, Hunt began work on canvas, meticulously translating what he had seen into a satirical

picture of mammoth proportions. He had accepted that he could not finish the picture in Syria, and forged ahead with his work, trying to get as much done as possible before they returned home.

In May he and Edith witnessed the Muslim pilgrimage from Jerusalem to Nebi Musa near Jericho. This was the largest Muslim procession in Palestine, and usually some 10,000 people took part. It was a festival of prayers, preaching and feasting, accompanied by the sound of the tom-tom, in which the wealthy supplied food for the poor. Edith wrote: 'Half-naked Fakirs dance before the processions. The lemonade stall men wore lively pink and yellow striped silk garments. Arabs in gay and beautiful embroidery sit about in the dust. Little children, heads covered with silver coins and eyes covered with flies!'[13]

When Hunt's painting was sufficiently far advanced for his purposes, he and Edith packed up the furniture from their house, and left Syria for ever. It was a poignant moment for Hunt, for whom the Holy Land symbolized everything that was important in his life and art. His quest for the authentic background to Biblical art was as significant to him as the search for the Holy Grail. He had gone to Jerusalem initially to seek ultimate truth to nature, in a spirit of piety. As time went on, the Christian doctrine increased in personal significance, and the element of worthy purpose in his work was now all-important. He had found his greatest fulfilment as an artist and as a man in the land of the Bible, and only the realization that he was too old for the dangers and privations of the East persuaded him that he now looked on Jerusalem for the last time.

On their return journey, they stayed for a few days in Gibraltar, where Edith wrote: 'My impression of Gib is "red coats". Our fellow countrymen had been playing Polo and the English ladies were coming from the mountains of Spain. The soldiers had a horribly pleasant task. Small they seemed, but quite capable in their own estimation of keeping the Rock against all comers.'[14]

Back in England after an absence of eight months, Hunt threw himself into his painting once more, working alternately at *The Miracle of the Holy Fire* and *The Lady of Shalott*. Both were immensely complex and demanding works, and although they presented nothing as serious as the problems of *The Triumph of the Innocents*, he handled his themes with all his customary intensity, draining himself mentally and physically in the process.

News of the sudden death of Tommy Woolner on 7 October 1892

came as a great shock to Hunt. Woolner had been ailing for two or three weeks, and was walking in a room in his house in Welbeck Street when he had a seizure. Death was almost instantaneous, and the funeral took place at Old Hendon Churchyard five days later. After his early struggles, Woolner had become a wealthy man, partly because his sculptures had become fashionable, and partly through judicious buying and selling of art treasures. While still maintaining his house in Welbeck Street, he had purchased a fine estate with a beautiful country house near Horsham, and had lived out his later years in luxury. Incredibly, the man who had failed to make his fortune in Australia in his youth, and who had struggled to bake his work in the open fire in his crib, left an estate valued at over £65,000.

Though Tommy and Alice Woolner had not spoken to Edith since her marriage, she went instantly into mourning. Her hair was turning grey now, but she was still a remarkably handsome woman. As for Hunt himself, he had as usual worked far too hard during their visit to the East, and his health had once more suffered.

One of the advantages of life with Edith was her insistence on a proper family holiday every summer. With the one exception of his first visit to France and Belgium with Gabriel, Hunt's foreign tours had always been strictly for work, but Edith changed all that. Usually they travelled to the Continent as a family, with Hunt returning after two or three weeks to get on with his painting, leaving Edith to finish the holiday with the children. In the summer of 1893 he and Edith took Gladys and Hilary to Germany. Hunt had the idea of using his articles in the *Contemporary Review* on the origins of Pre-Raphaelitism as the basis for a book, and wrote to Mrs Combe saying that he expected to finish it by Christmas 1893. As always, he was absurdly optimistic in his timetable, and it was twelve years before the book was ready for publication.

On 6 October 1893 Ford Madox Brown died, and Hunt went to the funeral at Finchley Cemetery. Time was mowing down his old friends at an alarming rate, and nowadays Hunt was rarely out of mourning. Worse was to come. Martha Howell Bennett Combe, who had been like a second mother to him, died on 27 December 1893, having survived her husband by more than twenty years. Early in the new year he went to Oxford for her funeral.

At the reading of the will it emerged that Mrs Combe had left Hunt the magnificent sum of £2000, while his son Cyril received £1000, which he used to set himself up independently as a tea-planter. Having

no children of her own, Mrs Combe had adored the young Pre-Raphaelites. Millais had been her first favourite, and she had never doubted his genius, but she had rarely seen him after his marriage to Effie. Charley Collins had been a sweet boy, and Woolner a lively companion. Gabriel had slid into her affections, but after his quarrel with Hunt he had drifted away. It was Hunt who had emerged as her great favourite, dear to her as the son that she and Thomas Combe had always wanted, lovable, entertaining, with a remarkable talent, the greatest religious painter of his age. The Combes were deeply pious, and Hunt had been greatly influenced by them. Mrs Combe also left £3000 to Keble College, to enable the organ to be raised above floor level, so that the space beneath could be converted into a chapel to accommodate *The Light of the World*.

At her death Mrs Combe owned the largest Hunt collection in private hands. The list of oil paintings was impressive: *A Converted British Family Sheltering a Christian Priest from the Persecution of the Druids*; *Miriam Wilkinson*; *The Afterglow in Egypt*; *London Bridge on the Eve of the Wedding of the Prince and Princess of Wales*; *The Festival of St Swithin*; *The Plains of Esraelon*; and *The Sleeping City*. In addition there was Hunt's portrait of her, which she described as 'The pastel from a Portrait done in 1860 by my Ivory Indian Cabinet'. She also owned a chalk portrait of Hunt by Millais, and paintings by other artists, including Millais, Collins and Rossetti. All these were bequeathed to the University of Oxford, together with the bulk of her estate.

During the course of 1894 Hunt devoted a lot of his time to the affairs of the Sunday Society, of which he was made President. The aim of the society was to campaign for the Sunday opening of national museums and galleries, libraries and gardens, so that these might be no longer the preserve of the leisured classes. It was a cause very dear to his heart, and Hunt remained in office until 1896, when Edith was elected Vice-President. During their association with the society, most of its aims were achieved. Nevertheless, Hunt did not always get the support that he expected. In June 1894 his Presidential Address was published in the form of a threepenny pamphlet, and he was delighted when he received a sympathetic letter from G. F. Watts, to which he replied:

I was particularly gratified by your kindness in writing to me of your cordial sympathy in the objects of the Sunday Society which I had undertaken to champion. I often found myself somewhat lonely

in questions connected with religion, for the orthodox people hate my words, as they hate my pictures, and the major part of the reforming world have a stronger disapproval of the point at which I stop. It is the penalty of being a free lance, but the pleasure is a fully compensating one to find an old friend, who is independently engaged in the same knight-errantry.[15]

One Sunday afternoon in July 1894, Holman and Edith visited the home of Arthur Hughes, taking the scenic route by the river on foot. They arrived somewhat wet, having been caught in a heavy downpour. Though Hunt appeared to have aged slightly, he showed no sign of his old Syrian ague or his asthma. He and Edith, as loving as ever, were contemplating a month's holiday, though they had not yet decided where they would spend it.

'He was endlessly interesting as ever,' recorded Hughes. '. . . Myself and Arty who happened to be with us and Godfrey, all open mouthed fascinated listeners greedily devouring all the well told story, and very sorry when the inevitable train time brought it to a stop.'[16]

In the spring of 1894 Lord Leighton, President of the Royal Academy, was taken seriously ill with heart disease. On medical advice he laid aside his office temporarily, and left for Algiers. Before leaving he wrote to Millais urging him to take on the office of Deputy President: 'My dear old friend, there is *only one man* whom *everybody*, without exception, will acclaim in the chair of the president on May 4th – a great artist, loved by all – *yourself.*'[17]

Millais had suffered various misfortunes lately. His house in Scotland had burned down in the middle of the night, though luckily nobody was hurt. More significantly, during the last couple of years he had been conscious of a lump in his throat, which as it developed, made him increasingly hoarse. For years he had been a heavy smoker and now he was beginning to pay the price of his indulgence. Though the doctors might not yet have put a name to it, Millais was suffering from cancer of the throat.

During the spring and early summer of 1895 the country was shocked by the scandal of the trial of Oscar Wilde, who ultimately stood in the dock faced with two charges of gross indecency. Homosexuality was not regarded as a crime anywhere else in Europe, and had only been made a criminal offence in England ten years previously. The trial was a total travesty of justice, but on the word of

self-confessed blackmailers and liars, Wilde was convicted and received the maximum sentence of two years' hard labour. Fearful that Wilde would not survive this savage punishment, his friend More Adey got up a petition for his early release, which he sent to many influential people of the day, of whom Hunt was one. Hunt's reply was remarkably lacking in human compassion. 'I have not failed to give myself the fullest opportunity of discovering any solid argument in the case which you from feelings of friendly humanity are pressing, to obtain the shortening of the sentence on Oscar Wilde,' Hunt wrote, 'but I must repeat my opinion that the law treated him with exceeding leniency, and state that further consideration of the facts convinces me that in justice to criminals belonging to other classes of society, I should have to join in the cry for doing away with all personal responsibility, if I took any part in appealing for his liberation before the completion of his term of imprisonment. While such a course might seem benevolent to malefactors, it would scarcely be so to the self-restrained and orderly members of society.'[18]

This letter shows how entirely Hunt missed the point, and illustrates how even men of genius and vision can be blinkered by the prevailing views of society. Though it is disappointing to find Hunt taking this attitude, it was the typical response to Adey's appeal, for the only well-known public figure who signed the petition was York Powell, Regius Professor of History at Oxford.

Hilary, who was now a fine lad of sixteen, was a boarder at Wellington College. Hunt was a loving and indulgent father, who often got him out of minor scrapes, and was proud of his good looks and mental agility. On 27 November 1895, he and Edith went to the college for Hilary's confirmation service. Edith, sentimental as ever, picked one of the grasses in the Long Walk and pressed it in the order of service, as a reminder of the occasion. Unfortunately Hilary did not complete his course at Wellington. To Hunt's distress, he was expelled for an infringement of the rules, and this time Hunt was unable to bail him out of his difficulties. Hilary, however, was undeterred, and celebrated the occasion by setting light to some barrels of pitch and rolling them down the hill.

Leighton died on 23 January 1896 and was buried in St Paul's Cathedral. Hunt, accompanied by Gladys, attended the funeral, and so did Millais, who carried the splendid wreath from the Royal Academy and placed it on the coffin as soon as it was lowered into the vault. Hughes, who was also at the funeral, wrote:

I met Hunt and he was delightful and most characteristic; Gladys very lovely, with him – he wanted me to join him in staying to see Richmond's paintings in the roof – looking for him in that vast crowd! Gladys privately mentioning to me that tho' they expected to meet they had not arranged where! and after the ceremony it was directly a moving throng of ordinary crowd. So of course we didn't meet, and Hunt was not allowed to go up without Richmond, so we went off and lunched, and the persistent Hunt would return to St Paul's to find Richmond again. We returned but could not then be admitted at all, until next service. So finally he gave up, and we all walked slowly, he talking most interestingly all thro' the city meeting crowds always pushing you out of hearing, so often the talk went into stranger ears, until we got to Sotheby's, where we went in for a spell, then on again as far as the National Gallery where we went in for another spell, then on to the Athenaeum, where we parted.[19]

On 20 February 1896 Millais was elected President of the Royal Academy. Among the many letters of congratulation which he received came one from Hunt, dated 24 February 1896:

My Dear Millais,

I don't know whether it is definitely settled yet that you shall be the President of the Royal Academy, but I have no doubt that it soon will be, for, whatever differences of interests there may be among the members, when once it was known that there was a possibility of your accepting the post, there could have been and there will be, but one feeling about the surpassing fitness of the choice of yourself . . .

That you may hold it for some years is my hearty wish, but I trust that you will not make any kind of promise to keep it for life. The post is quite a different thing to fill, in the amount of work required, to what it was in Sir Joshua Reynolds' time. London, with six million inhabitants and about three-quarters of these calling themselves 'artists', would wear any man to death if he felt there was no escape for him. It would assuredly interfere with his opportunity for work very mischievously. I was sorry that so true an artist as Leighton allowed himself to be hampered with the duties permanently . . . He did the duties magnificently, but he could have

worked magnificently also, and the work would have remained for all generations; and this may be the same with you.

Give my felicitations to Lady Millais, who will have to take so large a part in the new honour; and give my love to Mary.

Yours very affectionately,

W. Holman Hunt.[20]

Sadly, such choices were not available to Millais, who was now a dying man. A reporter in the *Daily News* wrote: 'There was something very pathetic in the way Millais lingered round the galleries of the Academy during the last days before it opened for the first time under his presidentship. He was in the rooms on the Saturday before the private view (the last of the members' varnishing days) shaking hands with old friends, and saying, in a hoarse whisper, which told its tale tragically enough, that he was better. He came again on Monday – that was the outsiders' varnishing day . . . Young men and old, they all looked in, mournfully realising it might be their last chance to see the greatest of their brethren . . . He came again on Tuesday. There was discussion amongst a few of the members about a picture that in the hanging had not got so good a place as it deserved. "Take one of my places," he said.'[21]

Millais died on 13 August 1896, and the funeral took place a week later. Like Leighton, he was buried in St Paul's Cathedral. Hunt, who was a pall-bearer, carried out this last duty for his old friend with a heavy heart. He was in distinguished company. The other pall-bearers were Philip Calderon, R.A., Sir Henry Irving, Sir George Reid, Viscount Wolseley, the Earl of Roseberry, the Earl of Carlisle, and the Marquis of Granby. Millais's great palette, brushes and maulstick tied with crape were on top of the beautiful old pall that decked the coffin.

To Johnny's son, Everett, Hunt wrote:

After fifty-two years of unbroken friendship the earthly bond has separated. New generations with fresh struggles to engage in ever advance and sweep away many of the memories of individual lives, even when these have been the most eminent . . . It would be a real loss to the world if your father's manly straightforwardness and his fearless sense of honour should ever cease to be remembered. There are men who never challenge criticism, because they have no sense of individual independence. My old friend was different, and he justified all his courses by loyalty and consistency as well as

courage – the courage of a true conscience. As a painter of subtle perfection, while his works last they will prove the supreme character of his genius, and this will show more conspicuously when the mere superficial tricksters in Art have fallen to their proper level.[22]

Not long after his death, some of Millais's effects were put up for sale. Among them was a pair of superb ebony chairs that had belonged to the giant Chang. Rossetti, too, had owned the chairs before Millais. Hunt had stopped making major purchases of antiques, but bought them, chiefly for sentimental reasons. Of the original Pre-Raphaelite Brotherhood, only Hunt, Stephens and William Rossetti now remained. The ranks of the younger, new-wave Pre-Raphaelites were also thinning. In October 1896 William Morris died. The two men had become good friends during the last few years, and Hunt lamented his passing. All in all it had been a sad year; but Hunt was far from ready to give up. As long as he had eyes to see, and a firm hand to wield his brush, he would continue the struggle for his art.

CHAPTER 17

—— ❀ ——

Sharing Milton's woe

O N 2 April 1897, Hunt reached his seventieth birthday, and to mark the occasion, Edith gave a special dinner party. Arthur Hughes, who was one of the guests, described the occasion:

It was on the lines of a very stately feast – only, with all the stiffness absent – beautifully friendly, and all beautifully done. Hunt and his wife so charming, and everybody so natural and quietly gay. Jones was almost Bohemian – it was lovely, when Lushington was telling me he had come up from Bath to hear him. 'Bath! and did not meet Mr Pickwick there?' and the Judge looked almost hurt! Then at dinner the chairs had been borrowed all over the house I think for mine was very low, and Kitty has gone on growing since she got married, and Jones across the table said 'Uge! I always thought you were rather a tall man – are you in a very low chair or is it that you are now dwarfed and shrunken with extreme old age?' Then he remembered with such nice pathetic kind of pleasure the old days, and I told him how I first saw him. Morris bought *April Love* and sent Burne Jones with a letter containing the cheque, and I was out, but returning just as he was a few doors away he stopped me, and said 'he thought I must be Hughes, because Rossetti had described me as a little like Morris, so he knew me.' And he said 'only to think of his having a cheque entrusted to him and that it actually passed thro' his hands to its proper destination. How different it would be *now*!!!

It was awfully sweet to hear his pleasure in recollecting the early days and doings and Rossetti's beautiful things, and how 'that was the best of all times,' and I felt more affection for him than I ever quite did before I think. And how that 'that was Rossetti's nicest

time when he was best and his work was too'! Sometimes I have
fancied Jones a little cold, but I don't mean to any more . . . I never
saw Hunt so lovable and simply sweet – altho' older, he seems
wonderfully well: both do. After the ladies had left the dining room
Hunt asked all to draw up at his end so Jones and Richmond came
next to him – and then Godfrey Lushington with the characteristic
modesty and sweetness of the family begged me as a personal favour
to sit by Hunt on his side; so there were four painters all together at
the top – and the others all below! And then Hunt told stories, and
everyone smoked and after most delightful music and last, Susan's
fiddle, so late, that I lost all trains, and had to walk home to Kew![1]

In little more than a year, Edward Burne-Jones, too, was dead. Hunt,
who had sincerely admired his work, described him as 'a man of
exquisite wit and humour', and said 'He superadded to Rossetti's
earlier spirit a certain classicalism of style in the posing and drawing of
the human figure.'[2]

Hunt was still at work on his two pictures, *The Lady of Shalott* and
The Miracle of the Holy Fire. His religious paintings continued to
generate enormous interest. There was much speculation about the
identity of the model for *The Light of the World*, and in January 1898 his
friend Clodd sent him a copy of a newspaper article on the subject.
Having heard an explanation which conflicted with what Hunt had
already told him, he asked him for the truth. Hunt replied:

My dear Clodd,
 I have been shut up in my bedroom for the last eight days with an
attack of bronchial asthma, which came upon me very suddenly. I
am not yet released, but I am able to write a few lines to a good
friend.
 Your marked copy of the *Chronicle* came in due course. What Mr
Bell says about Miss Christina Rossetti sitting for the head in the
Light of the World (after what you know of my having used a cast
from a clay model made by me, with a variety of male sitters, my
father, Millais, John Capper and, in person, furtively from Carlyle,
also from many departed heroes in effigy – the best I could get
serving as my model for different parts of the head), would
naturally raise a question in your mind but what he states is true,
because I felt that I had secured the male character in the head. As I
had to have some living being for the colour of the flesh – with

growth of eyebrows and eyelashes, the solemn expression, when the face was quiescent, of Miss Rossetti promised to help me with some shade of earnestness I aimed at getting, and so I felt grateful to Mrs R. and herself when they promised to come to Chelsea one morning. I had only one sitting, and in spite of my general plan then of relying upon one painting for my final effect, I did later retouch the head from a variety of men, one political refugee from Paris lodging above me, for his beard, being among the number. When Mr Bell came to pump me I was glad to be able to appear interested enough in the sepulchral poetess to remember the fact of her sitting; for the whole idea of poetry and religion which she represents, and also, which Gabriel is so adored for, seems like a nightmare in English thought . . .

 Yours affectionately
 W. Holman Hunt.[3]

One day later that year Hunt was visiting his old friend, G. F. Watts, now in his eighty-second year, at Little Holland House when a young medical student called Francis Fremantle called. A new maternity ward was to be opened in the hospital where he was a student, and the purpose of his visit was to enlist Watts's help in the decoration of the ward. Watts declined, on the grounds that he was too old, but said that Hunt would be just the man for the job. Hunt agreed to help, entering the scheme with enthusiasm, for it was complementary to a scheme he had once had for introducing art to the masses. Unfortunately, before the necessary funds were raised, the student was called away to the Boer War, and the scheme was dropped.

 Despite Hunt's advancing years, his interest in everything that went on in the world was unabated. In August 1898, when a Bill to make smallpox vaccination compulsory was going through Parliament, there was considerable public controversy, and Hunt could not resist joining the fray with a letter to *The Times*:[4]

Is not increasing ignorance of the ravages of smallpox and of the terrible mark which those who escaped with life had to bear until Dr Jenner's treatment came into operation one cause of the latitude with which our legislators extend to those who would leave the question of vaccination at the choice of any being in the state?
About the year 1862 I was conversing with the veteran Judge, the Rt. Hon. Stephen Lushington, and, as his memory was at the time

taking us back to the last decade of the eighteenth century, I asked – not without some reserved resignation of the prejudice that lies ever in aged breasts for the glories of the days of youth – what his view was of the relative beauty of ladies 'seventy years ago' and in the passing day. His warmth in answering was astonishing. 'Well,' he exclaimed, 'you can have no idea how it was that not more than one person in twenty was undisfigured by traces of the smallpox, and this generally to such a degree that whatever beauty there had been was very seriously marred; it followed then that when a woman had escaped there was a disposition to regard her as a beauty for this cause alone, and if with this she had chiselled symmetrical features and good form of face and figure too the admiration of her amounted to worship. The difference I see now is that every lady we meet would have been a beauty in my early days.'

I was quite able to understand the truth of this observation, for a considerable proportion of elderly people in the days of our talk were seen with marks of the disease such as in their youth would have been a serious blemish to their appearance. Now one rarely sees the signs of the infliction, and so I am inclined to think the curse is little dreaded.

During the course of the year 1900, Hunt's many friends subscribed to a fund to enable his portrait to be painted, in commemoration of fifty years' service to English art. The man chosen to paint the portrait was William Blake Richmond, a man whom Hunt liked and for whose work he had the utmost respect. Sitting for the portrait was therefore an enjoyable experience for him. This was, in fact, the second time that he had sat for Richmond, who had painted his portrait for his own collection in 1878. The new portrait was presented to Hunt with a silver salver and an address, at a gathering of many famous figures from the art world, which took place on 3 November 1900. The address was by Leslie Stephen, and read:

In fifty years lovers of English art have been deeply interested in your work. The part which you took long ago in one of the greatest movements which ever affected the artists of this country is not, and cannot ever be, forgotten. Since that time you have laboured in the service of your art with unremitting energy and fidelity to your ideal; encountering and overcoming difficulties and prejudices and manifesting in your life a noble simplicity of character and a warmth of heart which endeared you to many and a quiet enthusiasm which

years have not abated. Never aiming at any success by means unworthy to yourself, original and independent, you have been enabled to do justice to your great powers and your work will, we believe, be treasured by future generations of your countrymen. Most of your comrades have left us before the century, of which you have been an ornament, has closed. In their names, and in our own, we desire to express respect and affection, with every good wish for your future.[5]

'Hunt possessed not only the wonderful optics, but a marvellous brain behind, and a skilled, wonderfully trained hand to delineate,' wrote Hunt's friend, Charles Rowley.[6] The brain and the hand never faltered, but towards the turn of the century, his remarkable, eagle-sharp eyesight began to fade. The problem seems to have been aggravated by work on *The Miracle of the Holy Fire*, which was exceedingly intricate. The condition affected both eyes, and grew rapidly worse, being diagnosed as glaucoma. This initially manifested itself as the gradual loss of side vision, and by 1900 was sufficiently serious for him to give up the prolific letter-writing in which he had always delighted. From 1903 he began to rely on Edith to take dictation from him, though he continued to sign the letters himself. It is not certain whether at this stage he could no longer see well enough to write, or whether he merely wished to conserve what sight he had left.

The gradual onset of blindness was a double tragedy for Hunt, for in addition to reconciling himself to his condition, he had to cope with the threat to his work as a painter. His great fear was, that news of his problem would erode public confidence in his work. He and Edith therefore did everything possible to conceal the extent of the damage to his eyesight, from arranging photographic sessions in which he sat at his easel, brush in hand, to receiving visitors in the studio, where his work stood on the easel in its partly-completed state. On the whole these tactics worked well, but his obvious eye defects gave rise to speculation, and aroused the interest of the press. Edith had her own methods of dealing with reporters. She carefully kept her husband from them, and if they became too persistent, she simply threw them out.

Nevertheless, the unfinished paintings were a problem. In 1873 the architect William Butterfield had made the galling assertion that *The Light of the World* was too small to be an architectural feature of the

chancel of Keble College Chapel. More than a quarter of a century later this still rankled, and finally in 1900 Hunt decided to begin work on a much larger version of the original, while he still had eyes to do it. The new painting was almost four times as large as the original. At first he found that he could work quite well on this scale, but gradually his difficulties increased, and he was forced to seek assistance.

Edward R. Hughes, the nephew of Hunt's artist friend Arthur Hughes, was recruited for the task. Born in 1851, he had been Hunt's pupil, and was the ideal assistant, for he combined excellent artistic abilities with discretion and total loyalty to Hunt, for whom he had a great affection. Under Hunt's direction, he now carried out some of the less intricate work, and together they managed to make excellent progress. An Italian immigrant called Domenico Mancini, who had already modelled for G. F. Watts and Sir William Richmond, posed for the figure, while for the head, they worked from a life-sized model which Hunt had made.

Despite his age and increasing disability, Hunt still felt bitter at the non-recognition in England of his marriage to Edith, and he campaigned vigorously for reform. As Chairman of the Committee of the Marriage Reform Association, he wrote letters to the newspapers on the subject, speaking out frankly in favour of a change in the law. In June 1901, the Marriage Law Reform Bill was scheduled for hearing in Parliament, and Hunt wrote a series of long letters to *The Times* protesting at the unfair means being adopted to prevent its being heard. He pointed out that the 'deceased Wife's Sister' question had been before the country since 1835, and that in recent years the Bills on the subject had won large majorities in both Houses.

'The tactics of an illiberal and, may it not be said, extremely uncharitable section of the clergy have frustrated the will of Parliament,' he wrote. 'An example of this may be seen in the course adopted by Mr Balfour, who, instead of taking the large and Imperial view he professes to be guided by, seems to have allowed himself in this instance to become the agent of the ecclesiastical minority.'[7]

Balfour's tactics were to depose the Bill in favour of two other Private Members' Bills, knowing full well that there would be insufficient time left in the Parliamentary session for the Marriage Law Reform Bill to be heard. Hunt made the point that many people were suffering unnecessary hardship because of a law which prevented certain persons who were related by marriage only and not by blood from marrying. He was not particularly concerned about the embargo

on marriages with a deceased wife's niece, as there were relatively few such instances, but he claimed that cases of men wishing to marry the sister of a deceased wife were very common. This was probably true. In those days of large families and high mortality in childbirth, many widowers were suddenly left with large families to bring up single-handed. It was natural for widowers to turn to the sisters of their late wives for practical help and support, and in many such instances this led to the development of deeper feelings. Marriage was virtually the only career open to women in the Victorian era, but women greatly outnumbered men, and for many, taking the place of a dead sister was the only chance of fulfilment.

On 6 July Hunt took the offensive in *The Times* again. 'The Constitution of this country assumes that deference will be paid to the pronounced opinion of the majority;' he wrote, 'it is supposed to provide the means of redress for every popular grievance, and it specially aims at protecting the just liberties of a free people. These are its fundamental principles, now wholly subverted through the systematic obstruction resorted to by the minority . . . This small party in the State demands general submission to a doctrine against which all science revolts and which human reason repudiates. It insists that the law of the State shall conform itself to medieval canons that are utterly inconsistent with Christian charity and intellectual freedom. I protest against such despotic and unnatural pretensions, and appeal to all lovers of justice and religious liberty among my countrymen to release this nation from a worse than Eastern tyranny and to guard our popular institutions from menaces of an insidious ecclesiasticism. Let us as Britons never forget what have been the disastrous results uniformly following the resort to arbitrary and unconstitutional methods.'

In 1902 the Hunts were obliged to give up Draycott Lodge when it was compulsorily acquired for the building of a school. They moved to 18 Melbury Road, a brick and stucco gaslit house built by William Turner of Chelsea and sold on a ninety year lease. It was a prestigious location, close to Lord Leighton's former residence, and the ground rent of the houses was between £70 and £100 per annum, a large sum of money in those days. Hunt's treasures were carefully transported there – the Della Robbia, the Bellini, the Van Dyck crucifixion, all protected from the sunlight by Edith's taffeta curtains; the Richmond portrait of Hunt, bearded, serene, with a lifetime's struggle behind him; the sideboard given to him by Egg, with more of Edith's little

curtains round the legs, to hide the books piled underneath, and countless prized possessions, of real or sentimental value.

Despite his advancing years, Hunt still led a very active social life, and he and Edith were constantly entertaining, often on quite a large scale. The young Virginia Woolf vividly recalled a dinner party at their home in Melbury Road:

So it appeared that . . . I was about to have another lesson in the art of behaviour at the house of Mrs Holman Hunt. She was giving a large evening party. Melbury Road was lined with hansoms, four-wheelers, hired flies, and an occasional carriage drawn by a couple of respectable family horses. 'A very "dritte" crowd', said George [Duckworth] disdainfully as we took our place in the queue. Indeed all our old family friends were gathered together in the Moorish Hall, and directly I came in I recognised the Stillmans, the Lushingtons, the Montgomeries, the Morrises, the Burne-Joneses – Mr Gibbs, Professor Wolstenholme and General Beadle would certainly have been there too had they not all been sleeping for many years beneath the sod. The effect of the Moorish Hall, after Bruton Street, was garish, a little eccentric, and certainly very dowdy. The ladies were intense and untidy; the gentlemen had fine foreheads and short evening trousers, in some cases revealing a pair of bright red Pre-Raphaelite socks. George stepped among them like a prince in disguise. I soon attached myself to a little covey of Kensington ladies who were being conveyed by Gladys Holman Hunt across the Moorish Hall to the studio. There we found old Holman Hunt himself dressed in a long Jaeger dressing gown, holding forth to a large gathering about the ideas which inspired him in painting *The Light of the World*, a copy of which stood on the easel. He sipped cocoa and stroked his flowing beard as he talked, and we sipped cocoa and shifted our shawls – for the room was chilly – and we listened. Occasionally some of us strayed off to examine with reverent murmurs other bright pictures upon other easels, but the tone of the assembly was devout, high-minded, and to me after the tremendous experiences of the evening, soothingly and almost childishly simple. George was never lacking in respect for old men of recognised genius, and he now advanced with his opera hat pressed beneath his arm; drew his feet together, and made a profound bow over Holman Hunt's hand. Holman Hunt had no notion who he was, or indeed who any of us were; but went on

sipping his cocoa, stroking his beard, and explaining what ideas had inspired him in painting *The Light of the World* until we left.[8]

At fifty-seven years of age, Edith was still exceedingly active. While Holman worked at his paintings, she painted the staircase, decorated the kitchen walls with murals, and enamelled the bath with her own hands. There was plenty to occupy her here in this rambling old gaslit house, even though Hilary, like Cyril, was now living abroad. Gladys was still unmarried and living at home, and as an artist herself she was able to attend to many little items of business on her father's behalf. It was she, for instance, who went to view the original version of *The Light of the World* in the chapel at Keble College, and discovered that the title was hidden by the outer oak frame. Hunt accordingly dictated a stern letter to the College authorities, as a result of which matters were put right.

The Hunts looked on their move from Draycott Lodge to Melbury Road as a transfer from the country to a house in town, though nowadays both addresses would be regarded as being in the heart of London. Although in other respects they were satisfied with their move, they missed their lovely large garden. Now that Hunt had given up foreign travel, he decided to build himself a country cottage with a large garden where he and Edith could spend the summer months in peace. He accordingly acquired a large plot of land at Sonning on Thames, which was one of his favourite haunts. Gladys designed the house for her father. Before they moved into the house at Sonning, Edith had about thirty of their most important art treasures photographed, and painted over the photographs in water-colours, housing them in a specially made solander box embossed with gold.

In the winter of 1903, the large version of *The Light of the World* was finally completed. Shortly afterwards Hunt and Edith entertained Charles Booth, a wealthy Leicestershire ship-owner and his wife, Mary, to dinner in the house in Melbury Road. Booth, who was a partner in the Liverpool firm of Alfred Booth and Co., was a well-known philanthropist. He had devoted half his life to the collection and study of statistics, and had written *The Religious Influences of London* and *Life and Labour in London*. The visitors were eager to see *The Light of the World*, and when Hunt gratified their wish, they were completely overwhelmed by the painting. D. J. Furnivall, an agnostic, gave a contemporary account of what happened next:

And after Mr Hunt told him [Booth] that he could hardly hope to sell the picture because he should make it a condition that the buyer should not only leave it to a public gallery on his death but should speedily send it out to South Africa to preach its message to the Boers, whose clergy were still keeping up their enmity to the English, Mr Booth went home and wrote to Mr Hunt that he would not only buy the picture under his conditions but would undertake to send it also to Australia, and Canada, and then leave it to the Tate Gallery after his death, meantime taking care that careful reproductions of it in colour should be everywhere on sale at moderate prices. This frank and generous offer from a fine man was of course gladly accepted by the artist; and the picture has already been copied by two well-known firms at Eltham and Enfield.[9]

On 14 December 1903, Mary Booth wrote to her daughter Imogen:

Your father and I are going to London to dine with the Holman Hunts. This is to meet Lady Loch [widow of the Governor of the Cape and High Commissioner in South Africa] and talk over the best method of carrying out her and your father's plans about the new *Light of the World* . . . Lady Loch has always wanted that the round of the British Empire should see the picture and your father wants to buy it and give it to the Nation; but is going to arrange with Lady Loch and Mr Hunt about its going on tour in South Africa, Australia and Canada first; to be placed finally in a gallery here; the National or the 'Tate' or one of the others. I think Mr Hunt is very much pleased. If the nation accepts the gift; and they can hardly help doing so; he (Mr Hunt) will be assured that one first rate specimen of his work will belong to the nation; and it is one which in a very special way embodies his ideas on religion and life.[10]

This latter point was a very important one to Hunt, for it rankled with him that the only picture of his which had been acquired by the Tate at that time was *The Ship*, an interesting work but a minor one, which he had painted on local canvas on his third visit to Syria, before beginning work on *The Triumph of the Innocents*. The exact financial details have not come to light, but it is thought that Booth acquired the painting for £1,000, and spent a further £5,000 on the tour. Since Hunt's work was able to command a much higher price, it would appear that he

reduced the normal price on the understanding that his wishes for the future of the painting would be met.

On 29 January 1904, Mary Booth wrote to her husband from Gracedieu, their home in Leicestershire: 'Lady Pollock says she thinks Mr H. Hunt and Edith are ten years yonger since you bought the picture. She dined with them and he told her all about it in detail and Edith was radiant.'[11] In March and April 1904, the painting was exhibited by the Fine Art Society in New Bond Street, where it drew large crowds. An excellent colour print of the original version hung beside it, so that viewers could compare the two. The new picture was painted in a looser, broader style and was almost four times as large as the first painting. The head was raised, so that the eyes seemed to look directly at the viewer, and it was larger in proportion to the body. The alignment of the head was slightly altered, the lighting was more vivid, and the moonlight effect was of a deeper blue. A crescent and a star were added to the lantern, indicating that the picture was directed at Muslims as well as Christians.

Furnival wrote: 'I claim that this new *Light of the World* is the culmination and crown of Victorian English Art – nay, the greatest that our country has ever produced, and fit to range with the most glorious creations that the world has ever seen.'[12]

Meanwhile, however, Hunt's eyesight had deteriorated even further, and he decided to go to Wiesbaden in Germany to consult a famous German oculist. On being told that there were good prospects of improving his eyesight, he submitted himself to an operation, which involved cutting into the cornea of each eye. In the event, the operation failed, leaving him even worse off than before.

In February 1905, *The Light of the World* was shipped to Canada in the *Pretorian*. When it reached Halifax, Nova Scotia, where it was placed on exhibition in the Masonic Hall before going on tour, the snow lay thick on the ground. At first the tour arrangements were unsatisfactory and public response was poor, but as time went on interest increased. After this it toured Australia and New Zealand, being greeted wherever it went with rapturous enthusiasm.

Meanwhile, at home in London, Hunt finally finished *The Miracle of the Holy Fire*. Rowley wrote of it: 'Still more astounding is the *Holy Fire* picture, where this miracle of the Greek Church is shown with unsurpassed dramatic force. I know of nothing, ancient or modern, to match this wonderful scene in the Chief Church at Jerusalem when the fire is shown as coming from heaven to an excited crowd of devotees.

Motive, action, intensity, grouping, colour can go no further. This great work, along with the large *Lady of Shalott*, one saw constantly at Melbury Road.'[13]

Rowley's comments make it clear that although he admired the picture enormously, its satire was lost on him. This would have been a common reaction. The lack of a focal point and the complexity of the composition help to underline the chaotic nature of the ritual. Hunt had hoped that the painting would have a profound effect on those who advocated union with the Church of Russia and Greece, but it was nearly thirty years since he had first begun making sketches for the painting, and this was no longer a live issue. The picture was exhibited in the New Gallery, and afterwards in Liverpool. No buyer emerged, and finally Hunt decided to keep it in his own house.

In April 1905, when Edith was on holiday in Italy with Hilary, Hunt wrote a letter to Frederick Shields, saying that he had just finished *The Lady of Shalott*. His handwriting was exceedingly shaky, and he explained that he could hardly see at all except at a few inches' distance. In view of his blindness, people now began to question whether he had actually painted these last two great pictures himself, but friends came forward to set the record straight, including Edward Clodd, who wrote of *The Lady of Shalott*: 'Having seen it from its outline on the canvas and at frequent intervals during its progress, I can affirm that all the essential part of the picture was his work, and that only in the later stages, when near its completion, did his blindness compel him to call in the help of an artist friend.'[14]

The design for *The Lady of Shalott* went back to 1850, when he did a preliminary drawing. This was used for his 1857 illustration for Moxon's edition of Tennyson. It represents the breaking of the web, when the Lady breaks her vow not to look out of the forbidden window on the world, and sees Sir Lancelot below. The picture was intended to represent the eternal opposition between the forces of good and evil. Tennyson himself had taken issue with Hunt over the representation of the whirlwind effect in the Lady's hair, saying that he had never intended it, but Hunt was unrepentant, and this effect is an important feature of the painting, contributing to the vigour and movement in the overall design. So anxious was Hunt to get the precise effect that he desired, that he spent three years painting the hair, for which his model was Mrs Amelia Milnes. What is truly remarkable is that in this, his last great work, he returned to an early theme to create a Pre-Raphaelite painting which in its colour and

movement is as powerful as anything painted in the flush of youth and strength.

There were two other highlights of the year 1905. The University of Oxford conferred on Holman Hunt the honorary degree of Doctor of Civil Law, and later, King Edward VII awarded him the Order of Merit, which he had personally created. These were moments of great personal triumph for Hunt, and an acknowledgment that after a lifetime of struggle he had won a great victory for the Art of England. His works were well represented in an important exhibition at Whitechapel, under the title 'British Art Fifty Years Ago'.

Though Hunt's life as an active painter was now at an end, he felt that it was his duty to publish the true version of the origins of Pre-Raphaelitism. Taking as a basis the articles which he had contributed to the *Contemporary Review* in 1886, he produced a two-volume combined autobiography and account of the Brotherhood under the title *Pre-Raphaelitism and the Pre-Raphaelite Brotherhood*, which was published by Macmillan in 1905. The dedication, of which Edith was very proud, reads: 'TO MY WIFE as one of my insufficient tributes to her whose constant virtues ever exalt my understanding of the nature and influence of womanhood.'

Hunt still adored Edith, who had devoted herself selflessly to him throughout their long married life. In everything except his art she had tremendous influence over him, not always for the better. That enormous generosity of spirit which he had exhibited in his younger days was to some extent eroded after their marriage, as Edith's dogmatic pronouncements on everything that touched their lives gradually wore him down. Edith was not without personal vanity. Taking advantage of her husband's blindness, she secretly asked Edward Hughes to make certain small alterations to Hunt's portrait of her, in order that she might appear even more beautiful. The outline of her body was accordingly fined down, in order to make her look slimmer, and her lips, which had been pale and virginally pure, were reddened to make them more attractive.

For the blind artist himself, the image of his wife's pale, unsullied purity was the picture that he kept in his heart for the rest of his life. He was to the last faintly in awe of her womanhood, and cherished and courted her in old age long after the physical ardour of earlier years had left him. In her indomitable courage, both physical and mental, Edith won his respect, and this was one of the aspects of her personality

266

which made her the ideal wife for him, though she lacked his grand nobility of spirit.

On 24 October 1905 Hilary married Gwendolen Norah Freeman, known to the family as Norah. Her father was a wealthy King's Counsel, George Mallows Freeman, and her mother was Annie, daughter of Robert Holborn, a rich tea-merchant of Mincing Lane. Hunt both liked and respected George Freeman, who in 1919 became High Sheriff of Sussex and Baron of the Cinque Ports. Norah had been brought up in great luxury in their elegant house, 33 Philimore Gardens, Kensington, and was a talented amateur artist. She was also a young woman of charm and beauty, and as Hilary was exceptionally handsome, they made a fine couple as they walked down the aisle of St Mary Abbots, Kensington. The choir sang 'Oh God Our Help in Ages Past', and Susan Lushington played the violin. Afterwards Edith pressed a sprig of white heather in her order of service, just for luck.

Meanwhile, *The Light of the World* had reached Australia, where it made a triumphant tour, being greeted with enormous public enthusiasm. People who had never before seen a work of art travelled hundreds of miles to see it. Mrs Katherine E. Andrews wrote a fifteen-page booklet in celebration of the event, entitled *The Light of the World: The Painter and the Picture*. On 24 April 1906, Alfred Deakin, the Prime Minister of Australia, wrote to Charles Booth to thank him personally for sending the picture to Australia. In his reply, Booth said: 'Mr Hunt writes "The way the picture is moving our fellow countrymen in the colonies is delightful and I rejoice to find that your hopes of this interest are so richly fulfilled."'[15]

The picture moved on to New Zealand, where it continued its triumphal progress. But by now it was clear that disputes had broken out between the Hunts and the Booths over the tour of the picture and its ultimate destiny. Having made various stipulations about its future as a condition of sale, Hunt felt justified in sticking to the letter of the agreement, and in writing introductory material to accompany the picture on the various stages of its journey. All his life Hunt had been fiercely nationalistic, and confident of English superiority over all other races. This was a common sentiment in the heyday of British imperialism. In Hunt's opinion, the clergy in the Transvaal had been hostile to the British ever since the Boer War, and he regarded the exhibition of the picture there as a patriotic as well as a religious mission. With this in mind, he wrote an addendum to the printed matter which accompanied the picture wherever it went on the tour.

He also wanted to hold Booth to his promise to bequeath the painting to a public gallery, such as the Tate, and felt somewhat betrayed when suggestions began to creep in, that it should go instead to St Paul's Cathedral. Having had so much trouble with the authorities at Keble College, he wanted to steer clear of churches and cathedrals. Though the picture had come to be looked on as the sacred icon of the Church of England, Hunt was an artist through and through, and it was as an artist that he wished to be remembered by posterity.

Booth, who was an easy-going fellow, seems to have been happy enough to agree to Hunt's demands, but Mary Booth found them irksome in the extreme, and egged her husband on to challenge or ignore them, as the following letter, which she wrote to her husband from their London House at 24 Great Cumberland Road on 5 June, 1907, demonstrates:

My darling,

I am troubled about the commission you give me to pick up and patch the ravelled threads of the Holman Hunt addendum. You see I cannot agree with you that it does not matter, or that it matters very little.

I disapprove entirely, and think it would be wrong in you to allow anything which might be mischievous to go to South Africa. Everything matters there. You remember how we were only saved by the skin of our teeth from sending the picture first to South Africa, and under the charge of the gushing ladies of the S. A. League. We realized suddenly what was meant, and how what had only seemed to us in bad taste and rather silly, might be harmful.

And now, when we have steered clear of the danger, they would come in again by a side wind, less obtrusively, perhaps, but at an even more ticklish time; and when you are personally committed, by your acquaintance with the premier, and your letter asking them to welcome your picture, not to embarrass them by such a manifesto. You *cannot* escape responsibility for it.

So I send the thing back to you; and if you still think that you would like it tinkered at and sent out, it will be in your hands, on the other hand here is my advice.

I should write with the utmost friendliness, but quite frankly and plainly, to Mr Hunt; say that you are sorry you had not waked up to the import of what was proposed when you were with him, and that now, having read the addendum very carefully, you hesitate, in the

present state of affairs in SA to send it; – that you are fully conscious of what you owe to Lady Loch, and will try to put together a sentence or two to express this in your own words and let Mr Mack Jost have it to append to – to use in Natal.

About one thing I am certain – that Mr H. Hunt should not be allowed any latitude.

If he gets half a chance he will do mischief, for the very natural reason that he is full of it, and has been longing, ever since you bought the picture, to put in the knife in this particular way, and the way that, as I see it, we *cannot* allow. You must remember, of course you do, that the mere name of Loch raises party feeling out there, and is associated in the minds of everyone with his (Lord Loch's) strong, and to the minds of most of us, ridiculously strong views and methods.

To write to Mr Hunt, and say you think better not send his addendum will be all the easier, as you have to write to him about the St Paul's question, and can here easily agree to his wishes, as expressed in his fierce, fighting dispatch to you which I enclose. What you say about the addendum might be in a post script; as simple as possible as long as it is decisive.[16]

As usual, Mary Booth had her own way. By the time *The Light of the World* left New Zealand, it was estimated that four-fifths of the population of Australasia had seen it. Even in his seventy-ninth year, Hunt's star was still in the ascendant. Its tour of South Arica was no less successful, and Hunt was very gratified by the outcome, even though his addendum was not published.

Back home in England, two major art exhibitions of his works celebrated his achievement, under the title 'The Collected Works of William Holman Hunt, OM, DCL', in 1906, at the Manchester Art Gallery, and at the Leicester Galleries. Hunt could at this stage still see well enough to distinguish the different lines of every colour on the palette, provided that he held it within a few inches of his eyes. At the opening of the Manchester Exhibition he made a speech, entirely without notes, which lasted for three quarters of an hour. He later admitted candidly that he could no longer work without a fellow professional at his elbow to tell him whether or not the colours were properly blended before they dried. His frankness cost him dearly. *The Lady of Shalott* was so popular that plans were afoot to raise a public subscription to buy it. His remarks at the opening cast doubts in

the mind of the public as to how much of the picture he had actually painted himself, and the plan to purchase it was consequently abandoned.

In 1897 he had turned again to the picture of *Christ and the Two Marys* which he had begun half a century before, and had laid aside, mainly because of lack of cash to enlarge the canvas. He had painted in the figure of Christ, which had been roughly sketched, against a background of the Mountains of Moab in 1897. When his book, *Pre-Raphaelitism and the Pre-Raphaelite Brotherhood* was published in 1905, however, he stated that the picture was still unfinished. Nevertheless, Hunt was a man who hated leaving anything unfinished when once he had started it, and it was finally finished just in time to be included in the last few weeks of the exhibition of his work in the Manchester Art Gallery and in the whole period of the exhibition at the Leicester Galleries.

The Deceased Wife's Sister's Act, for which Hunt had campaigned so vigorously, was finally passed in 1907. It was a time of triumph for Hunt and for Edith. As far as the laws of England were concerned, their marriage was at last recognized as legal. There is little doubt that they had paid a high price for the illegality of their union, which had probably weighed as heavily against Hunt in the granting of ecclesiastical commissions and national honours as his conduct in the Bishop Gobat affair.

Hunt was, however, destined to lose his battle for *The Light of the World* to be hung in the Tate Gallery, for although Booth eventually offered it, his offer was apparently rejected by the governors. This rejection may have been engineered by the Booths, for Mary Booth was a clever, scheming woman and her husband now felt strongly that its rightful place was in St Paul's Cathedral. Eventually, having been satisfied that his painting would be treated with all the respect and care which were its rightful due, Hunt was happy to accept St Paul's as the proper location for his great masterpiece. After its tour of South Africa it was returned to Hunt at Melbury Road to await the presentation ceremony.

Originally the presentation of the picture was scheduled to take place in October 1907, but following a strenuous holiday in the mountains of Austria, Booth was taken ill with angina pectoris. The ceremony was accordingly postponed until Friday 5 June 1908, but Booth was still too ill to attend, and was represented by his son-in-law, Malcolm MacNaughton.

The congregation was large, and included Mary Booth, Lady Loch and Mary Millais, who was Hunt's god-daughter. Hunt himself was formally dressed in a morning suit with a black silk top hat, while Edith wore an eye-catching outfit topped with an enormous hat and veil.

When the picture was unveiled, the choir sang the psalm, 'Thy word is a lantern unto my feet and a light unto my path', followed by a reading from the Book of Revelation, chapter 3, which had been Hunt's inspiration. As he stood in front of the painting, tears welled up in Hunt's eyes and blurred what little sight remained in them. At the end of the ceremony, Edith and MacNaughton led him gently away, old, blind, helpless but unbowed by a lifetime of struggle for his art.

In December 1908, Hunt went to the tercentenary celebrations of Milton's birth at Burlington House. It was a prestigious assembly of people from the world of art and literature. Afterwards, George Meredith wrote to him: 'Your gallantry in going to Burlington House had been mentioned to me, and I envied you – not as being one of the audience, but for proving legs and hearing. At the same time I remember sadly that you are now sharing Milton's woe, most grievous in a painter. That you bear the affliction with courage I can believe . . . As to we two, we may say that the gods may rob us of everything except the heart to endure.'[17]

Now that his work was over, Hunt sat back and enjoyed his music and listened to poetry and drama. The garden at Sonning, and the river were his chief delight, and he never tired of picnics along the river bank, or bowling on the green of a country inn. Often he went for long walks, of up to ten miles along the country lanes. Sometimes, too, he spent a day at the races, or went to concerts and poetry recitals. He had an insatiable appetite for gadgetry and the inventions of science and still enjoyed nothing more than a lively conversation with friends. A secretary, Mr Crauford, helped him with his correspondence now, and many friends still visited him. Charles Rowley recalled one such occasion:

One Sunday I was entrusted with the veteran with his darkened vision for an afternoon walk. I had received strict instructions as to the way out and home in those pleasant lanes, but, true to my character as 'the Loser' we soon got wrong. It made no difference to my companion, although he knew full well that I had lost him. The rain came on, and we sheltered in a cottage, where he soon grew

friendly, and we got home some two hours late. But what a talk he had and what a willing auditor! . . . Nothing could have been more perfect and luminous than his delightful talk.[18]

On 30 July 1910, Hunt went with Edith to Sonning, intending to pass the summer reading *Don Quixote*, Montaigne and Meredith. With Edith's help he studied the philosophy of Tennyson's *In Memoriam*, and puzzled over the meaning of Shakespeare's sonnets. From time to time they toured the local beauty spots, and Mr and Mrs Forbes Robertson came and spent the day with them. On 21 August he went out for the last time. Next day it was obvious that he had caught a slight chill, which turned to asthma. Gradually he grew weaker, and finally, at his own request, he was brought back to London, virtually unconscious.

Holman Hunt died at 18 Melbury Road on 7 September 1910. Edith was with him at the end, together with Gladys, and Hilary's wife, Norah. The King sent a message of sympathy, and a purple pall with a broad border of bay leaves was made by his family and friends, including Gladstone's widow and daughter, and Mary Millais. He was cremated at Golders Green three days later. As the coffin left the house, all the blinds in the neighbourhood were drawn as a mark of respect. There were many wreaths, but only one on the coffin, a huge cross of arum lilies from the family. Archdeacon Wilberforce read the service, and the choir of St Mary Abbots, Kensington, led the singing of 'Oh God Our Help in Ages Past', and 'Fight the Good Fight'.

The state funeral took place at noon on 12 September in St Paul's Cathedral. Professor C. T. Currelly, representing Cyril, struggled up the steps through the crowd carrying the ashes in a heavy marble urn crowned with bay leaves, and placed it on the bier. The faithful William Rossetti, last of the Pre-Raphaelite Brothers, was a pall-bearer, together with Arthur Hughes; Sir Charles Holroyd, the Director of the National Gallery; Forbes Robertson, the actor; Lord Tennyson; Charles Booth; Sir Norman Lockyer and Professor Gollancz. Edith and Gladys, Hilary's wife Norah, and Mary Millais, Holman's god-daughter, led the mourners, Hilary and Cyril being in India.

Hunt's ashes were finally laid to rest inside St Paul's Cathedral, beside Johnny Millais. It was where he had wished to be.

Hunt's name on the stone slab, and on the order of service for the cremation, is given as 'William Holman-Hunt', hyphenated. It is said

that Queen Victoria expressed the wish that he should hypehnate his name, as befitted an artist of such importance. Hunt never acted on this, but after his death, Edith always used the hyphen.

Edith and Edward Clodd were joint executors of the will. The estate was valued at £16,169. 1s. 4d., a handsome sum for one who had started out as a penniless clerk in the City. Edith and the children were the main beneficiaries, but nobody was left out. The nation benefited from the bequest of the Richmond portrait, which went to the National Portrait Gallery.

Edith never stopped loving her husband with all her heart. As a tribute to his memory, she carefully edited the second edition of his memoirs, which was published in 1913. When she died in 1931, her ashes were buried beside his in the crypt of St Paul's Cathedral.

Epilogue

'IF the other P.R.B.'s had had to pass a vote as to which of their colleagues they admired most,' wrote William Rossetti, 'they would all, I conceive, have named Holman Hunt, while he, himself, would have named Millais. We thoroughly admired him [Hunt] for his powers in art, his strenuous efforts, his rigorous personality, his gifts of mind and character, his warm and helpful friendship. Not, indeed, that we should have ignored the more than co-equal claims of Millais, as a pictorial executant, but he had not had to fight a savage fight . . .'

Gabriel Rossetti's association with Pre-Raphaelitism was short lived. Soon he had reverted to the mediaevalism which was his real source of inspiration, and had surrounded himself with disciples, of whom Morris and Burne-Jones were the foremost. Though they possessed the seeds of genius, they acquired the name Pre-Raphaelite chiefly through association with Rossetti, and their guiding principles were quite different from those of Hunt and Millais. By January 1855 Hunt acknowledged that the Brotherhood was dead. He and Millais were now the only ones who still clung to the ideals of Pre-Raphaelitism. Five years later even Millais had conceded to the demands of popular taste, and Hunt was left to carry on the work alone.

Hunt's original objectives were to free English art from the rigid constraints of colour, composition and theme which had long held it prisoner; to take inspiration direct from nature; to popularise a realistic style of painting; and to give his pictures an important underlying meaning, usually moral or religious, which would prevent them from becoming a mere scientific record.

By the time he was thirty, Hunt had achieved all these aims. In the process he had abandoned his original desire to find acceptance within the walls of the Royal Academy, reconciling himself instead to a solitary professional existence, in which each new painting that he began was an individual struggle for perfection.

No expense of time and effort, no physical danger was too great for Hunt in his pursuit of realism. Although Hunt developed considerable

business acumen, personal wealth was only a secondary considera-
tion. He was prepared to accept a lower sum for reproduction rights of
his paintings in return for better quality engraving, and nothing gave
him greater pleasure than the knowledge that copies of his great
religious paintings adorned the walls of working class people through-
out the country.

There was no such thing as a typical Hunt subject, for Hunt prided
himself on his diversity of theme. Though from time to time financial
neccessity led him to accept commissions for portraiture, he was not
content to turn out competent likenesses, but sought to set new
standards of achievement. When he claimed in a letter to Stephens that
his portrait of Stephen Lushington was 'the best painted portrait of
modern times,' he was arguably correct in his assessment. It was a
standard of excellence that he was to achieve over and over again, for
nothing less would satisfy him.

Throughout Hunt's long and distinguished career, he clung to his
original Pre-Raphaelite ideals. By patient application, he refined his
talents at an early age, reaching the height of his powers by the time he
was twenty-four. What is remarkable is that his genius never dimin-
ished, and that the pictures he painted in old age are as vigorous and
compelling as the works of his early maturity.

After the first world war there was a revulsion of public taste against
everything Victorian, from the architecture of private dwellings and
national monuments to the furniture and ornaments that people put in
their houses. The work of Victorian artists suffered along with
everything else. Once more it was fashionable to laugh at the paintings
of the Pre-Raphaelites, and those lucky enough to have inherited
them, took them down from their walls and sold them for paltry
sums, or consigned them to attics and cellars.

In the nineteen sixties came a revival of interest in the Pre-
Raphaelites, whose pictures were taken out of the attics, dusted down
and restored to favour. Curiously, Hunt's just claim as the originator
of the movement has been denied, and his work has continued to be
largely neglected. Probably he has suffered simply for the lack of a
significant voice to speak out on his behalf. Yet whatever the cause,
the day will surely come when the public stand again before Hunt's
paintings with their prejudices cast away and the veils removed from
their eyes. Then, without a doubt, his mastery will be perceived,
and William Holman Hunt will be acknowledged as the true
Pre-Raphaelite.

Bibliography

Allingham, Helen, and Williams, E. Baumer: *Letters to William Allingham*, 1911

Angeli, Helen Rossetti: *Dante Gabriel Rossetti: His Friends and his Enemies*, 1949

Bennett, Mary: *William Holman Hunt: An Exhibition arranged by the Walker Art Gallery*, 1969
 Artists of the Pre-Raphaelite Circle: The First Generation, 1988

Burne-Jones, Georgiana: *Memorials of Edward Burne-Jones*, 1904

Chapman, Ronald: *The Laurel and the Thorn: A Study of G. F. Watts*, 1945

Clark, Anne: *The Real Alice*, 1981

Clarke, William M: *The Secret Life of Wilkie Collins*, 1988

Clodd, Edward: *Memories*, 1916

Cohen, Morton N. (Ed.): *The Letters of Lewis Carroll*, 1979

Cook, E. T.: *Life of Ruskin*, 1911

Davidson, Angus: *Edward Lear Landscape Painter and Nonsense Poet*, 1938

Dobbs, Brian and Judy: *Dante Gabriel Rossetti An Alien Victorian*, 1977

Doughty, Oswald: *A Victorian Romantic: Dante Gabriel Rossetti*, 1949

Doughty, Oswald, and Wahl, John R.: *Letters of Dante Gabriel Rossetti*, 1965

Fine Art Society, The: *Notes on the Pictures of Mr Holman Hunt Exhibited at the Rooms of The Fine Art Society*, 1886, With Criticisms by John Ruskin, LLD, DCL

Fox, Caroline: *Memories of Old Friends*, 1881–3

Fredman, William E.: *Pre-Raphaelitism, A Bibliocritical Study*, Cambridge, Mass., 1965
 (Ed.) *The PRB Journal*, 1975
 (Ed.) *A Pre-Raphaelite Gazette: The Penkill Letters of Arthur Hughes to William Bell Scott and Alice Boyd, 1886–97*, 1967

Fuller, Jean Overton: *Swinburne, A Critical Biography*, 1968

Gaunt, William: *The Pre-Raphaelite Tragedy*, 1942
 The Aesthetic Adventure, 1988

Gissing, A. C.: *William Holman Hunt: A Biography*, 1936

Glynn Grylls, Rosalie, *Portrait of Rossetti*, 1964

Graham, James: *Jerusalem: Its Missions, Schools, Convents, etc. under Bishop Gobat*, 1858

Green, Roger Lancelyn (Ed.): *The Diaries of Lewis Carroll*, 1954

Grigson, Geoffrey (Ed.): *William Allingham's Diary*, 1967

Bibliography

Hall Caine, T.: *Recollections of Dante Gabriel Rossetti*, 1882
 My Story, 1908
Hill, George Birkbeck: *Letters of Dante Gabriel Rossetti to William Allingham 1854–1870*, 1897
Holiday, Henry: *Reminiscences of My Life*, 1914
House, Graham: *Dickens' Letters*, 1965
Hueffer, Ford Madox: *The Pre-Raphaelite Brotherhood, A Critical Monograph*, 1907
 Ford Madox Brown: A Record of His Life and Work, 1896
Holland, Vyvyan: *Son of Oscar Wilde*, 1954
Holman-Hunt, Diana: *My Grandmothers and I*, 1960
 My Grandfather, His Wives and Loves, 1969
 'The Holman Hunt Collection: A Personal Recollection', *Pre-Raphaelite Papers*, Leslie Parris (Ed.), 1984
Holman-Hunt, Marion Edith: *Children at Jerusalem: A Sketch of Modern Life in Syria*, 1881
Holman Hunt, William: *Pre-Raphaelitism and the Pre-Raphaelite Brotherhood*, 1905 (second edition, revised by Edith Holman-Hunt, 1913)
 Bishop Gobat in Re Hanna Hadoub 1858
 'Pre-Raphaelitism: A Fight for Art' (series of three articles), *Contemporary Review*, April, May, June 1886
 'Painting the Scapegoat', *Contemporary Review*, June 1887
Hunt, Violet: *The Wife of Rossetti, Her Life and Death*, 1932
Jerusalem Diocesan Missionary Fund, The: *Fifth Annual Report*, 1853
Landow, George P.: *William Holman Hunt's Letters to Thomas Seddon*, 1983
 William Holman Hunt and Typological Symbolism, 1979
 Your Good Influence on Me – The Correspondence of John Ruskin and William Holman Hunt, 1977
 William Holman Hunt's 'The Shadow of Death', 1972
Layard, G. S.: *Tennyson and his Pre-Raphaelite Illustrators*, 1894
Lutyens, Mary: *Effie in Venice*, 1965
 Millais and the Ruskins, 1967
Maas, Jeremy: *Victorian Painters*, 1969
 Holman Hunt and The Light of the World, 1984
Marsh, Jan: *Pre-Raphaelite Women*, 1987
 Pre-Raphaelite Sisterhood, 1985
Meredith, William Maxse: *Letters of George Meredith*, edited by his son, 1912
Millais, John Guille: *The Life and Letters of Sir John Everett Millais*, 1899
Minto, J. (Ed.): *Autobiographical Notes of the Life of William Bell Scott HRSA, LLD*, 1892
Noakes, Vivien: *Edward Lear: The Life of a Wanderer*, 1968
Packer, Lona Mosk: *Christina Rossetti*, 1963
Parris, Leslie (Ed.): *Pre-Raphaelite Papers*, 1984

Ritchie, Hester: *Letters of Anne Thackeray Ritchie*, 1924

Rowley, Charles: *Fifty Years of Work Without Wages*, 1911

Rose, Andrea: *Pre-Raphaelite Portraits*, 1981

Rossetti, William Michael: *Dante Gabriel Rossetti: His Family Letters with a Memoir*, 1895

 Pre-Raphaelite Diaries and Letters, 1900

 The Works of Dante Gabriel Rossetti, 1911

 Ruskin: Rossetti: Pre-Raphaelitism: Papers 1854–1862, 1899

 Rossetti Papers, 1862–1870, 1903

 Some Reminiscences, New York 1906

 Fine Art Chiefly Contemporary: Notices Reprinted with Revisions, 1867

Rowley, Charles: *Fifty Years of Work Without Wages*, 1911

Ruskin, John, *The Works of John Ruskin*, ed. E. T. Cook and Alexander Wedderburn, 1903–12

Seddon, John P.: *Memoir and Letters of the Late Thomas Seddon, Artist, by His Brother*, 1858

Staley, John: *The Pre-Raphaelite Landscape*, 1973

Stephens, F. G.: *William Holman Hunt and His Works: A Memoir of the Artist's Life, with Descriptions of His Pictures*, 1860

 Dante Gabriel Rossetti, 1894

Sunday Society, The: *Report 1897–1902*

Surtees, Virginia (Ed.); *The Diaries of George Price Boyce*, 1980

 The Diaries of Ford Madox Brown, 1981

Tennyson, Hallam: *Alfred Lord Tennyson*

Troxell, Janet Camp: *Three Rossettis*, Cambridge, Mass., 1937

Von Schleinitz, Otto: *William Holman Hunt*, Bielefeld and Leipzig 1907

Wood, Christopher: *The Pre-Raphaelites*, 1981

Woolf, Virginia: *Moments of Being*, 1976

Woolner, Amy: *Thomas Woolner, RA, Sculptor and Poet: His Life in Letters*, 1917

List of abbreviations

AH	William E. Fredeman (Ed.): *A Pre-Raphaelite Gazette*
D&W	Oswald Doughty and John R. Wahl: *Letters of Dante Gabriel Rossetti*
DGR	Dante Gabriel Rossetti
DHH	Diana Holman-Hunt: *My Grandfather, His Wives and Loves*
FGS	F. G. Stephens: *William Holman Hunt and His Works*
FMB	Ford Madox Hueffer: *Ford Madox Brown: A Record of His Life and Work*
Fredeman	William E. Fredeman (Ed.): *The PRB Journal*
JEM	John Guille Millais: *The Life and Letters of Sir John Everett Millais*
Landow I	George P. Landow (Ed.): *William Holman Hunt's Letters to Thomas Seddon*
II	*Your Good Influence on Me*
Lutyens	Mary Lutyens: *Millais and the Ruskins*
Surtees I	Virginia Surtees (Ed.) *The Diaries of George Price Boyce*
II	*The Diaries of Ford Madox Brown*
Troxell	Janet Camp Troxell: *Three Rossettis*
TS	John P. Seddon: *Memoir and Letters of the Late Thomas Seddon, Artist*
WBS	J. Minto (Ed.) *Autobiographical Notes of the Life of William Bell Scott*
Walker Cat	Mary Bennett: *William Holman Hunt: An Exhibition arranged by the Walker Art Gallery*
WHH	William Holman Hunt: *Pre-Raphaelitism and the Pre-Raphaelite Brotherhood*, second (1913) edition
WMR	William Michael Rossetti
TW	Amy Woolner: *Thomas Woolner, RA*

Manuscript Source Abbreviations

Bod	Bodleian Library
BL	British Library
FP	Family Papers in the possession of Paul A'Court Bergne, Esq. OBE

List of abbreviations

GHH History of the Pre-Raphaelite Movement, an unpublished
 work by Gladys Holman-Hunt
Ryl John Rylands University Library Manchester
ULL University of London Library

Source notes and references

CHAPTER 1: CHILD OF THE CITY (PAGES 13–23)
1. WHH I p. 3
2. WHH I p. 5
3. WHH I p. 5–6
4. WHH I p. 3
5. WHH I p. 4
6. GHH
7. WHH I p. 7–8
8. WHH I p. 19
9. WHH I p. 25

CHAPTER 2: THE VAGABOND PROFESSION (PAGES 24–34)
1. JEM I p. 45
2. WHH I p. 27
3. John Forster: *The Life of Charles Dickens*, p. 129
4. WHH I p. 45
5. WHH I p. 49–50
6. WHH I p. 52
7. WHH I p. 52–53
8. WHH I p. 55–56
9. JEM I p. 91
10. ibid
11. WHH I 59
12. WHH I 61
13. ibid
14. WHH I
15. JEM I p. 65

CHAPTER 3: THE BROTHERHOOD (PAGES 35–47)
1. WHH I p. 100
2. R.A. Catalogue 1849
3. WHH I p. 80
4. WHH I p. 96
5. FMB p. 64
6. WMR 1 p. 39–40
7. F. G. Stephens: *Dante Gabriel Rossetti*, 1894, p. 13

8. Ibid p. 14
9. WHH I p. 97
10. WHH I p. 154
11. WMR 1 p. 40
12. ibid p. 45
13. ibid
14. DHH p. 38
15. F. G. Stephens, *Dante Gabriel Rossetti*, 1894, p. 10
16. WHH I p. 96
17. WMR 6 I p. 71
18. FGS p. 10
19. Hall Caine, *My Story*, p. 117
20. WHH I p. 98
21. ibid p. 111
22. ibid
23. WMR 1 p. 133
24. WHH I p. 113

CHAPTER 4: BROKEN RANKS (PAGES 48–59)
1. WHH I p. 115
2. ibid p. 118
3. WMR 1 p. 145
4. May 1848
5. ibid
6. WHH I p. 126
7. ibid p. 125
8. ibid
9. Fredeman p. 188
10. WHH I p. 127
11. ibid p. 135
12. WMR 1 p. 60–62
13. D&W I p. 71–72
14. WMR 2 p. 12–16

CHAPTER 5: THE STORM BREAKS (PAGES 60–71)
1. Bod Ms. Don e. 76
2. *Oxford and Cambridge Magazine*, I, 1856
3. WBS
4. WMR 3, p. 490
5. WMR 2, p. 264–5
6. ibid p. 269
7. ibid p. 271
8. WBS

9. WHH I p. 138–139
10. ibid p. 139
11. ibid
12. 20 April 1848
13. 4 May 1850
14. Fredeman, p. 242–3
15. Dobbs p. 72
16. WHH I p. 144
17. May 1850
18. ibid
19. ibid
20. JEM I p. 75
21. WHH I p. 219
22. Bod MS Don e. 78

CHAPTER 6: THE LIGHT OF THE WORLD (PAGES 72–86)
1. Fredeman p. 71
2. WMR 1 p. 84–85
3. D&W I p. 97–98
4. WMR 2 p. 23
5. TW p. 10
6. TW p. 9
7. Bod. Don e. 78 f. 19
8. Bod Don e. 66
9. WMR 2 p. 291
10. WHH I p. 175
11. Fredeman 2 May 1851
12. FMB p. 73
13. FMB p. 77
14. Bod. Ms. Eng. lett. d. 40 f. 30
15. Fredeman 10 May 1851
16. JEM I p. 119
17. WHH I 192
18. JEM I p. 123
19. ibid p. 137
20. ibid p. 124
21. Dobbs p. 80–81

CHAPTER 7: STRAYED SHEEP (PAGES 87–101)
1. JEM I p. 129–130
2. ibid p. 132–133
3. ibid p. 134
4. Jeremy Maas, *William Holman Hunt and the Light of the World*

5. JEM I 151
6. WMR 1 II p. 119
7. George Birkbeck Hill (Ed.): *Letters of Dante Gabriel Rossetti to William Allingham, 1854–1870*, p. 24
8. FGS p. 20
9. Ms. letter, Manchester Art Gallery
10. BL Ms. 46912 f. 22
11. RYL Ms. letter to Combe 19.12.1876
12. Christopher Wood *The Pre-Raphaelites*, p. 48
13. DHH p. 89
14. WHH I 241
15. Bod Don e. 66 f. 9
16. Bod Don e. 66 f. 16
17. BL 46912 f. 21–23
18. Davidson, Angus: *Edward Lear Landscape Painter and Nonsense Poet*, p. 83
19. Troxell p. 36
20. TW p. 45–46
21. TW p. 58–59
22. TW p. 50–51
23. TW 58–59

CHAPTER 8: FOR THE EAST INDEED (PAGES 102–117)
1. Walker Cat p. 36
2. Lutyens p. 90–91
3. WHH I p. 258
4. ibid
5. ibid p. 264
6. Landow I p. 151
7. WHH I p. 362
8. Landow I p. 152
9. ibid p. 155
10. Lutyens p. 100–101
11. ibid p. 97–99
12. Landow I p. 157
13. WHH I p. 267
14. WHH I p. 272
15. TW p. 70–71
16. JEM I p. 403
17. TS 43–44
18. WHH I p. 276
19. Landow II p. 25–26
20. JEM I p. 404
21. TS p. 43

22. ibid p. 51
23. ibid p. 59
24. FMB p. 99
25. JEM I p. 232
26. ibid p. 230
27. ibid p. 131–2
28. WBS p. 320–321
29. TS p. 61
30. WHH I p. 297

CHAPTER 9: THE VISION OF DESOLATION (PAGES 118–132)
 1. April 1854
 2. Jeremy Maas, *William Holman Hunt and The Light of the World*, p. 57–58
 3. 29 April 1854
 4. Hill, George Birkbeck, *Letters of Dante Gabriel Rossetti to William Allingham 1854–1870*, p. 41
 5. 13 July 1854
 6. 17 May 1854
 7. 24 May 1854
 8. Landow I p. 159
 9. WHH I p. 413–414
10. Landow I p. 159
11. TS p. 94–95
12. Landow I p. 149
13. TS p. 108
14. WHH I p. 272
15. TW p. 70–71
16. TS p. 111
17. TS p. 124
18. RYL Eng Ms. October 1854
19. Allen Staley, *The Pre-Raphaelite Landscape*, p. 102
20. TS p. 127–128
21. JEM I p. 236
22. WHH I p. 315
23. JEM I p. 235
24. WHH I p. 318
25. ibid p. 319
26. Bod Ms. Eng lett c. 296 f. 48
27. WHH I p. 325
28. RYL Eng Ms. 1210, 7 Nov. 1854
29. Landow I p. 162
30. ibid p. 164
31. WHH II p. 2

32. Troxell p. 39
33. ibid p. 39–40
34. ibid p. 40–41

CHAPTER 10 THE HANNA HADOUB AFFAIR (PAGES 133–150)

1. JEM I p. 237
2. Surtees II p. 117
3. JEM I p. 254
4. DHH p. 163
5. WHH II p. 20
6. ibid p. 28–29
7. DHH p. 163
8. Bod Ms. Eng lett 296, 1 Feb. 1856
9. Surtees II p. 172
10. WHH II p. 1
11. Troxell letter 21 Mar. 1855 from WHH to DGR
12. FMB p. 125
13. WHH II p. 118
14. WHH II p. 94
15. Bod Ms. Don e. 66 f. 88 1 June 1864
16. WHH II p. 94
17. FMB p. 131
18. Surtees II p. 181
19. ibid p. 182
20. FMB p. 131–2
21. *Letters of Dante Gabriel Rossetti to William Allingham 1854–1870*, p. 139
22. Georgiana Burne Jones, *Memorials of Edward Burne Jones I*, p. 139
23. TS p. 165

CHAPTER 11: THE AWAKENING CONSCIENCE (PAGES 151–165)

1. Bod Ms. Don e. 66 f. 30
2. DHH 177
3. Bod Ms. Don e. 66 f. 32
4. Ryl Eng Ms. 1214 WHH to Edward Lear 13 Mar. 1857
5. ibid 16 April 1857
6. WHH II p. 111–112
7. ibid p. 122
8. ibid p. 122
9. Bod Ms. Don e. 66 f. 36
10. Tennyson, Hallam: *Alfred Lord Tennyson*, p. 352
11. ibid pp. 308–309
12. ibid p. 354
13. WHH II p. 137

14. Landow II p. 27
15. Surtees p. 9
16. FMB p. 163
17. Surtees I p. 24
18. Davidson, Angus, *Edward Lear Landscape Painter and Nonsense Poet*, p. 103
19. ibid p. 104
20. Noakes, Vivien *Edward Lear: the Life of a Wanderer*
21. ibid p. 111
22. ibid

CHAPTER 12: BLIGHTED HOPES (PAGES 166–179)

1. TW p. 159
2. Bod Ms. Don d. 137 f. 204
3. Bod Ms. Don e. 66
4. Surtees I p. 26
5. TW p. 165
6. ibid p. 185
7. Henry Holiday: *Reminiscences of My Life*, 1914, p. 66
8. WHH II p. 146
9. Morton N. Cohen, (Ed.) *The Letters of Lewis Carroll*, 1979, I, p. 42–43
10. Roger Lancelyn Green (Ed.) *The Works of Lewis Carroll*, 1965, p. 891
11. JEM I p. 357
12. WBS II, p. 38
13. TW 193
14. ibid p. 196
15. D&W II p. 366
16. WMR 5, p. 133–134
17. D&W I p. 366
18. WBS
19. William M. Clarke: *The Secret Life of Wilkie Collins*, p. 125–126
20. WHH II p. 168
21. ibid
22. John Forster, *Life of Charles Dickens*, p. 747
23. Kenneth Robinson: *Wilkie Collins: A Biography* p. 127
24. ibid p. 145
25. Hallam Tennyson, *Alfred Lord Tennyson*, p. 387
26. ibid
27. Caroline Fox: *Memories of Old Friends*, p. 325

CHAPTER 13: THE HAPPY BRIDEGROOM (PAGES 180–195)

1. Bod Ms. Don e. 66 f. 109
2. Henry Holiday, *Reminiscences of My Life*, p. 66

3. *Notes on the Pictures of Mr Holman Hunt, Exhibited at the Rooms of the Fine Art Society, 1886*, p. 11
4. WHH II p. 178
5. WHH II p. 176
6. WHH II p. 177
7. WHH II, p. 179
8. Gaunt p. 88
9. Bod Ms. Don e. 66 f. 70
10. Roger Lancelyn Green (Ed.): *The Diaries of Lewis Carroll*, I, p. 202
11. Bod Ms. Don d. 137 f. 205
12. TW p. 228
13. WHH II p. 183
14. ibid
15. WHH II p. 190
16. Bod Ms. Don e. 66 f. 78
17. ibid
18. BL Ms. 45741 f. 108
19. Gaunt p. 157
20. ibid
21. TW p. 248
22. TW p. 249
23. Bod Ms. Don e. 66 f. 99
24. ibid f. 124
25. ibid f. 127
26. Anne Clark: *The Real Alice*
27. ibid
28. Ryl Eng Ms. 1214, undated fragment
29. Bod Ms. Don e. 67 f. 2
30. ibid f. 3
31. Bod Ms. Don e. 80 f. 64
32. Bod Ms. Don e. 67 f. 6

CHAPTER 14: THE LONELY WIDOWER (pages 196–214)
1. TW p. 275–276
2. WMR 5 p. 225
3. JEM II p. 12
4. Diana Holman-Hunt, article 'The Holman Hunt Collection: A Personal Recollection'
5. JEM II, p. 13
6. WMR 5 p. 245
7. ibid p. 298
8. Ryl Eng Ms. 1213, 23 July 1869
9. Bod Ms. Don d. 137 f. 209

**Source notes and references**

10. Bod Ms. Don e. 67 f. 29
11. WBS p. 88
12. JEM I p. 412
13. TW p. 284
14. Edward Clodd: *Memories* p. 202
15. Gaunt p. 161
16. JEM I p. 415
17. Gaunt p. 170
18. DHH p. 273
19. ibid p. 274
20. WBS p. 102–103
21. JEM I p. 415
22. Bod Ms. Don e. 67 f. 90 .
23. John Forster, p. 748.
24. Bod Ms. Don e. 67 f. 94

CHAPTER 15: RETURN TO JERUSALEM (pages 215–236)
1. Ryl Eng Ms. 1215
2. Bod Ms. Don e. 67 f. 217
3. ibid f. 218
4. BL ms 43910 f. 113
5. ibid f. 121
6. BL Ms. 38794 f. 227
7. ibid f. 128
8. ibid f. 224
9. ibid f. 247
10. Bod Ms. Don e. 67 f. 247
11. Ryl Eng Ms. 1215
12. ibid
13. ibid
14. WBS p. 222
15. Noakes p. 286–7
16. Georgiana Burne Jones p. 69
17. ibid p. 70
18. 2 May 1881
19. Bod Ms. Don e. 57 f. 57
20. WBS p. 229–233
21. ibid p. 233
22. Ryl Eng Ms. 1215
23. WMR I p. 309
24. WBS p. 312
25. Landow 2 p. 278
26. WHH II p. 278

27. WBS 311
28. ibid p. 227
29. ibid p. 228–229
30. BL Ms. A3404 24 May 1883
31. ibid 12 July 1885
32. Rowley, Charles, p. 143–144
33. WBS p. 311
34. Bod Eng Ms. lett e. 118 8 Nov. 1884
35. Landow 2 p. 53
36. Gaunt p. 166
37. WHH II p. 300
38. Landow 2 p. 56
39. GHH
40. f. 39

CHAPTER 16: LAST JOURNEY TO JERUSALEM (pages 237–253)
1. AH p. 16
2. ibid p. 17
3. E. Clodd p. 202–203
4. Mary Bennett: *Artists of the Pre-Raphaelite Circle*
5. E. Clodd p. 204
6. William M. Clarke p. 324
7. Ryl Eng 1215
8. ibid
9. RYL Eng Ms. 1239
10. AH p. 31
11. FP
12. BL 46445 f. 61
13. FP
14. FP
15. Bod Ms. Eng lett e. 118 f. 4
16. AH 62
17. JEM II p. 315
18. Vyvyan Holland p. 204
19. AH 70
20. JEM II 330
21. ibid p. 331
22. ibid p. 416

CHAPTER 17: SHARING MILTON'S WOE (pages 254–273)
1. AH p. 75–77
2. WHHII p. 387
3. E. Clodd p. 197–198

4. 4 Aug. 1898
5. *The Times* 5 Nov. 1890
6. Charles Rowley p. 143
7. *The Times* 19 June 1901
8. Virginia Woolf p. 153–4
9. ULL Ms. 797 II 91/1
10. ULL Ms. I 3981
11. ULL Ms. I 3991
12. ULL Ms. 797 91/1 f. 43
13. C. Rowley p. 145
14. E. Clodd p. 199
15. ULL Ms. 797 II 91/2 f. 39a
16. Jeremy Maas, p. 194–195
17. Letters of George Meredith Vol. II
18. C. Rowley

Acknowledgements

I owe a very great debt of gratitude to Hunt's granddaughter, Diana Holman-Hunt, author of *My Grandfather His Wives and Loves*. As copyright holder of Hunt's unpublished writings, she has not only given me permission to quote, but has unselfishly devoted much of her own valuable time to smoothing the path for me and giving me the benefit of her expertise. I am almost equally indebted to her son, Paul A'Court Bergne, OBE (Hunt's great-grandson), for giving me access to the family papers, and to his wife Suzanne and son Sebastian (Hunt's great-great-grandson), who have disrupted their own busy schedules for the sake of my research. Mrs Elisabeth Burt, adopted daughter of Hunt's daughter, Gladys, generously gave me authority to study and quote from *History of the Pre-Raphaelite Movement*, an extensive unpublished work by Gladys Holman-Hunt, and I greatly appreciate this. Dr Judith Bronkhurst, an acknowledged expert who is working on a catalogue raisonné of Hunt's work, has given me invaluable advice, for which I am sincerely grateful.

I acknowledge with thanks the facilities afforded me by the Bodleian Library, the British Library, the Courtauld Institute, the John Rylands University Library of Manchester, the Tate Gallery, and the University of London Library. Others to whom I am grateful for information and assistance are Lady Chitty, Professor William E. Fredeman, Dr. Selwyn Goodacre, Professor George Landow, Jeremy Maas, Jan Marsh, Brian Riddle, and Edward Wakeling. I have been given permission to quote as indicated in the notes from published works by Oswald Doughty, J. R. Wahl and Oxford University Press; William E. Fredeman, Oxford University Press and John Rylands University Library of Manchester; George P. Landow and John Rylands University Library of Manchester, Mary Lutyens and John Murray; Jeremy Maas; and Virginia Surtees and Yale University Press.

Pictures are reproduced by kind permission of The Ashmolean, Birmingham City Museum and Art Gallery, Mrs Elisabeth Burt, the Courtauld Institute, The School of Art History and Music, University

of East Anglia, the Laing Art Gallery, Newcastle, the National Portrait Gallery, Graham Ovenden, The Uffizi Gallery, Florence, and anonymous private collectors.

Index

moves to Tor Villa, 152; begins
collecting furniture, 152–3; collapse
of plans to live in artists' colony, 154;
learns of Rossetti's affair with
Annie, 154; discovers Annie is sick,
and moves her to Mrs Stratford's
house, 156; stays with the
Tennysons, 157–8; acquires Boyce's
picture of Annie, 159–60; paints
Monk's portrait, 160; Dickens
publishes the 'Calmuck' libel, 160;
publishes *Bishop Gobat In Re Hanna
Hadoub*, 161; Annie reported to
police for rent arrears, 162;
proposes to Annie and is rejected,
163; Lear stays with him, 164–5;
rejected by Miss Strong and
reconciled with Annie, but learns
of her affair with Lord Ranelagh,
167–8; advised by Dickens to
charge 5,500 guineas for his picture,
170–1; best man at Charles Collins'
wedding, 175–6; tours with
Tennyson, Palgrave and Prinsep,
176–8; receives claim for Annie's
debts, 178; calls on Lord Ranelagh,
179; resists Annie's blackmail
attempts, 179; repeats a rumour about
Rossetti's procuring abortions,
Swinburne is falsely accused and
lawyers are consulted, 181–2;
defends Woolner against J.O.'s
attacks in *The Times*, 183–4; Prince
of Wales admires Hunt's work,
186–7; is best man at Woolner's
wedding, 189; courts Fanny Waugh
and marries her, 190–1; resists
Annie's final blackmail attempts
but suffers financial losses, 191–2;
leaves for the East with Fanny,
192–3; delayed in Florence, where
Cyril is born, and Fanny dies,
193–4; returns to England with
Cyril, who narrowly escapes death,
198; paints Edith Waugh's portrait,
and falls in love with her, but their
union would be illegal, 200; returns
to Italy, paints Miss Lydiard and is
rejected by her, 200; falls out with
Woolner over collecting, 201–2; is
visited by William Rossetti and John
Tupper, who nearly dies, 202–3;

meets Ruskin in Venice, 203; returns
to Jerusalem, and paints *The Shadow
of Death*, 204–10; is reunited with
Cyril in London, 210; Edith
announces her intention of marrying
him, 211; he draws Charles Collins'
death portrait, 212; marries Edith in
Switzerland, 213; returns to
Jerusalem, and starts work on local
canvas, 215; Edith is pregnant, and
he buys a plot of land, 216; sends
Dilke his views on the R.A., 216–17;
birth of Gladys and difficulties
registering birth, 217–18; sends Edith
and the children to Jaffa, 219; has
difficulties with canvas, 220–1;
returns to England, 221; exhibits in
Grosvenor Gallery, 222–3; contracts
typhoid in Paris, 223; fights the
Devil, 224–5; birth of Hilary, 226;
quarrels with Stephens, 227; moves
to Draycott Lodge, 228; boils a horse,
228; mourns Rossetti's death, 229; is
visited by Ruskin, 230; has financial
difficulties, 232; lies at death's door,
235; his articles in the *Contemporary
Review*, 235; *The Light of the World* is
damaged, 236; he unveils the Rossetti
memorial, 237; death of his uncle,
238; last visit to Mrs Combe, 247–8;
final tour of the East, 244–6; Mrs
Combe's bequest, 247–8; elected
President of the Sunday Society,
248–9; he opposes the release of Oscar
Wilde, 250; is pall-bearer at Millais'
funeral, 252–3; his 70th birthday,
254–5; his letters to *The Times*,
256–7, 259–60; Richmond paints his
portrait, 257; the portrait is
presented, 257–8; onset of blindness,
258; he enlists Edward Hughes' help,
259; moves to Melbery Rd., 260;
builds cottage at Sonning, 262; sells
The Light of the World to Booth,
263; his picture goes on tour, 264,
267–9; his eye operation, 264; he
receives honorary degree and the
Order of Merit, 266; his exhibitions,
269–70; unveiling of *The Light of the
World* in St Paul's, 270–1; his last
days at Sonning, 272; his death at
Melbury Rd., cremation and State

Rathbone, Harold Stewart, 243
Reach, Angus, 66
Renunciation of Queen Elizabeth of Hungary, The (Collinson), 67
Reynolds, Sir Joshua, 37, 38, 251
Richmond, Sir William Blake, 174, 251, 257, 259
Rintoul, Henrietta, 146
Rogers, Henry, 21
Rossetti, Christina Georgina, 35, 38, 41–2, 51, 60, 61, 72, 92, 255, 256
Rossetti, Dante Gabriel, 8, 9, 11, 34–51, 53–8, 60–3, 66, 67, 73, 74, 80, 82, 85, 90–2, 95, 98–101, 103, 106, 109, 110, 115, 119, 131–3, 141, 142, 145–9, 153–5, 158–60, 173, 181–3, 196, 222, 229, 230, 234, 235, 237, 248, 253, 254, 256
Rossetti, Mrs Frances Mary Lavinia, née Polidori, 35, 41
Rossetti, Gabriele Pasquale Giuseppi, 35
Rossetti, Maria Francesca, 35
Rossetti, William Michael, 35, 38, 40–3, 45, 46, 50, 52, 54, 55, 60–3, 66, 72–4, 78, 82, 92, 95–8, 110, 133, 141, 146, 173, 194, 202, 203, 221, 229, 234, 235, 253, 272
Rowley, Charles, 232, 258, 264, 265, 271
Royal Academy, 36, 49, 67, 77, 87, 93, 101, 118, 119, 132, 136, 141, 147, 154, 159, 171, 172, 182, 198, 216, 217, 222, 249–52
Ruskin, Euphemia *see* Millais
Ruskin, John, 30, 31, 33, 34, 80, 81, 94, 97, 104, 107, 108, 153, 158, 203, 222, 226, 230, 231, 234–6

Sass's Academy, 35, 54, 64
Scott, William Bell, 41, 61, 64, 67, 115, 173, 174, 204, 208, 221, 224, 229–33, 237, 243
Seddon, Mary, 119
Seddon, Thomas, 101, 107, 109, 111–25, 133, 141, 147–50, 206
Shields, Frederick, 242–4, 265
Siddal, Elizabeth, ('Lizzie', later Rossetti), 64, 72, 75, 90, 103, 106, 133, 141, 143, 146, 147, 153, 154, 174, 229

Sim, Dr Robert, 123, 124, 133, 136, 139, 201, 206
Smith, Bernard, 38, 95, 97
Soleiman, 129, 130
Stephen, Leslie, 257
Stephens, Mrs Clare (formerly Clara Charles), 12, 13, 191, 201, 212, 221, 226, 227
Stephens, Frederic George, 11, 12, 13, 38, 40, 42, 43, 60, 63, 66, 73–5, 92, 93, 95–100, 103, 133, 141, 142, 145, 151, 152, 154, 156, 162, 163, 168, 178, 179, 185–7, 189–91, 193–5, 198, 201, 208, 211–13, 218, 220, 221, 223–7, 235, 242, 253
Stephens, Septimus, 38
Stephens, Holman ('Holly'), 201, 227
Stone, Frank, 62, 66, 68, 78, 118
Stratford, Mrs (Annie Miller's landlady), 156, 162, 167, 178, 179
Strong, Miss, 167
Swinburne, Algernon Charles, 174, 181–2

Tennyson, Lord Alfred, 143, 145, 157, 158, 176–8, 238
Tennyson, Mrs Emily, 157, 158, 166, 173, 178, 238, 265
Thackeray, William Makepeace, 144
Thomas, William Cave, 60
Thomson, Thomas Ranelagh Jones, 178–9, 191
Trevelyan, Lady, 174, 180
Tupper, George, 69, 73, 90
Tupper, John, 73, 75, 90, 202, 203
Turner, J. M. W., 22

Varley, John, 20
Victoria, Queen, 13, 173, 210, 273

Waterford, Marchioness of, 105
Watkins, Emma ('The Coptic'), 11, 90, 96, 160
Watts, George Frederick, 144, 145, 233, 248, 256, 259
Waugh, Alex, 206
Waugh, Alice (later Woolner), 12, 13, 186, 189, 211, 247
Waugh, Evelyn, 8, 9, 12, 13
Waugh, Fanny, *see* Hunt
Waugh, Dr George, 12, 166, 181, 186, 199, 211, 213